Cézanne

Opposite
Mont Sainte-Victoire from Les Lauves
(detail of 194),
1902–4.
Oil on canvas;
69·8 × 89·5 cm,
27¹⁄₂ × 35¹⁄₄ in.
Philadelphia
Museum of Art

Paul Cézanne's role as a forefather of early twentieth-century painting has provided him with an almost mythical status in the annals of modern art. Yet, as even his peers would attest in the painter's lonely old age, his stature within his own cultural landscape – that of late nineteenth-century France – was also colossal. Both his art and ambitions, in fact, would be informed by the distinctive social and historical circumstances of his era and by specific milieus. As opposed to many previous critical assessments of his work, one of the chief aims of this study will be to re-examine Cézanne's painting and professional life within its original context.

Cézanne was born in Aix-en-Provence in 1839. In his early twenties he travelled to Paris where he met with rejection from the official art world, for whom he would always be a remote, southern provincial. The rebuff led to his return home, thus establishing an alternating pattern of living in and around Paris and in southern France that he followed for much of his working life.

Although we can track, especially in his landscapes, Cézanne's peripatetic career, his work does not present itself as a tidy gloss on his life. Surprisingly, given his later critical renown, we know little of the painter's biography or even his ideas about art. His surviving letters to friends offer only glimpses of his theories and aspirations, while the inventive portrayals of him in the fiction of his friend, the writer Émile Zola, and even the enthusiastic accounts of Cézanne's earliest biographers, such as the Provençal poet Joachim Gasquet, offer material that is fragmentary or coloured by the authors' own agendas. Likewise, Cézanne's paintings

Cézanne Mary Tompkins Lewis

ART&IDEAS

Φ

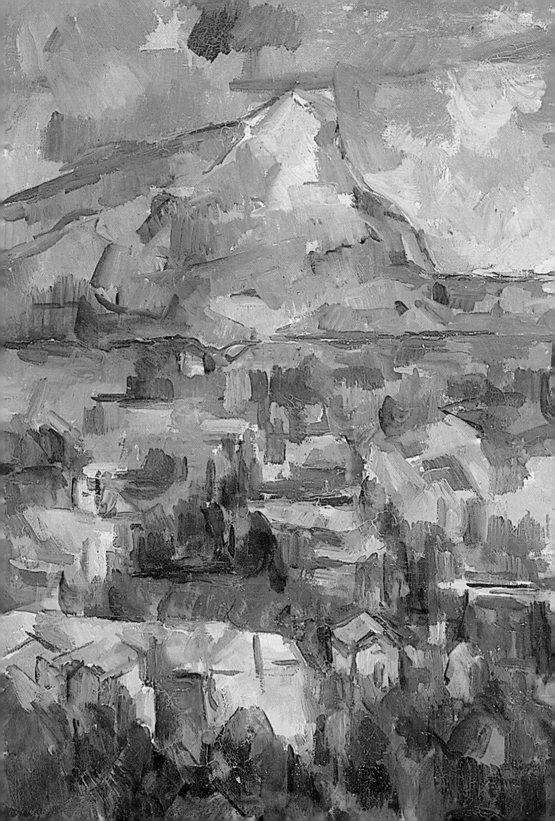

offer few directly narrative reflections of his conflicted personal relationships, notorious fearfulness of women and ambivalent yearning for both fame and isolation. Instead, the character of a sometimes tormented psyche, its doubts, loves and enmities, is met and mastered only on the surface of the paint, in a quest for formal values that could reconcile past and present and combine suffused narrative and pure form.

If Cézanne's work seems poised between a monumental past and an uncertain present, this was also true of late nineteenth-century France. The post-Napoleonic years had been mired in successive political and social upheavals, and the humiliating defeat and turmoil of the Franco-Prussian War (1870–1) only further clouded the nation's dark perception of itself. Doubt about France's cultural supremacy, its moral stability, even its physical vitality as a people, produced a concomitant rejection of authority, political ferment and a breakdown of the social order out of which would rise, in essence, France's modernity. Cézanne's belaboured attempts to fuse the transient vision of the Impressionists with the ideals and monumentality of the Old Masters capture with vivid strokes the battle for the very soul of French culture that was played out in the 1870s and 1880s.

In the arts, the hierarchies of the government-sponsored institutions, which reflected the stranglehold of the monarchy, were gradually subverted. The slow death of academic history painting, for example, long promoted by the authorities for the lessons in moral virtue it presented from literature and history, and the rise in its place of Realist genre and landscape, painted in *plein air* (open air), was only one sign of the new democratized order. Cézanne arrived in Paris in 1861, eager to fight in the great battle between the venerable titans of Neoclassicism and Romanticism, Jean-Auguste-Dominique Ingres (1780–1867)

and Eugène Delacroix (1798–1863), which had inspired so much early nineteenth-century painting. And he would always profess his allegiance to the masterful Romantic and colourist Delacroix, describing his plans to produce an apotheosis to the painter that would take shape only at the very end of his life (1). But he had realized long before that the battlefield of nineteenth-century art, like the history and culture that produced it, had changed irrevocably.

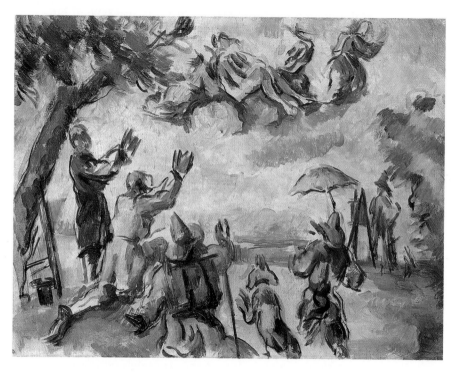

1
Apotheosis to Delacroix,
1890–4.
Oil on canvas;
27×35 cm,
10⅝×13¼in.
Musée Granet,
Aix-en-
Provence

Cézanne conceived of his art as distinctly different genres, and so should we. Although this book follows a loosely chronological approach, it is one that the artist himself makes problematic: because Cézanne signed and dated almost nothing in his career and was often quite casual in storing his works (he destroyed many) or assigning them specific titles, questions of chronology and provenance have always loomed large in any critical assessment of his work. Also, though there are points of intersection, his style did

not develop consistently in each of the thematic areas he treated, and this was part of his genius; the effects of his exquisite powers of observation when painting a motif in the landscape, for example, could hardly be expected to coalesce with those of the inventive skills he summoned when painting from his imagination. Thus, an underlying thread of the sequential narrative that follows is the artist's investigation of each of the great genres or categories of painting as unique in itself, one that was aided by an awareness, study and comprehension of the art of the past, even the quite recent past, that was unmatched by his peers.

And it is only one measure of the breadth of Cézanne's ambition and achievement that, unlike most of his Impressionist colleagues who came to specialize in one or two thematic areas (Claude Monet, 1840–1926, for example, chose landscape; Pierre-Auguste Renoir, 1841–1919, in his later years, portraits and nudes), Cézanne tackled them all. In the self-conscious, parodic mode of his first decade, and later in his ordered, sensate constructions before nature, Cézanne plumbed the traditional genres of art: history painting, the historic and *plein-air* landscape, figural narrative, realist genre, portrait, still life and the idealized nude, and one by one divulged their historic origins and their tired, spiritual insufficiency for late nineteenth-century France. His consuming passion, as he once described, 'to make of Impressionism the art of museums', involved doing so on his own terms, transforming each of these themes into ones that were original, grounded in the physical reality of a paint-laden surface indebted to Impressionist principles, and thus constantly challenging the cherished hierarchies around which those traditions revolved.

And to each of the genres he considered and contributed, Cézanne brought his own distinctive vision. In his landscapes of Provence, for example, the icons of his native countryside that are so familiar to modern viewers, Cézanne

reveals a sense of place and of history as powerful as any of his Romantic forebears, and a deeply felt, regionalist expression of a larger nationalist tide. In his still lifes, long the favoured genre of the forthright Realist painter, Cézanne focused so hard on the object and its effect, exerting so much energy into the effort, that, as the twentieth-century critic Clement Greenberg described, it is the paint and the painter who become most real. And in his paintings of bathers, the curious hybrids of fantastic figures and landscapes that so captivated Cézanne through-out his career, the depth of his painterly imagination and of his transgressive boldness is revealed.

Rich in its diversity, Cézanne's painting is bound together by the artist's incredible pictorial intelligence, his awareness of the past and of the physical properties of painting itself. More than any of the Impressionists, whose art has long been popular and accessible to viewers, Cézanne was a painter's painter. It was from his fellow artists that he received his first, most consistent and, with few exceptions, until the very end, his only expressions of support. After Camille Pissarro (1830–1903), one of the most encouraging was Monet, who purchased his work and showed it with great pride in his home at Giverny. But the Provençal painter's example could also be daunting, even to a painter who enjoyed tremendous success: when Monet was strug-gling or near despair in his work, his wife would quietly put away his Cézannes until the moment had passed.

A passionate, renegade painter in his early career, Cézanne remained a rebel even in old age, if not as blatantly as before. Having transformed in his art each of the themes he explored, Cézanne revolutionized the medium and reception of painting itself, at the end refocusing his and the viewer's attention on the physical properties and process of painting. More than any new formal systems, this was his legacy; it was also, as we will see, his liberation.

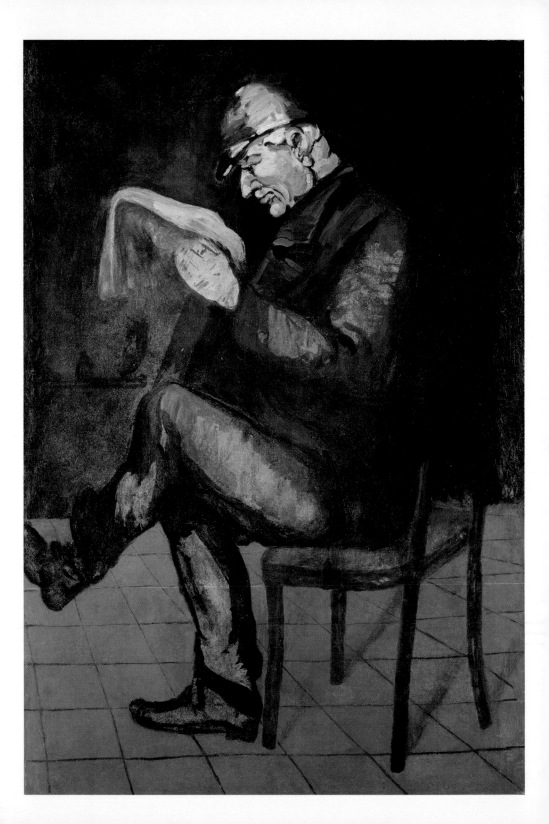

The environs of Aix-en-Provence, Paul Cézanne's home
town, are marked forever by his acute eye – sun-drenched
landscapes lushly planted with wheat, vineyards and
olives, solemn forests dominated by Mont Sainte-Victoire,
terracotta-coloured houses stacked on hillsides.

Cézanne was born in Aix on 19 January 1839 to Louis-
Auguste Cézanne, a struggling supplier and exporter of
hats (his millinery shop was at 55 Cours Mirabeau), and
his mistress, a former shopgirl, Anne-Elisabeth-Honorine
Aubert. The artist's sister Marie arrived two years later,
and in 1844 their parents were finally married. Another
decade passed before a third child, Rose, was born in 1854.
By then Louis-Auguste, despite humble beginnings in a
small village in the Var, a region to the east of Provence,
was enjoying new prosperity as a banker and moneylender
to local businesses. Yet, even though his affluence gave
him a certain status, the elder Cézanne and his family were
shunned by the local populace. Nurtured by centuries of
aristocratic tradition, native pride and a unique provincial
culture, nineteenth-century Aix-en-Provence defiantly
clung to its illustrious past. When the painter's childhood
friend, the writer Émile Zola, grumbled that their town
was 'asleep', 'living on its memories' and 'frozen in the
arrogant airs ... of its past', his peevish adolescent complaint
contained more than a grain of truth.

Boasting ancient hot springs, Aix was founded in 123 BC
as a Roman military outpost and spa. Much of the city's
culture and character has revolved around its Roman history
and its thermal baths. These still emit lukewarm and faintly
pungent waters, reminders of the days when wealthy visitors

2
*The Painter's
Father, Louis-
Auguste Cézanne,*
c.1862–5.
Oil on house
paint on
plaster;
167·6 × 114·3 cm,
66 × 45 in.
National
Gallery,
London

Edit. Rolland

AIX — Fontaine d'Eau Chaude

came to Aix to seek the waters' cures and enjoy the city's unhurried pace and gracious lifestyle. The outskirts of the city are still dotted with the ruins of aqueducts and reservoirs, and its streets punctuated with natural fountains.

The imposing bluffs of nearby Mont Sainte-Victoire are visible from almost any point in the city. According to legend, the brilliant red earth of the surrounding plain acquired its hue from the blood of invading Teutons whom the Roman consul Caius Marius defeated in battle in 102 BC. More peaceful events are associated with the mountain of Sainte-Baume rising further east, which was a medieval pilgrimage site and shrine to St Mary Magdalene. The patroness of Provence, she was believed to have spent her final years in these mountains, living in a cave as a hermit. Mary Magdalene too would figure in Cézanne's early work.

In the thirteenth century, Aix became the capital of Provence, with its own elaborate and self-conscious culture. Its troubadour poets celebrated its classical past in the

region's vernacular tongue, the *langue d'oc*. During his long reign, the Count of Provence, the 'good René' d'Anjou (r.1434–80) whose court at Aix became the toast of Europe, brought the city its first real taste of independence and prosperity. Well loved for the popular *fêtes* he introduced in Aix and for the Muscat grape he brought to the region, René's renown was to be recalled and celebrated during Cézanne's youth.

3
The Cours
Mirabeau,
Aix-en-
Provence, late
19th century

With the death of René's successor, Charles, Count of Maine, in 1481, the title to Provence reverted to the French crown, and Aix was once more relegated to provincial status. Turning inward, the region evolved a tradition of literature, music and art that would flourish in opposition to the cosmopolitan example of Paris. Four centuries later, Cézanne exemplified this spirit of independence in his self-imposed alienation from the capital and its tastes.

Provençal culture reached, perhaps, its fullest flowering in the seventeenth and eighteenth centuries. Along with a new provincial government, elegant new neighbourhoods graced by wide avenues like the Cours Mirabeau (3) and a substantial surge in population, this era gave rise to a distinctive school of painting, the École d'Aix. Its masters, Louis Finson (1570–1617) and Jean Daret (1613–68), were deeply influenced by the naturalism, dramatic light and poignant spirituality of the Italian artist Caravaggio (1571–1610). Finson's religious works and Daret's genre and mythological scenes were well known to Cézanne from his trips to local museums and are echoed in some of his early pictures. The canvases of Daret and Finson also decorated many of the local churches, and their paintings, including a few remarkable frescos, adorned the walls of many of the yellow–stone mansions which, with their red roofs and delicate iron balconies, still line the city's major thoroughfares.

After centuries in the limelight, Aix fell into decline in the years following the French Revolution. Progress itself

seemed to abandon Aix when the great French railway connecting Paris, Lyon and Marseille bypassed the city. Yet the town's isolation and apparent sleepiness contained within it the seeds of another, quieter flowering. While nearby Marseille became a bustling modern port and commercial gateway to the world, nineteenth-century Aix developed into the centre of a Romantic movement focused on its rich cultural past, one that Cézanne would embrace even in his youth. Reflecting not only the nationalist sentiment that swept nineteenth-century France as a whole but also a tangible nostalgia for its own bygone glories, the city of Cézanne's early years stubbornly, but triumphantly, resisted modernity.

A revolution of a different kind also took shape in Aix throughout the nineteenth century, one that more closely mirrored the fate of the French nation but may also have gathered impetus from the dramatic shift in the city's fortunes. By 1848, inefficiency together with the country's economic and political uncertainty had caused numerous commercial establishments in Aix to fail. As the aristocrats of old Aix watched its precipitous decline, and with it that of their own established fortunes, an emerging middle class seized the new opportunities offered to them by the economic and social upheaval. Taking control of local commerce, annexing small industries, buying up old estates and city mansions, and gradually gaining a foothold in the local government, the new bourgeoisie forced Aix to confront the present.

It was at this point that Louis-Auguste Cézanne, whose flourishing millinery shop and general business acumen left him unscathed by economic vicissitudes, was able to buy the remaining bank in town. Like many of the newly successful, whose prosperity only served to emphasize the decline of the old order, he was resented by aristocrats and working class alike and failed miserably when he tried for

election to the municipal council. Bold, brash and arrogant, his lowly origins, illegitimate children and the cold ambition and authoritarian demeanour that infuse Cézanne's early portraits of his father (2) pushed Louis-Auguste instead to the very edges of Aixois society.

Much less is known about Cézanne's mother. Tall, dark and quiet, she lived her adult life very much in the shadow of her overbearing husband. Even as a wealthy matron of Aix, Madame Cézanne remained almost totally illiterate, but although she seldom posed for her son and never fully understood his painting, she was devoted to his artistic ambitions. Comparing him to the Old Masters, she argued persuasively over Cézanne's future with the implacable Louis-Auguste and took her son's work with her whenever the family went to stay in the country.

Inevitably, our knowledge of the rest of the Cézanne family is refracted through Paul Cézanne's experience. Like his mother, the artist's sister Marie offered support and guidance, although she too later admitted to never understanding his art. A spinster and devoutly religious, she was always her father's favourite, probably because of her strong will and dominant personality. As her parents aged, she took over the running of the Cézanne household and estate, and also managed the finances of her brother, who spent long periods of his career working at home even after he had married. Marie's sustained devotion may have finally had a telling influence. When Cézanne, who had renounced religion in his youth, began to practise his faith again in old age, his friends suspected the intervention of his pious sister.

His younger sibling, Rose, born when Cézanne was already fifteen, seems to have played a much smaller role in his life. She married a wealthy local man and went to live in a large Provençal farmhouse in Bellevue, near Aix, which Cézanne would later paint. Both sisters seem to have been relatively

unaffected by much of the social ostracism which Louis-Auguste brought on his family, but the shy and sensitive young Paul suffered intensely despite the material comforts that surrounded him.

As the eldest child and only son of a provincial bourgeois family, Cézanne enjoyed a privileged childhood and solid classical education. He attended the École Saint-Joseph and then, as befitting his father's new-found stature, entered the more prestigious Collège Bourbon in Aix in 1852, when he was thirteen. Although introspective and temperamental, he was a diligent student and excelled in mathematics, science, history, Greek and Latin. He could quote effortlessly from Horace, Virgil and other classical authors, and some of his later painting was shaped by ancient literature. As a schoolboy, however, Cézanne devoted himself above all to writing florid and intense verse. Preserved in his earliest letters, these are often saturated with lurid or erotic visions, and reveal the passionate and at times tormented side of his character that would figure equally in his first paintings. In one poem, which Cézanne also crudely illustrated, a father serves his family a severed human head at the dinner table, while his children beg for more. And in *Une Terrible Histoire*, set in a desolate, black forest at midnight, a poet is stalked by Satan and embraced by a skeleton.

Though hardly masterpieces, Cézanne's emotional first poems won the admiration of his closest friend at the Collège Bourbon, Émile Zola. Small for his age, Parisian by birth and the son of a young widow who lived in poverty in Aix, Zola too had few friends and even less social status than Cézanne, who was one year older. As he later described their friendship, he found in Paul a loyal protector from 'the vulgar herd of dunces we had to contend with in class' and a kindred romantic spirit. Ironically, these twin giants of prose and paint started off down opposite paths. The youthful Zola poured much of his early energy into his art and

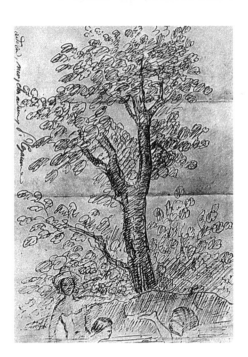

4
Bathing,
20 June 1859.
Pen drawing
on a letter to
Zola.
Private
collection

won numerous drawing prizes at school, while his friend,
Paul, awash in uncontrolled feeling, fancied himself a
writer. Yet, despite their marginal social status in Aix, they
shared (with a third compatriot, Baptistin Baille) romantic
dreams of a carefree youth and an illustrious future.
Roaming the Provençal countryside, swimming in the Arc
river, hunting and vigorously reciting poetry, the trio
became known as the 'inséparables'. One of the first surviv-
ing drawings from Cézanne's hand is, in fact, a rough pencil
sketch of three young swimmers under a spreading tree (4),
a vivid memory of just such expeditions. Zola, too, recalled
this idyllic period of their adolescence in his later memoirs:

We were three friends, three scamps still wearing out trousers on
school benches. On holidays, on days we could escape from study,
we would run away on wild chases cross-country. We had a need
of fresh air, of sunshine, of paths lost at the bottoms of ravines ...
In the winter, we adored the cold ground, hardened by frost ... In
the summer all our meetings took place at the riverbank, for then
we were possessed by water ... In the autumn, our passions

changed, we became hunters ... The hunt always ended in the shade of a tree, the three of us lying on our backs with our noses in the air, talking freely about our loves. And our loves, at that time, were, above all, the poets.

In nineteenth-century Aix-en-Provence, the Romantic movement took a firm and lasting hold, and provided yet another outlet for the three young dreamers. Native pride in its regional literature and cultural traditions and contemporary French nationalism brought a new awareness of provincial legacies. Protective of both their ancient tongue, the harmonious *langue d'oc*, which dated from Roman Gaul, and their specific culture, with its unusual blend of antique and medieval characteristics, regional poets joined together in Provence to rekindle their past. In 1854 a formal association was established, comprising seven Provençal poets, dedicated to spearheading this revival. The group was called Le Félibrige ('the Provençal writers') and its foremost member was Frédéric Mistral, who would later become a Nobel laureate.

The influence of Le Félibrige, and especially of Mistral, is threaded through the work of Cézanne and Zola, both of whom documented childhood experiences of the Provençal revival and drew on the heritage these poets illuminated. In his allegorical poem 'Calendau' of 1867, for example, Mistral celebrated the recent revival of the famed Aix *fête-Dieu*, an elaborate spectacle of Christian and pagan processions that dated to the time of René d'Anjou, and which Cézanne would one day sketch. And as an old man writing his memoirs, Mistral proudly noted the attendance of the young Zola, then a schoolboy at the Collège Bourbon, at one of the first poetry festivals the revival brought to Aix.

The energy and colour of the Provençal revival provided Cézanne with ample subject matter, as his untutored but exuberant early sketches attest. The acquisition of technique was a drearier matter. As early as 1854, when he was fifteen,

and no doubt with Zola's encouragement, Cézanne began to attend formal classes at the municipal drawing school in Aix, and by 1857, though he was still attending the Collège Bourbon, he had enrolled as a student of the local painter Joseph Gibert (1808–84). There he met Achille Emperaire (1829–98), whom he would later portray, Numa Coste (1843–1907) and countless other struggling young art students. Like most nineteenth-century art curriculums, especially those in the provinces, Gibert's teaching seemed designed to quell any spark of imagination. His classes emphasized only the superficial tricks of the trade – technical skill and tedious copying.

Unsurprisingly, apart from his freehand sketches, Cézanne's student output in Aix was wooden and dull. Only once did he come home with a prize. Despite his interest in art, he had no real sense of what he was going to do with his life. Yet his earliest sketchbooks, filled with rough drawings, scribblings, feverish poems and private notations, provide the first glimpse of the passion he would bring to his later art, and of recurrent bouts of despair that either fed or extinguished it. 'I am heavy, stupid and slow,' he wrote at this stage. The perceptive Zola excused Cézanne's frequent fits of rage or melancholy (in a note to their mutual friend Baille), saying, 'You must not blame his heart but rather the evil demon which beclouds his thought.'

Inner torments did not, clearly, prevent Cézanne's eventual development as a painter, though he suffered the usual disadvantages of a provincial birth. Like many art students far from sources such as the Louvre in Paris, he began to paint rudimentary replicas of paintings in the local museum, which had been founded the year before he was born. Although it gave pride of place to the seventeenth-century École d'Aix and also held a few real treasures, the work displayed in the Aix museum was on the whole far from distinguished. There were a number of paintings and

luminous, open-air sketches by the distinguished native artist François-Marius Granet (1775–1849), as well as a magnificent portrait of him as a student in Rome and several other important works by his more famous friend, Jean-Auguste-Dominique Ingres. Most of the collection, however, had been donated by the government. This type of legislative support for the arts involved numerous purchases at the officially sanctioned, competitive exhibitions of the Paris Salon, which for over a century had shaped French art and public taste, and then the dispersion of the most dismal acquisitions to the provinces. In 1857, when it acquired the abysmal *Kiss of the Muse* by Félix Nicolas Frillie (1821–63), which Cézanne mystifyingly chose to copy,

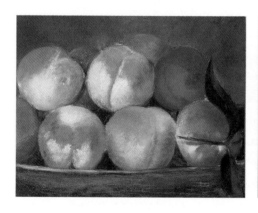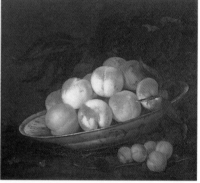

even the conservative art community in Aix complained about the crushing mediocrity of its bequests.

Cézanne's exposure to good painting in his youth, as his early works attest, was remarkably slight. It is hard to decide which is the more disturbing: the vapid character of the works he chose as models, or what the Cézanne scholar John Rewald has called his 'excruciatingly faithful' renditions of them. Only once, in a boldly cropped copy (5) of an earlier still life of peaches (6; attributed by some to the Dutch artist Aelbert Cuyp, 1620–91), did Cézanne offer some hint of his future promise.

The carefree days of Cézanne's boyhood came to an end when poverty forced Zola and his mother to move to Paris in 1858. Their friendship continued, however, in the voluminous letters that give us our truest sense of their mutual affection and common ambitions. Zola would write to Cézanne that he found Paris, then undergoing massive reconstruction, 'full of amusements, of monuments, of charming women', but he could not disguise his isolation and homesickness for Aix and all that it contained: his young friends, the annual *fêtes* and 'the picturesque landscape of Provence' that figures in his later novels and in so many of Cézanne's paintings. When Zola returned to Aix in the summer of 1858 to spend his vacation with his friends, they relived with relish the rituals in the countryside that had indelibly marked their youth.

After failing his baccalaureate in July 1858, Cézanne passed the examinations in November and, having completed his formal education, once more took classes in the local drawing academy. His father, however, had other plans for him. Louis-Auguste insisted that Cézanne enrol in the law school of the University of Aix, perhaps believing that a legal degree might prepare him for a position in the family bank. Cézanne's bitter letters to Zola reveal (in rhyme) his almost immediate disgust:

Alas, I have chosen the torturous path of Law.
I have chosen, that's not the word, I was forced to choose!
Law, horrible Law of twisted circumlocutions,
Will render my life miserable for three years.
Muses of Helicon, of Pindus, of Parnassus,
Come, I beg you, to soften my disgrace.
Have pity on me, on an unhappy mortal
Torn against his will away from your altar.

His college notebooks, scattered with fragments of legal texts and countless pen-and-ink sketches, illustrate even more poignantly his disillusionment.

5
Still Life with Peaches, 1862–4.
Oil on canvas;
18 × 24 cm,
7⅛ × 9½ in.
Private collection, on loan to the Art Institute of Chicago

6
Attributed to Aelbert Cuyp, *Still Life with Peaches,* mid-17th century.
Oil on wood;
37·6 × 42·1 cm,
14¾ x 16½ in.
Musée Granet, Aix-en-Provence

Increasingly frustrated with his studies and also with the drab provincialism of Aix ('a habitual and regular calm envelops our dull city in its sullen wings,' he complained), Cézanne at last began to have a clear vision of his future, to dream, as he recounted to Zola in a letter of 1859, of a studio in Paris, and of becoming an artist. And although he endured two years of legal studies and of constant struggle with his father (countered by numerous letters of encouragement and goading from Zola), Cézanne's vision began slowly to prevail. When Zola paid another visit to Aix in July 1859, the three 'inséparables' once more resumed their hikes through the countryside. This time, as Zola would later recall, Cézanne brought his paintbox. Dressed as rustic bandits, a popular theme in the painting of the time, his friends posed for one of the artist's first recorded paintings, which he would entitle *The Brigands*. It marks, perhaps, the point in time when Cézanne's youth and his adult life meet at the edges of his canvas.

Louis-Auguste's ambitions, never slight, were not limited to the future of his son. Not long after he pushed the reluctant Paul into law school, he purchased, in September 1859, the Jas de Bouffan (in Provençal, the 'Residence of the Winds'), a magnificent estate on the outskirts of Aix chosen to reinforce the family's social status (7). Its thirty-seven acres included a farm, vineyards, an elegant avenue lined with chestnut trees, a square pool with stone statuary and an eighteenth-century mansion that had served as a residence for the governor of Provence under Louis XIV. Although the main house was a shambles and would only be partially restored by its new owners, the Jas de Bouffan allowed the banker's family, like the established local aristocrats, to escape the hot summers in town. Once more, the presumptuous parvenu infuriated his Aixois neighbours.

The Jas de Bouffan was not only a proud acquisition and a promising investment for Louis-Auguste; it would become

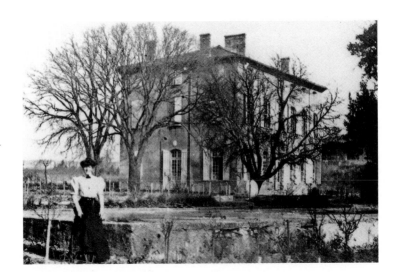

7
The Jas de
Bouffan, Aix-
en-Provence,
c.1900

a refuge for his romantic son throughout his life. In his
youth, the Jas de Bouffan provided Cézanne with a private
sphere in which he could freely experiment with a wide
range of themes and painting styles. Shielded from the
curious and unsympathetic eyes of his Aixois neighbours,
Cézanne often stayed there in his later years as well and the
estate's expansive, peaceful grounds, pool and stately façade
figure frequently in his art. It was here that he would first
test his dream of becoming a painter – against his own
developing instinct and under the scrutiny of his family,
especially of his harsh and sceptical father. By the end of
the 1860s, Cézanne had produced in its stately salon a large
and diverse ensemble of works that drew (sometimes ironi-
cally) on virtually everything he had yet seen, allowing him
to assess his own art against the backdrop of many prece-
dents. His paintings in the Jas de Bouffan can be viewed as
a vivid and immediate record both of these early influences
and of what the artist had to struggle to overcome.

Shortly after his father purchased the Jas de Bouffan,
Cézanne began work, reportedly with Zola's assistance, on
a large six-panelled folding screen that became something
of a touchstone for his later *œuvre*. Although some scholars
have seen in the work the hand of a previous artist, Cézanne

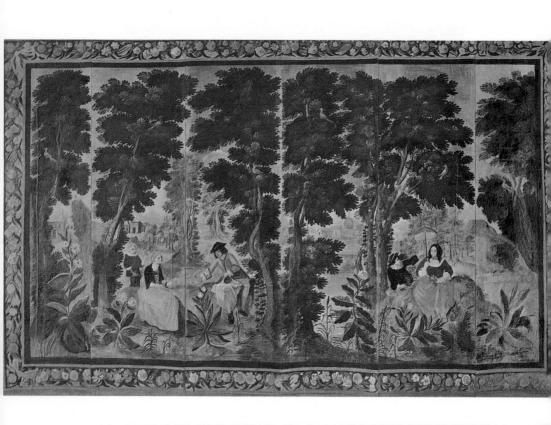

8
Decorative
screen,
*c.*1859.
Oil on canvas;
250 × 402 cm,
98³⁄₄ × 158⁷⁄₈ in.
Private
collection

9
*The Four
Seasons,*
c.1860.
Wall-painting,
detached and
mounted on
canvas;
h.314 cm, 124 in.
w.97, 109, 104,
104 cm,
38, 43, 41, 41 in.
Musée du Petit
Palais, Paris

seems, at the very least, to have added its two *fêtes-galantes* – scenes of stylish eighteenth-century figures in luxurious, wooded settings (8). Like other Provençal artists of his day and several contemporary critics, Cézanne was drawn to the art of the French Rococo school. As epitomized in the work of Jean-Antoine Watteau (1684–1721), Rococo paintings of a delicately perfect nature, depicting graceful figures in idealized, sunlit landscapes and exhibiting an equally sumptuous sense of luminous colour and painterly brushwork, were eagerly rediscovered in nineteenth-century France. Watteau's elegant *fêtes-galantes* offered not only refreshing antidotes to a moribund academic tradition, but exquisite icons of a gentler age. Cézanne copied several engravings of eighteenth-century paintings and would also translate many stock Rococo motifs into his picnic scenes of the 1870s. He must have held this early effort in special regard because he not only preserved it (unlike many of his juvenile works) but included it as background in a number of later paintings. The screen was even singled out for praise, with Cézanne reportedly proclaiming to the young painter and disciple Émile Bernard (1868–1941), who visited him in 1904, 'There's painting for you ... The whole technique is there, all of it!' Charming as it is, Cézanne's enduring fondness for the screen – the only one he ever painted – may have had an emotional source. It was intended specifically to adorn his father's new study, its ornamental flourishes perfectly answering Louis-Auguste's ambitious quest for elegance. For once, father and son were in accord.

In a letter to Cézanne of September 1860, Zola mentions that he looks forward to seeing, on his next trip to Aix, 'Paul's panels and Baille's moustache'. We can surmise, then, that Cézanne had begun work on his large-scale panel paintings of *The Four Seasons* sometime that summer (9). The ambitious project probably extended at least into the following year and was the first of a number of works to decorate the grand salon of the Jas de Bouffan. Although

still very much the effort of a student, Cézanne's timeless allegorical figures, tall, graceful and laden with traditional symbols, are interesting as exercises in style. Their forthright colour, linear forms and chiselled features reveal the artist experimenting, however naïvely, with a tradition of classical figure-painting that dated back to the Renaissance and persisted in nineteenth-century academic art. Cézanne knew already, however, that his future pointed in another direction. With obvious irony he signed each of the panels 'Ingres', whose acclaimed early masterpiece in the Aix museum, *Jupiter and Thetis* (10), he had earlier parodied. One panel is even mockingly dated 1811, the year in which Ingres painted his ambitious work.

Thus, at the very outset of his career when he took on no less a figure than Ingres, the celebrated leader of the French Academy whose painting offered, even in his old age, the pre-eminent contemporary model of the French classical tradition, Cézanne's rebellious posture as an artist was assured. As the art historian Nina Athanassoglou-Kallmyer has argued, Ingres always represented for Cézanne a special *bête noire*. In his early caricature (11) of the work so treasured by the city of Aix, Cézanne transformed the sensuous, malleable figure of the beseeching goddess, who personified Ingres's unique brand of fluid linearity, into an awkward, grasping nude. And in Cézanne's drawing, Ingres's terrifying deity, Jupiter, whose chilly omnipotence is assured in his massive bulk and remote bearing but tied to the whole by a surface as dense with pattern and texture as it is burnished, leans over in a clumsy, and very human, embrace. To the end of his life Cézanne detested the inherent artifice of Ingres's Neoclassical painting, rejecting both his penchant for studious allegory and for a style of abstracted line, flat colour and lustrous, polished surfaces. Decades later, and long after Ingres had died, Cézanne would still condemn his art, telling Bernard, 'Ingres is a pernicious classicist, and so in general are all those who

deny nature or copy it with their minds all made up, and look for style in the imitation of the Greeks and Romans.'

Moving from figure to landscape, and from a tradition of the idealized human form to one of perfected nature, Cézanne probably also produced his *Landscape with Fishermen* during this first phase of work at the Jas de Bouffan. Painted directly onto the walls of his family's new salon (and later transferred to canvas and cut into fragments), Cézanne's landscape echoed, in an earnest, self-conscious fashion, the example of the Baroque painter Nicolas Poussin (1594–1665), whose classical vision of an ordered, harmonious nature was still revered in the nineteenth century and would become such a touchstone in Cézanne's later years.

As in his figurative work, Cézanne no sooner pays homage to a genre than he moves on to explore its antithesis, in this case in such works as his *Landscape with the Tower of Caesar* (12), painted in *c*.1860–1. A small oil study, it recalls, in its broad paint strokes and fresh, radiant colour, the landscape sketches of the Aixois painter Granet (see 23).

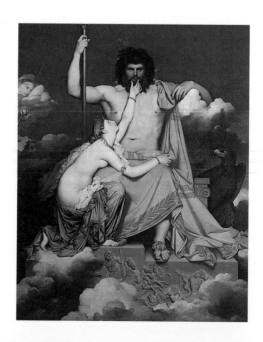

10
Jean-Auguste-Dominique Ingres,
Jupiter and Thetis,
1811.
Oil on canvas;
327 × 260 cm,
128 × 102 in.
Musée Granet,
Aix-en-Provence

11
Caricature of Ingres's *Jupiter and Thetis*,
c.1858–60.
Pen, brown ink and pencil on paper;
23.5 × 15 cm,
9¼ × 5⅞ in.
Musée du Louvre, Paris

It was probably painted directly from its subject, an actual surviving monument on the outskirts of the city. Yet, in this work Cézanne suggests that the two disparate landscape traditions – the idealized classical landscape and the more contemporary practice of painting from nature, need not be exclusive. As much as it depicts a specific and real subject studied at firsthand, his small landscape clearly reveals the subtle sense of order that Cézanne would continue to impose upon his views of nature. The diagonal inclines of the foreground hills converge from either side to meet precisely at the centre of the painting, which is marked by the lone vertical of a cypress tree. Directly below the tree, the major lines of the composition are reversed in the sloping, symmetrical roof-lines of a small cottage. In his *Landscape with the Tower of Caesar*, Cézanne not only painted one of his first views of the Aixois landscape but also presented a vision of natural order that reconciles ideal and actual, traditional and contemporary. And, as it would so often do in his later work (though on a grander scale), the ancient terrain of Provence seemed to inspire in the painter an inherently classical response.

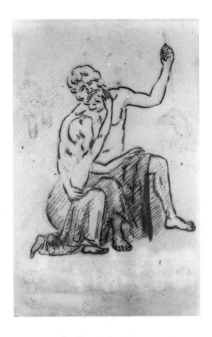

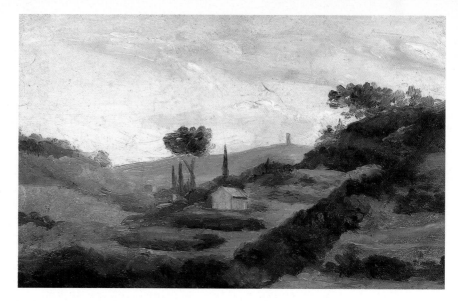

12
*Landscape with
the Tower of
Caesar,*
*c.*1860–1.
Oil on canvas;
19 × 30 cm,
7½ × 11⅞ in.
Musée Granet,
Aix-en-
Provence

Cézanne would return to paint additional works in the salon
of the Jas de Bouffan throughout the 1860s. His final
contribution to the markedly mixed ensemble of these
early years was probably his great early portrait of Louis-
Auguste Cézanne (see 2), which hung at the centre of the
alcove that held his *Four Seasons* and presided, lord-like,
over the room. Vigorously painted with thick, sometimes
even lumpy, strokes that barely contain its powerful sitter
and literally model his figure on the canvas, its style is
bolder than anything Cézanne had yet achieved and
strikingly appropriate to his subject. The massive swathes
of paint not only depict Louis-Auguste's likeness but
also suggest his formidable presence in the life of his son.
It is hard to imagine Cézanne arriving at such a defiant
and exuberant statement without first having seen the
revolutionary new art on view in Paris in the early 1860s.
Thus the portrait must be dated no earlier than *c.*1862. By
then, even his obdurate father had come to agree that his
son's future did not lie in the professional world of the
provinces, and Cézanne had made the fateful journey north.

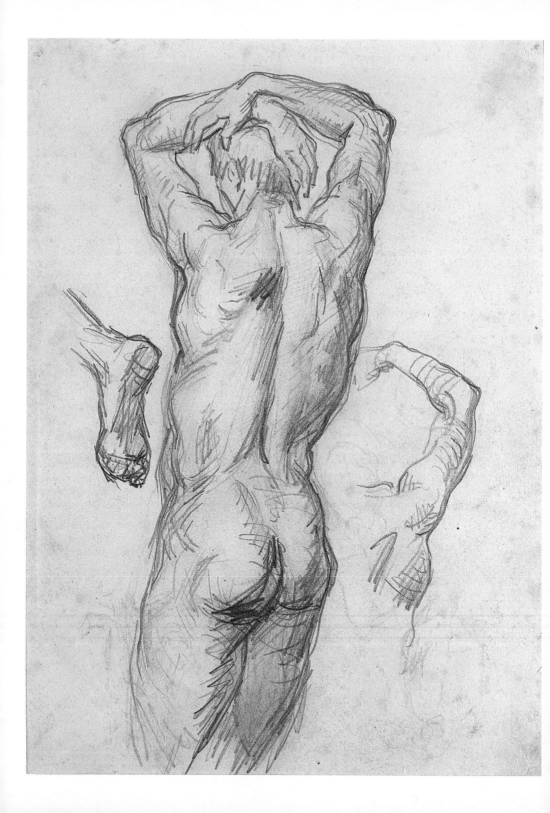

13
Nude Male Seen from the Back, c.1864–5. Pencil on paper; 24·1 × 17·8 cm, 9½ × 7 in. Picker Art Gallery, Colgate University, Hamilton, New York

In April 1861, after many letters from Zola urging him to escape the stifling confines of Aix, Cézanne, now twenty-two, finally went to Paris to realize his dream of becoming a painter. But even the florid descriptions of his literary friend left Cézanne wholly unprepared for the spectacle of Napoleon III's refurbished capital. With a shiny modern look, elegant new avenues and a booming economy – glittery outward signs that masked, in the 1860s, an increasingly rotten core – Second Empire Paris presented a vivid contrast to the sedate provincial life Cézanne had previously known. His art, ambitions and even his public persona in the 1860s would shift continually, as he struggled to find his way in the city's volatile new political, social and artistic landscape.

Cézanne's early painting is fraught with conflict and paradox, and like the period itself filled with a sense of restlessness and imminent change. At times, Cézanne took on the pose of the rebel artist, defiant both on canvas and in his social dealings. Yet he also looked to the Old Masters for inspiration or even validation, as he battled with the perennial self-doubts he had confided in his letters to Zola. Strangely, he both sought and then inexplicably spurned the approval of the official art world. It is in this period too that Cézanne established what would become a lifelong pattern of frequent retreats to his native Provence, which became a refuge where he could escape the rigours and inevitable competitiveness of the capital. Thus, although he sometimes seems a far more detached and even acerbic spectator of the period than many of his peers, it is against the changeable social fabric of Second Empire Paris and the attendant instability of its art world that Cézanne's problematic early work becomes coherent.

As Zola would recount in his later historical novels, Paris in this period radiated an intoxicating aura of glamour, progress and bourgeois opportunism. Louis-Napoleon, the nephew of Napoleon Bonaparte, had been elected president of the Second French Republic after the democratic revolution of 1848. Precluded from re-election by the constitution, he engineered a brisk but bloody *coup d'état* in December 1851, and proclaimed himself Emperor Napoleon III. With almost absolute power, he set about transforming Paris into a gilded mirror of his own imperial designs.

In the confident hands of Napoleon III's prefect, Baron Haussmann, the anarchic, medieval shape of old Paris was turned with steamroller-like efficiency into a virtual blueprint for the modern metropolis. By 1861, when Cézanne arrived, wide new boulevards offered splendid vistas and easy circulation. The unveiling of the refurbished Champs Élysées (14) was described in *L'Illustration* as nothing less than 'stupefying ... in its magnificence'. And throughout the decade new public gardens, magnificent monuments and ambitious commercial and housing developments radically altered not only the look of Paris but life within it, while underground, piped water and new sewers vastly improved the quality of public health and the environment.

Haussmann's building campaigns also boosted the city's economy, providing opportunities for labour and an infrastructure for future development. On a national scale, the Emperor's drive for industrial expansion and for new roads and railways stimulated the country's growth and productivity, giving rise to an era of enterprise, opportunism and extravagant consumption. In Paris, huge new department stores proliferated along the boulevards. These were later described by Zola in his novel *Au Bonheur des Dames* (1883) as the modern churches of the bourgeoisie, the focus of 'a new religion' that exploited the nascent buying power of the middle-class woman. At the same

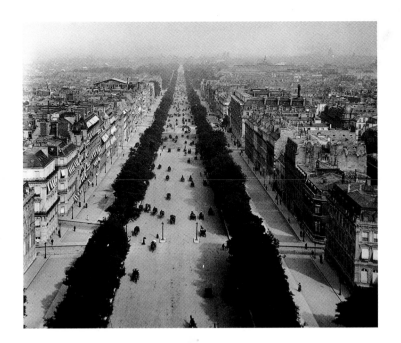

time, French theatre and opera enjoyed unprecedented
popularity, and an elite, materialist society made the new
Parisian parks, gaslit cafés and elegant restaurants their
playground. Radiant and gaudy, Paris became the 'new
Babylon' that attracted not only provincials, like Cézanne,
but also an international set of poets, painters and writers.

Behind the glittering, modern façade of Second Empire
Paris, however, stood a very fragile social and political
structure. The waves of popular unrest that had led to the
revolt of 1830, when the Bourbon monarch Charles X was
driven from power, had been followed by tense decades of
workers' strikes and uprisings under the citizen-king Louis-
Philippe, especially vehement within the city of Paris. The
proletariat revolution of 1848, conceived to end forever the
French monarchic tradition, had finally led to the election
of Louis-Napoleon. But plagued by crime, cholera and
repeated revolts of the working classes, Paris still seemed a
city virtually impossible to govern, and Louis-Napoleon's
return to an absolute monarchy was prompted by a need
for stability, as well as a desire to extend his regime.

By the early 1860s, when Cézanne arrived, the social and political fabric of the city, however sumptuous its surface, was beginning to fray around the edges. The broad new boulevards built under Haussmann, which allowed easy passage of carriages and omnibuses, replaced the narrow, twisting alleyways that facilitated makeshift barricades and revolt. Even if such revolt should materialize (as it would in 1871), the new terrain allowed arriving troops to outmanoeuvre their targets. This was urban planning as social policy. The ambitious new building projects with monotonous standardized façades replaced whole neighbourhoods previously inhabited by the poor. Slum dwellers were displaced as the *arrivistes* prospered in these glossy new enclaves. And Napoleon III's strange amalgam of authoritarianism and paternalistic concern for the worker did little to ease the precarious political atmosphere.

The contentious art world of Paris that confronted Cézanne mirrored the larger conflicts of the era, and its disputes often took on a political complexion. For decades, the battle-lines that governed issues of artistic theory and style in official circles had been clearly drawn between two élitist and now ageing adversaries, Ingres and Delacroix. The refined Neoclassicism of Ingres had already been rejected by Cézanne in Aix. But the impassioned, Romantic painting of Delacroix, who was just finishing the great masterpieces of his old age – the murals in the church of Saint Sulpice – was a huge discovery for the young provincial whose painting was already burdened with passions of his own. Above all, it came to signify the essential freedom, individuality and emotional depth that Cézanne himself sought in his art.

Cézanne's devotion to Delacroix's art would span the length of his long career. Delacroix drew on the past for historical and mythological subjects, and often emulated in his full-blooded works the paintings of sixteenth-century Venice, built with saturated colour rather than line. Like Delacroix,

Cézanne would copy *The Wedding Feast at Cana* (see 44) by Paolo Veronese (1528–88); and also like Delacroix, Cézanne studied the works of Peter Paul Rubens (1577–1640) in the Louvre. More than any other painter, the Flemish master fostered, in the art of his later admirers, a whole range of painterly antidotes to Neoclassicism. Cézanne also copied work by Delacroix, but the rich palettes, sensual images and exotic or imaginative subjects he encountered in Delacroix's art shaped his own emotional narratives that were far more private. Even in his old age and long after those early passions had been subsumed in Cézanne's late style, Delacroix remained an essential primary source of inspiration.

The combative dialogue between Ingres and Delacroix had, however, lost much of its momentum by the 1860s. Neither Ingres, in his well-bred, academic paintings, nor Delacroix, in his fervent, romantic visions, seemed equipped to deal with a city or a century undergoing fundamental change on all fronts. The prominence in Paris of the rebellious young painter Gustave Courbet (1819–77), who came from rural Ornans in eastern France, had in fact shifted the focus of the art world to vital new ground some time earlier. His bold paintings of peasants, earthy, unidealized nudes and rural landscapes (see 19) had seized centre-stage in his pioneering one-man exhibitions and also at the Salon in the late 1840s and 1850s. Broadly executed with thick, painterly strokes, Courbet's images acquired a crude, sculptural presence that powerfully embodied the revolutionary spirit of that era, defying established hierarchies of academic painting and embodying a new Realist canon.

By 1860, however, a younger Realist painter, the urbane and sophisticated Parisian Édouard Manet (1832–83) had taken on the defiant leading role that Courbet had filled in the previous decades. Manet's incisive, vigorously painted canvases would constitute another, potent alternative to the academic past, but one that embraced the subject of

modernity in a glossy, urban form. Ingeniously blending naturalistic images of modern city life with signs of painterly artifice, Manet's works vividly reflected the dramatic changes in the social and cultural landscape of Paris.

Shortly after his arrival in Paris, Cézanne visited the usual artistic shrines: the Louvre, the Luxembourg Palace, the royal château at Versailles, and also that year's Salon. The Paris Salon, then held biennially (it would shift to an annual schedule in 1863), served as both showcase and shop window for the contemporary art scene. Admission to the Salon, a necessity for any artist seeking traditional avenues of success, was decided by a jury who rigorously upheld the long-standing hierarchy of genres that had governed officially sanctioned French art since its inception. In a variety of evolving forms, history painting had long reigned supreme in French painting, and still thrived at the Paris Salon.

Taking its cue from biblical, classical and literary sources, history painting was originally intended to produce noble, edifying art for an educated and aristocratic viewer. Both its idealized forms and moralizing themes sought, at least on the surface, an exalted purpose for art. But by the mid-nineteenth century, traditional history painting had become increasingly impoverished. As Salon audiences became more bourgeois and their taste in art less sophisticated, many academic artists responded with large, uninspired works that were often mediocre in quality. Prominently on view at the Salon of 1861 were the celebrated *Nymph Abducted by a Faun* (see 38) by Alexandre Cabanel (1823–89) and the naked *Phryné* by Jean-Léon Gérôme (1824–1904), the kind of hackneyed erotic images in vaguely antique guise that both the bourgeois public and the Emperor (who bought the Cabanel) relished. Cézanne, writing to a friend, praised a 'stirring' battle picture by the now-forgotten history painter Isidore Pils (1813/15–75) and described as 'magnificent' both the nightmarish visions of Gustave Doré (1832–83) and the

delicate, miniaturist paintings of Ernest Meissonier (1815–91). Yet Manet's brilliant costume piece, *The Spanish Guitar Player*, also on view, was awarded an honourable mention (possibly with Delacroix's help), and even praised by the critic Théophile Gautier for its bold brushwork and truthful colour. Clearly, change was in the air.

Although he would soon rebel against the traditions and structured hierarchy of the Salon, at first glance it was all quite invigorating to the provincial artist. While he could dismiss many of the paintings in museums as 'tartines' or pot-boilers, Cézanne noted that of everything he had seen in Paris, the controversial Salon was 'what is really best, because all tastes, all styles meet there and clash'. Thus inspired, he devised a rigorous course of study that would allow him to absorb the vast pictorial riches of the capital.

The life upon which Cézanne embarked in Paris has an almost storybook quality, though it was marred by his persistent doubts and famously intransigent temper (in letters to Baille that summer, Zola complained about his friend's stubbornness: 'To prove something to Cézanne would be like trying to persuade the towers of Notre-Dame to dance a quadrille'). Most mornings found him drawing at the Académie Suisse, an informal art studio near Pont Saint-Michel. Offering no formal instruction but much-needed camaraderie, the school allowed painters, for a small fee, to work from a nude male or female model. In the early 1860s, it was frequented by young landscape artists who came to study anatomy, and thus became, almost incidentally, one of the hothouses of the subsequent movement of Impressionism. Cézanne met there such future Impressionists as Armand Guillaumin (1841–1927), and through Guillaumin, the Caribbean-born Camille Pissarro, who would become a lifelong mentor for the artist.

Cézanne's afternoons were usually spent sketching with Provençal friends in the studio of Joseph-François Villevielle

(1829–1915), an older Aix painter then working and teaching in Paris, or painting alone in the small room on the rue d'Enfer that he rented with an allowance from his father. Yet despite the freedom that the city offered, Cézanne's first stay in Paris was one of the most disheartening periods of his early career. As Zola wrote two months after his arrival, 'Cézanne has many fits of discouragement; despite the some-what affected scorn with which he speaks of fame, I see that he would like to gain it. [But] when he does badly he speaks of nothing less than returning to Aix and becoming a clerk.' In an early self-portrait (15), the absorbed, reserved young man in the photograph from which it is derived (16), c.1861, has become a study of dark despair.

Although Zola did everything to convince Cézanne to stay on, even agreeing to sit endlessly for a portrait that was never finished, his worst fears were confirmed when his old friend packed his bags in the autumn of 1861, after only five months in Paris. Their parting seems to have been cool. When the two finally resumed their correspondence some months later, Zola referred to their shared ambitions only fleetingly. Privately, he had begun to doubt whether Cézanne had it in him to succeed as an artist: 'Paul may have the genius of a great painter,' he wrote impatiently to Baille, 'but he'll never have the genius to become one.'

15
Self-Portrait,
c.1861.
Oil on canvas;
44×37 cm,
17³⁄₈×14³⁄₈in.
Private
collection

16
Photograph
of Cézanne,
c.1861

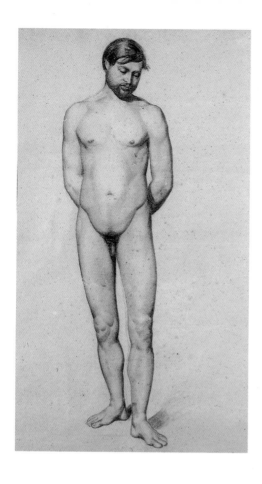

17
Male Nude,
1862.
Graphite
on paper;
61·5 × 47·8 cm,
24¹⁄₄ × 18³⁄₄ in.
Musée Granet,
Aix-en-
Provence

Back in Aix, Cézanne proceeded to act out the rest of Zola's
gloomy prophecy. He took a job in the family bank, but his
despondency soon convinced even Louis-Auguste to abandon
any lingering hopes of a business career for his son. And so,
seemingly stymied in his quest for recognition in a larger
arena, Cézanne began to repeat the pattern of his youth.
Once more he enrolled at the local art school and studied
with his old Aix friends under Gibert. In some areas, his
talent seems to have been as muted as his ambition.
Cézanne's life drawings from this period are painfully
correct. In such studies as *Male Nude* of 1862 (**17**), he relies
on exact modelling, immaculate contours and ideal propor-
tions to describe his subject in highly disciplined terms.
There is little to suggest the passion or even the significance
he would later attach to the subject of the human figure.

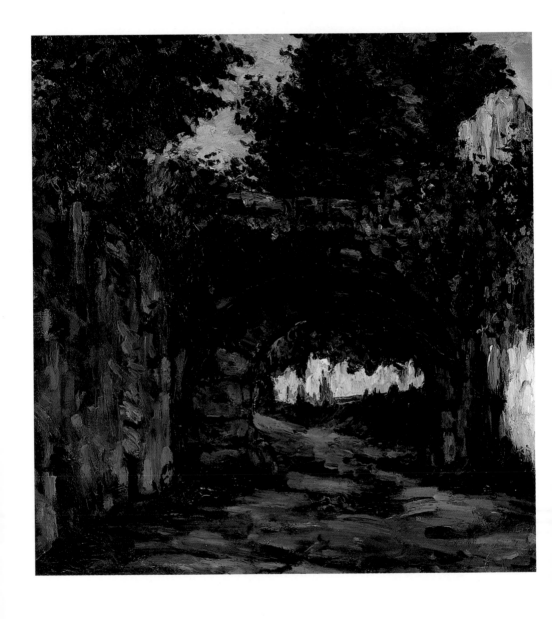

Yet if the drawings yield only an implacable surface, the paintings that probably also date from this restless year in Aix are filled with bold experiment and crude refashionings of the Realist art Cézanne had witnessed in Paris. His forceful early portrait of his father (see 2) and striking views of motifs in the Aixois countryside suggest that Courbet's work must have been very much on his mind. In paintings such as *La Voûte* (18) of *c*.1862, for example, Cézanne uses brilliant contrasts of deep greens, blacks and buttery yellows and a mix of short, broad and thick strokes of paint to create a sombre landscape that recalls, if somewhat naïvely, Courbet's art of the same period (19). While the environs of Aix would become central to Cézanne's later celebration of the Provençal landscape, in his earliest work they fulfilled a different role. Here he could absorb the vital currents of the latest painting at a safe distance from the capital, in solitude, and in terms of familiar subject. By the autumn of 1862, he was ready to confront Paris again.

Almost immediately upon his return, Cézanne rejoined Pissarro and his circle at the Académie Suisse. From this point, even Cézanne's life drawings chart an essential new course. In *Male Nude* of *c*.1864 (20), for example, the raw,

18
La Voûte,
c.1862.
Oil on canvas;
43·5 × 41 cm,
17¹⁄₈ × 16¹⁄₈ in.
Private
collection

19
**Gustave
Courbet**,
*The Brook of
the Puits-Noir,*
1855.
Oil on canvas;
104·1 ×
137·2 cm,
41 × 54 in.
National
Gallery of Art,
Washington,
DC

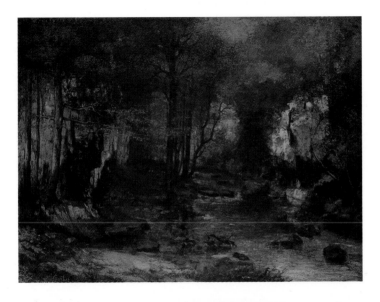

emotional power that already characterized his landscape painting transforms his study of the figure. The darkened, blunted and smudged marks of his drawing combine line and shading in single strokes, while softly shaded patches of grey turn blank paper into highlights. With a much freer handling of the material, Cézanne could now convey his forms not in terms of line, but of rich colour contrasts. Such expressive studies also suggest a new capacity to observe and not merely to repeat. Many of his fellow students – though not the prescient Pissarro – laughed at his rudimentary efforts, and he became known as 'l'écorché' – the flayed man – because he took their criticisms so much to heart.

While Cézanne suffered from the ridicule of his peers, he seemed better able to tolerate the rejection of the establishment. Probably to appease his father, he applied in 1862 to the École des Beaux-Arts, still the official school of the Paris art world and an essential first step for any ambitious young artist. But his painting was supposedly dismissed as 'riotous' by the examiners. Undaunted, a few months later Cézanne joined his Académie Suisse friends in submitting works to the 1863 Salon. The huge exhibition, which had engrossed him two years earlier, was now deeply enmeshed in controversy. When over half of the five thousand submissions (including Cézanne's) were rejected by an unusually harsh

20
Male Nude,
c.1864.
Charcoal
on paper;
20 × 25·7 cm,
7⁷⁸ × 10 in.
Private
collection

21
**Édouard
Manet,**
*Le Déjeuner
sur l'herbe,*
1862–3.
Oil on canvas;
208 × 264·5 cm,
82 × 104¹⁄2 in.
Musée d'Orsay,
Paris

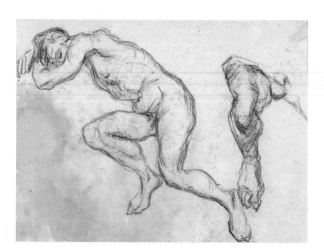

jury, many artists protested, demanding a forum where they could exhibit. The Emperor himself, always wary of unrest, tried to appease them by offering alternative space nearby.

Within two weeks the so-called Salon des Refusés opened, and it became a symbol of rebellion against the increasingly outdated art establishment. The show attracted as many as four thousand visitors on Sundays, when admission was free, but, by all accounts, they were disgusted with what they saw. Most critics shared the public's outrage, branding the work as 'slipshod', 'shameless' and 'uncivilized'. Yet in the face of such sweeping condemnation and ridicule, the artists found a new rapport among themselves and also a new champion, Zola, who would vehemently argue their case in print.

The paintings that Cézanne presented at the Salon des Refusés in 1863 cannot be identified; they seem to have been ignored by reviewers and even by Zola, who would soon be

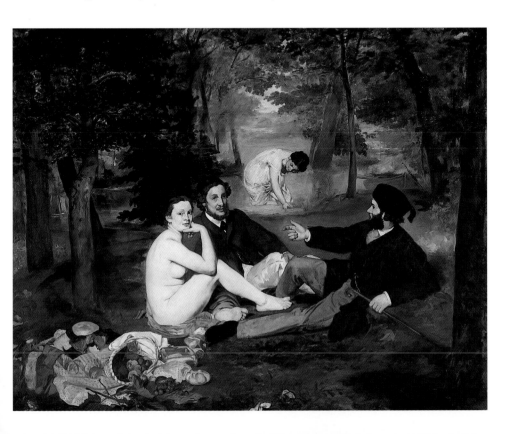

appointed critic for *L'Événement*, and who visited the
'counter-salon' with Cézanne during its brief run. Much of
the hostile criticism surrounding the Salon des Refusés was
aimed at Manet, whose scandalous – and seminal – *Déjeuner
sur l'herbe* (21) inflamed the public and impressed his fellow
exhibitors, including Cézanne, in equal measure. Manet
originally entitled his canvas *Le Bain*, suggesting a sedate
scene of idealized bathers in nature. But by painting a
highly specific female nude surrounded by male figures in
modern dress, and disconcerting still-life and landscape
elements in a strangely artificial setting, Manet spurned
the entire academic tradition in which mythological or alle-
gorical nudes inhabit beautiful, historic landscapes. With
no narrative or moral subtext to explain his provocative,
immodestly staring nude and her obviously contemporary
companions, and odd passages of either boldly flattened or
starkly tonal modelling, Manet's canvas was unequivocal in
its rejection of the past. Only much later would the paint-
ing's roots in Renaissance art be recognized. By then, almost
every young painter of the new vanguard, Cézanne among
them, had responded in some form to Manet's challenge.

No doubt emboldened by the personal relationships and
aura of collective defiance that emerged from the events of
1863, Cézanne's paintings of the following few years evince
a new power and conviction, reflecting many traits of the
complex movement of that decade. A sombre portrait,
signed and dated to 1864, is executed in a broad, tonal style
indebted to Manet, while the robust, textural method of
Courbet is now even more apparent in Cézanne's paintings
of the Provençal landscape. Although the open format and
luminous atmosphere of such works as his small landscape
of *c*.1865 (22) also recalled the *plein-air* sketches of the
Aixois artist Granet (23) or those of the better-known land-
scape painter Camille Corot (1796–1875), Cézanne crudely
built up the surfaces of his canvases much as Courbet had
done when painting his native Ornans. Realized with thick,

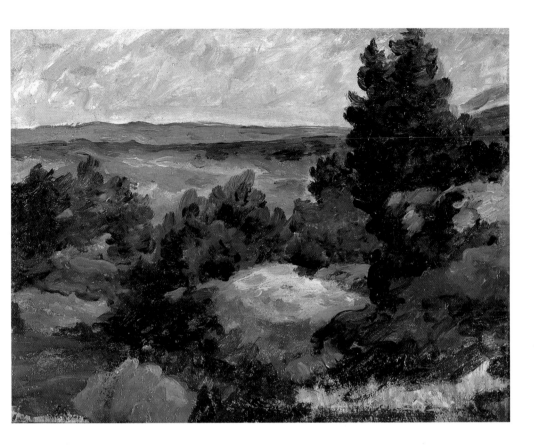

22
Landscape,
*c.*1865.
Oil on canvas;
26·5×35 cm,
10½×13¼ in.
Vassar College
Art Gallery,
Poughkeepsie,
New York

23
François-
Marius Granet,
Paysage de la
campagne d'Aix,
*c.*1840.
Oil on canvas;
27·2×35·1 cm,
10¾×13¼ in.
Musée Granet,
Aix-en-Provence

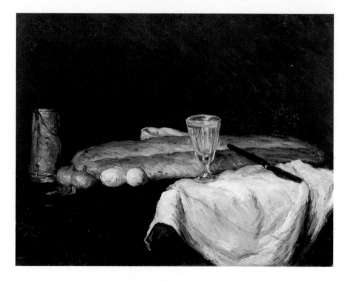

24
Still Life with Bread and Eggs, 1865.
Oil on canvas;
59 × 76 cm,
23¹⁄₄ × 29⁷⁄₈ in.
Cincinnati Art Museum

short touches of a heavily loaded brush or broad swipes of a palette knife, Cézanne's rugged landscape subjects became inseparable from his emphatic handling of the paint itself.

Cézanne seemed not only to pattern his painting after Courbet in this period, but also to assume the pose of the rebel artist. In a characteristic letter to Pissarro of 1865, he describes the paintings he plans to submit to the Salon as certain to 'make the Institute blush with rage and despair'. And when his work was again rejected the following year, Cézanne angrily petitioned the Superintendent of Fine Arts, Count Alfred-Emilien de Nieuwerkerke, to re-establish the Salon des Refusés. Though his efforts failed, more than a few friends applauded his new audacity and the bold work that courted rejection. 'Cézanne hopes to be refused at the exhibition [the Salon],' wrote an old Aix friend, Antoine-Fortuné Marion, in March 1866, 'and the painters of his acquaintance are preparing an ovation in his honour.'

Yet despite this brash public posture, Cézanne's motives, like his art, could be mixed. If he thumbed his nose at authority in person, he could still be indebted to it on canvas. Not all of his Realist paintings were meant to shock his viewers with a deliberately uncouth style or subject – many

reveal the artist's deep and self-conscious roots in older pictorial traditions. The sombre palette and sober, ordered composition of Cézanne's *Still Life with Bread and Eggs* of 1865 (24), for example, one of his rare signed and dated works, resembles Manet's dark, early still lifes. But its frugal subject and unusually restrained handling link it even more closely to the conservative realism of Théodule Ribot (1823–91) and François Bonvin (1817–87), whose work of the 1860s embodied a general enthusiasm for the French master of still-life painting, Jean-Siméon Chardin (1699–1779), and for the great naturalist tradition of seventeenth-century Spain. While the Salon regarded still life as second-rate to history painting and also to portraiture because of its humble themes, still lifes nevertheless often filled its galleries and also found a ready market among art dealers who served a growing middle class.

Shortly after retrieving his submissions from the infamous Salon des Refusés, Cézanne applied for a student card to copy at the Louvre and began what would become a lifelong apprenticeship with the Old Masters. By 1864 he had completed the first of many drawings from Rubens's *Apotheosis of Henri IV* (25), part of the Baroque master's magnificent cycle of the life of Marie de' Medici, Queen of France. Cézanne's study (26) of the left-hand section of Rubens's canvas, where the French monarch is assumed into heaven in the company of Jupiter and Saturn, is one of his largest and most exquisitely finished copies: the powerful, tangled curves that propel Rubens's figures upward are endowed with vigorous loops and dense cross-hatchings. The same transformed elements animate Cézanne's subsequent figure studies. In the *Nude Male Seen from the Back* of c.1864–5 (see 13), for example, the model's heavily muscled back and strained pose are emphasized by a similar series of Baroque curves and lower arcs that lend new life and formal grace to the drawing. Rubens's dynamic vision would also be translated into Cézanne's increasingly energetic brushwork.

Everything Cézanne looked at in fact, new and old, seemed
to bring the artist back to the palpable surface of his canvas
and, by the mid-1860s, to an inherently brutal style of paint-
ing related to the heavily impastoed work of his fellow artist
Courbet. But there is nothing in Cézanne's earlier art – or
in Courbet's – to prepare us for the palette-knife pictures
of 1866, an astonishing group of canvases which, for all of
their echoes of other works, are of staggering originality.
Comprising a few still lifes, landscapes and a series of
exceptional portraits, these paintings are the first of
Cézanne's output to form a cohesive body of work: we
glimpse in them a powerful new unity of style and the
passion and single-mindedness with which the mature artist
would pursue an idea to its brilliant conclusion. Despite
their conventional subject matter, the radical and violently
physical new palette-knife paintings must be seen as gestures
of both artistic and political defiance.

These new works prompted Antoine Guillemet (1841–1919),
a friend of Pissarro, to suggest to another Realist artist,
Francisco Oller (1833–1917), that Cézanne had acquired – by
virtue of his style alone – the mantle of the revolutionary

25
Peter Paul Rubens,
Apotheosis of Henri IV,
c.1622.
Oil on canvas;
394 × 727 cm,
155 × 286¹⁄₄ in.
Musée du Louvre, Paris

26
Apotheosis of Henri IV (after Rubens),
c.1864.
Pencil;
40·5 × 30 cm,
16 × 11³⁄₄ in.
Private collection

artist: 'Courbet is becoming classical. He has painted splendid things, but next to Manet he is traditional, and Manet next to Cézanne will become so in turn ... let's trust only ourselves, build, paint with loaded brushes, and dance on the belly of the terrified bourgeois. Our turn will come.'

One of his earliest efforts in this enormously self-assured new style was Cézanne's large, three-quarter-length portrait of an old friend, Antony Valabrègue (27). Cézanne had spent the winter of 1865 in Aix, some of it in the company of Valabrègue, a poet and writer, but by February 1866 he was back in Paris, eager to do battle with the Salon jury again. Valabrègue soon followed and became the subject of the painter's latest Salon submission. As the poet's image took shape on canvas – a looming likeness of leaden greys and blacks with eerie back-lighting – it grew into a defiant demonstration of the new direction in which Cézanne's art was moving. Cézanne wielded his palette knife like a sculptor, painting with swipes and gouges that modelled Valabrègue's features in crude relief. In some places, such as the clenched hands, he employed furious brushwork. Both artist and sitter expected the portrait to be rejected. And

indeed it was, despite the pleas of the established artist Charles Daubigny (1817–78). Daubigny's own unedited rural landscapes, like those of his fellow painters working near the village of Barbizon (about 100 km or 60 miles southeast of Paris), led him to prefer 'its daring to the nullities that appear at every Salon'. As Valabrègue recalled: 'A philistine in the jury exclaimed on seeing my portrait that it was not only painted with a knife but with a pistol as well.'

Having shot his bolt in Paris, Cézanne was back in Aix by the autumn, causing more consternation and excitement with his palette-knife pictures. Some of the curious locals who came to Cézanne's studio scoffed, and discovered that the artist's temper could be as volatile as his paint. However, Cézanne's small band of admirers in Aix was growing: a poem dedicated to him appeared in a local newspaper and painting with a knife became all the rage. 'Paul has been for Aix like the germ of an epidemic,' noted Fortuné Marion, 'and all the painters here, even the glass-makers, are beginning to work with a thick impasto.' Writing to Zola in November 1866, Valabrègue related his role in the provocative canvases that were appearing in rapid-fire succession:

Paul had me pose for the study of a head yesterday. The flesh is fiery red with scrapings of white flesh; it is a mason's painting. My face is so bright that it reminds me of the statue of the priest of Champfleury when it was covered with crushed blackberries. Fortunately, I only posed for one day. The uncle is asked to serve as a model more often. Every afternoon, a portrait of him appears.

Unfortunately, the painting Valabrègue describes seems to have been lost. But, as his letter suggests, the real hero of the palette-knife pictures was the artist's patient maternal uncle, Dominique Aubert, who sat for a series of portraits Cézanne produced during his stay in Provence. The earliest works of the group seem to be smaller paintings of heads and often show Uncle Dominique posed at an angle or with a cap or turban. In these, the artist arrived at a more

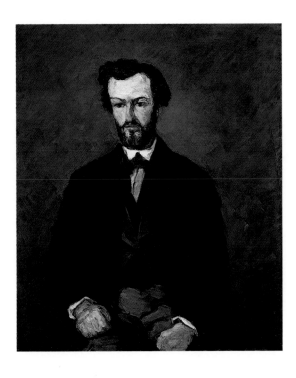

27
*Portrait of
Antony
Valabrègue,*
1866.
Oil on canvas;
116 × 98 cm,
45¾ × 38⅜ in.
National
Gallery of Art,
Washington,
DC

consistent and powerful version of the technique that was
becoming associated with his name. The paint is trowelled
directly onto the canvas in thick, even layers and then
built up with the knife into the features of his sitter
or the surrounding space. Though still crude, these rough
little works proposed a huge new idea for Cézanne's art:
that the structure of a picture could exist entirely on the
surface of a canvas and even within the material substance
of the paint itself.

Cézanne's brand of Realism, while indebted to Courbet
(though Courbet had never used this technique in portrai-
ture), was far more wilful, and even brutal, in its honesty
to the medium. The artist's touch had never been more
primary. As if to claim this feat for himself, Cézanne added
his own defiant image to the group. A small dark painting
(28) of *c.*1866 bears little resemblance to the brooding self-
portrait the artist had painted five years earlier (see 15).
The face is coarsely modelled with fat, jabbing strokes, and
the artist's glaring eyes emerge from deep sockets hollowed

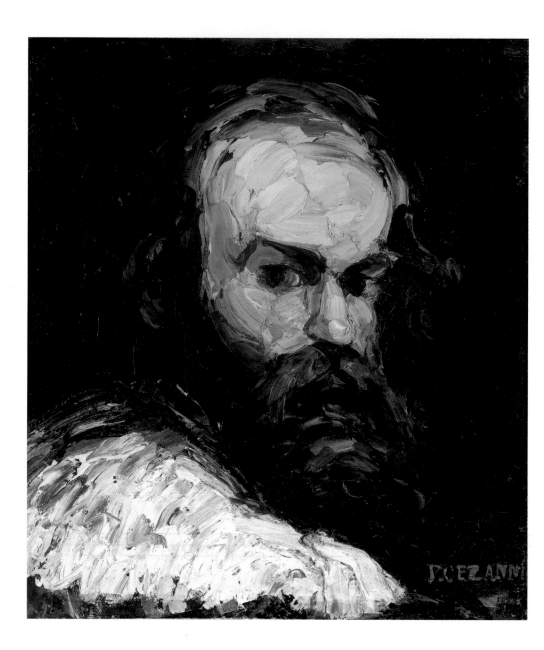

out on the canvas surface. With a ferocious expression framed by wildly painted, untamed beard and hair, Cézanne confronts his detractors and becomes a perfect subject for his own uncouth style.

Later in that same prolific autumn or early in 1867, Cézanne produced several half-length paintings of his uncle that fall, at first glance, into the category of costume pieces – a type of contrived figural subject utilized by Manet. These display little of the stylistic artifice or historicism cultivated in such pictures by the Realists. Instead, Cézanne used his model much as he would treat objects in his later still lifes. Both the thickly painted clothing and the subject's specific poses immediately direct our attention to his paint-laden surfaces. And in three of the largest and most expressive of the series, the artist's choice of costume seems to have been anything but arbitrary. Posing his uncle as a lawyer (the profession Cézanne's father had encouraged but which he had disdained), an artist (the more creative, bohemian role he had chosen) and finally and most expressively as a celibate monk – an anguished role with which he would later identify – Cézanne endows these three works with attributes far more intimate than those of conventional portraiture. It is this deeply personal meaning that contributes to the forceful physical presence of Uncle Dominique and places the series among Cézanne's most powerful paintings.

In *The Lawyer* (29), the figure's enormous gesturing hands emphatically assume the traditional pose of preaching or lecturing. Created with coarse slabs of paint that shape the contours of fingers and palms, they allude to the pontifical role of the jurist, an image that originated in ancient icons of Christ as judge. Honoré Daumier (1808–79) would popularize this motif in his numerous images of the legal profession (30), and Cézanne's palette, especially the brilliant cold blue of the scarf, may have also been drawn from Daumier's precedents. The figure's iconic, central

28
Self-Portrait,
c.1866.
Oil on canvas;
45 × 41 cm,
17³⁴ × 16¹⁸ in.
Private
collection

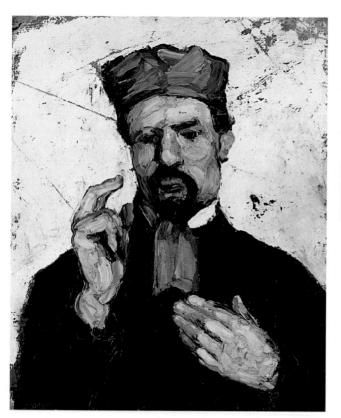

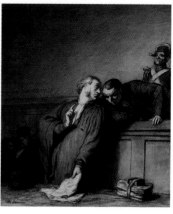

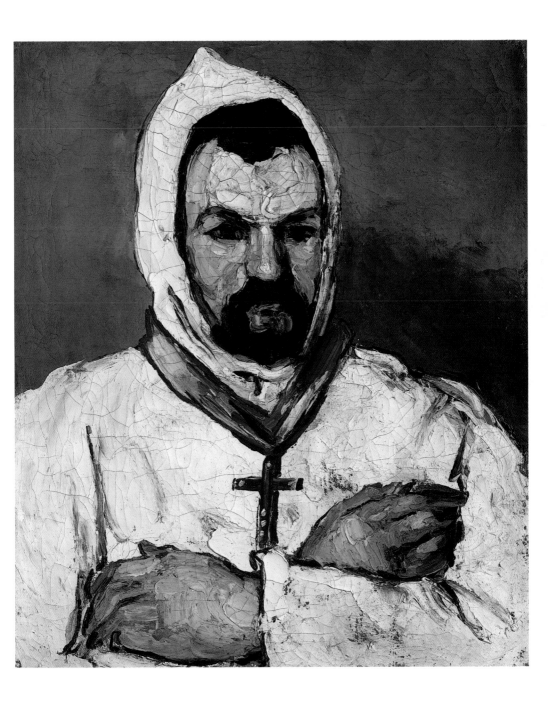

placement and frozen stare add a note of gravity and make it a particularly provocative, or even reverent, image of a rejected vocation. Surprisingly, Cézanne's painting of his uncle as an artist or artisan – the role distinguished by the model's tasselled blue cap and smock – is less impassioned.

By far the most expressive of Cézanne's three paintings is *Portrait of a Monk*, where he matches a physically confining pose and taut pictorial structure to the massive and vigorously realized image of a Dominican monk (31). Only a few years later Cézanne would paint the legend of the tormented monk Saint Anthony (see 42), popularized in a contemporary novel by Gustave Flaubert. Both artist and writer focused on the opposing forces of coarse sensuality and asceticism around which the story was constructed (and for which the ambivalent surface of contemporary Paris may have been a catalyst). In this earlier work, the figure's swarthy, scowling face and claw-like hands are rendered with a raw sensuality and vehemence striking even in this series, and his massive form is bound to the surface with thick sheets of cold white paint that make up the austere and constricting monastic robe. The huge figure is contained within Cézanne's canvas only by its rigid composition: a taut vertical axis and the horizontally crossed arms form a cross much like one worn by the monk. Not only its opposition of

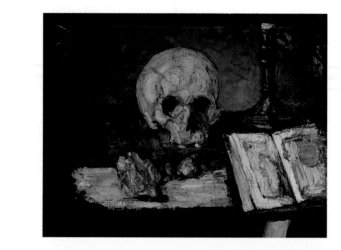

32
Still Life: Skull and Candlestick,
c.1866.
Oil on canvas;
47·5×62·5cm,
18³⁄₄×24⁵⁄₈in.
Private
collection

mass and intensely worked surface but its very composition invites complex interpretation; as the art historian Meyer Schapiro has suggested, 'The opposites of the sensual and the meditative, the expansive and the self-constraining' are well expressed here.

For all their crude bluster, then, the palette-knife paintings posited a newly sophisticated notion of picture-making, and the unity they achieved between surface vitality, subject and spatial construction made them a milestone for the artist. Although the portraits are the boldest products of this technique, Cézanne would also venture into the genre of still-life painting, as seen in *Still Life: Skull and Candlestick* (32). The wilted rose, burnt-down candle and skull in this painting were standard symbols of the *vanitas*, or meditation-on-death theme, but here they take on an even more powerful emblematic role by means of their brutal, heavily worked style. It was painted for Heinrich Morstatt, a German musician and friend of Cézanne, who had introduced the Aix circle to the passionate music of Richard Wagner.

Years later, Cézanne described the technique employed in the palette-knife pictures as his *manière couillarde* (from *couilles*, meaning testicles or guts), a potent moment of crude virility in the career of a painter whose method would more often be one of studious and even agonizing delibera-tion. Although the density of surface achieved so briskly in these few months would persist into the next decade in different paint applications, the artist's self-conviction would not. When doubt returned, the excessive energy and extremity of the paintings made them likely victims: many were destroyed by the artist in fits of rage or gloom.

In a letter to Zola of 2 November 1866, Guillemet describes *Portrait of Louis-Auguste Cézanne Reading 'L'Événement'* (33), a painting that exhibits both the palette-knife tech-nique and, in the lower half, a more rhythmic, measured

33
*Portrait of
Louis-Auguste
Cézanne
Reading
'L'Événement',*
1866.
Oil on canvas;
200 × 120 cm,
78³⁄₄ × 47¹⁄₂ in.
National
Gallery of Art,
Washington,
DC

style, and thus seems to bring this heroic period of effort to a close. Louis-Auguste is shown sitting in a flowered armchair, as Guillemet wrote, 'like a pope on his throne', and reading the radical newspaper in which Zola's views on art briefly held sway. Although in real life his father read the conservative *Le Siècle* (which, according to Guillemet, appeared in the painting's original state), Cézanne's substitution seems both a tribute to the newly successful Zola and an ironic rebellion against his father. Hanging behind the huge chair is one of the artist's palette-knife paintings, a small still life that serves as a manifesto of the artist's recent work. Perhaps Cézanne also sought here, in paint, the professional approval of Zola, who had yet to praise his art in print, or the blessing of his overbearing father, who appears less foreboding than in his stormy earlier portrait. Both were to elude him, like the official recognition the artist craved beneath his stubborn veneer of rebellion. By 1867 he was on the move again.

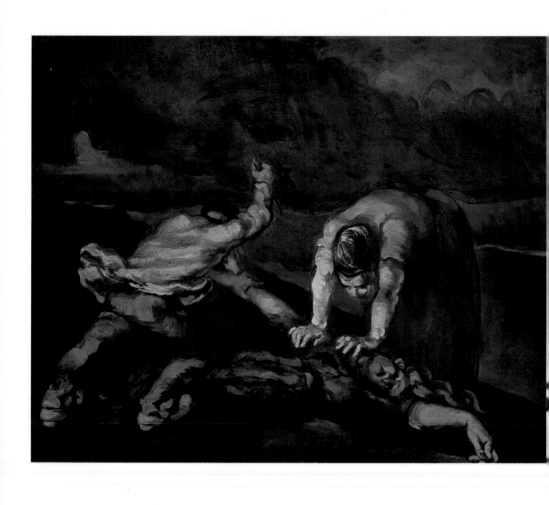

By the late 1860s, Cézanne was already a mythical figure in vanguard circles in Paris, as much for his theatrically crude behaviour as for his painting. His shabby provincial clothes, defiant manner and fiery temper pushed him to the fringes of the cosmopolitan art world which he so desperately wanted to join. He rarely visited the congenial Café Guerbois frequented by the most progressive young painters, including such future Impressionists as Monet, Renoir, Pissarro, and many of the critics. If he did, he holed up in a corner and spoke only to disagree. More often, he went out of his way to shock. Monet later remembered how Cézanne once approached the suave Manet, the centre of café society, and announced, 'I am not offering you my hand, Monsieur Manet, I have not washed for eight days.' And despite his privileged upbringing and the financial security he enjoyed from his bourgeois father, Cézanne affected in Paris an exaggerated southern accent and ill-kempt appearance, as if mocking the polished style of the other artists. John Rewald has suggested that the artist's entire being and not just his painting had to express his youthful revolt. Certain of his contemporaries also saw something compelling in his persona: both the novelist Edmond Duranty and Cézanne's friend Zola would base a fictional character – an uncouth, struggling painter – on him.

Historians of Cézanne's art have long noted the prominence of violence and romantic fantasy in his painting from the restless years of 1867–9. A number of these works feature striking scenes of sexual savagery, murder and death. For example, in *The Murder* (34), a gruesome and disturbing work of *c*.1868–9, a woman is held down and viciously knifed to death in a dark, blasted landscape. The vehemence and

34
The Murder,
c.1868–9.
Oil on canvas;
65 × 80 cm,
25⅝ × 31½ in.
National
Museums and
Galleries on
Merseyside,
Walker Art
Gallery

physical intensity of the earlier palette-knife works now embraced both brushstroke and brutal subject. Other canvases of this sort from the late 1860s, Zola tells us, were destroyed by the artist in fits of despair. And although by c.1870 these haunting and often bizarre works were beginning to be replaced by more fantastic, dreamlike pictures of brooding passions and anxiety, they did much to fuel the popular legend that surrounded Cézanne in his early career.

Part of that legend centred on the artist's alleged fear of women. His sexual torments had already been revealed in anguished early poems and letters to Zola, and were later used as grist to the mill in Zola's novel *L'Oeuvre* (1886). Describing the painter Claude Lantier, a fictional character based, in part, on his childhood friend, Zola wrote: 'Those girls whom he chased out of his studio he adored in his paintings; he caressed or attacked them, in tears of despair at not being able to make them sufficiently beautiful, sufficiently alive.' Such fears would continue to plague Cézanne throughout his life; at one point Cézanne even confessed his fears to Renoir, saying, 'Women models frighten me. The sluts are always watching to catch you off your guard.' And in a letter to Émile Bernard written shortly before his death, Cézanne reveals a similar tension between the power of imaginative transformation and the lurking demons of physical attraction, swearing never to submit to 'the debasing paralysis which threatens old men who allow themselves to be dominated by passions that coarsen their senses'. Yet we sorely underestimate the power of such works – both the truculent early narratives and the provocative later paintings of nudes – if we view them only as private erotic dreams or in terms of the dark myths they helped to sustain.

While the work of even the most progressive of his friends from the Café Guerbois was occasionally accepted at the annual Salons, Cézanne experienced only rejection.

Conceived not just to defy convention but to disturb and insult, Cézanne's early violent works paint a compelling picture of his public failure. Every painting he submitted to the Salon in the 1860s, in fact, was refused and many ridiculed as well. This would lead him, in one of his public displays of defiance, to advise young artists to send only their worst work to the Salon. While such outrageous works as *The Murder* clearly point to persistent private fantasies, they also reveal Cézanne's utter frustration with an art world whose attention he felt he could only attract by such shocking means. And when viewed against the painting that the entrenched artistic hierarchy deemed acceptable, Cézanne's works from the late 1860s are surprisingly well-informed and based on coherent artistic strategies, even at this pivotal early stage in his career.

However crude, such problematic early paintings repay another look. The brute force, lack of purpose and what the art historian Robert Simon has aptly called 'the sheer weirdness' of Cézanne's violent images as a whole tell a public as well as a private story. Like many of Zola's early novels (for example, *Thérèse Raquin* of 1867) which were also punctuated with scenes of disturbing sexual crimes, physical cruelty and hideous carnage, Cézanne's almost forensic works must be read as reflections of a moment in French history in which the breakdown of private sexual and social mores was perceived as indicative of much broader societal ills. Symptomatic of this, contemporary French literature and popular journalism were brimming over with lurid stories for which the public's appetite was apparently insatiable. The widespread imagery of sexual savagery and murder during this period took on a particular urgency as it was perceived to mirror the chaos and violent upheaval that had enveloped France as a whole.

Faced with deteriorating support and even outright opposition, by the late 1860s Napoleon III had gradually relaxed a

number of repressive policies: limited rights to strike, to organize and to assemble in public had one by one been restored to the worker, while the press enjoyed renewed freedom. Yet such concessions proved too little too late. Long before the machinations of the Prussian premier Otto von Bismarck, the demise of the Second Empire's government was hastened by a series of labour strikes (some ending in violence), protests and furious clashes between a displaced, increasingly militant underclass and an urban bourgeoisie who saw their way of life hanging in the balance.

Such episodes of public disorder, and the fears of anarchy and national decline which they fostered, also heightened a growing paranoia in France about violence in society in general. This may account, in part, for the prevalence of heinous crime in contemporary literature and imagery, and even in Cézanne's most macabre early works. Two highly publicized and gruesomely documented murders, often referred to as 'the thunderclaps', were seen by many Frenchmen as symptomatic of their rotting social structure.

COMPLAINTE
Sur l'assassinat de Madame RENAUD.

35
A *canard* from the mid-19th century

In September of 1869, a young half-German Alsatian worker named Jean-Baptiste Troppmann was arraigned for the brutal slaughter of a young, pregnant French mother, her husband and six children in a field northeast of Paris. The public's grim obsession with every aspect of the crime, and especially with the huge, spatular hands of the suspect (he himself was puny), was unceasing. Troppmann's death by guillotine five months later did little to quell the appetite for collective revenge. Similarly, the 'crime of Auteuil' committed late that autumn, when Prince Pierre Bonaparte (a notoriously hotheaded cousin of the Emperor) killed a supporter of the republican journalist Henri Rochefort in a duel, seemed to offer further proof of the moral bankruptcy of the imperial regime. As the historian Frank Jellinek has pointed out, such events assumed enormous significance in a country living in 'an atmosphere of approaching calamity'.

Both of these murders were the subjects of numerous popular *canards* (35), the cheaply produced broadsides that fed a barely literate section of French society with a steady diet of graphic violence and sensational crime and that were ubiquitous in the 1860s. These too may figure in Cézanne's defiant visual vocabulary. We know from his earlier, skilful academic studies that Cézanne was an accomplished draughtsman. The ineptitude suggested by the strange, violent drawings and paintings is, thus, deliberate. As Simon has argued, such intentionally clumsy forms as the grossly oversized hands and heads of the two women in *The Murder* find their closest parallels not in any of Cézanne's student work but in the naïve popular images that illustrated the morbid stories currently in circulation. They seem to have provided both the kind of subject matter and the crudely powerful forms with which Cézanne could attack the élite conventions of Salon art and the genteel sensibilities of his viewers and, at the same time, connect with the world around him. Despite their seemingly unreadable themes and often wilfully incompetent forms, these problematic early

36
The Abduction,
1867.
Oil on canvas;
90·5 × 117 cm,
35⅜ × 46 in.
Fitzwilliam
Museum,
Cambridge

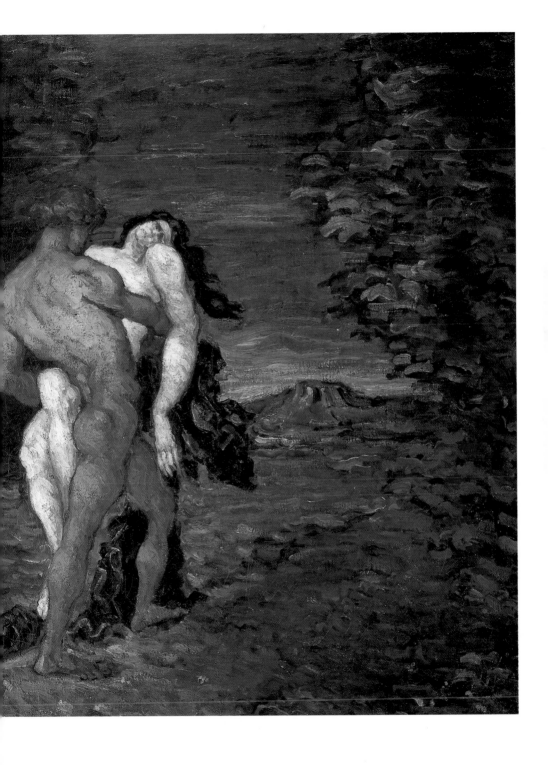

paintings offer a revealing glimpse of the charged political atmosphere that surrounded and informed them.

Interestingly, what is perhaps the most provocative of Cézanne's paintings of violent subjects, his monumental canvas *The Abduction* (36), moves us away from the dark alleys and mortuaries of a crumbling social order. Although we know that the artist painted, signed and dated it in 1867 – probably shortly after he returned to Paris from Aix – and then gave it to his friend Zola, its obscure subject and unusual form long rendered the painting mysterious. Unlike many of his other ruthless images, which are furiously painted and often bafflingly incomplete or inept, Cézanne's *Abduction* is a masterpiece of resolution and restraint. It employs unusually prudent brushwork for this period and an equally rare sense of overall finish (especially given its large size). Yet within its moody but balanced and carefully framed landscape, Cézanne paints a classical abduction scene that is every bit as radical and transgressive as the *canard*-like *Murder*.

The artist's source for the work is almost certainly a passage from Book 5 of Ovid's *Metamorphoses*. Cézanne's landscape is the island of Sicily, as vividly described by the ancient Roman author, complete with the distant volcanic peak of Mount Etna (which strangely resembles the more familiar Mont Sainte-Victoire), dense foliage and the storm-tossed lake on whose shores a mythic conflict took place. At the exact centre of this literary landscape, the artist stages his dramatic scene. A colossal, bronzed male nude, one of Cézanne's most impressive painted figures yet, whose heroic stance, ideal sculptural proportions and neatly plaited coif place him firmly in antiquity, represents the Underworld god, Pluto. Much as described by Ovid ('almost in one act did Pluto see and love and carry her off, so precipitate was his love'), the god forcefully seizes his victim and strides off into the shadowy landscape. His captive is the pallid and

37
Nicolas Poussin,
Echo and Narcissus,
c.1627.
Oil on canvas;
74 × 100 cm,
29¼ × 39¼ in.
Musée du Louvre, Paris

38
Alexandre Cabanel,
Nymph Abducted by a Faun,
1860.
Oil on canvas;
245 × 147 cm,
96½ × 57⅞ in.
Musée des Beaux-Arts, Lille

languishing goddess Proserpina, who is also nude and matches his colossal proportions. Trailing behind her is the garment that Pluto rent from her shoulder, while in the distance the island's two water nymphs mourn her capture. Cyane, who holds out the goddess's forgotten girdle that she will present to Ceres, Proserpina's grieving mother, also twists and sinks into the watery middle ground. The figure of her companion, Arethusa, was adapted from a classical painting that Cézanne had copied in the Louvre: Poussin's *Echo and Narcissus* (37). Like Poussin's water nymph, she too reclines but also melts into the lake in grief, as Ovid described. Not only its close adherence to such details in the ancient narrative but virtually every formal aspect of *The Abduction* suggests it to be a bold reworking of the kind of Salon painting that Cézanne had previously admired. In fact, despite its dramatic impact and obviously salacious subject (and his own growing notoriety as a rebel), *The Abduction* represents a major venture by the artist into the traditional realm of history painting.

As we have seen, by mid-century, history painting at the Paris Salons had dissipated into a form of predictable, painted entertainment for an increasingly bourgeois

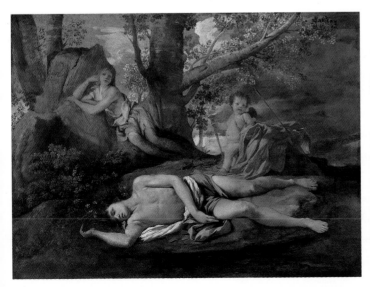

audience. And despite a growing interest in landscape, the related genre of the historic landscape, which had been officially recognized as a separate category by the École des Beaux-Arts since 1817, suffered as well. Offering a more idealized view of nature than in *plein-air* painting, and focusing more on nature than most history paintings, such landscapes had morally uplifting narratives or classical anecdotes that sanctioned their idyllic celebration of nature.

By the 1860s, even the vaguest hint of antiquity gave painters who openly catered to public taste an acceptable pretext to paint the idealized but still wanton nude in nature. Countless Salon submissions depicted the Rape of Europa, the Abduction of Amymone or of Deianira, or perhaps more tellingly, the assaults on numerous, unnamed and always unclothed nymphs or nereids by gods, fauns and satyrs in suggestive and sometimes openly erotic compositions. A case in point was the work of the popular painter Alexandre Cabanel, who was best known for his prurient *Birth of Venus* of 1863 but who achieved his first big success at the Salon of 1861 with his equally lubricious *Nymph Abducted by a Faun* (38). Despite its bestial passion, the work's purported mythological content made it highly acceptable. Napoleon III bought the work (which, like Cézanne's, featured a monumental bronze abductor and a pale victim) and exhibited it to renewed acclaim at the Universal Exposition of 1867, where Cézanne could have seen it again.

However, while this kind of popular Salon painting provides a general contextual framework within which to place Cézanne's *Abduction*, this work, despite its similar theme, seems to operate in a markedly different sphere. It manifests Cézanne's familiarity with a broad range of antique literature and classical painting and his desire to embrace both in his early work. Clearly, the artist intended it as a demonstration piece of sorts – perhaps to prove to his doubting companion, Zola, that the grand tradition of

history painting could yet be revived. Cabanel's work, by comparison, lacks any sense of either the literary narrative or the classical figure and landscape traditions around which *The Abduction* is so consciously constructed.

But it is in other ways that Cézanne's history painting truly transcends the popular academic art of the time. Despite its genteel origins and learned format, the real subject in *The Abduction* is not the eroticized nude that Salon viewers relished, but sexual violence. Cézanne's pale and powerless female nude is not ravishing but ravaged, or possibly even dead. The heroic traditions of past art – even the symbolic, moral terrain of the historic landscape – have been used to shape a particularly gruesome fantasy, in which sexual domination or desire is equated with violence or death. A strategic challenge to the conventions of artistic authority, the work also offers a fascinating glimpse of the subject of violence in this era from the artist's customarily oblique viewpoint. Cézanne's *Abduction* shares with his smaller, more tabloid-like *Murder* a dark currency of terror and unrest that had a powerful resonance in the last days of the Second Empire. In one fell swoop, he managed to manifest the darkest images of his own rage and fears and also the grim obsessions of a society increasingly preoccupied with doom. At the same time these images assailed, with a visual language that was as well informed as it was defiant, the pictorial models and authority of the cultural hierarchy that rejected him.

The harsh passions and intensity of these haunting works are echoed in a number of Cézanne's paintings that have survived from the late 1860s. More than one writer has suggested, for example, that the swarthy nude male in *The Abduction* finds its genesis in a large work also dated to c.1867, *The Negro Scipion* (39). Though painted from life (the subject was a well-known model at the Académie Suisse), Cézanne's canvas conveys all of the emotional power of his

more narrative early images. The expressive pose of the figure, his glistening, muscular form and long, mannered hands, realized, as in *The Abduction*, with short, swirling touches of the brush, distinguish this work from Cézanne's earlier academic studies. Even the artist's choice of palette – shadowy bronzes, blues and blacks against a cold sheet of white – adds to the painting's compelling strangeness. When Monet bought *The Negro Scipion* and hung it in his bedroom at Giverny some years later, he described it with pride to his friends as 'a painting of the greatest strength'. Its subdued tones would be repeated in other early figure paintings with similarly lugubrious strains: Cézanne's penitent *Mary Magdalene* of *c.*1867, a moving study of anguished sorrow and regret, and even a portrait of his friend, *Achille Emperaire* of *c.*1869–70 (see 104).

39
*The Negro
Scipion,*
*c.*1867.
Oil on canvas;
107 × 83 cm,
42⅛ × 32¾ in.
Museu de
Arte de São
Paulo Assis
Châteaubriand

Given the extremism of his work at this date, it is not surprising to learn that Cézanne's tastes in music ran to the progressive scores of Richard Wagner, who had startled Paris in 1861 with his bacchanalian opera *Tannhäuser*, and in contemporary literature to Gustave Flaubert. The author's scandalous novel of 1857, *Madame Bovary*, a realist tale of provincial adultery, had led to his celebrated prosecution for offending public morals. But it was in a different Flaubert text, the highly romantic *Temptation of Saint Anthony* of 1874 – which Cézanne already knew from excerpts published in the journal *L'Artiste* in 1856–7 – that the artist found a contemporary vehicle for some of his most ambitious early narratives.

Flaubert's elaborate retelling of the story of the hermit Saint Anthony, who is plagued by doubt and tempted by visions of voluptuous women and orgies, fuelled the imagination of a society that privately relished the increasing prominence given to sexual mores. The theme of the orgy frequently figured in the literature of the period, on stage, at the opera (not only in Wagner's *Tannhäuser* but also in

40
The Feast,
*c.*1867.
Pencil, crayon,
pastel, gouache
on paper;
32·5 × 23·8 cm,
12³⁄₄ × 9³⁄₈ in.
Private
collection

41
The Feast,
*c.*1869–70.
Oil on canvas;
130 × 81 cm,
51¹⁄₄ × 31⁷⁄₈ in.
Private
collection

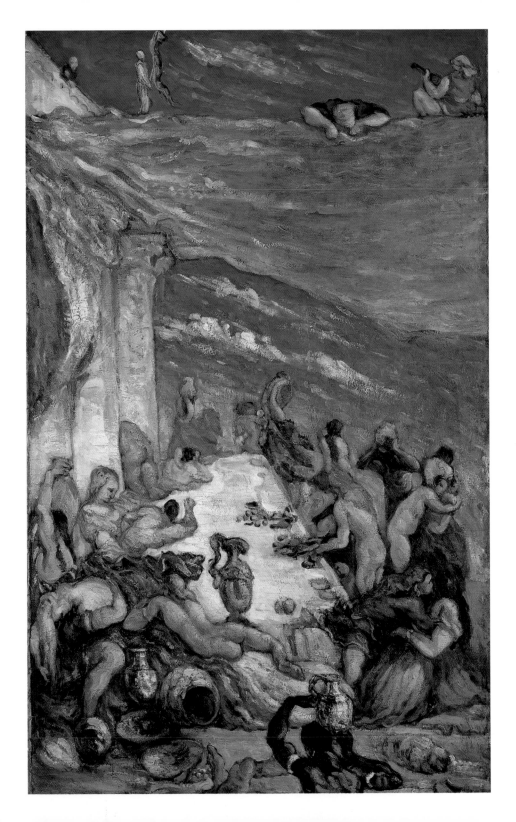

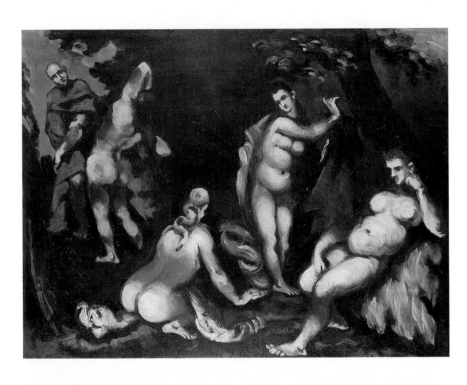

Charles Gounod's *Faust* of 1859) and in the work of Salon
painters who catered to a pleasure-seeking public. In a series
of early drawings and small watercolours (40), Cézanne
explored the theme on an intimate scale. His large painting
The Feast (41) of *c.*1869–70 is a comprehensive treatment
of the subject, for which Flaubert's description of the
riotous feast of Nebuchadnezzar was a principal source.
The towering columns disappearing into a shadowy mist, a
banqueting table stretching to the horizon, diners resting
on low couches, slaves and women bearing drinks, broken
and scattered crockery, and even the 'cloud [that] floats
above the feast, what with all the meats and steamy breath',
all point to the famous orgy passage published earlier in
L'Artiste. In additional details, Cézanne purposefully
augments the novel's central theme of sensual seduction:
the king's riches are manifested with frequent touches of
gold, morsels of luscious foods and ripe fruits are strewn on
the table and floor, and in an unmistakable pointing to the
moral, a sinister, undulating serpent invades the lower-right
corner. In several preparatory sketches, as well as in his final
canvas, Cézanne aligns the gaping orifice of the overturned
amphora – which greets the viewer at eye-level – with a nude
female or passionately embracing couple to make an obvious
sexual allusion. This abundance of temptations makes *The
Feast* a flamboyant pendant to Cézanne's first painting of
the tormented saint himself, the dark but equally fantastic
Temptation of Saint Anthony, also of *c.*1869–70 (42).

The grandest contemporary summation of the orgy theme,
and a major reason for its continuing popularity in
Cézanne's day, was the weighty philosophical machine by
Thomas Couture (1815–79), *The Romans of the Decadence*
(43), which drew crowds and critical notice at the 1847 Salon
and almost as much acclaim when it was re-exhibited at
the 1855 Universal Exposition. A massive scene of Roman
debauchery in a tightly ordered vestibule, where sculptures
of valorous Roman rulers preside over the decadent antics

42
*Temptation of
Saint Anthony*,
*c.*1869–70.
Oil on canvas;
57 × 76 cm,
22½ × 29⅞ in.
Foundation
E G Bührle
Collection,
Zurich

43
**Thomas
Couture**,
*The Romans of
the Decadence*,
1847.
Oil on canvas;
472 × 772 cm,
185⅞ × 304 in.
Musée d'Orsay,
Paris

of their descendants, Couture's painting depicted the harmonious, intellectual universe of the classical world in conflict with the carnal passions that plunged it into decline. Not surprisingly, by the 1860s, more than a few viewers saw in Couture's canvas a contemporary lesson for a demoralized French society.

Cézanne's *Feast* was a virtual parody of Couture's timely parable: the rigidly symmetrical chamber and heroic statues of *The Romans*, evocative of the moral probity and idealism of the classical past, are replaced by a riotous confusion of lustful, naked bodies, fragments of classical architecture that lead nowhere, and murky clouds that fill its wildly irrational space. His luminous palette in *The Feast* – of rich Venetian blues, reds and brilliant gold – looked to another well-known scene of banqueting and sumptuous colour, the Renaissance painter Veronese's *Wedding Feast at Cana* (44) in the Louvre. Additionally, *The Feast* is redolent with quotations of exotic passages from some of the most Romantic works familiar to Cézanne. The recumbent woman with flowing blonde hair on the lower left is taken from Delacroix's *Entry of the Crusaders into Constantinople on 12 April 1204* (1840), also in the Louvre, while the sensuous figures with upraised arms and the frantically clasping couples look back to his *Death of Sardanapalus* (45). Thus Cézanne's *Feast* is far more than a rich amalgam of images of debauchery from an age that revelled in them, and also more than a strange, dreamlike confrontation with the sexual torments that had become part of the artist's legend. Much like his earlier *Abduction*, it offers vivid testimony of Cézanne's consuming need to master, and even parody, the great painting and pictorial models of the past.

For Cézanne, however, as for Flaubert, the story of Saint Anthony struck a disturbingly intimate chord. 'I myself was the saint', wrote Flaubert in a letter discussing his novel. And in his first *Temptation of Saint Anthony* (42), Cézanne

44
Paolo Veronese,
The Wedding Feast at Cana,
1562–3.
Oil on canvas;
666 × 990 cm,
262⅛ × 389¼ in.
Musée du Louvre, Paris

45
Eugène Delacroix,
Death of Sardanapalus,
1827.
Oil on canvas;
392 × 496 cm,
154¼ × 192¼ in.
Musée du Louvre, Paris

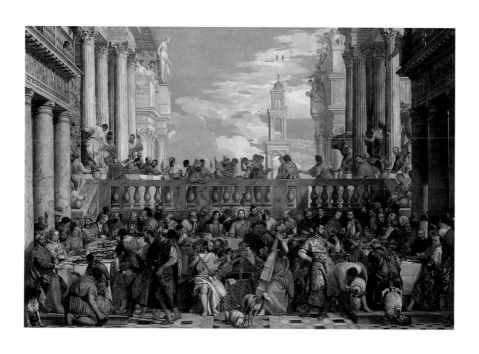

similarly identifies with his subject: in a dense, gloomy land-scape, four forbidding female nudes incarnate the sexual passions which the artist both feared and loathed. The most insolent of these appears to repulse, even as she brazenly seduces, the cowering monk at the back. The austere structure and rich, palpable paint of Cézanne's earlier *Portrait of a Monk* (see 31) now seem a prelude to the urgent battle played out here between the spirit and the flesh. Yet even in this most confessional of his early canvases, Cézanne constructs a pointed travesty of the traditional rhetoric of feminine beauty. His trio of posturing nudes in the foreground, laboriously arranged into a triangle, recalls such traditional subjects as the Judgement of Paris (a theme he had treated in the past), in which three nude goddesses vie to be chosen as the most beautiful; and even the related theme of the Three Graces, an established paradigm for the adoration of the female form. Cézanne's nudes, however, are thickly painted with swirling strokes, coarsely rounded contours and harsh contrasts of tone that make them sinister rather than sensuous, and render their suggestive poses ambiguous. We glimpse in them the strange un-readable gestures and forms of his later bathers. When an early critic of Cézanne complained that 'only the most incompetent devil would send these nudes to tempt a celibate saint', he failed to recognize that they were shaped not by questions of the artist's skill but by his will to spurn both his own desires and the cherished ideal of the female nude in art.

Two other narrative canvases from the years 1869–70 share this passion and complexity: *The Pastoral* or *Idyll* (46), which prefigures the later bathers paintings in its troubling illegibility, and the more contemporary *Déjeuner sur l'herbe* (see 48). Here again, Cézanne is operating in a parodic mode. And significantly, he inserts himself into both scenes, and so the dialogue he constructs with the past is not only obtuse but highly self-conscious.

In his visionary *Pastoral*, Cézanne paints a landscape that is not only ominous but almost absurdly erotic: phallic symbols flourish, such as in the thrusting dark trees, and even the atmosphere is heavy with an aura of dense sensuality. The intensely blue skies and water and luminous pink tones of the nudes and clouds saturate the senses further. Its combination of nude females, clothed male figures and verdant nature align Cézanne's painting, albeit mockingly, both with Manet's *Déjeuner sur l'herbe* (see 21) and with the great pastoral landscapes of Renaissance Venice. Like many nineteenth-century artists, in fact, including Delacroix and Manet, Cézanne would copy the archetypal *Fête champêtre* (47) in the Louvre, then attributed to Giorgione (*c*.1477–1510), and explore its symbolic harmonies between allegorical figures and idyllic nature. Yet the tormented self has not yet been extruded by tranquil form. At the centre of his own voluptuous universe Cézanne has painted himself, reclining like Delacroix's Sardanapalus (see 45) in a pose of deep, melancholic reverie, his posture mirrored by a reclining nude much like one in his related *Feast* (see 41). Although the fantasized roles of both actor and voyeur and the dramatic emotional conflicts of *The Pastoral* are now visibly the artist's own, they have become far less frightening in his dreamlike pastoral landscape.

The pastoral tradition and its eighteenth- and nineteenth-century re-imaginings were also behind Cézanne's *Déjeuner sur l'herbe* of *c*.1869–70 (48), an even more obvious reference, as its title suggests, to Manet's infamous canvas of the same name from 1863 (see 21). Like almost every young painter of his era, Cézanne was challenged by Manet's impudent rebuttal of the past in the contemporary picnic scene that had so captured the rebellious spirit of the Salon des Refusés in 1863. But more than Monet, Frédéric Bazille (1841–70), Renoir or any of the countless number of artists who recast Manet's composition in terms of their own emerging styles (and with little of his ironic wit), Cézanne

46
The Pastoral
or *Idyll*,
1870.
Oil on canvas;
65 × 81 cm,
25⅝ × 31⅞ in.
Musée d'Orsay,
Paris

47
Titian,
Fête champétre,
*c.*1510.
Oil on canvas;
105 × 137 cm,
41¼ × 54 in.
Musée du
Louvre, Paris

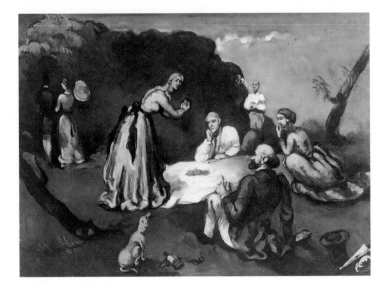

48
*Le Déjeuner
sur l'herbe,*
c.1869–70.
Oil on canvas;
60 × 81 cm,
23⅜ × 31⅛ in.
Private
collection

appreciated both its historic pedigree and its audacious
modernity. His own *Déjeuner sur l'herbe*, the first of several
variations on the theme, includes pointed references to the
Rococo *fête-galante*, an outgrowth of the earlier pastoral
mode and one that had also shaped Manet's version: the
motif of the promenade, or strolling couple common in
Watteau's elegant eighteenth-century *fête-galante* paintings,
appears at the far left in Cézanne's canvas; and the sharing
of food – and its equation of idyllic nature with licence and
love that Manet had blatantly updated – are also central to
Cézanne's conception, even without the presence of a nude.

Unlike Manet's work or the figure-in-landscape paintings of
his Impressionist peers, the arrangement and gestures of
the figures in Cézanne's *Déjeuner sur l'herbe* suggest
the subtle threads of dramatic interaction apparent in the
eighteenth-century *fête-galante*. Its sober mood hints, more-
over, that the rose-tinted world of the pastoral *fête* has also
been turned inside out, just as *The Abduction* worked to
subvert its heroic landscape. This sense of dark inversion
links Cézanne's *Déjeuner sur l'herbe* to the post-lapsarian
theme of the picnic in contemporary literature, and
especially in Zola's early novels. In his *Thérèse Raquin* and

Madeleine Férat (1868), the earthly paradise represented
by the picnic is haunted by guilt-ridden sex, violence and
murder. Cézanne re-creates this troubled and portentous
milieu, and once more inserts himself into an imaginary
archetypal scene (recognizable as the bald-headed figure at
front) that he saw as yet another stage for his own dark
narratives: sexual impulse leading inevitably to discord. By
the end of the decade, this strain in Cézanne's art would
be virtually exhausted; the self-conscious parodies and pas-
tiches of the 1870s, especially those revolving around Manet,
will be marked instead by their humour and subtle wit.

Some sense of this impending change of direction can be
gleaned in a few paintings that also date to the late 1860s.
Cézanne seems to have discovered that painting the material
reality of the landscape rather than deliberately contrived
fantasies was a deeply liberating act, and one that would
lead him to the discipline of painting *sur le motif* in nature.
But even before landscape assumed this new, formative role
in his art, Cézanne had turned to the medium of still life to
uncover organized segments of visual reality around which
he could construct his painting.

A comparison of two of Cézanne's early still lifes illustrates
the kind of respite that such a visually oriented genre would
eventually provide. His *Still Life: Skull and Candlestick* (see
32), one of the palette-knife paintings produced in the flurry
of activity of 1866, was discussed in Chapter 2 as an image
built around traditional symbols. In contrast, the exquisite
Still Life with Black Clock (49) of c.1869–70 is a study of
intricate formal balances and masterful design: the rococo
curves of the shell at left, the vertical, fluted vase at centre,
the sombre black box of the clock at right all rest on the
austere white slabs of the cliff-like cloth. And the precari-
ously placed cup and saucer hover somewhere between the
surface of the canvas and the viewer's space. Although the
imagery suggests some intimate level of veiled meaning – the

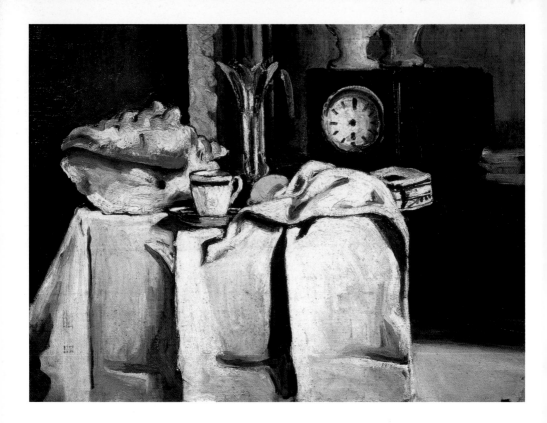

49
*Still Life with
Black Clock,*
*c.*1869–70.
Oil on canvas;
54 × 74 cm,
21¼ × 29⅛ in.
Private
collection

sensuous scallops and red-lipped mouth of the shell,
for example, seem poised to assume more than a formal
role – the work also resists our attempts to read any specific
symbolic connotations into it. Even the authoritative black
clock, missing its time-telling hands, refuses to act as a
traditional still-life symbol.

Much as he would in his later bathers, Cézanne constructed
his images around such carefully orchestrated paradoxes,
and the tensions they produced only enhance their visual
power. If the fragmented social order and concomitant
social evils of Second Empire France seemed at first both
to shape and to mirror Cézanne's unwieldy temperament,
these works, edging out from a dark and turbulent period
in his *œuvre* and in the historical context that informed
it, already point towards the compelling moral order of
pure form.

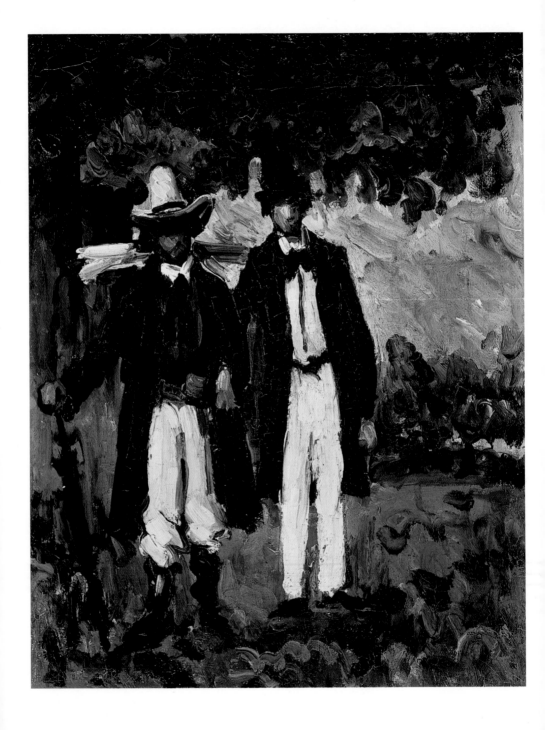

The decade of the 1870s was one of major transitions and achievement for Cézanne in each of the genres he addressed. And in the pervasive social and political turmoil of these years – as potent a framework for change as any France had seen in some time – Cézanne's artistic breakthroughs offer a fascinating mirror of his era. But the nature and the fullness of his development in this crucial decade are best grasped by separating his work into the individual genres he addressed, just as the painter did himself. Thus, the next chapters will trace his artistic evolution in the 1870s in terms of: (1) his landscapes, (2) the early nudes and bathers, and (3) the portraits and still lifes of this period.

As early as 1866, Cézanne had suggested to Zola the definitive role that landscape would assume in his work:

But you know all pictures painted inside, in the studio, will never be as good as those executed in the open. When out-of-door scenes are represented, the contrasts between the figures and the ground are astonishing and the landscape is magnificent. I see some superb things and I shall have to make up my mind only to work out-of-doors.

Illustrating his letter was what might be thought of as a declaration of intent: a rough drawing of a project (never realized), for which he had already produced an oil sketch (50), of his old friends Marion and Valabrègue as artists setting out for the motif. Though brusquely set down with thick strokes of a loaded brush, the poet Valabrègue, on the right, is striking in top hat and black coat. His companion, Marion, who sometimes tried his hand at painting, is shown wearing a Barbizon hat, a landscape painter's pack hitched to his back, and carrying an easel. This lively sketch

50
Marion and Valabrègue Leaving for the Motif, 1866. Oil on canvas; 39 × 31 cm, 15⅜ × 12¼ in. Private collection

suggests Cézanne's new-found faith in the benefits of *plein-air* painting as established by the Barbizon painters, and in Provence by his predecessor, Granet. Although it would be almost five years before landscape would play a primary role in Cézanne's art, another project of 1866 outlines the discipline and consonance that painting *sur le motif* could bring to his art.

Cézanne's small *View of Bonnières* (51) can be securely dated to the summer of 1866. After another disappointing submission to the Salon that spring, the artist left Paris to spend a few months in the village of Bennecourt along with Zola, Valabrègue and others. Bonnières was a small hamlet just across the Seine and linked to Bennecourt by ferry, but Cézanne's close-up view may well have been painted from a boat or from a small isle in the river. Forcefully executed with a palette knife, like the bold *Uncle Dominique* portraits of a few months later, his river land-scape offers a study in balance and stable form: the perfect centrality of the church spire reflected in the water below, the calculated symmetry of the two diagonal footpaths emphasized by thick swathes of a luminous hue, and the gentle curve of the reflected shoreline that is reversed in the arc of the ferry line above. Almost devoid of anecdotal refer-ence (we can just make out the tow-horse and the sketchy peasant figures in the barge), the painting focuses with unusual rigour on the flattened, frontal view of Bonnières; its spare scheme provides Cézanne with the kind of intrinsic order he would later find in the Provençal landscape.

Not all of Cézanne's early landscape subjects were as con-ducive to the composition of calm stability he found at Bonnières; in its delineation of a serene, subtly organized whole, his view of the village is unusual in this period. Far more typical in its impetuosity, for example, was the artist's claustrophobic view of a steep and narrow street in Montmartre, *The Rue des Saules* of 1867–8, a small, heavily

51
A View of Bonnières, 1866.
Oil on canvas; 38 × 61 cm, 15 × 24 in.
Musée du Docteur Faure, Aix-les-Baines

worked canvas painted in Paris a year or two later on which Cézanne clearly struggled to impose a similar measure of control. And while he almost never made preliminary studies for landscapes, a drawing and two paintings of *The Railway Cutting*, executed near the Jas de Bouffan, offer further evidence of his efforts to wrest from such observed motifs the vision of sober order achieved in his best works.

His preparatory study for the first version makes clear the laboriousness of his task. In the drawing, Cézanne repeatedly stressed the dominant diagonals and verticals of his

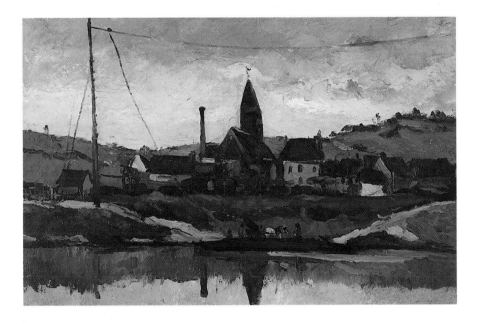

motif with conspicuous ink accents. But in his first painting of *The Railway Cutting* (52), which dates from *c*.1867–9 and was roughly sketched in oil on a small board, robust new curves that are tied at midpoint by a series of strong diagonals dominate the composition. The dynamic foreground is realized in vibrant tones of orange, yellow and green against a distant blue horizon and focuses on the strong vertical forms of a church tower, a pole and the fiery red ball and shaft of a signal that marks the railway. All parts of the landscape are thus held in balance, but the artist's vigorous

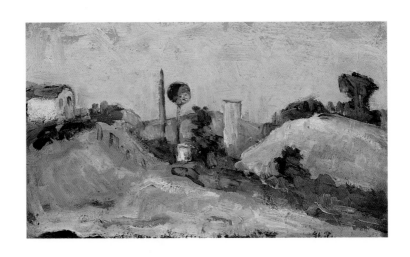

strokes, thick impasto and brilliant palette make it a tenuous one at best. In the final canvas (53), painted in c.1869–70, we see the culmination of his ambitious project. With a more subdued palette of earthen terracottas and greyish blues, a minimum of detail and a far more measured touch, Cézanne shifts his viewpoint to include the outlying Mont Sainte-Victoire on the right. Above the horizontal expanse of the low enclosing wall of the Jas de Bouffan, which boldly flattens the foreground space and echoes the lower framing edge of the canvas, and against a magnificent azure sky, a series of ordered curves draws the viewer back to the distant, simplified mass of the ancient mountain.

52
The Railway Cutting, c.1867–9. Oil on board; 19 × 33 cm, 7¹₂ × 13 in. Barnes Foundation, Merion, Pennsylvania

53
The Railway Cutting, c.1869–70. Oil on canvas; 80 × 129 cm, 31¹₂ × 50¹₄ in. Neue Pinakothek, Munich

As it often would in subsequent works, the motif of Mont Sainte-Victoire seems to signal the heroic pictorial feat so carefully laid out before it, a vision of seemingly effortless equilibrium on a new, monumental scale. More than a few later admirers would point to this definitive version of *The Railway Cutting* as a landmark in the painter's evolution, one that resonates with the same imposing calm and sober power that mark his best still lifes of the same period (see 49). Yet even Cézanne's landscape style would oscillate for a crucial period between such stringent formal logic and the more restless, moody landscapes that followed close behind.

Cézanne divided his time in the 1860s between Provence and Paris, and his landscapes allow us to chart his restless journeys and unsettled early ambitions. However, even though landscape painting was assuming a larger role in his art, Cézanne's submissions to the Salon returned to more familiar ground. In the spring of 1870, the painter presented two of his boldest recent figure paintings: a nude that pointedly recalled his provocative earlier art and a large expressive portrait (see 82 and 104). Both, as we will see, would become key to the evolution of his figural work in the 1870s (see Chapter 5). Yet although the jury that year was one of the most liberal in recent memory and Renoir, Pissarro,

Edgar Degas (1834–1917), Bazille and others of his friends found their work accepted, Cézanne's canvases were rejected. This too may have spurred his interest in the less controversial subject of landscape.

In July, just after the Salon closed, hostilities broke out between French troops and the better-trained Prussian forces of Otto von Bismarck, and it quickly became clear that Napoleon III had manoeuvred his country into a futile international conflict. By early September, the Second Empire had fallen: the Emperor surrendered with his men on the eastern front, and the Prussians marched virtually unopposed towards Paris. Within days, the capital was surrounded and a punishing, four-month siege began. In the ensuing upheaval of that long, cold winter and the following spring, the camaraderie of the Café Guerbois circle was shattered: Monet and Pissarro escaped to London, Renoir was drafted, Manet and Degas enrolled in the National Guard as volunteer gunners (but saw little action), and one of the youngest of the group, Bazille, was killed in battle. Cézanne, as his landscapes reveal, laid low in his native Provence.

He had left Paris after serving as a witness at Zola's wedding in May 1870 and seems to have spent the summer at the Jas de Bouffan. By the autumn, he had moved to the small coastal village of L'Estaque, just west of Marseille. Seemingly removed from the turmoil that pervaded most of France, Cézanne quietly divided his time there, as he later recounted, between landscape painting and working in his studio. Yet things were probably not quite so tranquil: from a letter written that winter by his friend, Marius Roux, to Zola, we learn that Cézanne's name was on a list of young men in Aix who were being sought for having evaded military conscription and that the police had searched for him at the Jas de Bouffan. By June 1871, as Zola told their mutual friend Paul Alexis, Cézanne may even have fled L'Estaque and 'hidden himself in Marseille or in some hole of a valley'.

In fact, Cézanne was escaping not only the local authorities but the watchful eye of his father, who did not know about his liaison with Hortense Fiquet, a tall, dark artist's model he had met in Paris a year or two earlier, when she was only nineteen. Originally from the village of Saligney, near Dole, in the Jura, Hortense had lived in Paris with her mother until the latter's death and during the war went to live secretly with Cézanne in L'Estaque. His bleak, precipitous landscapes from this time seem consistent with the disquietude, both personal and political, that surrounded him.

Cézanne spent many extended periods in L'Estaque throughout his career; it provided both a familiar refuge and striking motifs of a steep, spectacular terrain. In a letter written some years later, Cézanne lauded the dazzling Mediterranean light of L'Estaque, which reduced the forms he painted there to 'silhouettes' of brilliant contrasts. In comparison to the modern and much larger Marseille, an exotic and raucous international port that had taken on new importance with the opening of the Suez Canal in 1869 (it would acquire an even larger role as a trading base after France lost Alsace in the treaty of 1871), L'Estaque remained a humble fishing village. Only a few smoky factories that dotted its rocky hillsides and buttressed its seafaring economy suggested any link with the present.

The few works that survive from that cold winter and spring are ominous and dark. Chief among them is *Melting Snow at L'Estaque* (54). With its furious, sweeping strokes that emphasize a violent downward thrust, it has been memorably described by the noted art scholar Lawrence Gowing as 'the fearful image of a world dissolved, sliding downhill in a sickeningly precipitous diagonal between the curling pines which are themselves almost threateningly unstable and Baroque, painted with a wholly appropriate slipping wetness and a soiled non-colour unique in his work'. Equally unsettling is Cézanne's *Village of Fishermen at L'Estaque*, a

landscape of the same period that conveys a similarly plunging view to a swirling shore and sea. And the wintry palette of almost monochromatic tones, heavy skies and vehement brushwork in his *Melting Snow at L'Estaque* are repeated in a related L'Estaque canvas (55) of crude fishermen's huts covered with greyish snow. Each of these paintings is marked by a conspicuous gloom that sets them apart from the artist's earlier landscapes. Along with his more narrative images of terror and violation, they powerfully evoke the climate of fear and despair that pervaded France at this time, from which not even Cézanne could escape.

The news that winter was bitter. A provisional government had been established under Adolphe Thiers, who signed an armistice with the Prussians in January 1871. But by the spring, civil war had broken out in Paris and a second siege would follow. The largely working-class members of a new, left-wing Commune rejected Thiers's Third Republic and forced its National Assembly to retreat to Versailles. By early May, government troops were at war with working-class Parisians and their supporters. And by the end of that month, after horrific bloodshed, the Commune was crushed and a chastened country was left to ponder its uncertain future. So much of what had been achieved in the Second Empire now lay in ruins: bombed-out boulevards (56) and

54
*Melting Snow
at L'Estaque,*
c.1870.
Oil on canvas;
73 × 92 cm,
28³⁄₄ × 36¹⁄₄ in.
Private
collection

55
*Fishermen's
Huts under
Snow,*
c.1870.
Oil on canvas;
59 × 78 cm,
23¹⁄₄ × 30¹⁄₄ in.
Private
collection

56
The Rue de
Rivoli after the
Commune,
May 1871

buildings (including parts of the Louvre), demolished
railways and viaducts, widespread economic ruin and a
terrorized populace replaced the glittering metropolis
and boundless optimism of the previous decades. In 'l'année
terrible', as Victor Hugo aptly called it, France not only suf-
fered an enormous human toll (with 25,000 killed in a single
week in late May) and the loss of two key provinces, Alsace
and Lorraine, but also sacrificed its position at the forefront
of European culture and society. Within two-and-a-half
years France would pay off the staggering five-billion-franc
indemnity promised in the peace treaty of May 1871, but
it would take far longer for the nation to recover from the
Prussian humiliation and the civil strife of the Commune.

The painters, poets and philosophers gradually made their
way back to a far more sober capital city than the one they
had left a year or so earlier. Manet, in fact, had witnessed
some of the devastation, and his searing images of civil war

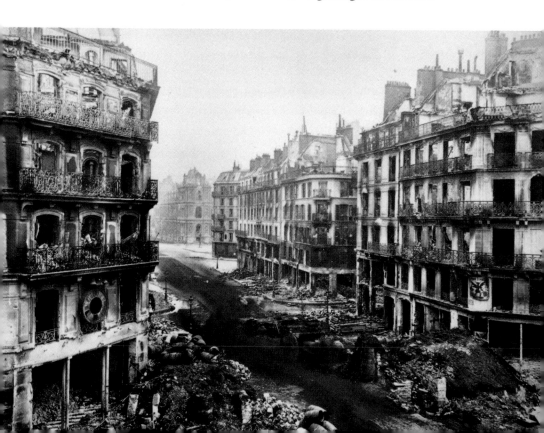

on the streets of Paris brought home the trauma of recent events to those who had escaped them. Renoir too, returning just before the bloody end, captured in a rough sketch the execution of a Communard. Even some academic painters who had stayed behind to fight, such as Meissonier, the Salon favourite, painted strangely unsatisfying reminders of the *débâcle*, one that not even the traditional language of heroic symbol and allegory could ennoble.

Cézanne, now finally free from the threat of military draft, went first to Aix (though probably not with Hortense Fiquet) and it is most likely that he painted the small and intensely hued *Avenue of Chestnut Trees at the Jas de Bouffan* (57) while visiting his family, in the late summer months of 1871. In this landscape, which is built around a careful system of receding parallels and direct contrasts of brilliant light and shadow, the artist reaffirmed his earlier goal to impose upon such motifs in nature a formal logic of balance and order. His new range of vibrant colours – the many shades of green and yellow in particular – as well as the variety of his brush-strokes suggest that his art would soon take a new direction.

In the autumn, he too returned to Paris, settling by December with Hortense in a small apartment on the Left Bank. Here, faced with the eerie, burnt-out remnants of war, an official art world that had quickly reconstituted itself but remained as hostile as ever, and perhaps above all the imminent arrival of his first child, Cézanne could not escape a mood of dark gloom that characterized his work. One of the canvases that can be securely dated to the winter of 1871–2, and also one of the artist's rare cityscapes, is *Paris: Quai de Bercy – La Halle aux Vins* (58), which was painted from a window in his second-floor apartment. Although the market place was a bustling and noisy commercial centre for vintners (Achille Emperaire would complain when he visited the artist that there was 'enough uproar to wake the dead'), Cézanne pictures it as deserted under a dreary sky and

57
*Avenue of
Chestnut Trees
at the Jas de
Bouffan,*
c.1871.
Oil on canvas;
37 × 44 cm,
14⅝ × 17⅜ in.
Tate Gallery,
London

58
*Paris: Quai de
Bercy – La Halle
aux Vins,*
1872.
Oil on canvas;
73 × 92 cm,
28¾ × 36¼ in.
Portland Art
Museum,
Oregon

focuses on the stacked-up barrels of wine, a motif inherently unstable in itself. With a palette of mostly browns and murky greys, the painting resonates with the same oppressive spirit as his recent landscapes of L'Estaque. Soon afterwards Cézanne gave the picture to Pissarro who, always encouraging, admired its 'remarkable vigour and strength'. But it also seems to have marked the end of this unique phase in Cézanne's career as a landscape painter. In 1872 Cézanne left Paris and moved with Hortense and their infant son, Paul, to Pontoise to work side by side with Pissarro (59). Cézanne's new landscapes, which often echoed the work of the older artist and the growing circle of painters, including Guillaumin, who surrounded him, signalled the beginning of a vital new chapter in his art.

Pontoise was an easy train ride from Paris, and its railway bridge, destroyed by the French early in 1871 to halt the Prussians, was one of the first to be rebuilt. A historic country town that celebrated its anti-Parisian character, it was perched on a hillside overlooking the Oise river. And while access to Paris would make Pontoise a desirable site for factories and for wealthy Parisians seeking a weekend residence, it clung to its distinctly rural nature. This must have been part of the town's attraction for the unassuming Pissarro, who moved there in 1866. In the unstable early years of the Third Republic, the environs of Pontoise and Auvers-sur-Oise could also provide images of a model rural community and a productive economy that appealed to a beleaguered nation eager to revitalize and rebuild itself.

Cézanne's first landscape in Pontoise (60) was a small replica of a painting which Pissarro had completed the year before in Louveciennes, a village near Versailles where he had lived with his family from 1869 until 1872, apart from seven months in England during the Franco-Prussian War. Pissarro's son Lucien later recalled the circumstances surrounding Cézanne's copy: 'My father was then starting

to do light painting; he had banished black, the ochres, etc. from his palette ... He explained his ideas about this subject to Cézanne, and the latter, to understand this, asked him to lend him a canvas so that he could, in copying it, judge the possibilities of this new theory.' A comparison of Cézanne's landscape with that of Pissarro (61) shows how quickly the younger artist mastered his mentor's new technique. With short, disciplined brushstrokes appropriated from Pissarro, a brightened palette and small patches of pure colour standing in for traditional modelling, Cézanne's canvas is freed from the emotional turmoil and fiery execution of so many of his earlier landscapes. Yet there were already signs that his art would follow its own course. Cézanne's version employs much starker contrasts of light and shadow, which emphasize the blocky forms of the village architecture and the fall of sunlight on the road. And he eschews much of the scenic detail that highlights Pissarro's rustic scene: his trees have less foliage, the neat rows of the cultivated gardens are literally brushed over, and the peasant woman and child are almost crudely sketched in. The painting is in fact among Cézanne's few rural landscapes to include figures at all. Though sustained by Pissarro's example and tutelage, Cézanne's sensibility would be utterly different.

Soon after arriving in Pontoise, Cézanne settled with his family in the neighbouring hamlet of Auvers-sur-Oise. Its picturesque riverside setting and bucolic charms had earlier engaged Corot and Daubigny, and by 1890, when the Dutch painter Vincent van Gogh (1853–90) arrived, it had become something of an international artists' colony. Pissarro often joined Cézanne there, and introduced him to Paul Gachet, a kindly physician and amateur artist who likewise encouraged him, and also copied and even purchased some of Cézanne's paintings. Gachet's tall, picturesque white house is in several of Cézanne's first views of Auvers. One of these, *The House of Doctor Gachet at Auvers-sur-Oise* (62), is painted in muted tones and probably dates to the early

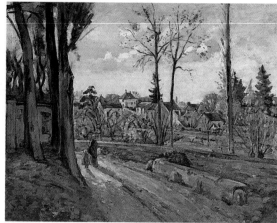

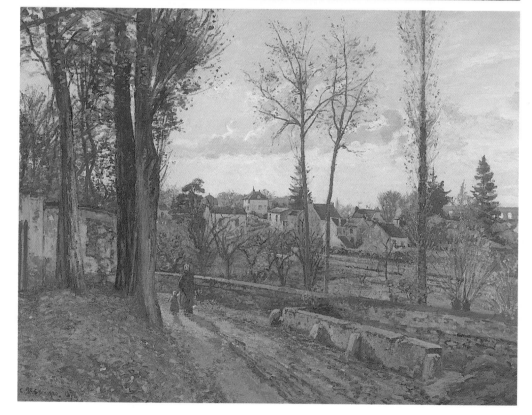

months of 1873. Small touches of paint, which point to Pissarro's direct influence, describe the early spring foliage on either side of the curving road that leads to Gachet's home. The house itself and the surrounding architecture compose a study in crisp geometric forms. Perhaps most characteristic of Cézanne's style here, rather than his mentor's, is his handling of the empty road, which recalls the artist's earlier painting of a Montmartre street. The tactile surface and light tonality of the village street make it seem to tilt upwards rather than recede convincingly in depth. A winding road stretching into the distance typically invites the viewer into a painted landscape. Here it denies him access and even serves, strangely, to isolate the village from any human interaction. Many of Cézanne's later rural landscapes would also feature such shallow, curving roads, not only for their paradoxical visual effects but because they could contribute to the intricate formal harmonies of his painted surfaces.

Even more frontal and flattened in effect is *House of Père Lacroix, Auvers-sur-Oise* (63) of 1873, one of the few canvases of the period that Cézanne signed and dated. Its brilliant palette and lush foliage situate the painting more exactly within the summer of that productive year. Although it probably follows *The House of Doctor Gachet* by only a few months, the painting offers one of Cézanne's most complex systems of correspondences to date: near and far pictorial elements, light and dark hues and a range of vibrant brushwork play off each other to create a vivid surface of complementary opposites. At the centre, a perfectly placed window ties the work together. Cézanne seems already to enjoy a new-found confidence, at least in part because of the continuing counsel and support he received from Pissarro.

The work of Pissarro, who was a socialist and a passionate supporter of the local peasantry (among other things, he

helped to organize a local bakers' union), was much more heavily invested in the associations of an idyllic rural milieu than Cézanne's was. A comparison of paintings of the same landscape by Pissarro and Cézanne bears this out. While Cézanne's *Auvers, Small Houses* (64) of *c.*1873–4 focuses on the forms of luminous white farmhouses in a brilliant green field, Pissarro's related painting, **Harvesting Potatoes** (65), offers a harmonious vision of rural labour. The blank plastered façades and vacant spaces that provided Cézanne with his motif serve only as a backdrop to Pissarro's timeless depiction of a harvest. Similarly, while Cézanne constructed his composition around the visual rhymes created by the verticals of the chimneys, trees and compressed parallel strokes at left and by the horizontal framing elements of

62
The House of Doctor Gachet at Auvers-sur-Oise,
*c.*1873.
Oil on canvas;
61·6 × 51·1 cm,
24¹⁄₄ × 20¹⁄₈ in.
Yale University Art Gallery, New Haven

63
House of Père Lacroix, Auvers-sur-Oise,
1873.
Oil on canvas;
61·5 × 51 cm,
24¹⁄₄ × 20 in.
National Gallery of Art, Washington, DC

the narrow band of sky and foreground wall, Pissarro's pictorial unity is more symbolic: the stark geometry of the farmhouses serves as a foil to the labouring peasants who alternately stand or crouch at work in the landscape, and the parallel rows on the distant, cultivated hillside are opposed by the more ruggedly worked and crudely painted foreground field. Such comparisons underscore the studied conservatism and growing utopian emphasis of Pissarro's *œuvre*. The self-consciously rural and even agrarian nature of many of Cézanne's early Auvers landscapes is better gauged when compared not with the paintings of Pissarro, but with those of the same period by Renoir or Monet.

At first glance, Monet's *Houses at the Edge of the Field* of 1873 (66), for example, is easily likened to Cézanne's *Auvers,*

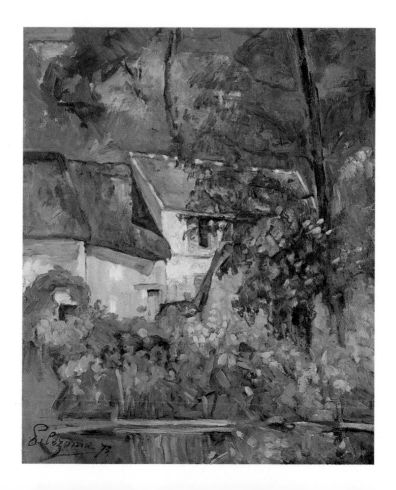

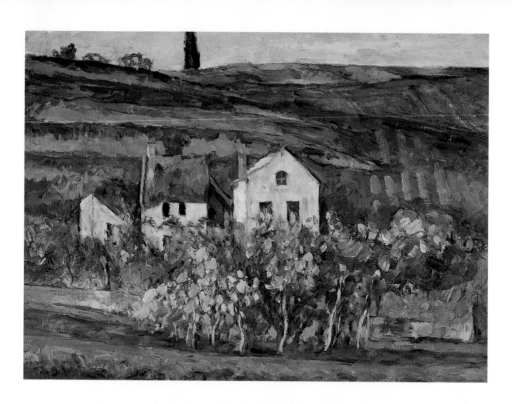

Small Houses: both depict the distinct contours of white houses in verdant, sun-lit landscapes that are framed by horizontal bands of sky and foreground fields. Each employs the broken brushstroke used by many early Impressionists, with Monet's strokes both smaller and more varied. Yet the two canvases present strikingly different views of – and attitudes towards – the landscape. Cézanne's farmhouses are situated in the middle of what is obviously agricultural terrain; the striated patterns of the cultivated hillside must have appealed to a painter who so consciously sought in nature motifs of unified order. The vertical screen of trees with thickly painted foliage at centre, which bridge near and far, soften the lines of the architecture and are echoed in the bold parallel paint-strokes at the far right, further add to Cézanne's vision of a harmonious rural nature.

In contrast, Monet's painting, for all its flower-strewn fields and fresh, airy light, offers a more urban – or suburban – landscape: the central motifs of small houses compete for our attention with the tall church spire beyond, and the open foreground and private ornamental gardens contrast with the densely built-up space of the city behind. Even without knowing, as the Monet scholar Paul Tucker has shown, that Monet's motif is the development of new houses on the fringes of the rapidly expanding town of Argenteuil (on the Seine northwest of Paris), where there had once been tilled fields, one senses a different kind of subject matter than that pursued in Cézanne's painting: the abrupt meeting of these two worlds. In contrast, Cézanne's *Small Houses* creates an image of nature that is stable and untouched by modern changes in the landscape.

As a mark of continuing discontent with the official Salon, at the end of 1873 a group began to organize themselves into an independent artists' cooperative, with Pissarro leading the effort. And on 15 April 1874, under the direction of Monet, Renoir, Degas and Pissarro, the inaugural exhibition

64
Auvers, Small Houses, c.1873–4. Oil on canvas; 40·5 × 54·5 cm, 16 × 21½ in. Fogg Art Museum, Harvard University Art Museums, Cambridge, Massachusetts

65
Camille Pissarro, *Harvesting Potatoes*, 1874. Oil on canvas; 33 × 41 cm, 13 × 16¼ in. Private collection

66
Claude
Monet,
*Houses at
the Edge of
the Field*,
1873.
Oil on canvas;
54 × 73 cm,
21¹⁄₄ × 28³⁄₄ in.
National-
galerie, Berlin

of the Société Anonyme (as they chose to call themselves) opened in the former studio of the photographer Nadar on the elegant Boulevard des Capucines. This show has since often been termed the first Impressionist exhibition.

Cézanne's *House of the Hanged Man, Auvers-sur-Oise* of *c*.1873 (67) figured prominently in the show. It could have functioned, along with Pissarro's submissions, as a kind of manifesto for the 'school of Pontoise'. Although its provocative title (its origins remain uncertain) threatened to revive the artist's notorious reputation, Cézanne constructed here a rigorously observed view of a quiet corner of the rural hamlet he inhabited. Like so many of his paintings of country roads and paths, the foreground is unstable, the spatial transitions uncertain and the viewer's entry into the landscape difficult, but the whole remains symmetrically framed and ordered. And throughout, the crisp rectangles of windows, doors and houses are softened by screens of barren tree branches, a device he probably learned from Pissarro. Yet Cézanne's formal manipulations do not obscure the painting's pointedly rustic character. His inclusion of rocky outcroppings, tufts of wild grass and, on the right, the curving form of a quaint thatched-roof cottage, grounds his painting securely in its picturesque realm. But the

rough-hewn surface of his canvas, reworked with a heavily loaded brush, also gives it a sense of raw, physical power.

Even though he was devastated by scornful reviews, Cézanne came to recognize the pictorial feat this painting represented. He sold it at the exhibition to Count Armand Doria, a prosperous landowner and avid collector, who later sold it to another of the artist's early patrons, Victor Chocquet. Over the next decades, Cézanne borrowed it back three times to hang in exhibitions (including the 1889 Universal Exposition in Paris) as evidence of his achievement. Cézanne's *House of Père Lacroix* (see 63) may have been another of his submissions to the 1874 exhibition; not only its large size, signature and date but also its exuberant embrace of an Impressionist style that still owed something to Pissarro mark it as a work that was probably intended for public viewing.

When the exhibition closed a month later, it was obvious to many of its 3,500 visitors as well as to the painters themselves that both the authority and hierarchies of the Salon system had been substantially weakened by the event. Likewise, while the sales at the exhibition were meagre, the interest of dealers such as the maverick Paul Durand-Ruel and even a few private collectors like Count Doria pointed to a growing bourgeois art market that would soon challenge the patronage of the state. Thus, what had been regarded by many as 'nothing more serious than a student revolt' in fact became a watershed in the history of modern painting.

Some scholars have sketched out the political and broader historical contexts of Impressionism, as it came to be called, and their work is crucial to an understanding of the loosely defined movement in its infancy. Linked more by their rebellious defiance of long-established hierarchies in art than by any singular style or theory, the avant-garde painters who came together in 1874 sought not only an alternative to the annual Salon but a showcase that could offer them both public and fiscal recognition. Their

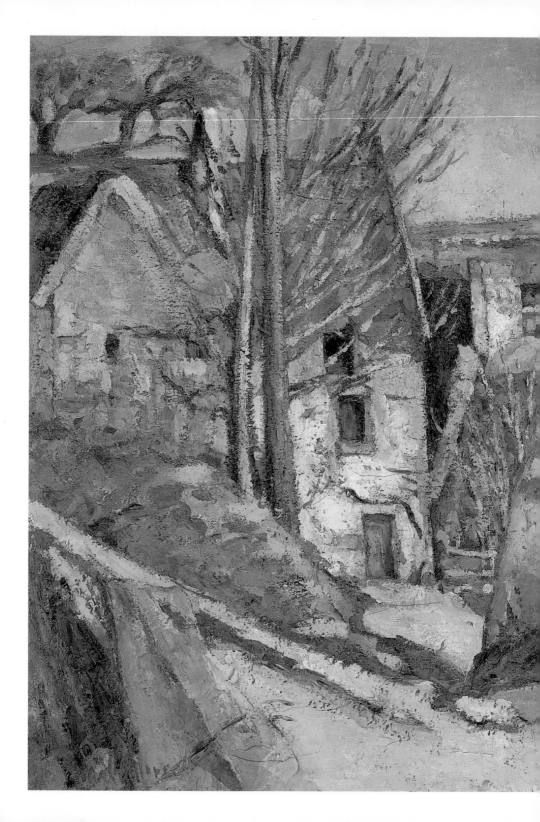

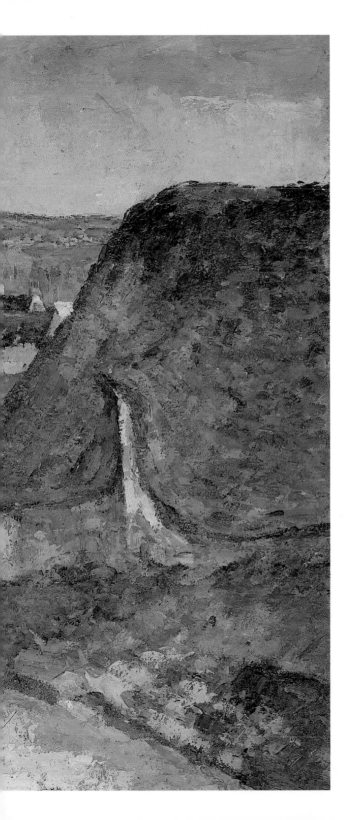

67
*House of the
Hanged Man,
Auvers-sur-Oise,*
c.1873.
Oil on canvas;
55 × 66 cm,
21⅝ × 26 in.
Musée d'Orsay,
Paris

art would embrace a vast range of modern subjects and individual approaches and elicit an equally wide spectrum of critical responses. Both the positive and negative reviews they garnered help to situate the works on view in Nadar's studio within the charged political climate of this era.

The critical tensions provoked by the exhibition were not merely aesthetic, therefore. Instead, it cast into relief the struggle between a faltering status quo defending its primacy and a group of artists, impatient of academic convention and already socially marginalized, whose war-fragmented lives were nourished on the one hand by the dazzling immediacy of nature and on the other by an almost colloquial view of urban life. Many would see in the new painting, which emphasized the unique *sensation* of the artist – his or her personal response to the visual stimuli of nature as conveyed through an equally subjective range of individual brushwork techniques – both a celebration of originality and a welcome deliverance from the banalities of the academic routine. Likewise, the Impressionists' frequent focus on the urban world and suburban retreats enjoyed by their middle-class viewers signalled to some critics new hope for the future and progress of French art, and even for the country itself. Tucker has suggested that the theme of a nation regenerating itself is, in fact, central to Monet's seminal *Impression, Sunrise* (68) – one of several works from which the term Impressionism was coined – a brilliant, sketch-like rendering of sunlight falling through mist over the industrial port and shipbuilding factories of Le Havre.

When the first Salons after the war proved particularly lack-lustre, the Impressionists' alternative, and often more hopeful, vision of France seemed to swell in importance. Yet some of the criticism that greeted their first exhibitions was virulent – and some of this virulence took its impetus from the embers of the old nationalism. The shameful memory and enduring effects of the Franco-Prussian War

and the Commune produced a conservative backlash in the early years of the Third Republic that permeated all sectors of French society, including the art world. In an era that openly feared the loss of established axioms of authority and standards, the Impressionists' pointed rejection of traditional notions of finish and subject matter in art could just as easily be perceived as subversive. Often dubbed in the conservative press as 'Intransigeants' – a term that was coined, as the art historian Linda Nochlin has argued, from the political lexicon, where it implied radical or anarchist leanings – the seemingly unassuming painters of the

68
Claude
Monet,
*Impression,
Sunrise,*
1872.
Oil on canvas;
48 × 63 cm,
18⁷∕₈ × 24⁷∕₈ in.
Musée
Marmottan,
Paris

modern French landscape would long struggle with this dual perception of them. As late as 1877 the critic Frédéric Chevalier would describe what he saw as the deliberate incoherence and disruptive vision of the first Impressionist canvases as analogous to the chaos of the period.

As soon as the first Impressionist exhibition closed, Cézanne packed his bags and headed south for the summer. But news of the show's infamous reception in Paris followed him to Aix. Among others, the drawing master Gibert, now the curator of the local museum, visited him in his studio and

asked to see his paintings. As Cézanne recounted in a letter to Pissarro,

To my assertion that on seeing my productions he would not have a very accurate idea of the progress of evil and that he ought to see the works of the great Parisian criminals, he replied: 'I am well able to conceive of the dangers run by painting when I see your assaults.'

Harsh criticism was not the only hazard of declaring independence from the Salon: when the accounts of the exhibition were finally settled, it was discovered that the painters had earned not only considerable derision but that each owed 184·50 francs. Yet Cézanne emerged from the whole bold experiment with a sense of conviction and hope-fulness that was virtually unprecedented in his career. Back in Paris that autumn, he wrote encouragingly to his mother:

I am beginning to consider myself stronger than all those around me, and you know that the good opinion I have of myself has only been reached after serious consideration ... the hour always comes when one breaks through and has admirers far more fervent and convinced than those who are only attracted by an empty surface.

Cézanne did not participate in the next Impressionist exhibition, which took place in 1876, but contributed sixteen works of considerable variety to the important show of 1877. Brilliantly organized by Gustave Caillebotte (1848–94) to bolster the group's public stature, the third exhibition narrowed the works to a representative cross-section of paintings by its most gifted members. Monet, for example, had thirty works on view; Degas, twenty-five. And the show was also newly balanced in terms of its subject matter: on the walls of the large apartment rented by Caillebotte in the fashionable new neighbourhood near the Palais Garnier (and just across the street from Durand-Ruel's galleries), visitors could see still lifes, portraits,

landscapes, city views, interiors and even an occasional nude. Although it provoked derisive reviews and mocking cartoons, as in the past, many critics were quick to applaud the show's (and the group's) impressive new direction. To their growing band of supporters, the Impressionists seemed to offer one of the few beacons of optimism and artistic possibility in a decade still clouded by postwar malaise.

Many of Cézanne's submissions, including several still lifes and watercolours, hung in the large third gallery which he shared with Renoir, Pissarro and Berthe Morisot (1841–95). Over the door in a nearby room one could also glimpse his *Scène fantastique*, which seemed to hark back to the artist's earlier, enigmatic subject paintings. But it was his seminal canvas of *Bathers at Rest* (see 99) that most aptly summed up his potent originality and growing importance as a painter of both figures and landscapes. As Rewald has suggested, it is quite likely that Cézanne substituted this painting for the study (*étude*) listed in the catalogue; he may well have realized the crucial public significance of the 1877 exhibition for his own, as well as the group's, critical stature.

The collector Chocquet lent a number of works by Cézanne to the third group exhibition, and *The Sea at L'Estaque* (69) was probably among them. This work, commissioned after Cézanne had left Pontoise to head south in the spring of 1876, offers an essential watershed in the artist's career. Writing to Pissarro from L'Estaque that summer, Cézanne describes a striking new sensibility:

I've begun two small subjects showing the sea for Monsieur Chocquet ... It's like a playing card. Red roofs over the blue sea. If the weather becomes favourable I may perhaps carry them through to the end ... there are motifs here which would need three or four months' work, which would be possible, as the vegetation doesn't change. The olive and pine trees always keep their leaves. The sun here is so tremendous that it seems to me as if the objects were silhouetted not only in black and white, but

in blue, red, brown and violet. I may be mistaken, but this seems to me to be the opposite of modelling. How happy our gentle landscapists of Auvers would be here.

After producing scores of views of the tranquil northern light and motifs of Pontoise and Auvers, the blazing sun, dramatic vistas and saturated palette of the Mediterranean landscape clearly revitalized him. We can see that drama emphasized in *The Sea at L'Estaque*: the artist opposes the dense foliage and weighted forms of the foreground, rendered with short, parallel brushstrokes, with the flattened colour masses of the azure sea and distant horizon. The critic Georges Rivière, who would be deeply impressed with *Bathers at Rest* (see 99) in 1877, also noted the compelling power of *The Sea at L'Estaque*: its 'astonishing grandeur and an unprecedented calm' clearly set it apart from some of the more prosaic landscapes by Cézanne's colleagues.

The boldness, monumentality and new grandeur of Cézanne's L'Estaque paintings from the late 1870s represented not only a powerful embrace of the familiar topography, brilliant light and drama of the south but a subtle retreat from his earlier Impressionist style. And though the work of many of the Impressionists at this point would also undergo major reassessment, Cézanne refused to participate in any of the later Impressionist shows. In paintings from subsequent L'Estaque stays, such as the *Bay of Marseille Seen from the Village of Saint-Henri* of c.1877–9 (70), Cézanne would pursue the pictorial metaphor of a 'playing card'-like space which he mentioned in his letter to Pissarro. Here, a more uniform, blunted brushstroke and modulated tones rendered his motif more cohesive, even systematic, but the effect is still grand and severe: the flattened, vertical profiles of the factories, steeples and plumes of smoke punctuate the dominant horizontality of his motif; only the strangely curving wall in the foreground breaks into their dialogue of opposites. With an eye carefully honed by Pissarro but now

69
The Sea at L'Estaque, 1876. Oil on canvas; 42 × 59 cm, 16¹⁄₂ × 23³⁄₈ in. Collection Rau, Zurich

70
Bay of Marseille Seen from the Village of Saint-Henri, c.1877–9. Oil on canvas; 66·5 × 83 cm, 26¹⁄₄ × 32¹⁄₄ in. Formerly Urban Gallery, Tokyo

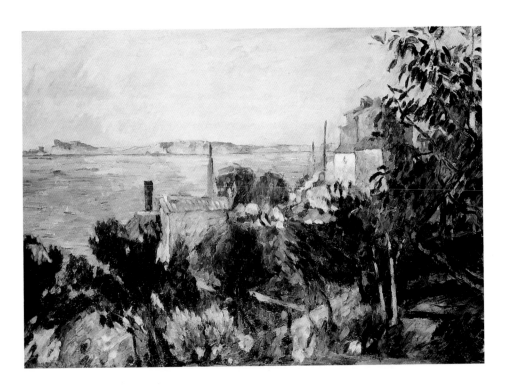

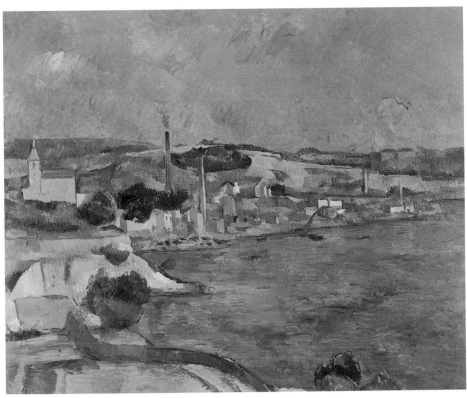

on familiar terrain, Cézanne allowed the pictorial strength of the landscape itself to supplant the emotional strains of his L'Estaque paintings of 1870–1 (see 54, 55).

Cézanne was back in Auvers and Paris for much of 1877, and the striking new confidence he had acquired in the south visibly affected his painting. Working again in Pontoise, Cézanne and Pissarro each painted a view of an orchard just behind the older artist's home. A comparison of the two canvases reinforces our understanding of Cézanne's increasingly independent style and systematic brushwork, techniques that embraced the formal drama and structure

71
Camille Pissarro,
Orchard in Spring, Pontoise,
1877.
Oil on canvas;
65·5 × 81 cm,
25³⁄₄ × 31⁷⁄₈ in.
Musée d'Orsay,
Paris

72
Orchard in Pontoise, Quai de Pothuis,
c.1877.
Oil on canvas;
50 × 61 cm,
19³⁄₄ × 24 in.
Private
collection

he now sought in the landscape. Whereas Pissarro (71) allows the texture of the flowering trees, clouds and planted fields, conveyed with a Monet-like technique of tiny, broken touches of paint, to become the real subject of his work, Cézanne's canvas (72) is a subtle study of opposing spatial relationships. As often before, he sought the diagrammatic tensions in the scene, focusing on a low retaining wall and blank façade at centre that parallel his picture plane and emphasize the inherent flatness of his surface. These are balanced by the oddly projecting volumes of the house at the upper right and the bizarre curving tree below, objects

that argue for a different perspective. Cézanne's brushstroke is now an essential part of his spatial language, a development illuminated by the art historian Pavel Matchotka: 'It has neither the sensuous, random delicacy of the fully developed touch, nor the constructive function that the parallel touch assumes in Cézanne's work in about 1880. Here, the blockish strokes follow and define the planes they compose.'

It is, seemingly, only a short step from the block-like painting technique of *Orchard in Pontoise*, which Gowing has termed the 'style of 1877' and which will also figure in some of Cézanne's portraits of the period (see Chapter 6), to the artist's celebrated method of systematically covering a canvas with an overall diagonal pattern of short, parallel strokes. The art historian Theodore Reff has identified this technique in a number of works from the late 1870s as the painter's 'constructive stroke'. Yet this distinctive style, which Cézanne jealously guarded as his own and which is found in a series of landscapes from the end of the decade and almost consistently after *c*.1880, seems to surface first in the artist's paintings of imaginary subjects. As will be seen in our discussion of *L'Éternal féminin* (see 93), Cézanne's parallel, constructive brushstroke lent even his most erotically charged paintings of nudes a sense of controlling order, as if by form alone he could rein in their emotional excesses. Clearly, then, there is no easy logic in defining the elusive chronology of Cézanne's stylistic development. Even crucial changes appeared to evolve in cycles: both formal and expressive considerations continued to play major, and sometimes interchanging, roles in shaping his art. But Cézanne's growing attention in the late 1870s to an organized system of mark-making, one that attempted to wed the animated, paint-laden surface to a more lucid, formal language of volumetric forms and ordered spaces, is also part of a larger, and sometimes political, debate that surrounded Impressionist painting as a whole at the end of that decade.

73
Harvest,
c.1876–7.
Oil on canvas;
45·7 × 55·2 cm,
18 × 21³⁄₄ in.
Private
collection

74
Vincent
van Gogh,
Harvest,
1888.
Oil on canvas;
72·5 × 92 cm,
28¹⁄₂ × 36¹⁄₄ in.
Van Gogh
Museum,
Amsterdam

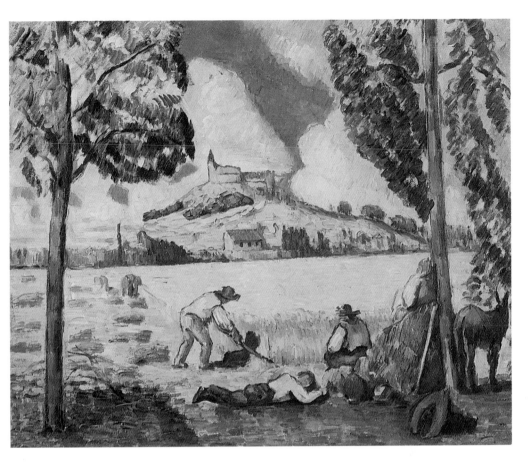

75
Nicolas
Poussin,
Summer (Ruth
and Boas),
1660–4.
Oil on canvas;
118 × 160 cm;
46½ × 63 in.
Musée du
Louvre, Paris

One work in particular from this period seems to stand at a critical juncture: Cézanne's *Harvest* of *c.*1876–7 (73). Among his most serenely classical statements, this painting is one of the boldest and earliest examples of his constructive-stroke technique, and also exceptional because it is both a land-scape with figures and a vivid imaginary construction. *The Harvest* was among the six works by Cézanne which Paul Gauguin (1848–1903) owned and held a special fascination for him (it would later awe Pablo Picasso; 1881–1973). Much as Cézanne needed recognition, however, avid acquisition by a rival could be double-edged. Even before he met Cézanne, Gauguin would ask Pissarro (to Cézanne's consternation) for the underlying formula which their fellow artist had discovered for 'compressing the intense expression of all his sensations into a single and unique procedure'. Cézanne later complained that Gauguin 'stole' his technique, but although he certainly copied motifs from *The Harvest* in several works and tried his hand at a similar style, Gauguin never truly mastered this distinctive form. But perhaps some retribution was exacted for even making the attempt: Gauguin was forced to leave *The Harvest* with the Parisian dealer Alphonse Portier when he left for Martinique in 1887,

and there it was admired by Vincent van Gogh, then also at a formative stage in his career.

Van Gogh later recalled *The Harvest*'s brilliant palette, which he thought 'washed out the colours of everything else' in the gallery and formed a powerful depiction of 'the harsh side of Provence'. Writing in 1888, Van Gogh's assumption that the subject of the painting was Provençal is hardly surprising. Although its theme of rural labour recalls Pissarro's paintings of Pontoise peasants, the quality of Cézanne's light and his motif of a rocky hilltown were far more characteristic of the south than of the countryside of northern France. So strong was the association of Cézanne with the imagery and culture of Provence – a perception the artist himself encouraged – that he may have mediated other painters' perceptions of it, as suggested by Van Gogh's harvest scenes (*eg* 74), painted in nearby Arles.

Yet, for all of its uniquely Provençal characteristics, Cézanne's *Harvest* is an imaginary landscape, most likely painted in the artist's studio. It has often been likened to an Old Testament harvest scene, *Summer* (75) by Poussin, the seventeenth-century French master of the classical tradition. Cézanne reportedly admired his biblical landscape in the Louvre, and a comparison of the two paintings is revealing. With similarly framing and symmetrical trees, a horizontal lower band of vibrant greens, and a massive, measured sweep across the open fields of wheat, Cézanne employs Poussin's signature devices to direct our eye to the distant and perfectly centred motif of a hilltop village. Even the labouring peasants, recast from Poussin's figures of Ruth and Boaz, stretch across its stage-like space and echo the painting's lower edge. As the art historian Richard Shiff has shown, many nineteenth-century commentators and artists, Cézanne among them, considered such idealized, historic landscapes to be Poussin's highest achievements. Observing nature at first hand, Poussin transformed it in his paintings

76
*Pool at the Jas
de Bouffan,*
*c.*1878.
Oil on canvas;
52·5 × 56 cm,
20⅝ × 22 in.
Private
collection

according to his own classical ideals by imposing a rigorous, pictorial scaffolding and by subjecting every element of the work to a timeless, rational order. Much as he does in his masterful *Bathers at Rest* (see 99), a painting of the same period and cohesive pictorial logic, Cézanne revives in *The Harvest* the classical tradition and legacy of Poussin to create a new vision of a timeless and systematic harmony. And in this densely ordered composition, Cézanne's rhythmic, parallel brushwork acquires essential new meaning, both as a legacy of his early Impressionist style and as a signature mark of compelling order.

Though its role could be critical in his imaginative works, Cézanne came to employ his parallel constructive stroke only gradually in the motifs he painted from nature. He

spent most of 1878 in Provence, dividing his time between Aix and L'Estaque, and thus the austere *Pool at the Jas de Bouffan* (76), painted in flattened strips of pigment and structured around the simplest of formal grids, probably dates from the early spring of 1878. The lean vertical of the leafless tree at centre nearly slices the painting in half and, along with the horizontal line of the pool, forms a rigid symmetry that strips the image to its essentials. Even the cold light and pallid sky and pool evoke the artist's restraint before the barren, wintry scene, as if he had paused to reflect on the spare beauty of the natural motif in itself.

Cézanne's personal life in 1878 was no less bleak. Hortense and their young son Paul followed him south and lived in secret that year in Marseille, while the artist struggled to provide for them. Yet when, in March, his ageing father confronted him with suspicions about the existence of a mistress and child (the banker had unsealed and read a letter addressed to Cézanne from Chocquet), he vehemently denied it. In rebuke, Louis-Auguste cut his son's monthly allowance to a meagre 100 francs, and Cézanne was forced to turn to Zola, then enjoying his first real success as a novelist, for monthly subsidies so that his own family could survive. His letters to Zola from Provence are filled with renewed

77
Bottom of the Ravine,
c.1878–9.
Oil on canvas;
73 × 54 cm,
28³⁴ × 21¹⁴ in.
Houston Museum of Fine Arts

78
Pierre-Auguste Renoir,
Rocky Crags at L'Estaque,
1882.
Oil on canvas;
66·3 × 80·8 cm,
26¹⁸ × 31⁷⁸ in.
Museum of Fine Arts, Boston

self-doubt. His work, he complained, showed only 'poor results and [was] too far removed from the general understanding', and he remained nothing more than 'an unhappy painter who has never been able to achieve anything'.

Cézanne would leave the south in late February 1879 and not return for several years, painting in Paris, in the nearby towns of Melun and Médan, and again in Pontoise with Pissarro. But despite his private turmoil, before he ventured north he seems to have produced a series of works in which the lessons of his initial constructive-stroke period achieve a brilliant culmination: paintings that are explicitly tied to his native Provence and that would form the basis of his great classical landscapes of the following decade.

Among these works are two superb and strikingly original canvases. Cézanne's *Bottom of the Ravine* (77) of c.1878–9, an unusual vertical picture of soaring rocky bluffs seen from the base of a mountain, is built up of the ordered and rigidly diagonal strokes that were his signature by this date. Its thickly contoured paints of exceptionally brilliant hues render the stark forms almost in relief, as if the artist had devised yet another means to render the flattened, 'playing card'-like forms of his subjects reflected under the 'tremendous' sunlight of L'Estaque. Renoir visited the artist in L'Estaque in 1882 and was equally moved by the region's dramatic scenery. Yet in Renoir's views, such as the *Rocky Crags at L'Estaque* (78), his softer brushwork and bluish shadows reassert the landscape's essential depth and imposing natural structure. Not until the Fauvist landscapes of L'Estaque by Georges Braque (1882–1963) would Cézanne's audacious vision find its match.

Late in 1883, on his way home from a painting trip in Italy, Renoir again visited Cézanne in L'Estaque, this time accompanied by Monet. Now it was Monet's turn to admire what the increasingly reclusive painter had produced. When he returned to paint his first views of the Mediterranean

79
The Sea at L'Estaque,
c.1878–9.
Oil on canvas;
73 × 92 cm,
28¹⁄₄ × 36¹⁄₄ in.
Musée Picasso,
Paris

80
Claude Monet,
Bordighera, Italy,
1884.
Oil on canvas;
60 × 73 cm,
23⁵⁄₈ × 28¹⁄₄ in.
Private collection

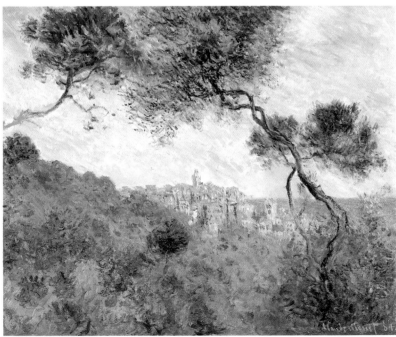

81
Nicolas
Poussin,
*Landscape with
the Body of
Phocion carried
out of Athens*,
1648.
Oil on canvas;
117 × 178 cm,
46 × 70 in.
The Rt Hon.
the Earl of
Plymouth,
on loan to
the National
Museums and
Galleries of
Wales, Cardiff

coastline a few months later, in works such as *Bordighera,
Italy* of 1884 (80), Monet clearly carried with him the
memory of paintings like Cézanne's *Sea at L'Estaque* of
c. 1878–9 (79).

In this view of the Mediterranean seen through trees, with
its more muted parallel strokes, unified palette and boldly
schematic forms, Cézanne had produced one of his most
consciously classical compositions. Its Poussinesque devices
of graceful, parenthetical trees, flattened foreground and
distant, framed horizon have led the art historian Richard
Verdi to describe it as Cézanne's *Phocion*, a reference to
one of Poussin's quintessential classical landscapes (*eg*
81). And yet the rigorously harmonized design of *The Sea
at L'Estaque* is enlivened by a plunging viewpoint, the
flattened expanse of ocean (especially at the upper left)
and the decorative effect of interlocking branches, which
mingle near and far. Not only Monet but also Picasso, who
acquired the painting in the 1940s, would recognize the
colossal achievement it represented at this critical juncture
in Cézanne's career.

Throughout the 1870s Cézanne also continued to paint from his imagination and to study the art of the past, producing images of female nudes in fanciful interiors and many paintings of male and female bathers set in verdant landscapes. Together, they mark the beginning of Cézanne's lifelong preoccupation with the kindred themes of the painter's model and the bather. But like his paintings in other genres from the same decade, these imaginative works also chart a complex evolving course: while the earlier works are marked by impassioned brushwork and potentially disturbing figures, works from the end of the 1870s exhibit a new-found harmony and equilibrium. And his heroic bathers paintings from the end of this transitional decade, especially the consummate *Bathers at Rest* of c.1876–7 (see 99), established Cézanne's growing importance as a painter of figures as well as of landscapes.

The large painting of an aged, reclining nude that Cézanne submitted to the Salon of 1870 seems to have been a particularly ruthless affront to the jury. Now lost, it is known only from a brutal caricature (82) by the journalist known as Stock and from the memorable accounts of those who chanced to see it. The canvas depicted a naked old woman whose 'sad ruins', as one critic later recalled, 'were stretched out on a dazzling white sheet'. A crude popular print hung on the black wall behind her, and in the foreground a blazing red cloth was shown draped over a small chair. Rejected by the jury, the painting was owned by Gauguin in the 1880s and may have inspired some of his own more unorthodox reclining figures. When the canvas was later seen in the paint-dealer Père Tanguy's shop in Paris, it impressed countless younger painters, including Émile Bernard, who

82
Caricature of Cézanne, showing the lost painting of a nude, Album Stock, 1870

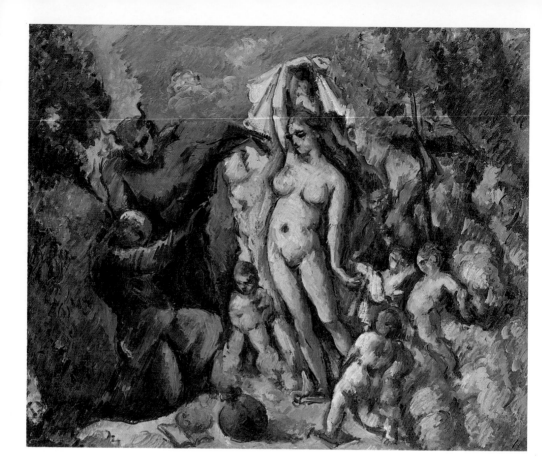

found it 'a masterly piece' despite the 'quite ugly' model it
featured. As in his painting *The Abduction* (see 36) or *The
Pastoral* (see 46), Cézanne once more confronted here an
established pictorial genre. Both an allusion to Manet's
infamous painting of a courtesan, *Olympia* (84) of 1863, and
an even bolder reworking – and rebuttal – of the pictorial
tradition of the idealized, recumbent nude, Cézanne's
lost canvas moved his figural painting onto vital new
ground, and hence the disappearance of the work seems a
particularly acute loss to an understanding of his early art.

As we have seen, the artist's personal trepidation before the
unclothed female model was a central ingredient in his
heroic struggle as a painter and the myth it inspired. It
helps to explain why Cézanne's female nudes are almost

83
*Temptation
of Saint
Anthony*,
c.1877.
Oil on canvas;
47 × 56 cm,
18½ × 22 in.
Musée d'Orsay,
Paris

84
**Édouard
Manet**,
Olympia,
1863.
Oil on canvas;
130·5 × 190 cm,
51⅜ × 74⅞ in.
Musée d'Orsay,
Paris

always products of his imagination, rather than studied from life, and remain evocative long after the literary narratives take on a lesser role in his art. Like his revealing earlier version (see 42), Cézanne's Temptation of Saint Anthony paintings from this period (*eg* 83) – in which the frightened ascetic monk lurches back or shields his eyes from the wanton and threatening nude temptresses – are among the artist's most deeply autobiographical works. Yet Cézanne's early female nudes also reflect a wide range of new attitudes in art and society about the nude as visual object, modern subject and social icon.

In the group of works from the early 1870s entitled *A Modern Olympia*, Cézanne paid homage to Manet's *Olympia* that had electrified viewers at the Salon of 1865. Although Cézanne's later version (85) in the Musée d'Orsay is better known and, ever since its inclusion in the first Impressionist exhibition, was the subject of extensive critical speculation, his first *Modern Olympia* (86), which dates from *c*.1869–70, offers the more telling reflection of the libertine attitudes that Manet's painting came to represent. Like Manet, Cézanne overturns the hierarchies of the past both in his subject and in the image. The modern courtesan, for whom sex was a marketable commodity rather than evidence of an ideal love, is rendered by Cézanne in equally unidealized terms: she cowers, awkwardly, on the luminous

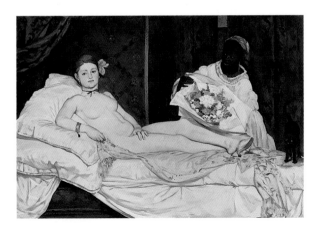

stage of a bed, and the curtains, drawn back theatrically, exhibit her as just one offering in a luxuriant brothel, complete with fruit, wine, flowers and an exotic attendant. The male viewer (or client) whom Manet had only implied in his painting is included by Cézanne. Both viewer and voyeur, this lumbering onlooker, who resembles both Cézanne and his fellow provincial Courbet (in the later version, Cézanne pictures himself as a stylish urbanite or *flâneur*, *à la* Manet), takes no part in the sensual environment. Perhaps Cézanne's viewer, frozen into the shadows, is stunned, even bewildered, by the naked projection of overt and unidealized female sexuality splayed out before him.

As late as 1890, after Monet had initiated a public subscription to buy Manet's painting for the Louvre, the *Olympia* still elicited scathing critical reactions, and often from a position of nationalist pride. 'What will foreigners ... think', asked the conservative *La Liberté*, when 'amidst these magnificent treasures they find this bizarre Olympia ... this creature advertising vice and [representing] the most incomplete art in the Louvre?'

In the 1870s, Manet's *Olympia* offered even more imminent cause for reflection. Throughout that incendiary decade, as France struggled to comprehend its crushing defeat by the Prussians and the horrors of the Commune, fears of national degradation plagued critics of all persuasions. As the historian Rupert Christiansen has described, many Frenchmen feared that

the materialism of the Second Empire had literally poisoned France: the fall in the birth rate, the recourse to prostitution and the spread of venereal disease, the consumption of absinthe, the overindulgence in illicit sexual activities leading to impotence and mania, the comforts and pleasures of modern Parisian life – all these had enfeebled French blood and muscle, poisoning the race with the vices of envy and greed and sloth.

85
A Modern Olympia, 1873-4.
Oil on canvas; 46 × 55 cm, 18⅛ × 21⅝ in.
Musée d'Orsay, Paris

86
A Modern Olympia, c.1869-70.
Oil on canvas; 56 × 55 cm, 22 × 21⅝ in.
Private collection

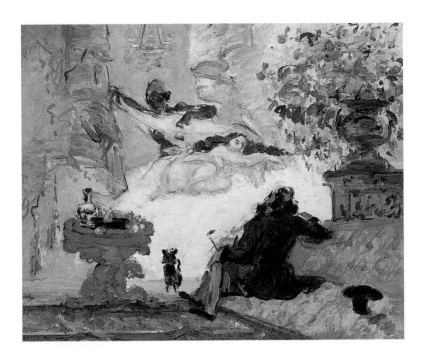

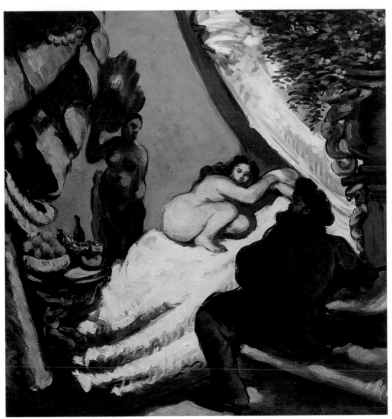

Increasingly common on the streets of Paris and as a subject in art and literature, the modern prostitute became just one symbol of this inherent national malaise. A literary counterpart could be found in such books as Zola's novel *Nana* (1880), where his fictional lower-class courtesan destroys every rung of society she touches and so came to personify the female sexual force as one of virulent corruption. A cartoon entitled *The Evening Spider* (87) that appeared in *Le Monde Comique* in 1875 gave visual form to the popular conception of the modern prostitute as a powerful and dangerous woman, spinning her web to lure and ensnare.

87
The Evening Spider. Cartoon in *Le Monde Comique,* 1875

88
Édouard Manet, *The Plum,* c.1877. Oil on canvas; 73·6 × 50·2 cm, 29 × 19¾ in. National Gallery of Art, Washington, DC

89
The Courtesans, c.1871. Oil on canvas; 17 × 17 cm, 6¾ × 6¾ in. Barnes Foundation, Merion, Pennsylvania

The unbridled female was equally disturbing to established artistic conventions. The explicit handling that had characterized both Salon and vanguard paintings of courtesans at mid-century, keeping them clearly identified and safely at bay in vaguely historical or anecdotal genre settings, found little place in the numerous later Impressionist paintings that seemed to continue the theme. Often, as the art historian Hollis Clayson has argued, both the social and moral standards of their modern female subjects were left purposefully ambiguous, as in Manet's *The Plum* (88).

Cézanne may have been one of the first to realize the subject's potent capacity for suggestion and innuendo. The threat of modern feminine sexuality is undiluted and at the very core of both the private and public meanings inscribed in such paintings as his radical *Courtesans* (89), of *c.*1871. Such compelling transitional works as this represent difficult negotiations among the forces – formal, personal and socio-historical – that produced the dark romantic and more narrative art of the late 1860s and those that would result in Cézanne's idyllic later paintings of bathers.

In this small, crowded canvas of intensely coloured paints and animated figures, the artist approaches a modern subject in very contemporary terms. The two standing women – at left and centre – boldly project the painting's intense, harsh eroticism. Although partially dressed, their revealing costumes flaunt hard, angular breasts. Their taut, flexed arms, huge staring eyes, hawk-like faces and stiffly cocked heads are exaggerated versions of the attitude of shameless provocation found in the background nude of Cézanne's first *Temptation of Saint Anthony* (see 42). Now, however, the viewer is implicated as voyeur. And the work's brutal visual language powerfully attests to the artist's intention

90
La Baignade,
*c.*1875.
Oil on canvas;
19 × 27 cm,
7¹₂ × 10⅜ in.
Private
collection

91
Three Bathers,
*c.*1874–5.
Pencil, water-
colour and
gouache on
paper;
11·4 × 12·7 cm,
4¹₂ × 5 in.
National
Museums and
Galleries of
Wales, Cardiff

92
Three Bathers,
*c.*1875.
Oil on canvas;
30·5 × 33 cm,
12 × 13 in.
Private
collection

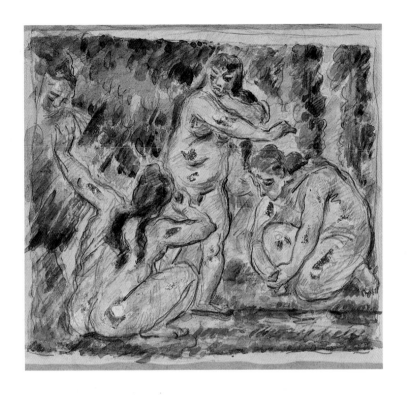

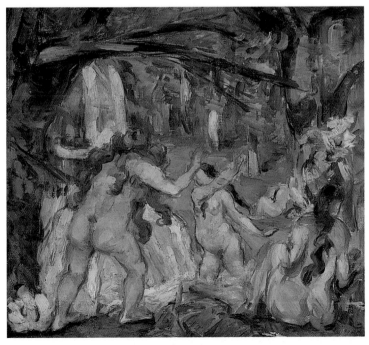

to confront his disturbing subject through the very thrust of his brush. Both the formal treatment and the larger sexual, social and political implications of Cézanne's courtesans will be reflected in some of his first paintings of bathers. Thus, the earlier narrative work, already arresting on its own terms, provides us with the tools to approach the increasingly complex material of the 1870s more comprehensively.

The potent sexual undercurrent of Cézanne's *Courtesans* is transferred to an idyllic natural setting in his painting *La Baignade* (90) of *c.*1875. A tiny canvas, it represents three male bathers peering surreptitiously across the water at a roughly sketched female nude, who poses provocatively in the sunlight. Despite its small scale, the painting's depiction of sexual *frisson* within a landscape – the elements of which mirror and contain its inhabitants within distinctly gendered spheres – outlines one of the major underlying themes and the formal schemas that link the early bathers to Cézanne's previous work. Its compact, block-like brushwork also hints at the role that Cézanne's constructive stroke will have in his subsequent paintings of bathers.

Both the voyeuristic subject and the familiar, gendered relationship – male adulation of the overtly sexual (and therefore powerful), mysterious but inaccessible female – is replicated in two images of *Three Bathers* roughly contemporary with *La Baignade*. However, in these – a watercolour (91) and a related painting – the female bathers have moved to the foreground and assumed, both pictorially and thematically, a dominant position they will subsequently retain. The dramatic meeting of voyeur and nude – already an arresting confrontation between two 'secret' acts – is forcefully expressed in the gesture of rejection on the left and in the recoiling central nude. As the art historian Mary Louise Krumrine has demonstrated, the artist initiates in such works the felicitous triangular plan, from which he will rarely depart in his later *Baigneuses*, both to contain

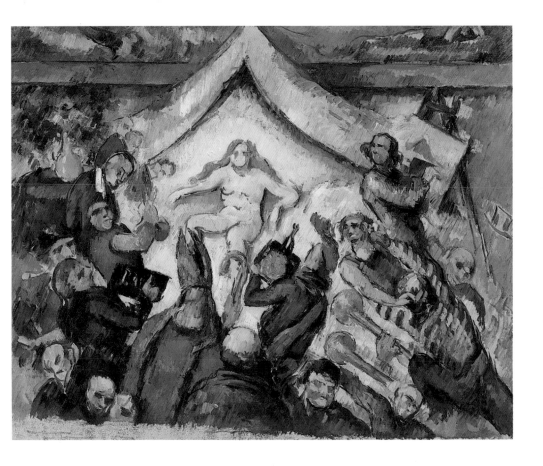

93
*L'Éternal
féminin,*
c.1877.
Oil on canvas;
47 × 56 cm,
18½ × 22 in.
J Paul Getty
Museum, Los
Angeles

the female bathers and also, as here, to separate them from the intrusive male viewer. It is this powerful geometry that contains the potentially disturbing female forces that a fractured society could not control. As we see in a most unusual version from the mid-1870s (92), without the confinement of that rigidly restrictive format, a sense of virulent sexual energy, suggested by the agitated nudes and fervid paintstroke, was in danger of invading the idyllic domain.

Thus, away from his sylvan, structured landscapes, Cézanne's nudes could acquire a different tone. In an important painting (93) and related watercolour of *c.*1877 entitled *L'Éternal féminin*, Cézanne seems to offer an ironic homage to the sexually empowered female nude. With the stage-like theatricality that the artist reserved for his most erotically

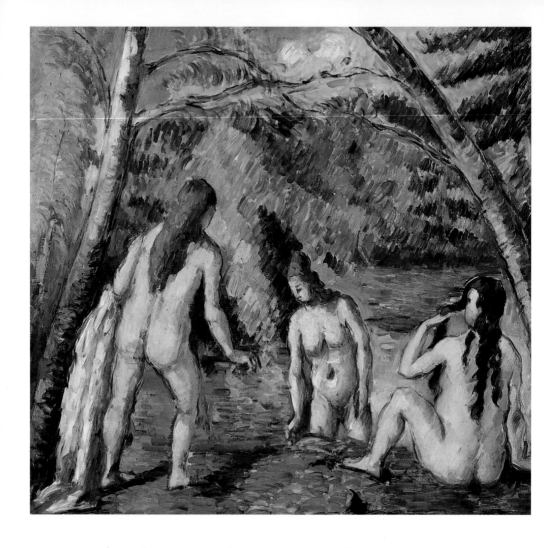

charged scenes, the triangular canopy enshrines a coarse
and colossal recumbent nude who is coldly indifferent to
the obsequious male admirers from all levels of society
around her. With a nod to countless precedents, including
Delacroix's *Sardanapalus* (see 45), Manet's *Olympia* (see 84)
and, in its idolizing image of feminine sexuality, to
Goethe's *Faust* and perhaps even to Zola's *Nana*, Cézanne
gives full expression to this compelling climate of potential
sexual anarchy. But despite her inescapable sexual aura,
one that attracts the adoring gaze of all who surround
her (including a painter at his easel), Cézanne's *L'Éternal
féminin* is herself rendered sightless, her bloodied,

emptied eye sockets leaving her incapable of confronting her voyeuristic male viewers.

So formidable was this icon that Cézanne seems to have struggled to temper, or contain, its force by means of his new methodical style. Theodore Reff has rightly signalled *L'Éternal féminin* as 'the most radical example of Cézanne's tendency in the 1870s to compose the entire surface of small parallel strokes, whose pervading diagonal rhythm, like the force in a magnetic field, draws even the objects represented into an alignment'. While Cézanne would later explore this constructive stroke in his paintings from nature to imbue them with an enduring solidity that he found lacking in early Impressionism, its emergence in such imaginary canvases as *L'Éternal féminin* was surely stimulated at least in part by its troubling subject matter. It is only his measured, parallel brushstrokes, which cover the canvas with a systematic rhythm of uniform touches of paint, that lend the work any semblance of tangible order.

Such lingering oppositions between disturbing themes and rigidly controlling pictorial elements would be resolved in the series of paintings of *Three Bathers* of c.1877–80, including the version (94) once owned by the painter Henri Matisse (1869–1963). After nearly a decade of parodic or disquieting nudes, whose fearsome sexuality is so strikingly staged, the monumental lumbering bathers in these paintings inhabit a framing and sympathetic landscape. They share with their imagined setting a rhythmic and pulsating surface of ordered marks of paint, a now signatory constructive brushstroke that helps to order Cézanne's fantastic figures and landscape and also lends them the immediacy of a motif observed in nature. Along with his parallel brushwork, Cézanne employs here a brilliant palette and a perfected pyramidal format effectively to neutralize the disquieting sexuality implicit in the earlier work (eg 90). We recognize a huge achievement in his magnificent

94
Three Bathers,
c.1877–80.
Oil on canvas;
52 × 54·5 cm,
20½ × 21½ in.
Musée du Petit
Palais, Paris

Three Bathers paintings, a new-found sense of harmonious order Matisse would praise in the version he owned for the 'exceptional sobriety of its relationships'.

Many of Cézanne's paintings of bathers from the 1880s were marked by a similar, triangular composition and regularized brushstroke. Although lingering hints of sexual confrontation, of a narrative tradition, even of an evocative silent dialogue, reappear in such works as ***Five Bathers*** of *c*.1885, now in Basel, in each the abstract serenity of Cézanne's private universe lies undisturbed within his charged formal system. This new, personal brand of idealism, already evident in the late 1870s, will be triumphantly restated in his late ***Large Bathers*** painting of 1906 (see 200): social and sexual politics are subsumed in a radiant and powerful pictorial form.

Thus, at a time of social and moral turmoil, Cézanne took up the theme of the provocative, unidealized and overtly sexual female, and within a decade had transformed it into

95
Pablo Picasso,
*Les Demoiselles
d'Avignon*,
1907.
Oil on canvas;
244 × 234 cm,
96 × 92 in.
Museum of
Modern Art,
New York

a serene statement of natural empathy. Although neglected by historians of his art, the larger historical context was not lost on one of Cézanne's most astute admirers, Picasso, who knew not only many of Cézanne's images of bathers (as well as owning one) but also his seminal early painting *The Courtesans* (see 89), which Ambroise Vollard held in his gallery in Paris in the 1890s. For his own, far better-known but strikingly similar painting of prostitutes, *Les Demoiselles d'Avignon* (95), Picasso chose to transform not so much Cézanne's tranquil later bathers – whose fame as a whole far outdistanced that of the artist's earlier figural works – but rather his aggressively sexual and degenerate images from the early 1870s into an icon resonant with the decadence of his own era.

The harmony of Cézanne's later works, like the intensity of the earlier, must also be viewed in terms of a changing cultural and social milieu. As we have seen, in the wake of the Franco-Prussian War and the Commune, France had suffered from a conservative backlash that penetrated all sectors of its society and cultural discourse, including even its critical perception of contemporary French art. A staunch monarchist and former leader of the anti-Commune forces, Marshal MacMahon, had been elected president in 1873 with a mandate for the restoration of civil and social order, a *rappel à l'ordre* already heralded in political caricatures (96). In the repressive, right-wing climate of his authoritarian 'government of moral order', there was little room for defiant individualism, even that espoused in Impressionist painting: this was the era, after all, in which a vanguard artist could be branded with the political epithet of 'Intransigeant'.

By the late 1870s, however, with the consolidation of a stable liberal regime under Jules Grévy in the by-then firmly established Third Republic, a new calm descended on Paris, and Impressionist painting experienced a similar

transformation. Many artists, among them Renoir and Gauguin, began to question the continuing validity of their oppositional styles. Separating themselves from the radical subjects and political overtones the movement had acquired in the chaotic 1870s, they tried to restore a sense of permanence, timelessness and harmony to their art. Cézanne's increasingly more organized compositions of female nudes may likewise reflect a search in society at large for a new and enduring moral order. Surely it is the evolving significance of his subject, spanning a complex moral and social spectrum, that gives the female nude such a permanent and resonant place in Cézanne's art.

This argument for a broader historical and cultural approach to the understanding of Cézanne's paintings of female bathers is reinforced by a consideration of his male bathers. As they evolve, in the 1870s and early 1880s, along different but parallel lines, these invite many of the same critical questions about the relationship between private, public and formal values. It has become almost a commonplace to preface a discussion of Cézanne's male bathers with a reference to his rough pencil drawing of three young swimmers sketched on the back of a letter to Zola in 1859 (see 4) – his first image of bathers and a romantic memory of youthful expeditions in the Aixois countryside. But because the painter's eventual subject is not only bathing but the nude or partially nude and athletic male figure, we should also look to his first studies after the heroic male nude in the art of the past for an indication of the artist's early discernment of that larger tradition. A number of Cézanne's rudimentary drawings, including such classicizing images as his nude figure on a chariot of c.1856–8, acknowledge more conventional notions of the role of the male nude in art, and became part of the lexicon he would transform to such effect. This may explain why comparatively few of his idyllic youthful sketches find their way into his subsequent large compositions of male bathers.

We have seen how Cézanne both responded to and departed
from the complex symbolism associated with the female
form. The male figure, surrounded by far more lofty associa-
tions, posed a similar challenge. Traditionally, the nude or
largely nude and virile male form presents a sign of physical
strength and moral courage, evolving from a classical
tradition in which these two phenomena were equated.
If the isolated female figure in art can be vulnerable or
provocative, the isolated male, clothed only by the veil of
classicism, is heroic. If female physicality can be potentially
disturbing or indicative of a fecund, harmonious nature,
male perfection is a moral force which affects, but is not
defined by, the natural world. Significantly, the virile male
nude has long been privileged as a signifier of the ideal in
times of revolution and historic change.

In the late 1870s, Cézanne produced two working models for
the subject of male bathers that would serve as a basis for

his later monumental compositions on the theme. In his *Five Bathers* of *c.*1876–7, for instance, we see the genesis of the rhythmic, frieze-like formats that will distinguish his later male bathers paintings from their female counterparts, as well as early prototypes for many of his subsequent male figures. But it is in the *Bathers at Rest* paintings from this period that we find the artist grappling with the wealth of historic associations that surrounded the male nude in the art of the past. The evolution of this fascinating and distinctive series offers a revealing mirror of its charged historical context as well as a reminder of the renewed significance that the subject of the male nude was enjoying.

A rough watercolour study of *c.*1875 (97) is the first indication we have of Cézanne's conception for the series as a whole. With its unusually agitated ink lines and intense pigments, this small drawing attempts to convey the sensation of a motif observed directly in nature. Already, his composition focuses on the central, vertical nude. In the small oil version of *c.*1876 (98), the nervous energy of the first is transferred to both paint and image as the artist renders a scene of gaunt bathers with a brilliant chartreuse palette and short, jabbing strokes of paint. The fourth bather, seen from behind on the left – tiny and problematic in the previous sketch – here stretches provocatively before a tree: a seemingly eccentric recasting of the female figure found on the left side of the earlier *Temptation of Saint Anthony* (see 42). Even the sloping leftmost tree offers an odd analogue to the tormented monk. Such contradictions, formal and otherwise, however, are resolved in Cézanne's masterful third version of the subject (99), of *c.*1876–7.

Although the evidence will probably never be conclusive, most agree that it was this final version that hung at the definitive third Impressionist exhibition in 1877. One of sixteen works shown by Cézanne, it served even then as a manifesto of his unique vision. Its strange, dream-like

97
Bathers at Rest, *c.*1875.
Pen and India ink with watercolour on paper;
13·1 × 21·8 cm,
5⅛ × 8⅝ in.
Bridgestone Museum of Art, Ishibashi Foundation, Tokyo

98
Bathers at Rest, *c.*1876.
Oil on canvas;
38 × 45·8 cm,
15 × 18 in.
Musée d'Art et d'Histoire, Geneva

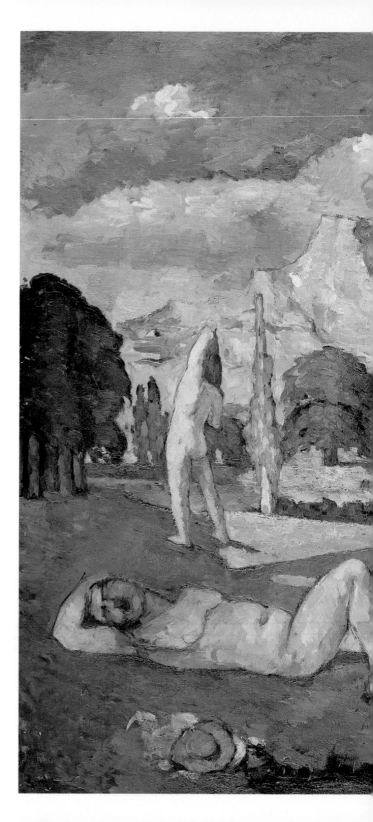

99
Bathers at Rest,
*c.*1876–7.
Oil on canvas;
79 × 97 cm,
31¹⁄₈ × 38¹⁄₈ in.
Barnes
Foundation,
Merion,
Pennsylvania

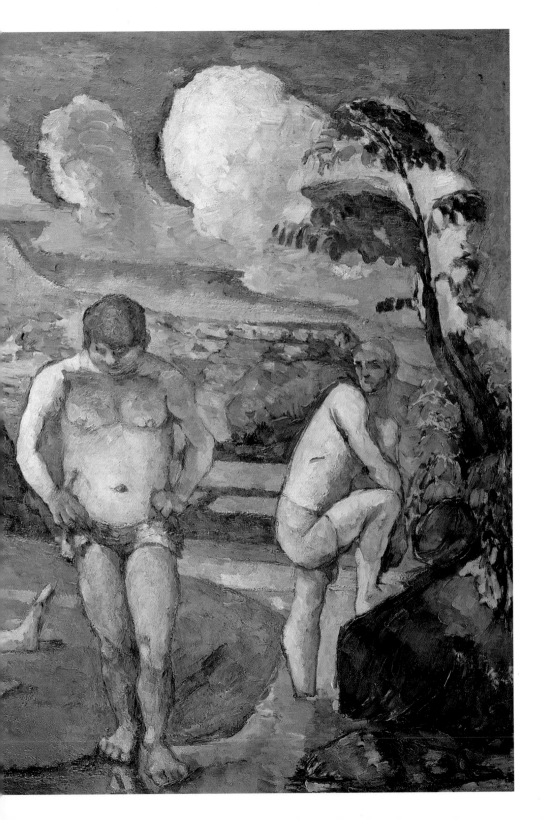

figures inspired some of the exhibition's most passionate critical responses. Typical were those of critics who pilloried the bluish cast of the strange bathers and the odd, thick clouds 'of a ceramic-like whiteness' that float above their heads (comments, however, which help us to identify the last version of the theme as the one on view). Another critic, though describing the artist as a 'faithful Intransigeant', and his bathers 'in plaster' as sufficient to 'cause the Messalinas of the world [a reference to a lascivious wife of the Roman emperor Claudius] to swear forever to chastity', also noted: 'If nothing else, the artist has produced works of the highest morality.' It was no doubt the heavily worked, solitary bathers in this painting that inspired Georges Rivière's enthusiastic observation that 'the movements of the figures' in Cézanne's paintings 'are simple and grand like those in antique sculpture'. Even Pissarro, when he saw the *Bathers at Rest* in Cézanne's massive one-man show at Vollard's gallery in 1895, would focus on the 'bathers of extraordinary sobriety' when he described the canvas in a letter to his son Georges.

With few exceptions, then, the *Bathers at Rest* has been viewed almost exclusively in terms of its compelling figures. In fact, although it is probably contemporary with some of Cézanne's paintings of female bathers that exhibit a pervasive constructive-stroke technique, this work is distinguished by its highly worked impasto, which models its figures in virtual relief and seems to freeze them rigidly in place. As the art historian T J Clark has suggested, it is a dream-work, composed of separate, over-determined parts that resist a surface and thematic unity: the build-up of paint around each of the bathers, as Clark describes it, 'seems directed to some final disengagement of figure from ground'. Yet punctuating that strange, visionary image is Mont Sainte-Victoire, an icon of observed reality as solid, durable and physically intense, and also, we might argue, as mythologized, as any of Cézanne's figures. Rarely in the bathers

paintings do the figures compete so hard for attention with the elements of the landscape around them, and rarely also does the artist intermingle the worlds of physical, factual nature and fantasy. In fact, at least some of the painting's unusual dream-like quality derives from the tension in which the artist holds the tradition of the historic landscape and its constituent subject of bathers. Cézanne's emphatic, curiously disconnected figures may strain that genre to its limits, but his monumental and densely configured landscape is anything but subordinate to them. Thus, the *Bathers at Rest* canvas becomes not only a seminal early model for the theme of male bathers in Cézanne's art, but part of the evolving genre of landscape painting in his *œuvre* as well.

Cézanne was no stranger to the historic landscape. He had previously manipulated the tradition in such pictures as *The Abduction* (see 36). And this same kind of polemical engagement with the historic landscape distinguishes his *Bathers at Rest*. It too must be read not only as an emblem of the artist's individual goals during the period in which it was painted but within the essential logic of its era.

The critic Roger Fry long ago noted that this heroic painting of bathers not only evidenced a great transformation in Cézanne's art but also echoed the example of Poussin. No doubt Fry was influenced by Cézanne's often-quoted remark that he wanted to 're-do Poussin over again according to nature', but the critic ventured further than most writers in substantiating such a heritage. It is, Fry wrote, 'the exact placing of plastic unit' and the overall emphasis on structural design in *Bathers at Rest* that suggests, above all, that 'Poussin had intervened'. As we have seen, Cézanne's dialogue with Poussin has often been explored in terms of the painters' more purely landscape paintings, for example Cézanne's *Harvest* (see 73) that draws closely on Poussin's *Summer* (see 75) in the Louvre.

100
Nicolas
Poussin,
*Saint John on the
Island of Patmos,*
1640.
Oil on canvas;
100·3 × 136·4 cm,
39½ × 53¾ in.
The Art
Institute of
Chicago

101
Hermes,
c.320 BC.
Marble;
h.154 cm, 60⅝ in.
Musée du
Louvre, Paris

A comparison of Cézanne's ***Bathers at Rest*** with Poussin's
great classical landscapes with figures, paintings such as
Saint John on the Island of Patmos (100), however,
bears out even more convincingly Fry's observation that
in Poussin Cézanne found a kindred spirit. Although
Cézanne's figures in ***Bathers at Rest*** assume a separate,
heroic monumentality, they also inhabit a dense, impen-
etrable world that is as rigidly sealed, ordered and framed
as any of Poussin's historic landscapes. A limpid atmosphere
in both the Cézanne and the Poussin paintings and a
uniform sense of line and sculptural contour throughout,
as seen in the foreground rocks and framing trees, figures,
distant mountains, even the muscular clouds, contribute
equally to the compressed and insistent surface design of
each, one that has no need of a controlling pyramidal
format. And while Cézanne's two leftmost figures – the
reclining (and quite possibly female) nude and the standing

nude at back – recall the charged, erotic figurès of such earlier paintings as his *Temptation of Saint Anthony*, they also echo, like Poussin's evangelist, the framing edges of the canvas and contribute not to a narrative but to a rigorous composite order. Similarly, the tautly upright male figures, redolent as they are of the male nude in classical sculpture – the bather on the right has been shown to derive from a statue of Hermes in the Louvre (101) – take on the sober formal roles of Poussin's architectural remains.

Within this rigidly structured universe, Cézanne's forms underscore an endless range of visual correspondences – for example, the series of opposing diagonals that converge on the central, axial figure. And these harmonious elements link all the disparate parts of his composition into a cohesive whole. Such hard-won visual affinities, and the solidity of the painting as a whole, suggest that Cézanne was imposing here the same kind of subtle and controlling order that he brought to his contemporary images of female nudes in nature, though by radically different means.

Cézanne did not copy or quote here from Poussin; instead he drew on Poussin's examples of an ideal, ordered world in which figural and natural landscape elements reflect and reinforce one another. The burdened sensuality of Cézanne's earlier figures may well be displaced here onto the heavily worked surface of his canvas, as Clark has suggested, but it is also nullified in Cézanne's structured, moral universe. Likewise, his athletic, classical male figures, though they hint at the realities of the flesh, participate in the idealism of the densely configured landscape they inhabit.

In looking to the heroic example of Poussin, Cézanne was in fact participating in the ongoing debate about the essential characteristics of French art. This nationalist dialectic took on a new urgency in the aftermath of the Franco-Prussian War and became particularly intense in the 1870s and 1880s, when France was doubting its worth and searching to define

the unique attributes of its national culture that could shape the country's future. For some, like Renoir, truly French art was represented by its eighteenth-century school of painting, as his later work would indicate. A few, including Pissarro, believed that the only true French style had been Gothic, and that French art from the Renaissance onwards had been compromised by influence from Italy. But for many, including Cézanne, it was precisely this Italianate strain, as epitomized by Poussin and the French Academy in Rome, which represented French art at its most French: an ideal balance between philosophical content and observed nature, achieved in a rigorously structured and therefore moral domain. By including the densely sculptural and historic face of Mont Sainte-Victoire in this otherwise fantastic scene, Cézanne not only reinforces its revived classicism but relocates that tradition on recognizably French – in fact, specifically Provençal – soil.

We cannot doubt that Cézanne was mediating a persistent, if idiosyncratic, strain in French painting when we recall that the conventions of the historic landscape had been revived in France during an earlier period of national crisis and moral imperative. The French Neoclassical painter Pierre-Henri de Valenciennes (1750–1819) had also looked to Poussin in his attempt, during the era of the French Revolution, to define the genre of the historic landscape as a natural corollary to the heroic history paintings of the Neoclassical school. Valencienne's widely read treatise on perspective and landscape painting, published in 1800, helped to establish the notion of a moral consonance between perfected man and perfected nature that resonated in the genre of the historic landscape. This was his legacy to a school of nineteenth-century classical landscapists whose painting identified the landscape of Italy, and in time that of southern France, with lofty ideals, as opposed to northern motifs or models which, however expressive, were seen to embody a more humble reality.

Valenciennes's heirs included his student Jean-Victor Bertin (1767–1842), whose work Cézanne knew and owned in two engravings, and also several artists of the nineteenth-century École Provençale. The provincial painter Prosper-Joseph Grésy (1804–74) was one of these; his idyllic 1854 canvas of bathers under a cathedral-like vault of trees, now in Marseille, has frequently been likened to Cézanne's later *Large Bathers* (see 200). But an earlier work, Grésy's *Mont*

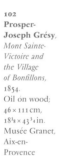
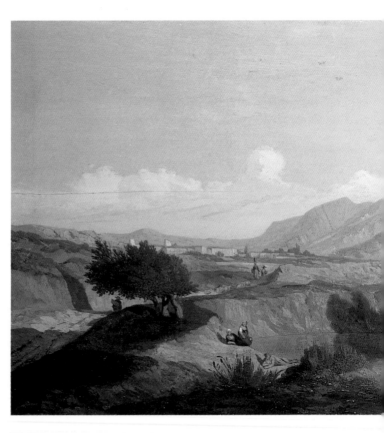

102
Prosper-Joseph Grésy,
Mont Sainte-Victoire and the Village of Bonfillons,
1854.
Oil on wood;
46 × 111 cm,
18⅛ × 43¾ in.
Musée Granet,
Aix-en-Provence

Sainte-Victoire and the Village of Bonfillons (102), may be even more relevant to our understanding of *Bathers at Rest*: in it, Grésy pictures bathers at the centre, in perfect union with nature and framed by the heroic mountain (here viewed from the northwest). Thus, in reviving the historic landscape tradition of Poussin and his heirs in his native Provençal terrain, Cézanne was moving it onto particularly

fertile ground. The link between topography and idealism was already a staple of southern culture.

When we look at Cézanne's *Bathers at Rest*, then, we see not only a battle between figure and ground, or between observed and idealized nature, or between a dense, impacted surface and dreamlike vision, but an image of a revealing and crucial duality: the curious, problematic figures on the left – redolent of his charged early narratives – the

emblematic and naïvely classical male figures on the right, the idealized landscape behind. In itself, the painting offers an image of moral decay and physical regeneration. As with so many of Cézanne's later bathers paintings, the work speaks of an emerging cult of the body that is bound up with the larger movement of French nationalism, and the urgent drive for physical as well as cultural rejuvenation.

Yet Cézanne's polemic impulses are never grounded in one reality only. In *Bathers at Rest*, the degeneracy most feared by the artist, and the one he so visibly conquers, is that of his own, earlier art, gauche and tormented. Even within the highly unconventional context of the 1877 Impressionist exhibition, Cézanne's painting defiantly proclaimed a growing certainty about his own identity: a southerner among northerners, a provincial in confident possession of a classical tradition, a maturing painter honouring his own artistic struggle. The *Bathers at Rest* stands as a palpable achievement from a master at a crucial mid-point in his career.

Though plagued by doubt throughout his working life, Cézanne must have realized the heroic feat which his *Bathers at Rest* represented because he would recast its massive and muscular central male figure once more, in the singularly powerful *Large Bather* of c.1885–7 (103). Although, as a tentative drawing suggests, he may have employed studio photographs and studies from a live model, probably his son, the deeply absorbed yet actively striding figure, which Meyer Schapiro has aptly described as 'a statue in a landscape', is far more than the sum of its myriad sources. In its roughly canonical, athletic proportions, iconic frontal presentation, forward-stepping posture, and even in its somewhat stiffened *naïveté*, Cézanne's *Large Bather* triumphantly recalls the tradition of the male nude in art, one that dates as far back as the athletic *kouroi* figures of the early Classical period. And while Cézanne's figure is rigorously joined to the landscape he inhabits by such visual rhymes as the diagonal of the bent arm and the corresponding rock edge, or the cool blue-greys that define his form as well as tie it to the pool of water and distant mountain, that landscape is not fecund now but spare to the point of absence, and so projects the notion of moral consonance between perfected man and perfected nature even more powerfully.

103
Large Bather,
c.1885–7.
Oil on canvas;
127 × 96·8 cm,
50 × 38⅛ in.
Museum of
Modern Art,
New York

It is hardly surprising that Cézanne found so few precedents for his heroic bather in the tumultuous earlier years of nineteenth-century France. With the instinct for synthesis of past and present that characterizes all his work, the painter reintroduced the monumental male figure at the moment when it would make sense to a newly invigorated culture, one that had survived the chaos and repression of the 1870s and now stood on a historic threshold of hope and change. This culture, too, had informed the emblematic harmonies of his female nudes in such paintings as his *Three Bathers* (see 94) from the same period, allowing us to see from two complex and developing perspectives the painter's brilliantly original vision as it evolved within the specific logic of his era.

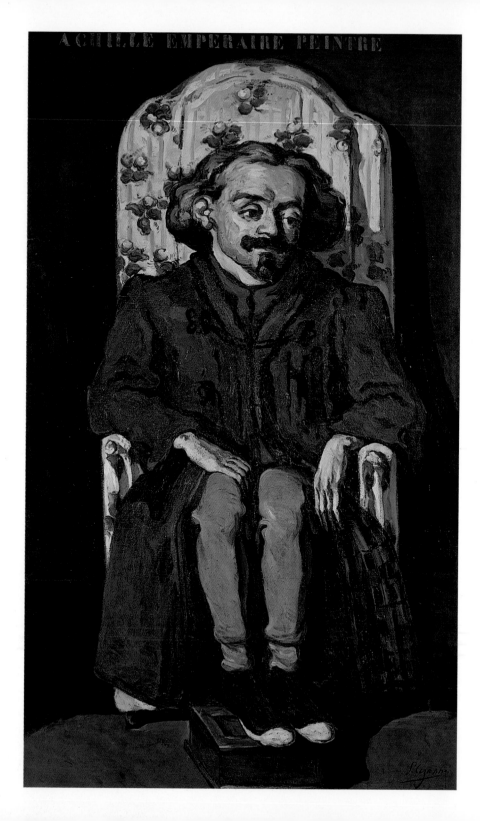

Cézanne's portraits and still lifes from the 1870s also allow
us to trace his complex development in this pivotal decade,
as he confronted issues posed by these specific genres
in his day and imposed the broader effects of his own
Impressionist-derived style on the subjects and images they
presented. Clearly, he wrestled early on with the paradoxes
inherent in the very notion of an Impressionist portrait
or still life: how an innovative and usually sketch-like
technique based on a highly subjective response to a visual
motif could be reconciled with these most hidebound of
academic subjects. Yet, often the probing thematic questions
and pictorial lessons proffered by his portraits and still
lifes of this period helped to shape Cézanne's painting
as a whole.

104
*Portrait
of Achille
Emperaire,*
c.1869–70.
Oil on canvas;
200 × 122 cm;
78³⁄₄ × 48 in.
Musée d'Orsay,
Paris

Sharing space in the same contemptuous cartoon that had
derided his lost nude of *c.*1870 (see 82) was a brutal carica-
ture of Cézanne's poignant *Portrait of Achille Emperaire*
(104), a painting also rejected that year by the Salon jury.
In this powerful tribute to the older Aixois painter, Cézanne
employs the large, vertical format usually reserved for
more heroic images of authority. The work gives striking
expression to the subject's misshapen form: in the throne-
like flowered armchair in which the artist's father had
previously posed (see 33), Emperaire's outsized head looms
above his stunted, dwarfed body cloaked in a humble
dressing gown, while his fragile, spindly legs are propped up
on a small foot-warmer. Cézanne had perfected Emperaire's
rueful expression in several superb preparatory drawings
(*eg* 105), and together with his friend's long, delicate hands
and the bold, block-lettered inscription he added above –
ACHILLE EMPERAIRE PEINTRE – the canvas becomes

105
*Portrait
of Achille
Emperaire,*
c.1867–70.
Charcoal;
43·2 × 31·9 cm,
17 × 12¹⁄₂ in.
Öffentliche
Kunst-
sammlung,
Kupferstich-
kabinett,
Basel

one of Cézanne's most sympathetic early likenesses. It is
also a potent summation of the emotional pitch and
dark romanticism of his first decade of painting. Even the
melancholic palette of stark contrasts – deep blues, reds,
black and swarthy browns – harks back to the earlier figural
works. And while the monumental portrait may also have
been conceived as yet another grand parody of established
pictorial models – perhaps even, as Nina Athanassoglou-
Kallmyer has argued, as a mocking allusion to the pathetic
empereur Napoleon III whom the goateed *Emperaire*
somewhat resembled – such additional contexts do little
to lessen the direct emotional impact of Cézanne's
ambitious painting. Describing its startling effect, the
artist supposedly declared, 'I paint as I see, as I feel – and
I have very strong sensations.'

In 1874 Cézanne himself would be the subject of a heroic
portrait by Pissarro (106), a touching memento of their years
together in Pontoise. Dressed in the rough, bulky garb of
the country and shown with a beard, long hair and cap,
Cézanne is portrayed by Pissarro as the virtual embodiment

of the rural Pontoise school. Tacked to the wall behind him are glimpses of a canvas and caricatures that testify to his achievement in these years and to his ruggedly independent spirit: at the lower right, Pissarro offers fellowship with a quote from one of his own Pontoise landscapes; above it is a caricature of the rebellious, bohemian Courbet, who likewise seems to be saluting his fellow provincial painter, Cézanne. And, at left, Pissarro includes a satirical allegory of France paying off the Prussian indemnity (taken from a political cartoon of the postwar President Thiers from the left-wing journal *L'Éclipse*), a figure who also appears here to toast the painter at centre. Although the radical politics alluded to in the portrait can be more closely linked to Pissarro than to Cézanne, the work clearly offered the younger painter a vivid show of support; like Cézanne's tribute to Emperaire, it also hints at the compelling new functions portraiture will assume in his own work during this transitional period.

Pissarro remained one of Cézanne's most encouraging and faithful admirers. And some of the artist's new-found confidence is echoed in an astonishing self-portrait that dates to this period. In its composition, Cézanne's *Self-Portrait with a Rose Background* (107) of c.1874–5 is closely tied, in fact, to a self-portrait that Pissarro executed in 1873, as well as to Pissarro's 1874 painting of Cézanne and a related engraving. But as in many of his early Impressionist landscapes or paintings of nudes, Cézanne's self-portrait is also built around a rich and luminous new palette: thick, swirling strokes of pink-toned terracottas (much like those in his *Modern Olympia* of c.1873–4, see 85), overlapping whites and a deep brownish-violet merge in this imposing likeness. Its sweeping, confident technique and radiant colour are matched by the figure's massive solidity and piercing stare. Years later, the poet Rainer Maria Rilke summarized the painting's trenchant power:

106
Camille
Pissarro,
*Portrait of Paul
Cézanne*,
1874.
Oil on canvas;
73 × 59·7 cm,
28³⁄₄ × 23¹⁄₂ in.
Private collection
on loan to the
National Gallery,
London

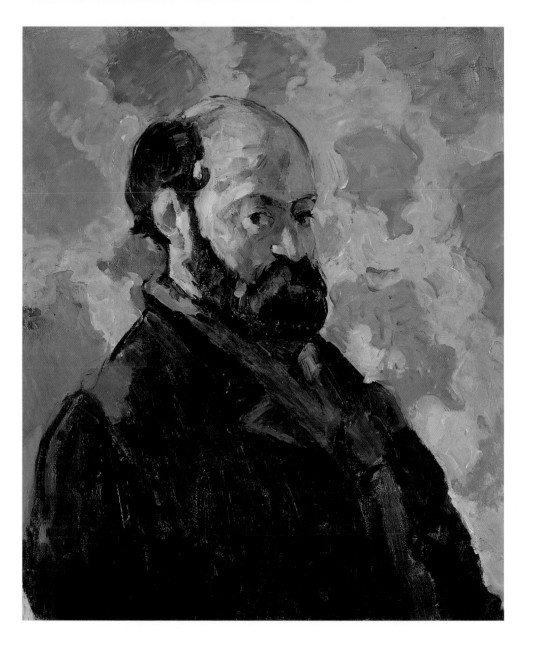

107
*Self-Portrait
with a Rose
Background,*
c.1874–5.
Oil on canvas;
66 × 55 cm,
26 × 21⅜ in.
Private
collection

it is drawn with eminent assurance ... its strength apparent even in those spots where, broken up into shapes and planes, it becomes only the outermost of a thousand contours ... [And] it is almost touching to see him confirm how intense and incorruptible he could be in his observation by portraying himself with such selfless objectivity.

Although we can sometimes perceive the influence of Pissarro, the charged handling and original character of Cézanne's portraits from the mid-1870s make them, on the whole, quite unlike those of his Impressionist peers. In fact, portrait paintings would account for a relatively small portion (less than ten per cent) of Cézanne's output in this decade. Yet, significantly, Cézanne chose to include one of his most radical portraits to date in the third Impressionist exhibition of 1877.

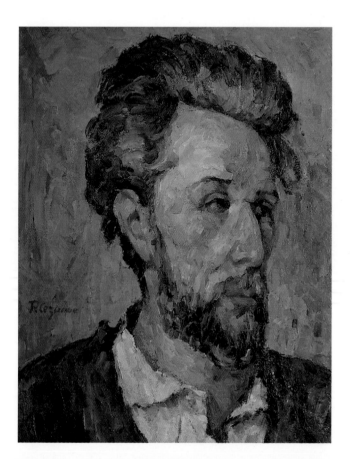

108
Portrait of
Victor Chocquet,
*c.*1876.
Oil on canvas;
46 × 36 cm,
18⅛ × 14¼ in.
Private
collection

The work represented the amiable Victor Chocquet, a minor government official and ardent admirer of Delacroix who had met Cézanne through Renoir and had become his first real patron. At the exhibition, Chocquet daily took on the most scornful visitors, vehemently defending all of the painters on view and especially Cézanne. His collection of Cézanne's work would in time number thirty-five, but in 1877 it was already formidable. In addition to the *Scène fantastique*, Chocquet owned, among other works, *Auvers, Small Houses* (see 64), an important small painting of three bathers, several still lifes, an early version of *Bathers at Rest* (see 98), a landscape of L'Estaque and this haunting portrait of himself of *c*.1876 (108), the first of a number that Cézanne would produce. Ironically, it was this painting which seemed to inflame the critics especially and which Chocquet would feel called upon to defend most fiercely.

Listed in the catalogue as a study for a *Head of a Man*, Cézanne's crusty, earth-toned portrait was ceaselessly mocked. 'Let us also mention the *Head of a Man*, which looks like Billoit [an infamous murderer] in chocolate,' one critic wrote in *L'Événement*. Another took issue with the lean, elongated features that rendered the image so expressive: 'He is a worker in a blue smock who has a face as long as if it had been sent through a rolling mill and as yellow as that of a dyer who has worked with ochre for a long time.' The harshness and daring were clearly deliberate: of all the portraits Cézanne would produce of Chocquet, this one bears the least resemblance to his genteel subject. Vigorously executed with thick, broken touches of pigment, a luminous palette and a flattened perspective that emphasizes the nearly oblique angle of the pose, Cézanne's portrait manifests a rich, painterly virtuosity that invests his image with a compelling new meaning.

To comprehend Cézanne's ambitious reworkings of the formal portrait, it is important to understand the aesthetic

decline of portrait painting in the waning years of the nineteenth century. The advent of the camera and, with it, the cheaply available portrait photograph stimulated a far wider consumer market for the traditional painted portrait as well. At the Salon, portraiture became one of the surest paths to commercial, if not critical, success. In 1867, the critic Théodore Duret had pronounced it 'the triumph of bourgeois art', and the following year Zola echoed his comments, noting that 'the flood of portraits rises each year, threatening to inundate the entire Salon'. This increasingly commonplace vogue for portraiture rendered the genre's idealizing precedents and traditional forms empty and insipid. The walls of the Salon were now covered, Zola complained, with 'silly grimacing faces'. Thus, while Ingres's portraiture remained the standard against which all academic examples were measured, little of the icy calm and imposing presence of such aristocratic portraits as, for example, his 1856 painting of Madame Moitessier (109) survived in the derivative and even painfully banal portraits of his followers, such as *Madame Brohan* (110) by Paul Baudry (1828–86).

The vast expansion of the portrait market was not confined to academic painters. In their early careers, even Monet and Renoir turned to portraiture to procure some of their first lucrative commissions. For a brief period in the late 1870s and early 1880s, in fact, Renoir would have few rivals as a society portraitist. And, for Degas, who rarely sought such commissions and whose naturalistic and deeply probing likenesses stand somewhat apart from those of his peers, the genre was an essential one that broached both the academic traditions and modernist strategies embraced by his art. Thus, while the Impressionists produced some of the most exquisite portraits of their age, their typical concern was not to penetrate their subjects as individuals but more to capture them as informal models, at ease, in airy, luminous settings, and often as decorative staffage in paintings of the bourgeois society celebrated in their art. Yet again, Cézanne chose the renegade's path, bypassing decorative placement for a re-engagement with the past and boldly confronting the altered status of portraiture in his era.

Cézanne may also have been aware of Chocquet's enthusiasm for exactly the type of vigorous, expressive portrait he produced of him. According to the art dealer Ambroise Vollard, Renoir's unusually forceful self-portrait of 1875 (111) was jettisoned by the artist in his studio but rescued from a rubbish bin there by Chocquet. A virtuoso display piece, in which Renoir's self-image as a moody, introspective genius is underscored by his visibly agitated brushwork, the painting was lent by Chocquet to the second Impressionist exhibition, where it too was simply titled *Head of a Man*. Critics noted its striking originality.

At the third Impressionist show, Cézanne's painting of Chocquet would have also functioned more as a painterly manifesto and *fantaisie* (image) of cultivated genius than as a direct portrait. Rather than an exacting likeness, Cézanne's painting pays tribute to his patron's cutting-edge

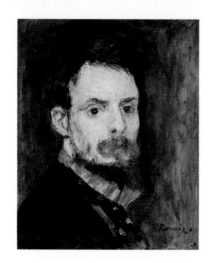

111
Pierre-
Auguste
Renoir,
Self-Portrait,
1875.
Oil on canvas;
39·1 × 31·7 cm,
15³⁄₈ × 12¹⁄₂ in.
Sterling and
Francine Clark
Art Institute,
Williamstown,
Massachusetts

112
Portrait of
Victor Chocquet
Seated,
1877.
Oil on canvas;
46 × 38 cm,
18⅛ × 15 in.
Columbus
Gallery of Fine
Arts, Ohio

tastes and enthusiastic engagement with the new art by means of the aggressive style employed to depict him. But, as Meyer Schapiro has written, 'In the portrait of his admirer, Cézanne speaks also of himself.' The brooding intensity, powerfully compressed forms, and warm terra-cotta tones of his painting hinted not only at the complex significance portraiture would come to assume in Cézanne's later art but also at the gradual break with his earlier Impressionist style that is evident in some of his landscapes of this period.

Though it is hard, and sometimes hazardous, to make a comparison between Cézanne's works in separate genres, something of the same block-like brushstroke that distinguishes his bold L'Estaque landscapes from the late 1870s (see 79), and marks within them a retreat from his earlier Impressionist technique, can also be found in his *Portrait of Victor Chocquet Seated* (112) of 1877. And while many scholars have pondered this work at length because it seems to display an essential new idea of pictorial unity, its distance from Impressionism was more than a matter of form. Cézanne also presents us here with a surprisingly conventional image of a collector.

The nervous energy and elongated features of the earlier, bust-length painting of Chocquet are missing from Cézanne's 1877 portrait. Instead, he depicts Chocquet in the guise of a worldly bourgeois collector, comfortably seated in the midst of the gilt-framed paintings and antique furniture he treasures. In a related still life of the same style and period, *A Dessert* (113), which was probably also painted in the collector's home, Cézanne again uses Chocquet's collection of exquisite objects and elegant old furniture to create an image of luxury quite unlike the more humble domestic still lifes he had painted with Pissarro (see 116, 117).

Though Cézanne's portrait may owe something to Degas's 1868 painting of James Tissot, his pictorial means here

are radically new. The casual posture Chocquet assumes, for example, one that the collector had earlier adopted for a portrait by Renoir, forms a taut central axis around which Cézanne constructs a dominant grid of vertical and horizontal elements. And the flat, mosaic-like blocks of glowing colour amplify the artist's ordered composition by creating a dense tapestry of paint-strips that adhere to the surface of his canvas. These also suggest the coloured facets of the elaborate rug, the patterned wall, the marquetry of the elegant desk and even the pursed lips and modelled

113
A Dessert,
*c.*1877–9.
Oil on canvas;
59 × 73 cm,
23¹⁄₄ × 28³⁄₄ in.
Philadelphia
Museum of Art

chin of the subject at centre. Thus, despite its pleasing colour harmony and conventional format, Cézanne's *Portrait of Victor Chocquet Seated* represents, as Lawrence Gowing wrote, a new 'embracing system of analogy and correspondence'. Knitted together like Chocquet's inter-locked hands, two spatial and pictorial vocabularies – that of the canvas itself as a flat, painted surface and that of the subject's ornate three-dimensional interior – are reconciled by means of Cézanne's solid, deliberate touch.

Cézanne's painting *Madame Cézanne in a Red Armchair* (114), which was painted around the time of the Chocquet portrait, displays the same mastery of the artist's new form, and must also have been intended to challenge the increasingly stale state of portraiture. Here we find the same technique of applying paint in blocks and interlocked strips of colour – rich, unmodulated blues, greens and deep red. And the decorative, patterned wallpaper once more calls attention to the paint-laden surface of the canvas. The result is a radiant tapestry in which it seems 'each spot had a knowledge of every other', as Rilke famously noted. Yet there is an unusual sense of gentleness and a sympathy for his subject that sets the painting apart from those of its Impressionist peers and even from Cézanne's other, less accessible likenesses of Hortense Fiquet (*eg* 142, 145, 146). (Although this canvas grants her the status of wife, Cézanne would not, in fact, marry her for almost another decade and even then would often live apart from her.)

The rigid, grid-like composition that had determined Cézanne's view of Chocquet and was favoured by the painter in many of his landscapes of this period (see 76) is softened here by the supple curve of the subject's arms and interlaced fingers, the arc of the red chair and the tasselled, rounded ends of the armrests and chair-back that are echoed in the looping bow on her dress at centre. Her face, calm and serene, is delicately built up from the whole palette of colours that surround her, and even her pose is more curved and graceful than Chocquet's: she leans slightly to one side and allows the massive armchair to embrace her almost protectively. The armchair also serves subtly to balance the composition. In *Madame Cézanne in a Red Armchair* the artist offers us a rare glimpse of the cool, quiet reserve of his future wife, who pulls back from his ordered composition and saturated paint surface to imbue the painting with a commanding formal presence, lacking in so many Impressionist portraits.

While in his landscapes of this time Cézanne's painting style would often progress beyond the block-like strips of colour displayed here towards his celebrated method of systematically covering a canvas with short, parallel strokes, the same cannot be said of his portraits of the late 1870s. For all that it had become a virtual signature in his work by then, Cézanne's constructive-stroke technique seems to have been accorded a much smaller place in his portraiture. Not until his later, masterful self-portrait of *c.*1880–1 (115) did the artist fully and successfully integrate its rich, tactile effect with an expressive study of an individual physiognomy, and notably it was his own. Schapiro has described the strange 'wedding of the organic and the geometric' here: how its uniform, slanting brushwork ties the lozenge-patterned wallpaper to the rhyming shapes of the eyes and nose, for example, and lends them an ordered but strangely abstract air. Both cooler and more calmly composed than his earlier self-portraits, this one suggests a quiet harmony like that achieved in his bathers and landscapes from the late 1870s, while also pointedly – and publicly – linking the artist's prized technique with himself.

114
Madame Cézanne in a Red Armchair,
Oil on canvas;
*c.*1877.
72·5 × 56 cm,
28¹⁄₂ × 22 in.
Museum of Fine Arts, Boston

115
Self-Portrait,
*c.*1880–1.
Oil on canvas;
33·6 × 26 cm,
13¹⁄₄ × 10¹⁄₄ in.
National Gallery, London

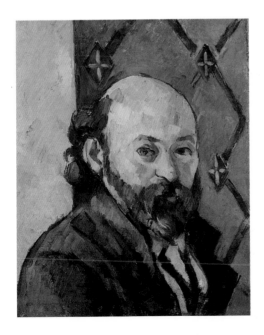

Finally, in the many and exquisite still lifes he painted in the 1870s, we can again plot Cézanne's essential passage from his first, exuberant embrace of a new style indebted to Pissarro to his later, Impressionist-derived but newly harmonious works of c.1878–80. As we have seen in his works from the late 1860s, Cézanne was both well versed in the symbolic and formal conventions of traditional still-life painting, the most humble in the hierarchy of academic subjects, and poised to defy them. For example, his *Still Life with Black Clock* (see 49) had both spurned the symbolic reading suggested by its accumulation of objects and resisted the stable geometry which is usually dictated by such visual groupings, leaving both its 'meaning' and pictorial properties ambiguous. More than any of his peers, in fact, Cézanne was drawn to still life not only for its famously solitary and controlling aspects (the chance to organize his motif first in his studio and then on canvas must have made the genre a compelling one), but because it offered him a new platform for bold artistic experimentation. The centrality of still-life painting in Cézanne's work of this transitional decade is evident both in the numerous examples he painted and in the fact that he chose to include five still-life canvases in the important Impressionist exhibition of 1877.

For all their pictorial innovations, however, the charged and resonant character of Cézanne's still lifes impels us to consider them as compositions with both formal and thematic concerns, an approach first outlined by Schapiro in his 1968 ground-breaking study, 'The Apples of Cézanne: An Essay on the Meaning of Still Life'. Quoting from such widely varied sources as classical myth, Renaissance poetry, the novels of Zola and the artist's own earlier painting (*eg* 85), where apples had assumed an ancient symbolic role as expressions of temptation and eros, Schapiro explored Cézanne's numerous painted apples as sites of both formal invention and sublimated desire, and changed forever our perception of the artist's still-life painting as a whole. Thus,

as in his paintings of nudes from this decade, the artistic struggle and evolution which we find mapped in Cézanne's still lifes of the 1870s is one that is informed by a broad spectrum of critical approaches.

In his small, unstructured and impetuously painted *Green Apples* of c.1872–3 (116), probably one of the first still lifes from the artist's early stay in Pontoise, we sense Cézanne's titanic efforts to overcome the vicissitudes of his earlier Romantic painting. Though much of the youthful agitation persists in the churning framework of swirling strokes, scattered shadows and perilously unstable forms, the painting presages the order that is to come: the large volumetric apple at centre, marked by a squarish touch of white, fixes our eye on Cézanne's new sunlit palette and the rugged and broken brushwork that would become the hallmark of the rural Pontoise school.

In his later and more complex *Still Life with Soup Tureen* (117), probably painted in Pissarro's studio between 1875

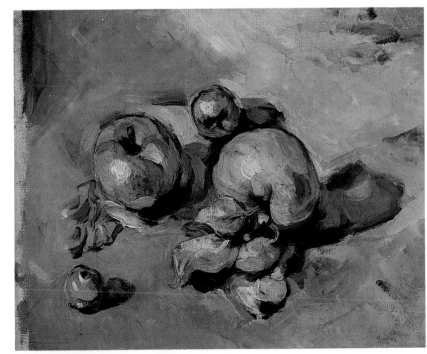

116
Green Apples,
c.1872–3.
Oil on canvas;
26 × 32 cm,
10¼ × 12⅝ in.
Musée d'Orsay,
Paris

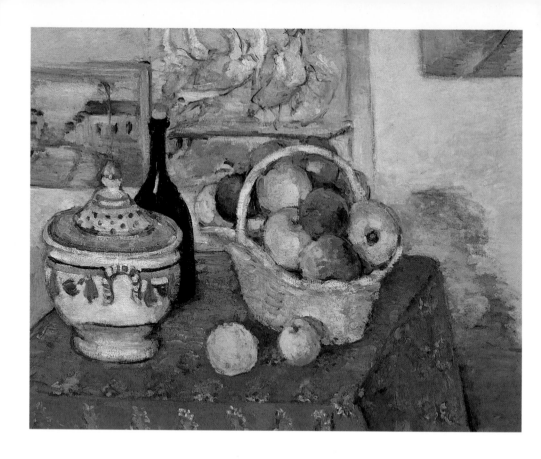

and 1877, Cézanne frames his tabletop arrangement with canvases by his mentor, including the same Pontoise landscape that Pissarro had included as background in his portrait of Cézanne (see 106). A woven straw basket, not unlike one painted by Pissarro a few years earlier, is overflowing with ripe apples and balanced by a painted faience soup pot and tall, dark wine bottle, the elements of a simple peasant meal. But it is the artist's rough-hewn, continuous touch that announces most clearly his affiliation with Pissarro and his Impressionist circle. In its intensely coloured palette and profusion of pattern that spills over the table's rim and even affixes itself to the lower edge of the canvas, we also glimpse in this work the modernist paradigm Cézanne's still-life paintings would present to Matisse, among many other artists.

117
*Still Life with
Soup Tureen,*
c.1875–7.
Oil on canvas;
65 × 83 cm,
25⅝ × 32¼ in.
Musée d'Orsay,
Paris

If his *Still Life with Soup Tureen* can be read as a summation of sorts of his Impressionist years in Pontoise, perhaps even as a homage to the venerable Pissarro, Cézanne's still lifes from the 1870s that were painted in Provence partake just as richly in its distinctive milieu. Ironically, however, it may well have been during 1878, a year, as we have seen, of personal and financial crisis, that Cézanne painted his luxurious still life *Dish of Apples* (118), a work of such exquisite order that it is now regarded as a masterpiece. At one time owned by Chocquet, it may have been commissioned by the stalwart patron as a gesture of needed support. It is certain that the painting was done in Aix: in the background, Cézanne includes the decorative screen he had painted as a young man for the Jas de Bouffan. Some scholars have dated the work to an earlier visit home, largely because the artist's red signature in the lower-right corner is also found on a number of his paintings shown at the 1877 Impressionist exhibition. But the complexity of the brushwork – thick, squarish and layered strokes in the still life in front, and a thinner and more fluid handling in the ornamental background – as well as its classically conceived composition and balanced palette argue in favour of the later chronology.

One of the most imposing still lifes the artist had completed to date, the painting reads much like Cézanne's Poussin-esque landscapes from the end of the 1870s (**eg 73**), except that the spatial ordering has been deftly reversed. The mound of monumental apples and the strangely massive peak of white cloth (more than one writer has likened its rock-solid shape to the profile of Mont Sainte-Victoire) are perfectly centred in the foreground of his canvas and framed by vertical bands of colour and the hanging floral designs of the Rococo screen behind. The artist's arrangement of colour – the saturated tones of his palette appear in the near still-life elements, the more transparent ones farther back – likewise responds to the painting's rigid and

118
Dish of Apples,
*c.*1878.
Oil on canvas;
45·5 × 55 cm,
17⅞ × 21⅝ in.
Metropolitan
Museum of
Art, New York

119
Apples,
*c.*1878.
Oil on canvas;
19 × 26·7 cm,
7$\frac{1}{2}$ × 10$\frac{1}{2}$ in.
The Provost
and Fellows of
King's College,
Cambridge, on
loan to the
Fitzwilliam
Museum,
Cambridge

inverted pictorial scaffolding. Even the rounded contours of the sugar bowl, the lone green apple, the plate, and the arcing edge of white linen at left serve to contain his still-life arrangement and push forward the painting's vision of a classical harmony on a small scale. After such an achievement, it is hard to imagine how its author could still question his abilities.

Such grandly resolved compositions, which anticipate the larger, more 'symphonic' still lifes of the following decades, were matched by the range of experiments Cézanne carried out at the same time in a series of smaller, more informal paintings of fruit. These have often been characterized as studies or spontaneous exercises, but they hold their own as visual statements and have an important bearing on his later work. In many of them, Cézanne seems to have been exploring the effects of his constructive stroke when applied on an intimate scale. Thus, in *Apples* of *c.*1878 (119), issues of composition and spatial definition abruptly disappear. Seven isolated apples are simply gathered on a flat surface and rendered close-up in rugged, parallel strokes of paint that build upon the balance of warm and cool tones and the overall texture of the artist's measured touch. The painting soon became famous: following its exhibition in Vollard's gallery in 1895, Degas bought it to hang in the private museum he hoped one day to open. After critics had lavished praise on the 'ravishing forms' and 'furious pugging' of colours found in these tiny still lifes, Cézanne became known as the prodigious 'painter of apples'. Both in its aesthetic distance from his earlier, tempestuous *Green Apples* (see 116) and in its continuing suggestion of the implicit meaning of the artist's subject matter, Cézanne's *Apples* summed up the momentous achievements of a prolific decade of promise.

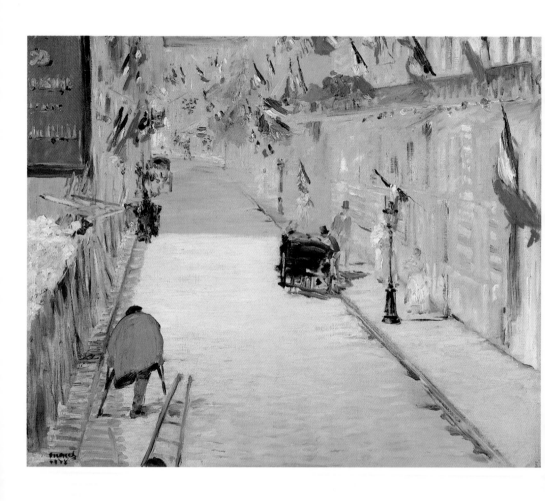

When Cézanne returned to Paris in March 1879 after an absence of about eighteen months, he found that the city's artistic and political climate had dramatically changed. In 1878 a carefully orchestrated Universal Exposition had been staged in Paris to demonstrate to the world the nation's full recovery from the Prussian humiliation, and its organizers studiously avoided any hint of controversy. Thus, although the renegade Courbet had died only months before, and in exile because of his involvement with the Commune, he was denied the customary retrospective given to important French artists at such expositions; only a single, neutral seascape of his was put on view. Among others, Zola vociferously condemned such transparent political acts. And a more public and heated debate had also ensued in these months over another overtly partisan campaign: the effort to establish a commemorative national holiday.

120
Édouard
Manet,
*The Rue
Mosnier
Decorated
with Flags,*
1878.
Oil on canvas;
65·5 × 81 cm,
25¼ × 31¼ in.
The J Paul
Getty Museum,
Los Angeles

As the art historian Jane Mayo Roos has shown, the euphoric celebration of the first Fête de la Paix on 30 June 1878 was exposed as another political pretence, this time by Manet in his ***Rue Mosnier Decorated with Flags*** (120). Here, on a narrow, near-empty street and under a canopy of patriotic flags, Manet depicts the new *fête* in terms of the legacies of the painful and still quite recent past: a rubble-strewn lot where elegant Second Empire buildings had once stood, a crude wooden barricade and shattered pavement, and most poignantly, a pathetic veteran on crutches, dressed in the common labourer's blue smock, a scathing index, in fact, of exactly what the *fête* itself had been designed to obscure. Although the government, in its sponsorship of both the Universal Exposition and the Fête de la Paix, had hoped to foster

a restorative nationalist pride, it would take much more than pre-packaged ebullience to erase the memory of the tumultuous years that had inaugurated the decade of turmoil and false starts. Finally, however, the monarchist Marshal MacMahon resigned in early 1879, and a truly republican form of government was established with the election of Jules Grévy as president. The tide of nationalism that emerged in this period as a major cultural and intellectual force in France evolved within this complex political matrix. As we will see, Cézanne's landscape painting of the late 1870s and early 1880s, like that of many of the Impressionists, is marked by the altered political and cultural landscape he discovered in Paris that spring.

Grévy and the liberal majority in both parliamentary houses began to chart the republican course that the nation had sought for a decade. Within months, the revolutionary 'Marseillaise' was adopted as the national anthem, Bastille Day (previously considered too inflammatory a date to commemorate) became the national holiday, and the surviving Communards were given amnesty.

The role of the arts, and of the state as their patron, would also be transformed by the increasingly republican climate. In 1878, the rules of the Salon underwent revision to allow for a more open-minded jury, and this became the first of a number of reforms that the state would implement. Perhaps anticipating further changes, in 1879 Alfred Sisley (1839–99), Renoir and Cézanne chose to sit out the fourth Impresionist exhibition and instead submitted works to the Salon. As Sisley noted in a letter to Théodore Duret, 'It is true that our exhibitions have served to make us known ... [but] We are still far from the moment when we can do without the prestige attached to official exhibitions.' Although only Renoir would see his work accepted by the Salon that year (Guillemet's entreaties on Cézanne's behalf went unheeded), in time all of the Impressionists would respond to the

change in political climate in various ways. In 1880, Monet sent two paintings to the Salon jury, his first submissions in a decade, and one would be hung in what amounted to the largest Salon exhibition ever. Finally, in 1881, the state relinquished control of the Salon to the newly created Society of French Artists, which would judge and hang all future Salons and was open to anyone who had previously exhibited there. As the Director of the École des Beaux-Arts pronounced, it was high time to establish a 'Republic in the arts'.

The new minister of fine arts, Jules Ferry, actively courted the Impressionists. In his speech at the 1879 Salon awards ceremony, he appealed especially to the landscape painters who were dedicated to 'the truth of the open air' to rejoin official ranks and present their work to the Salon. His solicitation coincided with the larger, nationalist aims of the Republic. Landscape painting had long been seen as a liberating, anti-hierarchical genre of art, an arena of artistic and ideological freedom in which both the antiquated restrictions of the Academy in art and the modern effects of industrialization in nature could be either confronted or escaped. However, as we have seen in Pissarro's paintings of Pontoise or in the urban views of Manet, the painted landscape was hardly untrammelled territory. The noted critic Jules-Antoine Castagnary had described its nationalistic implications as early as 1866: landscape painting allowed artists to reflect their country's 'essential character', he wrote, and 'to take possession of France, its soil, air and countryside'.

In the 1860s, in fact, as part of an earlier jingoistic drive, Napoleon III had promoted exactly this sense of a tangible, national identity by making it state policy to buy and distribute to provincial museums numerous Salon paintings by French landscapists. Aware of the political connotations that could surround such ostensibly neutral terrains, the right-wing regime of MacMahon purchased many fewer

Salon landscapes. Thus landscapes as well as figure paintings from the 1880s invite complex readings, and the forms they took negotiate anew the character of the country and the artist's place within it. Cézanne's landscapes from the early 1880s display an increasing sense of monumentality, at times a bold new grandeur, and an ever more cohesive, ordered structure. In imposing formal terms, they both mirror and celebrate the nation's own restorative pride in itself as it rallied during this period.

121
Bridge at Maincy, c.1879. Oil on canvas; 60 × 73 cm, 23⅜ × 28¾ in. Musée d'Orsay, Paris

Cézanne continued to distance himself from earlier Impressionist art in the early 1880s, not only because he sensed, as Monet would, its stylistic limitations and now dated polemical edge, but because of his growing awareness of what Schapiro has aptly called Impressionism's 'spiritual inadequacy': its focus on the immediate present and the ephemeral and its determined lack of engagement with the great French art of the past. As with his bathers paintings of *c.*1880, Cézanne struggled in his landscapes of this period to reconcile his Impressionist-derived technique and the motifs he found in nature with a sense of France's heroic, classical tradition, reflecting a 'nationalism' that was more than skin-(or scenery-) deep. Although he would never, like Monet, take on the rich diversity of the French countryside as his subject, Cézanne's focus on – and increasing identification with – the motifs and mythic landscape of Provence in the 1880s becomes one of the most defining features of his art and, in itself, a regionalist expression of the sweeping nationalist tide.

Building on the discoveries and transformations resulting from his months of intensive work in Provence in 1878–9 (and ignoring his ritual defeat at the Salon), Cézanne produced some of his most powerfully structured landscapes to date after returning north that spring. After a short stay in Paris, he moved with Hortense and their young son Paul to Melun, a small outlying town on the River Almont, where

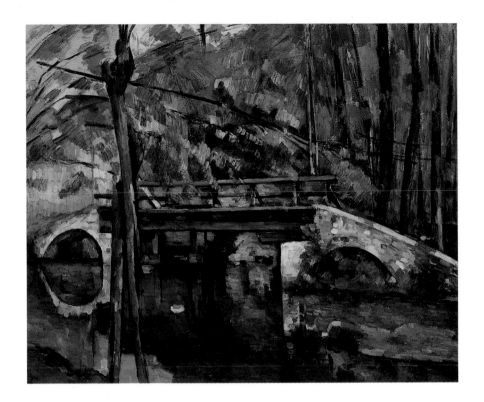

they would live until the spring of 1880. And it was probably
during the first few months of his time in Melun that he
produced *Bridge at Maincy* (121), a landscape marked
equally by its studied equilibrium and verdant spring
green palette. Within its tightly woven surface, Cézanne's
constructive stroke appears in a highly consistent form
in short parallel touches, providing a perfect balance for
the work's rigorous stability and virtually symmetrical
composition. Pavel Machotka has compared the painting
with photographs of the site and noted the artist's discreet
orchestration of its space, colour and surface textures: for
example, the way the tree establishes the left foreground
space close to the surface of the painting but also acts as
a *repoussoir* to push back the objects behind it, or the
way the steep angle of the buttress at right is echoed in
the branches above and reversed in the mill roof at left
to form an implicit but stable triangle at centre. Such
subtle manipulations, which transform the subject into

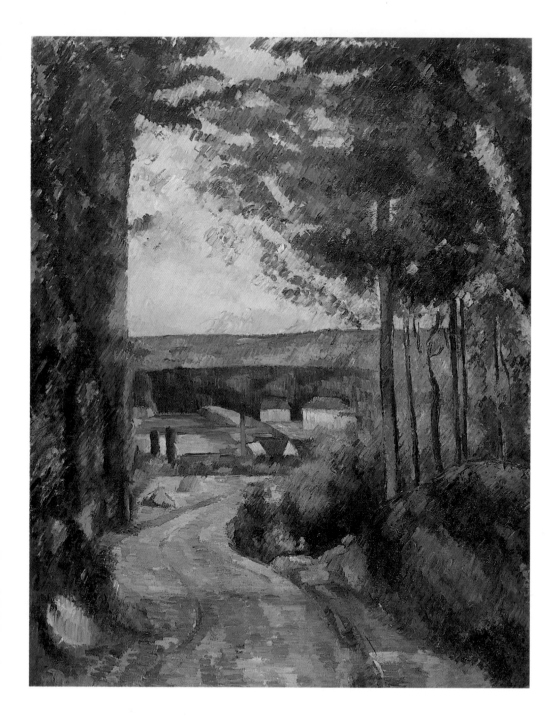

a harmonious formal motif that remains rich with visual incident, also establish Cézanne's essential dual stance as an arbiter of the classical French tradition of landscape and a scion of the Impressionist school.

In a tall, vertical canvas that may also date from the artist's stay at Melun, *The Road to the Pond* of *c*.1880 (122), Cézanne employs the familiar motif of a winding road, framing trees and an overall grid-like composition to create an even more cohesive and self-consciously classical landscape. With a more distant central horizon and far less specific subject than the previous work (some have placed the motif on the banks of the Oise near Auvers), this painting becomes an exercise of sorts in updating the classical landscape models of Poussin and Claude Lorrain (*c*.1604–82). These had persisted, as we have seen, in Neoclassical painting of the early nineteenth century and were among the formal standards against which even later artists continued to measure their landscapes. Significantly, the factory chimney, the modern bridge and, above all, the painted surface of dense, striated marks of paint that so defiantly establish Cézanne's distinctive constructive stroke locate the work in the decisive years of the early 1880s.

As with other aspects of the artist's evolution, it is useful to look at parallel developments in the lives and works of his more diagrammatic contemporaries, since shifts in Cézanne's thoughts and paintings are often elusive. For example, the changes evident in Monet's paintings within this new republican climate are germane. By the late 1870s Monet had already begun to reject the pleasurable city and bourgeois settings of suburban Paris that figure so frequently in his earlier work to focus on more extreme, and usually isolated, landscape motifs. By the 1880s he had set himself a programme to paint the countryside of France in its rich diversity and, thus, to make his Impressionist style reflective of his native landscape as a whole.

Monet's efforts to enlarge and enhance the status of Impressionism, by now a recognized movement, were also driven in the 1880s by the challenges posed by the rising band of younger Neo-Impressionist painters, especially Georges Seurat (1859–91). In his strangely hieratic images of leisure and distinctive execution in juxtaposed, small touches of complementary colour – the product of his new 'scientific method' of capturing the perception of colour as light – Seurat defiantly challenged both the basic axioms of the Impressionist school and Monet's leading role within it.

Monet's drive to expand and validate Impressionism as a potent French visual language would be matched in the 1880s by Cézanne's desire to give his own art a new sense of critical legitimacy, if not at the Salon, at least in the eyes of his friends. Many of them, just then experiencing a measure of success, were helping to shape France's new cultural landscape: Valabrègue had recently published a fine volume of poetry, Paul Alexis's play *Celle qu'on n'épouse pas* had opened to good reviews in Paris, Monet's successful one-man show in Paris in June 1880 was the talk of his crowd, and Renoir, after his acclaimed showing of large portraits at the 1879 Salon, had procured other major portrait commissions.

Zola was enjoying the greatest success of all. From Melun, Cézanne wrote repeatedly to his old friend to congratulate him on his string of current literary triumphs: the appearance of an important collection of critical essays, the dramatic production of his novel *L'Assommoir* on the Parisian stage and the long-awaited publication of *Nana*. Cézanne did not comment on Zola's more theoretical work, *The Experimental Novel*, which also appeared that year, and he mentioned only in passing his friend's recent series of articles on the Impressionists.

At the urging of Monet and Renoir, Cézanne had requested from Zola 'a few words' in print with the aim of 'showing the importance of the Impressionists and the real interest

they aroused', and the artist must have been surprised by Zola's stinging criticism of the movement that appeared in the periodical *Voltaire* in June 1880. Although he had shared with Monet, Renoir and their circle in the movement's exhilarating early days a bold commitment to naturalism and a spirit of daring independence, by 1880 Zola's work had begun to focus on the plight of the working classes in the Third Republic and to be shaped by his own professed 'scientific' method of writing, based on detailed, factual descriptions and a journalistic style. And he was clearly dismayed that the Impressionists, for all of their early promise, had not followed suit. In Zola's eyes, their more recent art lacked not only its earlier polemical edge but also a clearly defined basis in science. And they did not have an acknowledged leader. 'The man of genius has not arisen,' he wrote, 'this is why the struggle of the Impressionists has not reached a goal; they remain inferior to what they undertake, they stammer without being able to find words.' Cézanne's *Château at Médan* (123), a studiously constructed painting that is also notable for its large number of preparatory studies, seems designed, as Richard Verdi and others have suggested, to confound Zola's view.

As befitting his new critical and financial status, in 1878 Zola had purchased a house at Médan on the Seine only a short distance from Paris. Cézanne visited him there in the autumn of 1879 and the following summer returned to paint views of Médan from a small island opposite Zola's house. In many of these, including *Château at Médan*, he uses the intervening space of the river with magical precision, at once distancing the viewer and radiating a subtle order imposed by its reflections, out of which rise a resolute grid of horizontal bands and the spaced verticals of trees. Reff has described Cézanne's constructive stroke here as 'one of the purest examples of this technique', and the painting's uniform surface of parallel touches reinforces its rigid geometry. Some of this effect is captured in the exquisite

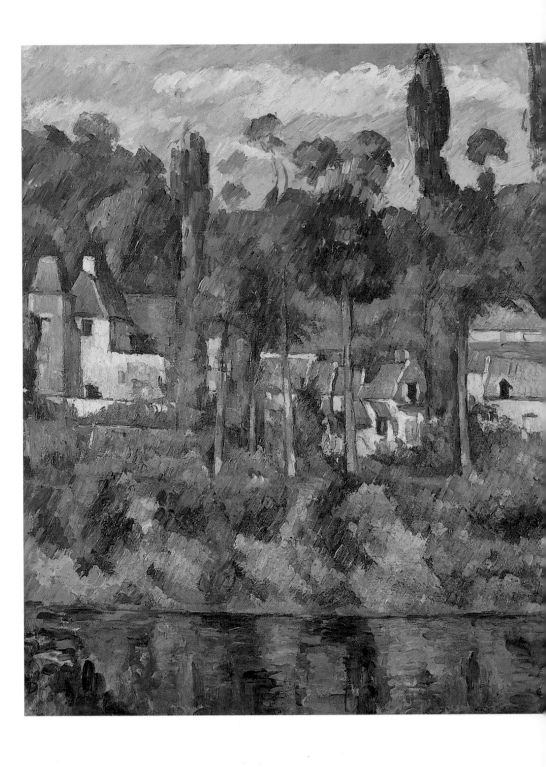

123
*Château
at Médan,*
1880.
Oil on canvas;
59 × 72 cm,
23³⁄₈ × 28³⁄₈ in.
Glasgow
Museums,
Burrell
Collection

124
*Château
at Médan,*
1879–80.
Pencil, water-
colour and
gouache on
paper;
31·3 × 47·2 cm,
12³⁄₈ × 18⁵⁄₈ in.
Kunsthaus,
Zurich

watercolour study (124), where translucent colour is applied in vibrant, angled strokes over an earlier, architectonic pencil sketch. Yet, executed from a slightly different position than the final oil painting, this viewpoint lacks the framed, central motif perfected in some of the preparatory drawings and, likewise, the balancing masses of architecture on either side that render the final version one of Cézanne's most masterful and serene landscapes from his middle period.

In this canvas, Cézanne's cohesive pictorial logic extends even to his constructive stroke and presages the disciplined brushwork that will also shape Georges Seurat's first

monumental paintings, such as *Bathers at Asnières* of 1884 (125). Unlike Monet, Cézanne seems to have had relatively little contact with Seurat's works and, having largely removed himself from the milieu of the Impressionist exhibitions, is not known to have felt challenged by the latter's example or later prominence. Neither did Cézanne's lifelong devotion to realizing on canvas his unique sensations in nature allow him to share Seurat's belief that the emerging scientific theories about colour, line and geometry

could become tools in the conception of modern art. Yet the two artists' attempts to replace the fleeting, broken touches of the Impressionists with techniques of a still recognizable but visible new harmony, as well as their shared interest in creating a monumental new art that revitalized the subjects of modernity or observed nature with forms of an ideal order, situate their painting on evocatively parallel paths.

Thus, in his *Château at Médan*, anticipating the range of brushwork in Seurat's Asnières canvas, Cézanne's horizontal strokes denote the water below, diagonal strokes represent the shoreline and the sky above, and vertical touches of paint make up the buildings depicted at the viewer's eye-level. All of Cézanne's works known to date from that summer in Médan relate to this culminating painting, and it is little wonder that he forewarned Zola of the time his project could take. Indeed, Cézanne's *Château at Médan* looks every inch a product of the long, solid work and careful 'scientific' analysis that Zola found so lacking in Impressionism (and that Seurat would become known for), and if the critic failed to note the painting's massive implications, Cézanne's friends did not. Gauguin bought the work soon afterwards and kept it for as long as his shaky finances allowed. Even near death, he remembered Médan's 'sparkling countrysides of deep ultramarine, heavy greens, shimmering ochres' and trees that were aligned and interlaced to 'orchestrate [Cézanne's] simple poem'.

After his productive stay with Zola at Médan, Cézanne returned with his family to Paris; by May of 1881 they had settled again in Pontoise, near Pissarro, and would remain there until sometime in the autumn. In Pontoise, Pissarro's circle of rural Impressionists was growing. Now it was Gauguin's turn to paint at the feet of the master. In 1883, he even moved into Pissarro's home in the nearby village of Osny and continued to emulate the older painter's style and choice of rustic subjects, many of which he would later

125
Georges
Seurat,
*Bathers at
Asnières,*
1884.
201 × 300 cm,
79¹⁸ × 118¹⁴ in.
National
Gallery,
London

rediscover in Brittany. Cézanne, too, still sometimes painted at the side of his mentor, but his landscapes from this period – of Pontoise, Auvers-sur-Oise and their environs – underscore his now completely divergent style and artistic strategies. Thus, in many of these he attempts to wrest from the serene rural countryside more dramatic viewpoints and more imposing formal motifs than he had explored during his earlier stays. For example, a sweeping panoramic landscape from this period, usually entitled *The Oise Valley* (126), employs both traditional framing trees and a patterned screen of foreground foliage to structure our view of the distant horizon. Its harmonious composition and rich, painterly surface of short vertical strokes made it a prized possession of the painter Paul Signac (1863–1935), a disciple of Georges Seurat. It would ultimately figure in Signac's famous theoretical treatise, *D'Eugène Delacroix au néo-impressionnisme* (1899), as evidence of how Cézanne's constructive technique 'comes closest to the methodical division' of Seurat's style and that of his circle.

Though deceptively simple to the eye, Cézanne's constructive-stroke paintings were treasured by his fellow painters above all; perhaps only they were equipped to realize the extent to which these works transformed the spontaneous broken brushwork employed by many of the Impressionists into one of an enduring and disciplined pictorial logic. Even the perennial Impressionist, Monet, would come to own one: *The Turn in the Road* (127) of *c.*1881, probably also painted in the region around Pontoise. It is an unusual painting in this cohesive body of work in that it is built around an arcing, decorative curve: the teasing motif of a winding road that Cézanne so often favoured in his views of rural hamlets again flattens out here and even disappears as it stretches strangely upwards on his surface. But this motif also offsets and unifies the geometry of the seemingly abandoned village, its blank walls, taut vertical trees and even the over-all system of the painter's ordered, parallel touches, some

rather thinly applied. When Monet acquired it in 1894, he was immersed in decorative concerns of his own – several of his series paintings of trees likewise exploit an elaborate curve as an abstract formal device. While in no way deriving from Cézanne's inventive *Turn in the Road*, this common preoccupation must have made it appealing enough to hang at Giverny with his other paintings by Cézanne.

126
The Oise Valley, c.1880. Oil on canvas; 72 × 91 cm, 28³⁄₈ × 35⁷⁄₈ in. Private collection

By October 1881, Hortense and their son Paul had returned to Paris, and Cézanne had headed south to Provence, where he would paint almost continuously for the next few years. His work of the early 1880s would establish him in the eyes of his friends and contemporary critics as the primary modern painter of the Provençal landscape. The artist's constructive technique became even more defined and comprehensive in the familiar bright sunlight and rugged environs of Aix and L'Estaque. But even though he was away from Paris and the Impressionists, Cézanne still had

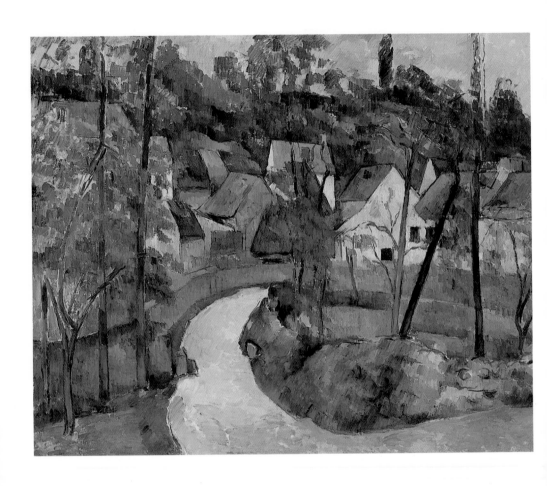

127
*The Turn in
the Road,*
c.1881.
Oil on canvas;
60 × 73 cm,
23⅜ × 28¼ in.
Museum of
Fine Arts,
Boston

to contend with a wealth of widely held preconceptions about landscape painting in general and the Provençal *plein-air* subject matter he would make his own.

The distinctive terrain of Provence had long been associated with the classical world because of its well-known ancient history and position on the shores of the Mediterranean, and as we have seen in Cézanne's *Bathers at Rest* (99), its topography could be linked even in his art to a mythical sphere. This correlation was also often spelled out, in different ways, in nineteenth-century academic landscape painting. The late Neoclassical landscape *Souvenir of Provence* (128) by Paul Flandrin (1811–1902), for example, presents a timeless, arcadian vista inhabited by pastoral figures in classical draperies and with only the vaguest indication of what the regional coastline of Provence actually looked like. Everything about this painting, in fact, declares its poetic artifice and academic form: the luminous, far-off horizon and the gently receding perspective into space, its complex and sweeping foreground, which allows the viewer entry, the elaborate, silver-tipped foliage, its polished surface, even the *souvenir* of the painting's title. One of the few landscapes to be bought by the state in the mid-1870s, its historic associations and studiously academic composition made Flandrin's painting an example of the kind of heroic motif and ennobled art that conservatives hoped to revive.

In his view of *L'Estaque* (129), *c*.1882–3, which strangely resembles the earlier landscape by Flandrin, Cézanne approaches the classical view of the Mediterranean in Provence in a manner that almost inverts academic form. The unique topography and brilliant light of the village had inspired some of his most forceful landscape paintings, and here his motif is both grounded in visual reality and wilfully structured by the painter to suggest the new grandeur and ordered monumentality common to his greatest paintings

128
Paul
Flandrin,
Souvenir
of Provence,
1874.
Oil on canvas;
90 × 118 cm,
35$\frac{1}{2}$ × 46$\frac{1}{2}$ in.
Musée des
Beaux-Arts,
Dijon

129
L'Estaque,
c.1882–3.
Oil on canvas;
80 × 99·3 cm,
31$\frac{1}{2}$ × 39$\frac{1}{8}$ in.
Museum of
Modern Art,
New York

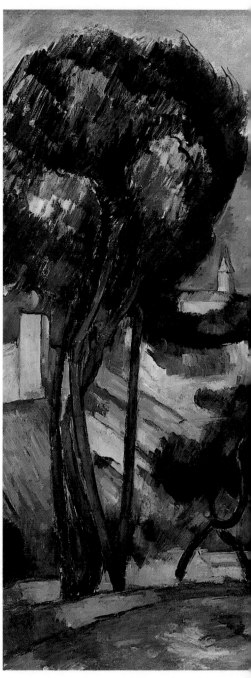

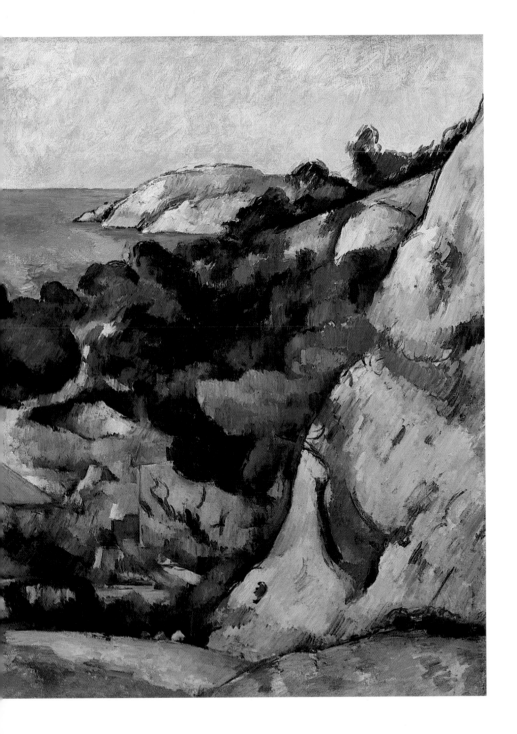

of the decade. From a vantage point high above L'Estaque, Cézanne constructs a dense series of flattened, receding planes to describe the steep angles of his plunging perspective at centre and also of the rising ground at right, and his angled parallel brushstrokes reinforce their brazen opposition. The unstable, inverted central pyramid – formed by the white cliffs and at left by the pines and rooftops – further challenges the easy, artificial grace and flowing space of landscapes by the artist's academic counterparts. And yet, taken as a whole, Cézanne's painting is rigorously organized and unified, offering a glimpse of the unshakeable order and equilibrium which he would perfect in his definitive paintings of L'Estaque from the mid-1880s. Monet would acquire this work too in the 1890s.

Cézanne's Provençal landscapes of the early 1880s must also be considered in relation to another, more contemporary tradition. Scholars have often linked the evolution of French landscape painting, and especially that of the Impressionists, to the arrival of the French railway, which facilitated the growth of leisure and tourism in the latter part of the century. Much like the sunny seaside views of Normandy captured in the early work of Monet, or the rustic Brittany we know from Gauguin's paintings, Provence's unique landscape in its real, unidealized form was also well known by this date. In fact, as early as the 1860s, Provence, like Normandy and the Côte d'Azur, had become a haven for affluent northerners, especially in the winter; its warmth and remote beauty attracted countless artists as well as tourists who sought there a kind of refuge in nature from modern urban life. Indications that its scenery had become something of a pictorial cliché included the large number of Provençal landscapes on view at the Salon of 1865, and the complaint of a critic there that painters always chose the best-known motifs. In many instances this was a marketing strategy: the paintings were designed for an urban, and usually Parisian, audience, and therefore were

bound to dwell on the most recognizable Provençal subjects. As the art historian John House has commented, it was through the contrasting urban culture and audience that these images of rustic nature found their meanings and their market. By comparison, Cézanne's attachment to the landscape of the south was far more intimate than that of a tourist or travelling painter, and his stake in its imagery quite different. Although he continued to attempt success at the Salon, his relative financial security (thanks to the modest but perpetual allowance from his father) and bold ambition to embrace the great painting of the past, meant that he neither wanted nor needed to gear his painting specifically to the demands of the new bourgeois market. This, too, would serve to distance his landscape painting from later Impressionist art. And by the 1880s, the period of his most serenely harmonious landscapes, Cézanne's paintings reflect, in their increasing nobility and grandeur, the concurrent regionalist movement in Provence.

In the 1860s, as we have seen, Provence became the site of one of the strongest political and cultural provincial revivals in France under the leadership of the poet Frédéric Mistral and the local regionalist movement, the Félibrige. By this time, a recognizable school of Provençal landscape painters was already well established. The Marseille artist Émile Loubon (1809–63) and his local followers were known by the bold facture (or visible surface texture), radiant palettes and often panoramic viewpoints that they used to describe Provence's spectacular, sunlit topography. And when one of their group, Paul Guigou (1834–71), made his debut at the Paris Salon in 1863 with his large canvas *The Hills of Allauch, near Marseille* (130), Théodore Duret recognized the hand of a native painter: 'He had painted his land like a man who has entered right into it ... who seized its soul.'

Something of the same verve and gripping formal intensity of Guigou's work distinguishes Cézanne's landscapes of

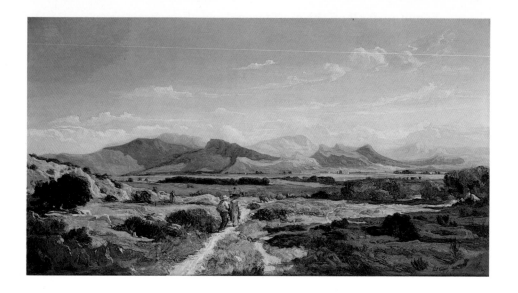

Provence from this period, several of which embrace radically new motifs and approaches to his subjects. In his *Rocks at L'Estaque* of c.1882–3, for example, a close-up view of the massive bluffs above the village cast in twilight shadow, Cézanne's now heavy, constructive brushstroke both stabilizes the sloping hillside and tangibly paraphrases the motif's gouged and fissured texture. Equally compelling in both its subject and handling is his *Houses in Provence* (131) of c.1879–82. Its saturated palette and tight system of vertical paint-strokes place the work solidly within Cézanne's constructive-stroke period, perhaps, some have argued, dating from his previous stay in Provence. Yet, strangely, the houses at centre escape this rigorously worked handling; their shadowed, sharply angled corners, the multiple vanishing-points of their rooflines and the reduced scale of their windows and doors emphasize instead their insistent and complex geometric volume within the landscape.

Interestingly, the subject has been identified from a nineteenth-century popular engraving. In Cézanne's day, it was widely celebrated as the ancient mountainside birthplace of Pierre Puget (1620–94), the renowned Provençal sculptor whose Baroque works were deeply admired and

130
Paul Guigou,
*The Hills of
Allauch, near
Marseille*,
1862.
Oil on canvas;
108 × 199 cm,
42½ × 78⅜ in.
Musée des
Beaux-Arts,
Marseille

often copied by Cézanne. When he visited the Puget gallery
in the Louvre, Joachim Gasquet tells us, Cézanne was struck
by the sculptor's stirring, emotional pieces: 'Puget has
the mistral [the wind of Provence] in him,' he reportedly
said. 'That's what makes his marble move.' And yet in
Cézanne's painting, though the artist emphasizes the
concrete forms of the houses, there is otherwise little
sense of his motif's poignant, nostalgic value. Instead, it
provoked one of his most radical compositions and has
often been cited as a precursor to later abstract painting,
especially Cubist landscapes.

In his subsequent landscapes from this extended sojourn in
the south, Cézanne formalized a group of distinctive motifs
that he would investigate at length and from a variety of
perspectives. In them, the familiar subject of Provence
becomes restorative, even, at times, magisterial. Thus, for
example, his paintings of the Gulf of Marseille of *c.*1885
(*eg* 132) offer a far more expansive and harmoniously
resolved view than the one he laboured to construct, for
example, in his earlier *L'Estaque* (see 129). Though still
built around the immense contrasts that had long drawn
him to Provence – the brilliant reds, oranges and greens of
buildings and the landscape that oppose the rich violet-
blues of the sea and mountains, or the powerfully modelled,
volumetric forms and patterned order of the foreground
opposing the undulating, natural line of the distant horizon
and the flat expanse of sea – all parts are bound together
by the painter's even, and now delicately nuanced, touch.
A series of visual correspondences renders the painting's
harmony even more intrinsic: for instance, the vertical
chimneys that pace our vision as we move from side to
side, and the angled puff of bluish-white smoke in the
foreground that finds its echo in the distant diagonal
pier. In these views from L'Estaque of *c.*1885, Cézanne was
not only perfecting his approach to landscape, but also
celebrating his vision of Provence.

One resolving image seems to express much of Cézanne's achievement. Though Mont Sainte-Victoire had figured in some of his early paintings (**eg 53**), Cézanne seems to have almost rediscovered it during this definitive stay in Provence as both a motif in nature and an evocative ancient landscape subject. An indication of its growing importance, perhaps even of his attachment to it as an icon of Provence, is that he studied it in rare preparatory drawings and from various perspectives before tackling it on a larger scale on canvas.

In his small, spare watercolour, now in Vienna, of a *Pine Tree in the Arc Valley* of c.1883–5, for example, we glimpse the kind of motifs that lent themselves so well to Cézanne's stated purpose 'to re-do Poussin over again according to nature'. The horizontal line of the viaduct, made up of regularly spaced arches, cuts the painting neatly in half and is balanced by the elegant pine tree at left. That relationship is reversed in his related painting *Mont Sainte-Victoire Seen from Bellevue* of c.1882–5 (133), a massive, panoramic view of the Arc river valley with its simple farm buildings and patterned fields marking the path to the familiar, mountainous landmark. Here it is the central tree that divides the painting into two vertical halves, but also pulls it powerfully together: on the canvas's densely worked surface the tree's lower branches merge with the texture of the distant background to draw it near, into one cohesive whole. Within this serenely ordered composition, Cézanne gives equal play to the ancient motifs and distinctive natural forms that made his Provençal subjects so compelling. Even the railway, so long a hallmark of modernity in the contemporary Impressionist landscape, takes on in this work the cloak of the past. As the art historian Joseph Rishel has observed, 'It is perhaps not surprising, given the sense of permanence and certitude Cézanne found in this vista, that many of its features assume the weight of its history: the train trestle transforming into an ancient aqueduct, the straight cut of the railway, a Roman road.'

131
Houses in Provence - The Riaux Valley near L'Estaque, c.1879–82. Oil on canvas; 64·7 × 81·2 cm, 25½ × 32 in. National Gallery of Art, Washington, DC

132
The Gulf of Marseille Seen from L'Estaque, c.1885. Oil on canvas; 80·2 × 100·6 cm, 31⅜ × 39⅜ in. The Art Institute of Chicago

133
Mont Sainte-
Victoire Seen
from Bellevue,
*c.*1882–5.
Oil on canvas;
65·5 × 81·7 cm,
25³⁴ × 32¹⁄ in.
Metropolitan
Museum of Art,
New York

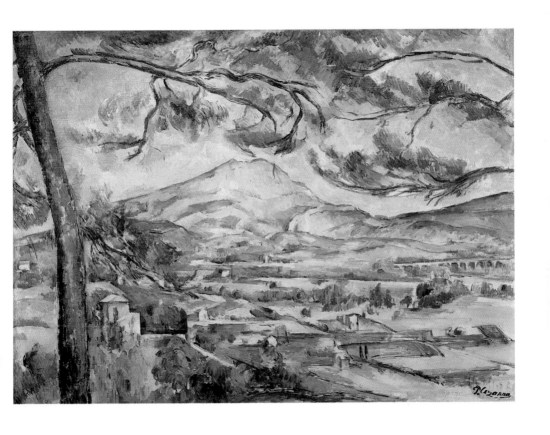

134
Mont Sainte-Victoire with Large Pine,
*c.*1885–7.
Oil on canvas;
59·7 × 72·5 cm,
23¹₂ × 28¹₂ in.
Courtauld
Institute
Gallery, London

Cézanne's slightly later *Mont Sainte-Victoire with Large Pine* (134) may be calling forth a different past. The single, graceful pine that aligns itself with the leftmost edge and echoes the far-off contour of the mountain, recalls a youthful letter to Zola: 'Do you remember the pine tree which, planted on the bank of the Arc, bowed its shaggy head above the steep slope extending at its feet? ... May the gods preserve it.' His ardent feelings for his native countryside were transmuted by the older artist into such tranquilly ordered views that rise above the restless drama of the valley floor.

Thus, even in this decade of such studiously harmonious compositions, the question of classicism in Cézanne's landscape painting remains a complex one because he never simply surrendered his motifs to a formula from the tradition of classical landscapes. In his letters, conversations and most of all in paintings that intimately explore what he called his *sensations* in the landscape, he remained true to the nature before him. But the landscape he encountered in Provence was laden in his eyes, both physically and spiritually, with a salient classical sensibility that gave it a unique place in his art. This fruitful balance is one that he seems fully to discover in his momentous paintings of Provence from the early and mid-1880s, years in which the region itself was swept by a rekindling of Provençal nationalism. While many of his first biographers, painters such as Émile Bernard or Maurice Denis (1870–1943), would strive to cast him simply as the new Poussin, their efforts would be more a reflection of their own struggle to shake off the continuing legacy of Impressionism than a true assessment of Cézanne's proud and enduring vision of his native Provence.

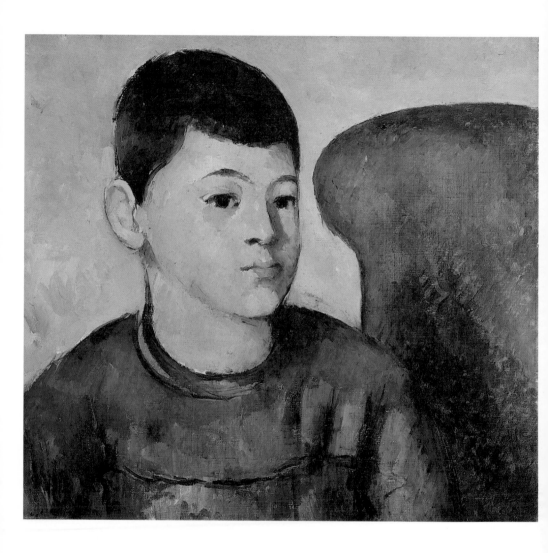

The imposing motifs and tranquil harmony of Cezanne's
magisterial views of Provence from *c.*1885–7, such as *Mont
Sainte-Victoire with Large Pine* (see 134), mask the bitter
conflicts that marked his private life during these same
difficult years. Though he had often found in painting
an idyllic refuge from adversity, at no other period did
it offer him greater sanctuary from the persistent doubts
and unstable emotional affairs that haunted him even in
middle age. And in Cézanne's landscapes, still lifes and
solitary portraits of his family and himself from the late
1880s, we find the artist struggling to consolidate the
discoveries of his most recent art, as if the serene order
and promise of his mature painting could supplant the
personal imbroglios he seemed incapable of escaping.

In the first few months of 1885, Cézanne was stricken with
an acute attack of neuralgia (a painful affliction of the
nervous system) and complained to Zola that for a while at
least he had enjoyed 'only moments of lucidity'. This was
followed by a brief, disastrous love affair in Aix, about
which little is known beyond a tortured love letter Cézanne
composed on the back of a drawing. And from a series of
anxious letters he wrote to Zola that summer, we can sense
the artist's fragility and track his restless wanderings in the
north: to La Roche-Guyon (not far from Paris), where he
briefly visited Renoir, to Villennes and Vernon, near Médan,
where he stayed after trying, unsuccessfully, to finagle an
invitation to visit Zola, and finally, by August, back to Aix,
where he again took up painting the surrounding landscape,
including the new motif of the nearby village of Gardanne.
Beyond his work, however, Cézanne's life in Provence now
was interrupted only, as he confessed to Zola, by visits to

135
*Portrait of Paul
Cézanne, the
Artist's Son,*
c.1883–5.
Oil on canvas;
34 × 37.5 cm,
13³⁄₈ × 14³⁄₄ in.
Musée de
l'Orangerie,
Paris

'the brothel in town, or something like that, but nothing more'. The artist's growing resignation to the fact that he might never enjoy a mature, loving relationship may have led him finally to cave in to his family's wishes to legitimize his union with Hortense. On 28 April 1886, just six months before his father died (on 23 October) and almost seventeen years after they first met, the two were married in Aix.

It was also in April of 1886 that Cézanne received from Zola a copy of the author's most recent novel, *L'Oeuvre*. Taking the bustling and competitive art world of Paris as his subject, Zola carried on in fiction his critical battle with what he perceived as the disappointing legacy of the Impressionists. Thus, the fictional writer and critic Pierre Sandoz grouses at one point about the new painting: 'Isn't it irritating [that] this new notation of light, this passion for truth pushed to [the level of] scientific analysis ... is leading nowhere, because the right man isn't born?'

Perhaps because he knew the Impressionists more intimately than any of his contemporaries and had once championed their cause, Zola's indictment left them feeling particularly betrayed. Monet would write to the author after receiving a copy of *L'Oeuvre*:

I have always had great pleasure in reading your books. This one interested me doubly because it raises questions of art for which we have been fighting for such a long time ... [But] I am afraid that in the moment of our succeeding, our enemies may make use of your book to deal us a knockout blow.

Renoir too would complain and even Antoine Guillemet, one of Zola's most ardent admirers, admonished Zola about his 'very depressing book' and wrote, 'Let us hope, by God, that the little gang, as Madame Zola calls it, does not try to recognize themselves in your uninteresting heroes, for they are evil into the bargain.' For Cézanne, as Guillemet feared, the publication of *L'Oeuvre* would be even more painful.

The novel's tragic hero, Claude Lantier, was a mad but brilliant painter whose character had a number of sources: Balzac's tormented artist Frenhofer in *The Unknown Masterpiece*; in some respects both Monet and Manet; and (as later readers came to recognize) Cézanne. Lantier's youth in a small, provincial town, and friendship with Sandoz, closely mirrored the childhood years that Cézanne had shared with Zola in Aix, while the fictional painter's fear of physical contact and of women, his stormy relationship with his mistress, the model Christine, and impassioned first paintings stole equally from Cézanne's early history. But Zola's portrait of Lantier was particularly unforgiving. Determined at first to reconcile in his painting the purely visual and (vaguely) scientific ('things and beings as they behave in real light'), Lantier gradually loses his way. Abstract theories of colour replace his earlier focus on nature, he becomes obsessed with his painting of a mystical (and fatal) woman and dreams of realizing all his goals in a single monumental canvas. The painter's descent into madness and despair ends when he commits suicide in front of his failed masterpiece.

Though Zola's story ends on a highly melodramatic note, its deluded hero's obvious links to Cézanne were immediately apparent to the painter himself, and the novel's publication brought the two men's lifelong friendship to a bitter end. After reading the book, the artist sent Zola a brusque note of thanks and the two never communicated again. Even as late as 1896, when Cézanne was finally enjoying a measure of critical success and Zola was basking in glory following his heroic role in the controversial Dreyfus case, the critic took time to pronounce him a failed genius and to disparage the Impressionists as a whole.

Several scholars have viewed Cézanne's paintings from these years – dense and solidly constructed architectural motifs in the landscape and thus works which stand apart from the

bulk of his painting of the mid-1880s – in the light of his troubled personal history. We know that he lived and painted in Gardanne, not far from Aix, from the autumn of 1885 until the following summer and can thus ascribe his related views of the region to this period with some certainty.

Gardanne was a picturesque hilltop village, not unlike that which Cézanne had imagined a decade before as the backdrop for his idealized landscape, *Harvest* (see 73). Its roughly pyramidal form, which was covered at the base by a cluster of yellow 'cubes' of houses with bright red roofs and topped by a tall, squarish bell tower, was explored by the artist from a variety of viewpoints. In the version illustrated (136), the most deliberate and finished of the group, Cézanne exploits this mass of interlocking, box-like forms to solidify and anchor his new architectural motif. From a vantage point just outside the town walls that allows this broad, panoramic view, his subject rises in an ordered, step-like fashion to the crowning, central tower, its ascent evenly paced by the succinct geometry of the motif's forms and the painter's thin, uniform strokes.

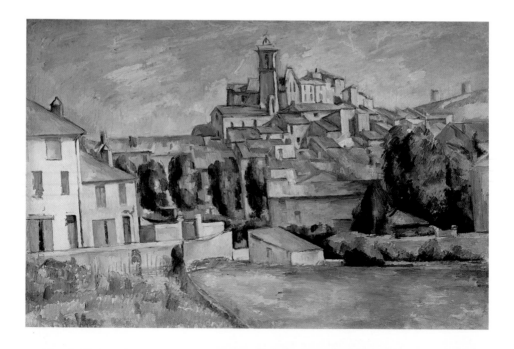

Perhaps, some have surmised, this new and distinctive body of work and its unusual focus on compact and densely formed architectural motifs (that anticipate later Cubist landscapes) can be viewed as having offered the artist a chance to sublimate his own compelling doubts in a period of unrelenting chaos, or even an opportunity to confront once more, as he had in his *Château at Médan* (see 123), the critical condemnation to which Zola had subjected him – so publicly – in *L'Oeuvre*. While such suggestions can never truly rise above the level of speculation, the artist himself made constant references during this period to the refuge offered by his landscape painting in Provence. After complaining of his neuralgia in one of his last letters to Zola, Cézanne went on to write that now 'my head has eased and I go for walks on the hills where I view many a beautiful panorama'. Likewise, after alluding to his recent string of disappointments in a letter to Chocquet of May 1886 ('I had a few vineyards, but unexpected frosts came and cut the thread of hope'), he assured his patron that his landscape painting would serve to sustain him:

I have nothing to complain about. Always the sky, the boundless things of nature, attract me and give me the chance to look with pleasure ... I must tell you that I am still occupied with my painting and that there are treasures to be taken away from this country, which has not yet found an interpreter equal to the abundance of riches which it displays.

In Gardanne, Cézanne was joined by Hortense and their son Paul, who attended school that year in the village. Despite his increasingly remote relationship with Hortense, his wife and son also seem to have provided some degree of solace during this difficult period, as well as serving as subjects for his painting. Cézanne's quickly sketched images of Paul as a child, which offer a rare window into the more compassionate side of the artist's character, had long reflected his pride and deep affection as a father. But by the mid-1880s,

136
Gardanne,
c.1885.
Oil on canvas;
63 × 99 cm,
25 × 39 in.
Barnes
Foundation,
Merion,
Pennsylvania

the artist's son was in his teens, old enough to take on the torturous task of sitting as a subject for his father, and the results could be more finished. It may well have been during the months they shared together in Gardanne that the artist painted his exquisite and highly sensitive *Portrait of Paul Cézanne, the Artist's Son* (135). The largest and most complete of Cézanne's early paintings of his only child, this canvas shares with some of the Gardanne landscapes a thin, and at times almost transparent, layer of paint, a muted background palette and a unifying, formal language of reciprocal, but now curving, shapes.

Cézanne's discovery of an inner, generative rhythm within a motif may well have evolved in the course of his drawings, both from life and from his studies of the Old Masters in the Louvre, and a momentary glance at their role in his work of the 1880s informs our discussion of the brilliant synthesis his painting of this period holds. For some time now, the artist had found the exuberant curvilinear contours in Baroque paintings and sculptures nearly irresistible, and on his visits to Paris he spent many hours sketching in the Louvre's seventeenth-century galleries. He returned again and again, for instance, to draw the coiling, spiral forms of Puget's emotional *Hercules* or Rubens's anguished figure of Bellona from his *Apotheosis of Henri IV*.

An endlessly compelling canvas for him from the famous *Marie de' Medici* cycle, Cézanne had first turned to Rubens's work (see 25), as we have seen, in the mid-1860s to copy – rather prosaically – the heroic figure of the ascending monarch at left (see 26). But by the late 1870s or early 1880s, when the sensual thrust of his own painting had diminished, Cézanne's eyes drifted across the canvas to Rubens's expressive and powerful figure of the war goddess Bellona. And in the ten copies we know of after this archetypal nude, we can track Cézanne's evolving fascination with its rhythmic grace: thus, while Bellona's wrenching,

137
Bellona (after Rubens), c.1879–82. Graphite on paper; 48 × 30 cm, 18⅞ × 11¾ in. Private collection

138
Bellona (after Rubens), c.1896–9. Graphite on paper; 20·9 × 12·2 cm, 8¼ × 4¾ in. Öffentliche Kunstsammlung, Kupferstichkabinett, Basel

muscular pose is beautifully captured in his finite drawing of *c.*1879–82 (137), his later drawings trace and retrace the fluid line of her contour and discover within it a vibrant animation (138).

The lessons of the Baroque masters gradually filtered into Cézanne's own drawings and paintings from life during these years, though usually without the emotional drama that attended his studies in the Louvre. Thus, in a spare and elegant still-life drawing of *c.*1881–4 (139), perhaps a souvenir of the domestic life he sometimes led with his family, Cézanne sketches the household objects in front of him not whole, but in terms of the broad, elliptical contours they share across a boldly recessed surface. In a later drawing, *Still Life: 'Pain sans mie'* (140), *c.*1887–90, a more elaborate

composition of tabletop objects is also generated by an elliptical shape, found in the trademark label (and emphasized by the curve of its proto-Cubist typography) at right: the flattened edge of the bowl, the slightly distended shape of the carafe and the tilted top edge of the pitcher all pointedly echo its sweeping curve. In both drawings, a connective array of broad and richly retraced ellipses animates the artist's composition of ordinary, inanimate objects and ties together his fragmentary record of their mimetic contours.

Even Cézanne's most complex works of the late 1880s, such as his masterful painting *The Kitchen Table* (141), *c.*1888–90, were the product of the same, insightful search for a generative, rhythmic matrix of reciprocal curves and configurations like that which had shaped his earlier painting of his son. In this incredibly ambitious still life, the chaos of an overcrowded table (one that scarcely supports the large, fruit-laden basket), of discontinuous surfaces and of competing perspectives somehow coheres into an ordered whole by means of the repetitive rhythm of curves at centre in the fruit, jars and pitcher, and the verticals aligned all around that provide a frame. Even its deep but disruptively unreadable space is bridged where these two systems converge: the curved handle of the straw basket delicately touches the point where the distant back

139
Still Life with Carafe,
*c.*1881–4.
Graphite on paper;
19·9 × 12 cm,
7³⁄₄ × 4³⁄₄ in.
Öffentliche Kunstsammlung, Kupferstichkabinett, Basel

140
Still Life: 'Pain sans mie',
*c.*1887–90.
Graphite on paper;
31·8 × 49·2 cm,
12¹⁄₂ × 19³⁄₈ in.
Private collection

141
The Kitchen Table,
*c.*1888–90.
Oil on canvas;
65 × 80 cm,
25⁵⁄₈ × 31¹⁄₂ in.
Musée d'Orsay, Paris

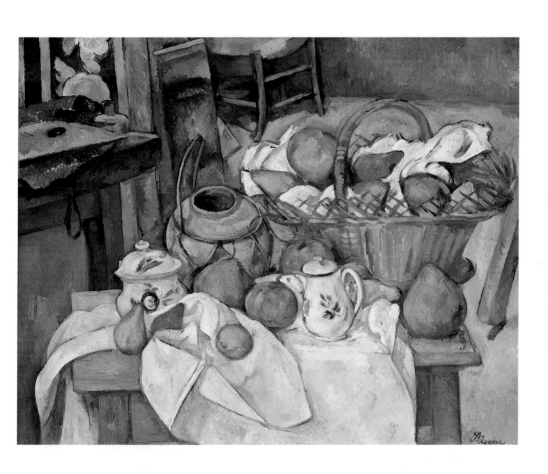

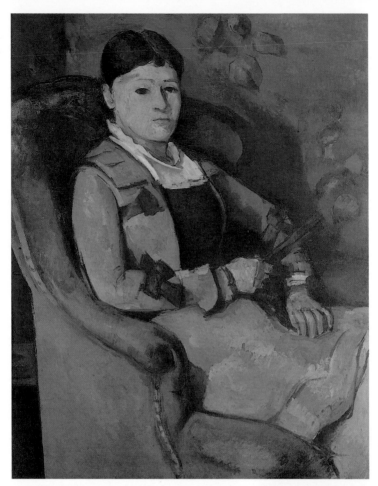

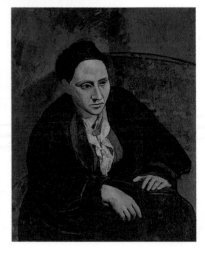

wall meets the incongruously ascendent floor. Not surprisingly, however, in the portrait of his son (see 135), the deeply recessed spaces of such tabletop arrangements have been collapsed to bring the image forward, in itself a sign of the artist's paternal attachment to his subject.

Although Hortense Fiquet was his most frequent, and surely most patient, portrait model, Cézanne's paintings of her rarely manifest the same level of personal engagement. As we have seen, his earlier *Madame Cézanne in a Red Armchair* (see 114) conveyed a sense of her quiet reserve that makes it truly exceptional. We know of at least twenty-four portraits of his wife that Cézanne executed in oil, and critics have long described the sightless eyes and mask-like miens that obscure, rather than reveal, her presence in many of them. Some have gone so far as to compare Hortense's role in Cézanne's art to that of the purely formal elements he painted in still lifes. But the painter's jarringly opaque portraits of his wife, fraught with paradox as they are, were in fact thoughtful constructions that challenged the very nature of portraiture in radically new ways, and thus became compelling models for later modern painters.

The artist's masterful *Portrait of Madame Cézanne in an Armchair* (142), begun by the artist in the late 1870s but only finished a decade later (and this may explain, in part, its aura of cool detachment), offers a case in point. Here, the motif's commanding formal elements supplant whatever more subjective aspects might once have existed in the portrait: the sharp edge of Hortense's jawline and of her right arm are echoed in the arm of the chair, the diagonal line of her fan is repeated in the folds of her skirt, the blue-grey tones and thin brushwork of her garment tie it to the patterned wall behind. Finally, the rosy-purplish tones of the chair offset the figure's wan face and the painting's otherwise solemn palette. Not only would its formal power make *Madame Cézanne in an Armchair* a compelling

142
Portrait of Madame Cézanne in an Armchair, begun 1878, reworked c.1886–8.
Oil on canvas; 92·5 × 73 cm, 36¼ × 28¾ in.
Foundation E G Bührle Collection, Zurich

143
Gertrude Stein (right) in her Paris apartment sitting beneath the portrait of Madame Cézanne, 1922.
Baltimore Museum of Art

144
Pablo Picasso, *Portrait of Gertrude Stein,* 1906.
Oil on canvas; 99·6 × 81·3 cm, 39¼ × 32 in.
Metropolitan Museum of Art, New York

model for Paul Gauguin, who was to produce a virtual copy of it and of a still life by Cézanne in his *Portrait of a Woman* of *c*.1890, but the painting's strangely reductive visage also had far-reaching consequences for early twentieth-century art. At one time owned by the famous American writer Gertrude Stein, the canvas hung for many years in her Paris apartment (143). It was well known to her circle, which included Picasso and, as many have surmised, helped to shape Picasso's radical and stubbornly mask-like portrait of Stein from 1906 (144).

145
Portrait of Madame Cézanne,
*c.*1886–7.
Oil on canvas;
46 × 38 cm,
18⅛ × 15 in.
Philadelphia Museum of Art

146
Portrait of Madame Cézanne,
*c.*1888.
Oil on canvas;
99 × 77 cm,
39 × 30¼ in.
Detroit Institute of Arts

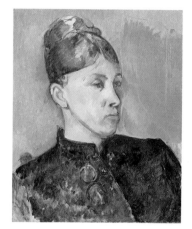

In another *Portrait of Madame Cézanne* (145) of *c*.1886–7, a painting once owned by Matisse, the rigid contours and blank, impenetrable face of the artist's wife offer little more than a stark canvas for a rich display of pigments. As with many of Cézanne's portraits of the 1880s, little of the artist's constructive-stroke technique survives here in the painting's thin, wet surface. Instead, lean, unmixed strokes of pink, blue, green and ochre afford the portrait a sense of delicacy, even of femininity, which the image itself denies,

unmasking, at the very least, what must have been some of the painting's fascination for the great colourist Matisse. Likewise, in a slightly later and larger portrait (146) of *c*.1888, Hortense is frozen in an unflattering, icon-like pose at the exact centre of Cézanne's composition, her rigid bearing, flattened form, tightly clasped hands and tense, unreadable face offering a tantalizing analogy to Van Gogh's hieratic portraits of the paint-dealer Père Tanguy, from the same years. Such works would later help to shape the consciously archaic portraits of Amedeo Modigliani (1884–1920). Yet Cézanne's painting is also marked by a palette of remarkably inventive range, a patterned background and an animated, Impressionist surface of thinly applied strokes which indicate a sense of immediacy and of a tangible (or material) sensuality that the image itself sternly forbids.

As we will see in his likenesses of the inhabitants of Aix and of his patrons from the 1890s, portraiture remained an essential genre for Cézanne because it allowed him to approach the human – and here even the familiar, female – subject without having to navigate what remained for the artist the treacherous terrain of human sexuality. However remote his housekeeping arrangement with Hortense (and it was always unconventional), these two critical paths had to merge in some form in his images of her. And, in fact, nowhere else in his portraiture does Cézanne struggle with such apparent effort to distance himself from his subject – even as he paints it – as he does in such images of his wife. This visible fact has led some scholars to describe the artist's sense of deliberate, painterly touch in these works – the rich, sensuously handled surfaces that seem so foreign to the uncompromising pictorial forms they support – in terms of the painter's own, sublimated sensuality.

Yet not all of the artist's paintings of Madame Cézanne manifest this difficult, distancing tendency; at times, in fact, Hortense seems to have provided Cézanne with far more

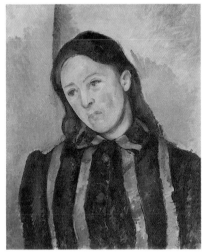

147
*Madame
Cézanne with
Hortensias,*
c.1885.
Graphite and
watercolour on
paper;
30·5 × 46 cm,
12 × 18⅛ in.
Private
collection

148
*Portrait of
Madame
Cézanne with
Loosened Hair,*
c.1890.
Oil on canvas;
62 × 51 cm,
24⅜ × 20⅛ in.
Philadelphia
Museum of Art

than a schematic visual premise or a compelling surface for a displaced, sensualized touch. And though they are few in number and have been little studied, his highly sensitive and sometimes overtly idealized portraits of Hortense must also be considered within a broader context. For example, in a delicate watercolour of *c.*1885, *Madame Cézanne with Hortensias* (147), the artist tellingly juxtaposed an exquisite portrait drawing of her – just awakened and in bed – with a blooming branch of hydrangeas, the flower from whose French form, Hortensia, her own name derived. The perfect oval contour of her face and the heavy-lidded eyes, which focus here and gaze outward, are echoed in the leaves of the bouquet at left, lightly washed with watercolour. Like punning visual and verbal pendants, the page as a whole suggests a degree of sentiment and sympathy for the subject that is matched only in Cézanne's paintings of his son.

Although some critics have seen such expressive delicacy only in his drawings of Hortense and attributed it to the more ephemeral characteristic effects of the medium, Cézanne's approach and painterly touch could be equally ethereal in his oil paintings of his wife, as evident in the later *Portrait of Madame Cézanne with Loosened Hair* (148), *c.*1890. Here, Hortense's gentle features and the expressive tilt of her head likewise intimate fragility and a mood of melancholy. Even the subject's flowing hair and the soft, feminine curves conveyed in her striped bodice separate it from many of Cézanne's other portraits of his wife (*eg* 146), in which Hortense's figure is more often flattened or forcefully contained by a rigid composition and/or by the weight of the painter's brushstrokes. In contrast, here, Cézanne's animated, fluid surface finds a match in his graceful, responsive image.

Finally, idealized attributes and sparse but dynamic brushwork define Cézanne's large and austerely beautiful *Madame Cézanne in the Conservatory* (149). The portrait

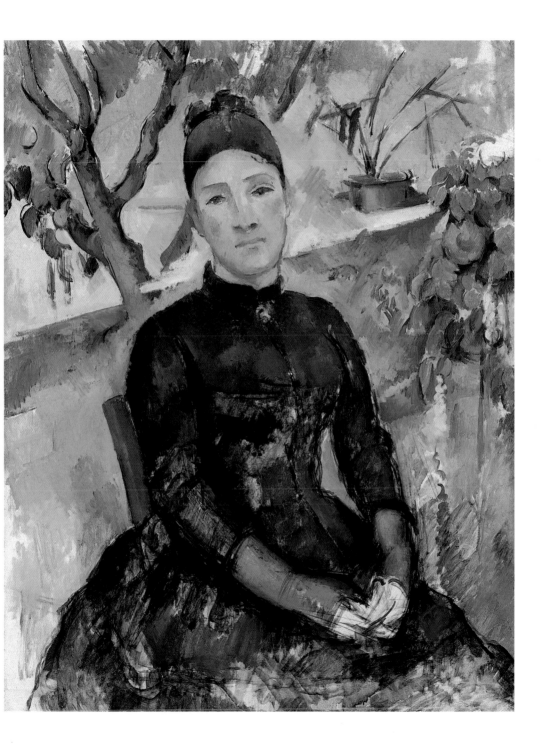

is usually dated to *c.*1891–2, a period Hortense spent living in an apartment in Aix with their son. Years later Paul remembered his mother posing for the work in the flower-filled greenhouse at the Jas de Bouffan, the family estate where Cézanne still lived apart from them and with his aged mother. One of the artist's final paintings of his wife, it seems to reconcile, both formally and thematically, much of what he had suggested in his earlier paintings of her.

Although it anticipates the more complex pictorial settings of many of his genre portraits of the 1890s, Cézanne's

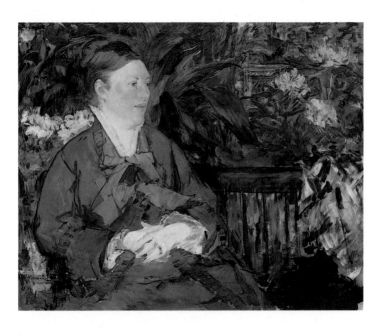

150
Édouard
Manet,
*Madame
Manet in the
Conservatory*,
1879.
Oil on canvas;
81·5 × 100 cm,
32¼ × 39⅜ in.
Nasjonal-
galleriet, Oslo

canvas also offers a subtle reworking of a familiar theme in portraiture in which a woman is depicted as a natural component of a flowering, protective environment. Several of the Impressionists had portrayed women in conservatories, a modern iron-and-glass amenity that had become the rage of Second Empire bourgeoisie and even figured as a key setting in Zola's *La Curée* of 1878. But it was Manet who most visibly updated the motif in 1879 in several well-known paintings of women in verdant Parisian greenhouses. His *Madame Manet in the Conservatory* (150) invites

comparison with Cézanne's later picture. In each, the subject's simple, dark costume, severe coiffure and primly correct pose serve as a foil to the decorative natural foliage that surrounds her. But the pastel palette of the flowers, which is echoed in the women's faces, softens them, alludes to their femininity and unifies the dual themes of the paintings.

In other ways, however, Manet's naturalistic likeness that reveals so much about the matronly, good-humoured Suzanne Manet throws into relief Cézanne's portrait of his wife: the angled, egg-shaped head, schematic and chiselled features, incised brows and the arc of hair that wraps her skull so tightly become, in Madame Cézanne's image, stylized features of an opaque mask that, though strangely beautiful, once more keeps the viewer – and the painter – at bay. Perhaps, then, it was not only by means of his deliberate painterly touch, the displaced emblem of the physical contact he so studiously avoided, but also in such boldly idealized constructions, that Cézanne cultivated a substitute for the imperfect reality he knew (the 'vineyards cut by frosts'), the fate to which, as his letters suggest, he had become resigned by this date.

In another of his paintings that presage the great contextual and genre portraits that were to follow, Cézanne depicted himself with a palette and posed in front of an easel (151). One of the most detached of his many dispassionate self-portraits, the painting has proven unusually difficult to date. On largely stylistic grounds, Rewald has placed it as late as *c.*1890: it shares with such portraits as *Madame Cézanne in the Conservatory* large areas of thinly applied colour and a tendency towards schematic form. Yet, it is difficult to reconcile this image of the engaged, resolute artist at work with the greying and withdrawn old man who peers out at the viewer in self-portraits from just a few years later (see 173). Many others, however, have suggested a somewhat

earlier chronology for the painting, which closely resembles self-portrait drawings of the artist commonly assigned to the mid-1880s. And the work's unmistakable resemblance to Van Gogh's *Self-Portrait in Front of an Easel* of 1888 (152) has led scholars to wonder if the Dutch artist could have seen Cézanne's canvas at Tanguy's shop in Paris before embarking on his own self-image. The humble paint dealer, a former Communard, had championed Cézanne for over a decade and by this time had assembled quite a cache of his paintings. Since no dealers as yet had taken on Cézanne's work, Tanguy's narrow little art-supply shop on the rue Clauzel enjoyed a certain celebrity among the young vanguard painters as the only place in Paris where one could see the work of the reclusive Aixois artist. Van Gogh, who regularly visited Tanguy but is not known to have met Cézanne, continued, nevertheless, to hold him in the highest regard (the sentiment was not reciprocated) and seems to have adopted both the format and the thematic approach of Cézanne's monumental self-portrait as an artist.

Like some of his earlier self-portraits, in which he depicted himself in a specific guise or role (such as a barbarous rebel in 1866, see 28), Cézanne's *Self-Portrait in Front of an Easel* must be seen as a poignantly personal construction. As Schapiro has pointed out, the work is composed in the flattened terms of the physical canvas itself, and these are expressive of the painter's condition: the body and head are square in shape and framed by the palette and easel, the vertical edge of the palette and sleeve meet and seem parallel to the frame, and even the reddish table at lower left has the rigorous geometry of a Cubist work. Cézanne's image beautifully conveys a sense of isolation or protective refuge that he finds in his art: his obscured gaze, the blank façade of his face, the unseen painting before him and the naïvely unforeshortened palette on his arm, which serves as a barricade to the outside world, shield him and his art from the critic or spectator.

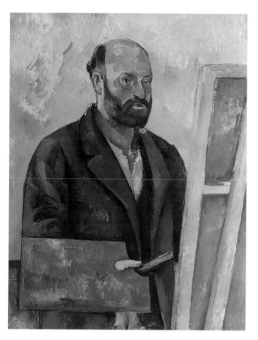 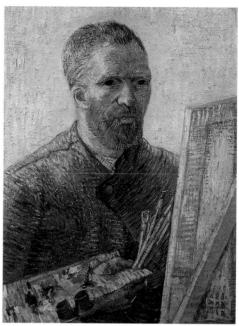

151
*Self-Portrait
in Front of
an Easel,*
c.1890.
Oil on canvas;
92 × 73 cm,
36¹⁄₄ × 28³⁄₄ in.
Foundation
E G Bürhle
Collection,
Zurich

152
**Vincent van
Gogh,**
*Self-Portrait
in Front of
an Easel,*
1888.
Oil on canvas;
65 × 50·5 cm,
25⁵⁄₈ × 19⁷⁄₈ in.
Van Gogh
Museum,
Amsterdam

For all of its unique appeal, however, the image of the
painter at his easel was a customary one; it had long carried
connotations of professional validation and even projected a
sense of artistic immortality. Only a few years earlier, after
giving up his career as a stockbroker, the young Gauguin
had proclaimed his new career as a painter in his similarly
expressive *Self-Portrait in Front of an Easel*. And like Van
Gogh, Cézanne may also have looked to Rembrandt's well-
known *Self-Portrait at an Easel* or to Poussin's archetypal
Self-Portrait, both in the Louvre, for models in staging his
own authoritative image as a painter.

Moreover, as the art historian Carol Zemel has shown,
artists' portraits had a new currency in this era of
continuing nationalist sentiment. Mirroring the well-
known collection of self-portraits at the Uffizi art gallery
in Florence, the arts administration of the Third Republic
inaugurated a similar display in the Louvre in 1888 as a
poignant manifestation of the nation's artistic tradition
and cultural hegemony. Philippe de Chennevières, director

of the École des Beaux-Arts, saluted it as 'a family gallery –
every house that takes pride in itself should have its own;
... artists in a nation are a superior family.' And in the
following year, the centennial of the French Revolution,
patriotic publications included Henry Jouin's *Musée de
portraits d'artistes* (Paris, 1889), which offered a directory
of portraits of three thousand French artists throughout
the country. Thus Cézanne's rather orthodox self-image
in terms of his profession placed him in timely as well as
prestigious company.

In his large and imposing *Self-Portrait in Front of an Easel*,
however, painted just before Cézanne experienced his first
real taste of success, the artist was also probably settling a
painfully personal score. Dressed in a proper coat and shirt,
wielding his brushes and palette – the emblems of his trade
– and standing stolidly and deeply absorbed behind his
painter's easel, Cézanne powerfully asserts here his identity
and dedication as an artist, an ambitious and sober profes-
sional status on which not even Zola and the fictional
Lantier could cast a shadow.

At the end of 1888, Cézanne was again living in Paris, renting an apartment on the historic Île Saint-Louis and also (perhaps enjoying the sizeable legacy he had received after his father's death in 1886) a small studio on the Left Bank where he sometimes painted. His son Paul later remembered posing for him in this studio, not alone now but with a friend, Louis Guillaume, for the large and strangely sober painting known as the *Mardi Gras* (153) of c.1888–90. Several unusually finished portrait drawings of the two boys preceded the final work, including sensitive studies (*eg* 154) that beautifully capture the maturing features of the artist's sixteen-year-old offspring. A small number of exquisite watercolour sketches and rather fluidly painted oils of the right-hand figure are also related to this project, attesting to the unusual significance it must have held for the painter. Even the finished *Mardi Gras* bears the crusted marks of numerous reworkings. But this imposing double portrait is also a fanciful construction built around the stock *commedia dell'arte* characters of Pierrot and Harlequin and is the first of a number of large, ambitious subject pictures in which Cézanne openly confronted the great figural traditions of the Old Masters.

Long before its irreverent band of socially marginal figures came to inhabit the canvases of such early modernist painters as Picasso, André Derain (1880–1954), Georges Rouault (1871–1958) and the Italian Futurist Gino Severini (1883–1966), the *commedia dell'arte* had proved visually resonant, providing artists and the popular stage with improvised subjects and stylized charades that were only loosely bound to a narrative. Originating as vernacular street theatre in Italy, the *comédie* in France had become

153
Mardi Gras,
c.1888–90.
Oil on canvas;
102 × 81 cm,
40⅛ × 31⅞ in.
Pushkin State
Museum of
Fine Arts,
Moscow

249 Late Figures, Genre and Portraits

154
Studies for Mardi Gras, 1888–9. Pencil on paper with white highlights; 24·5 × 30·6 cm, 9⅗ × 12 in. Musée d'Orsay, Paris

155
Carnival Scene, c.1885–8. Graphite on paper; 15 × 23·6 cm, 5⅞ × 9¼ in. Öffentliche Kunstsammlung, Kupferstichkabinett, Basel

a staple of popular culture by the sixteenth century and its unruly heroes a commonplace in French painting since the age of Watteau. In the nineteenth century, the figure of Pierrot – already immortalized by Watteau's elegant, sad clown, *Gilles* – was reborn in the Théâtre des Funambules as a wan, wistful dreamer in the guise of the mime Jean-Baptiste-Gaspard Déburau (Marcel Carné's famous 1945 film, *Les Enfants du Paradis*, pays homage to this period). In contemporary romantic paintings, this sweet, defenceless figure, much maligned by society, metamorphosed into a symbolic type for the modern artist, as can be seen most poignantly in the art of Daumier.

Even in the most contrived situations, Pierrot's opposite was the devilish trickster, Harlequin. With his distinctive diamond-patterned costume and cocked hat, he personified the insolent sexuality and mocking, irreverent tone that delighted *comédie* audiences. And for the young Picasso, who first saw Cézanne's painting at Vollard's gallery in the late 1890s, the character of Harlequin would provide a potent *alter ego*, a guise he assumed in a number of brooding, early self-portraits.

Cézanne was no doubt well versed in the anarchic antics of the *comédie* characters: he had previously produced at least three narrative sketches with Harlequins, including the

Carnival Scene (155). In these scribbled and roughly worked drawings of *c.*1885–8, he vividly captured the character's rapacious sexual appetite and the stagey, vaudevillian violence of the popular tradition as a whole – and the *comédie*'s typical conflation of the two must have struck a distant familiar chord. All three drawings represent the same capricious episode: as one Harlequin reaches lustfully towards a seated female figure, another Harlequin, with the tricorn hat that indicates a cuckold, bursts through the door. Cézanne may have been familiar with several contemporary operas, or a current ballet, based on Jean-Pierre Claris de Florian's play of 1782, *Les Jumeaux de Bergâme*, in which two brothers – both Harlequins – battle it out for the same woman. Degas also seems to have known this particular story-line; scholars have linked several of his pastels of Harlequins from this period to specific scenes in an opera based on Florian's play that opened in Paris in January 1886. For Degas and Cézanne, by then both ageing and reclusive, the raucous diversion of the *comédie*

would provide imaginative stimulus: Degas would capture the high drama of this particular *comédie* story in a single expressive figure in bronze, and Cézanne would distil the essence of the *comédie*'s chief protagonists in his subsequent *Mardi Gras*.

Although Cézanne's solemn painting scarcely invites a close narrative reading, it is a blatantly theatrical production: with spectacular curtains, a stage-like space, elaborate costumes, props (Harlequin's customary white baton and black, hand-held mask), mannered postures and even Harlequin's trademark sneer, Cézanne has inscribed his *Mardi Gras* with much of the subject's traditional subversive import. Lawrence Gowing noted the element of provocation that was common to *comédie* subjects in the opposing gestures of the two figures – the ramrod-straight stance of the artist's son, who appears to lean back while his friend stoops awkwardly forward, almost as if to incite him – and described it as 'seemingly automatic'. The effect is, indeed, ritualistic and strange. Also, the likenesses of the two figures in the painting are less naturalistic and individualized than those in the preparatory portrait drawings: the arched brows and regularized, chiselled features of both anticipate, in fact, the mask-like face of *Madame Cézanne in the Conservatory* (see 149), painted slightly later in Aix. In several senses, then, the artist seems to have stepped back from his immediate visual motif to create a monumental costume piece that explores, as did the *commedia dell'arte* itself, the creative tension between traditional forms of narrative and the theatrical language of artifice, masquerade and improvization. For an artist who was determined to distance his art from the established norms of subject painting while retaining its expressive gestures and resonant power, and also to challenge pictorial traditions of portraiture, here was a ready-made theme. Part of Cézanne's legacy to twentieth-century painting was his codification in *Mardi Gras* of the unstable, ambiguous and powerfully autonomous creative

realm of the *commedia dell'arte* that made it such a compelling subject for early modernist painters.

Cézanne's recent inheritance allowed him the new luxury of hired models. Thus it was also during the unusually prolific Parisian stay of 1888–90 that the artist produced a series of four paintings and two watercolours of a slender young Italian model, identified as Michelangelo della Rosa, sporting longish hair and wearing a distinctive fitted waistcoat. Not unlike the palette of his contemporary *Mardi Gras*, which was keyed to the red and greenish-blacks of the Harlequin costume, the brilliant red of this garment becomes the key element around which each of the *Boy in the Red Waistcoat* paintings, as they are called, is constructed. In several versions, it is set off by thin touches of blue, green and lavender in the background, again mirroring the colour effects of the *Mardi Gras*, and by the wainscot and wine-red horizontal band on the wall, which Rewald has associated specifically with the Parisian apartment Cézanne rented during these years, thus helping to date the series.

Perhaps in part because a professional model was more apt to pose for an extended period than an inconvenienced friend or relative, the *Boy in the Red Waistcoat* paintings are among Cézanne's most finished portraits to date. The brushwork is vigorous and more fluid than in his *Mardi Gras*, and the paintings' broad rhythms, rich chromatic harmonies and frequent interspersed passages of bare canvas create a dynamic surface effect that contrasts with the quietude of the images described. And, returning to methods formed early in his career, in several of these paintings Cézanne explores allusive poses and moods culled from the art of the past. Thus, the particularly graceful figure in one canvas (156) can be likened to aristocratic Italian portraits of the sixteenth century by Agnolo Bronzino (1503–72) or Jacopo Pontormo (1494–1556), as well as to elegant likenesses by Watteau (*eg* 157) that suggest a similarly evocative and

languid mood. Likewise, Cézanne's *Boy in the Red Waistcoat* (158) takes on a traditional posture of pensive melancholy, which the artist had used to powerful effect in his morbid early painting and which would resurface in the sombre, elegiac canvases of his old age. In yet another version, once owned by Monet and described by him as the most beautiful painting in his collection, the model turns to assume a crisp, classical profile, evoking comparison with earlier Renaissance prototypes. Thus, although some scholars have detected in the series a pervasive personal sadness or semblance of romantic pathos (as in 158), the artist's aims seem to have been rooted much more in his enthusiastic exploration of the traditions of past art than of his own temperament. Much as he had in his *Mardi Gras*, Cézanne explores in the *Boy in the Red Waistcoat* paintings a vocabulary of expressive gesture and pictorial form stripped of any narrative impetus or specific personal mean-ing, but empowered by its transmutation of the Old Masters.

Some of the self-assurance that emanates from the works done in Paris during this period must have stemmed from a fortuitous change in the artist's critical fortunes, for it was during these years that Cézanne enjoyed his first tangible tastes of success. In 1888, the critic Joris-Karl Huysmans mentioned Cézanne, whose work he had once dismissed, as the 'too much ignored painter' in a laudatory article for the journal *La Cravache*, in which he went on to credit Cézanne with contributing even 'more than the late Manet to the Impressionist movement'. He reiterated his new perceptions the following year, in an important chapter devoted to Cézanne in his book *Certains*. Also in 1889, Cézanne saw his venerable *House of the Hanged Man* (see 67) displayed at the Universal Exposition in Paris, thanks to the loyal Chocquet, who had refused to loan some of the antique furniture in his collection unless a painting by Cézanne was also exhibited. And finally, late in 1889, the polemical writer and curator Octave Maus invited Cézanne to exhibit with

156
Boy in the Red Waistcoat, 1888–90. Oil on canvas; 92 × 73 cm, 36¹⁄₄ × 28³⁄₄ in. National Gallery of Art, Washington, DC

157
Jean-Antoine Watteau, *Portrait of a Gentleman*, c.1715–20. Oil on canvas; 130 × 97 cm, 51 × 38 in. Musée du Louvre, Paris

158
Boy in the Red Waistcoat, 1888–90. Oil on canvas; 79·5 x 64 cm, 31¹⁄₄ x 25¹⁄₄ in. Foundation E G Bührle Collection, Zurich

the band of twenty young Belgian artists known as Les Vingts, a liberal group who would become known especially for their support of Neo-Impressionist painting. The following year Cézanne sent two landscapes and a recent bathers canvas to Maus's Brussels show, joining Sisley, Renoir, Van Gogh and other vanguard European artists. Thus, by the end of 1889 and after many years of isolation, Cézanne was cresting a small but growing wave of attention, and it seems to have proved invigorating. With new conviction and a newly honed figural language, he returned to Aix soon afterwards and began work on a masterful series of figure paintings that would constitute his most sustained and eloquent reflection to date on the painting of the Old Masters.

159
Still Life with Pitcher (after Chardin), *c.*1890. Pencil on paper; 19·9 × 12 cm, 7³₄ × 4³₄ in. Öffentliche Kunstsammlung, Kupferstichkabinett, Basel

160
Jean-Siméon Chardin, *The Skate*, 1728. Oil on canvas; 115 × 146 cm, 45¹₄ × 57¹₂ in. Musée du Louvre, Paris

Cézanne had continued in the late 1880s his practice of studying from the Old Masters. Along with the lessons learned in the great figural canvases of *c.*1888–90, the artist took home with him to Aix copious recent drawings after sculptures and paintings in the Louvre. From this period onwards, in fact, Cézanne's sketchbooks record an engrossing study of form, examined in a range of historic works that has little precedence in his earlier drawings. Thus, glimpses of antique nudes, dynamic eighteenth-century sculptures, Poussin's shepherds, Renaissance portraits and always Rubens's *Medici* cycle will share space in his late sketchbooks with the painter's studies from life. Among more recent masters, Delacroix still commanded his most

enthusiastic admiration; it may well have been the death of Chocquet in 1891, with whom Cézanne shared a passionate devotion to the Romantic painter's work, that inspired him to take up again his lifelong project to paint a homage to Delacroix (see 1). Likewise, the emotional intensity that returns in Cézanne's late painting, as evidenced in the refulgent colour and freer and more fluid brushwork that characterizes his work from c.1888 to his death in 1906, also derives to a considerable degree from his renewed kinship with the art of the older Romantic master. And years later, when he advised his young disciple Émile Bernard on the

role that such studies from past art should assume in an artist's work ('The Louvre is a good book to consult but it must be only an intermediary. The real and immense study to be undertaken is the manifold picture of nature'), Cézanne was echoing Delacroix's counsel from a few decades before: 'One always begins by imitating ... ', Delacroix had written in 1859, '[But] what is known as creation in the great painters is only a special manner in which each of them saw, coordinated and rendered nature.'

As Cézanne sought to establish in his own painting this essential balance between observed nature and the heritage

161
Mercury (after
Pigalle),
c.1890.
Pencil on
paper;
38 × 27·8 cm,
15 × 11 in.
Museum of
Modern Art,
New York

162
**Jean-Siméon
Chardin**,
*Self-Portrait
at an Easel*,
1779.
Pastel on
paper;
40·5 × 32·5 cm,
16 × 12¹⁄₄ in.
Musée du
Louvre, Paris

163
Self-Portrait,
c.1896–7.
Lithograph;
49·8 × 37 cm,
19⅝ × 14⅝ in

of the past, the example of Chardin, the eighteenth-century French master whose works convey a kind of humble, truthful naturalism in a range of genre scenes and still lifes, assumed a new importance. Although Chardin had received little attention in the early nineteenth century – when still-life painting itself was held in low esteem – by mid-century, with the advent of Realism, his painting had generated considerable new interest. In Cézanne's own earlier still lifes of ordinary kitchen objects and spare groupings of rounded fruit and glasses on a narrow ledge, there is ample evidence that he, like Manet, Henri Fantin-Latour (1836–1904) and other Realists, had looked closely at the exquisite Chardin still lifes in the Louvre. In Cézanne's great, symphonic still lifes of the mid-1890s, as we shall see, a different aspect of Chardin's still-life production will play an important role. But sometime around 1890, and as far as we know for the only time in his career, Cézanne drew directly from a painting by Chardin. In his *Still Life with Pitcher* (159), a partial study of *c*.1890 after Chardin's diploma painting *The Skate* (160), Cézanne emphasizes the subtle tonal variations and

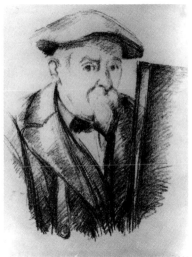

geometric volumes of the lower-right corner of Chardin's canvas with a complex system of pencil hatchmarks. Rarely have rough graphic markings in shades of grey conveyed so much information about form and modulated colour, as if the sketch was a contained promise of glory to come. In late watercolours, such as the *Apples, Carafe and Sugar Bowl* of 1900–6, these lessons were translated back into colour, imbuing Cézanne's images with a traditional sense of draughtsmanship and formal density, conveyed now by sheets of pulsating light and areas of brilliant colour.

The two artists also shared a fascination with the sculpture of Jean-Baptiste Pigalle (1714–85), a contemporary of Chardin. Pigalle's famous statuette of *Mercury* figured prominently in Chardin's allegorical *Attributes and Rewards of the Arts*, which paid homage to the sculptor, and also in his genre painting *The Drawing Lesson* (which was widely available in engravings), where it served as an appropriate model for the student draughtsmen. Cézanne had already copied the same piece in a rather tentative study of the 1870s, and turned to it again in three more accomplished drawings that also date to his studies in the Louvre of *c.*1890 (161). With a series of broad, repeated

curves and contour lines, passages of shading and an unusu-
ally intimate, foreground vantage point, Cézanne conveyed
a new feeling for the small sculpture's dynamic volume
and implicit monumentality, directly embracing Chardin's
lesson in drawing and artistic tribute.

Although he showed little interest in pastels, Cézanne would
also marvel over Chardin's superb *Self-Portrait* in the
Louvre, describing in some detail for Bernard the artist's
gifted feeling for luminous effects in this delicate medium.
Some scholars have even linked his own self-portrait in oils
of *c.*1881–2 (in which Cézanne, like his predecessor, wears an
unusual white cap) to this pastel. Likewise, Chardin's late
pastel *Self-Portrait at an Easel* (162), from which the aged
painter looks out at us with a weary gaze, is strikingly
close to Cézanne's own moving *Self-Portrait* (163) of
*c.*1896–7, which he drew on transfer paper for one of his
rare lithographs. Like Chardin, he too poses before his easel
but has shed the aura of energetic confidence and painterly
authority evident in earlier portraits. Finally, Chardin may
well have stimulated Cézanne's renewed interest in the early
1890s in the field of genre painting, which he would pursue
throughout the decade in his numerous images of the
townspeople of Aix. Before leaving Paris, the artist must
have looked intently at the eighteenth-century master's
picture *The House of Cards*, one of twenty Chardins to
enter the Louvre collection in 1869 as part of the huge
bequest left to the museum by Dr Louis Le Caze. There are
convincing indications that this work in particular was the
key to Cézanne's preparatory studies for his *Cardplayers*,
the series on which the artist would embark just after he
returned to Aix at the end of 1890.

Countless models from a vast range of past art have been
evoked to explain the monumental gravity and silent
grandeur of Cézanne's five paintings of Provençal peasants
playing cards, among the first works of his *œuvre* to be

widely acclaimed as masterpieces and perhaps the finest of all his genre paintings. The earliest version, generally conceded to be the multi-figured canvas of *c*.1890–2, now in the Barnes collection (164), represents one of the largest and most ambitious efforts of Cézanne's career. Its rare even texture of consistently smooth strokes marks it as an unusually finished work. With only a few variations and on about half-scale, Cézanne repeated his composition, something he seldom did, in a second canvas now in New York.

Both paintings display an emphatic order and stability unusual even by Cézanne's standards: his rustic workers are massively conceived and symmetrically grouped in mute concentration around a table at the exact centre of his stage-like space. The V-shaped legs of the middle figure (strangely mismatched with his upper body), the tilted perspective of the table and central placement of its drawer, and – in the Barnes version – the cropped rectangular frame directly above formally enhance the rigid order so at odds with Cézanne's sociable genre subject. It is the resulting iconic formality and ceremonial demeanour of Cézanne's *Cardplayers*, as much as their harmonious composition, that has led to an encyclopaedic search for visual sources. The paintings have been likened, among other things, to 'prototypes' in antique sculpture, the painting of the Italian Primitifs and later Italian depictions of the New Testament *Supper at Emmaus*, most credibly the version in the Louvre by Veronese, whose painting Cézanne had long revered. Within the field of genre, Baroque examples of the same subject, especially the *Cardplayers* by Mathieu Le Nain (*c*.1607–77) in the Aix Museum, and even similar nineteenth-century renditions of the theme that were available in popular engravings have been summoned as sources that the artist could have studied and then translated into far more sedate terms. Yet no single earlier painting, either religious or secular in origin, can suffice as a source for the series as a whole, or even for a painting within it. Cézanne's

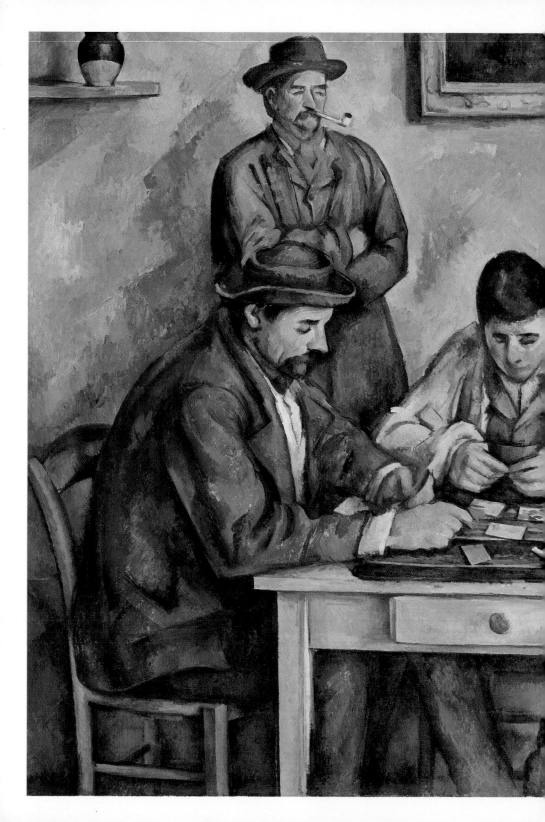

164
The
Cardplayers,
c.1890–2.
Oil on canvas;
135 × 181 · 5 cm,
53¹⁄₈ × 71¹⁄₂ in.
Barnes
Foundation,
Merion,
Pennsylvania

massive, immobile figures and composition of ordered calm, which he reduced to its most quintessential elements in the later and more refined two-figured versions of the theme, are profound distillations of both his analysis of the art of museums and his diligent studies from life. Their solemn gravity evokes above all his concerted effort in these years to balance in his art the heritage of tradition and the fullness of painting from nature.

In a letter of February 1891, Paul Alexis informed Zola that his erstwhile friend was then 'painting at the Jas de Bouffan, where a worker serves him as a model'. From Cézanne's numerous preparatory sketches and watercolours of single figures playing cards, we can assume that Alexis was referring to works related to the larger multi-figured canvases, and that the subsequent paintings included the compiled effects of such drawings from life. The smaller, two-figured compositions seem to have been the result of a similar process. Thus, for example, the subject of his elegant, broadly painted *Man with a Pipe*, a watercolour of c.1892–6, takes his place at the left side of the table in Cézanne's small and perhaps final *Cardplayers* of c.1893–6 (165). And although, as we shall see, his other paintings and drawings of Aixois labourers will reveal them as types, rather than as individuals in the sense of portrait subjects, Cézanne's quiet empathy for these peasants, perhaps even a lingering nostalgia for the simple life they represented, is already evident in the preparatory sketches. Here, too, Chardin may have had a role.

165
The Cardplayers, c.1893–6.
Oil on canvas;
47 × 56 cm,
18½ × 22 in.
Musée d'Orsay, Paris

One of these studies (166) is obviously drawn from a specific model; Cézanne has overlaid its delicate linear structure with touches of brown and black wash to cast the figure convincingly in depth and also to capture his distinctive profile and mood of quiet concentration. However, his figure also closely recalls the protagonist of Chardin's *House of Cards* (167) in the Louvre. Cézanne's seated farmworker

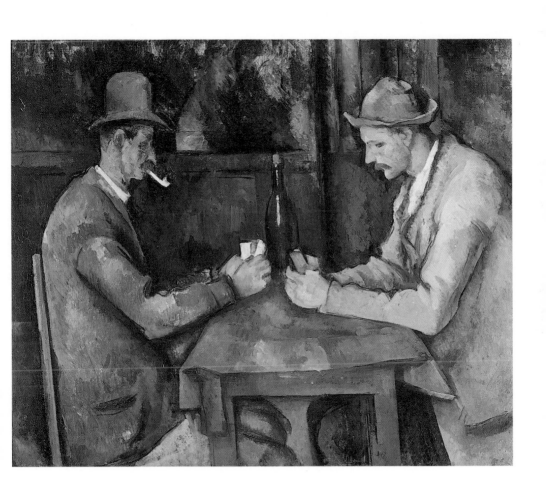

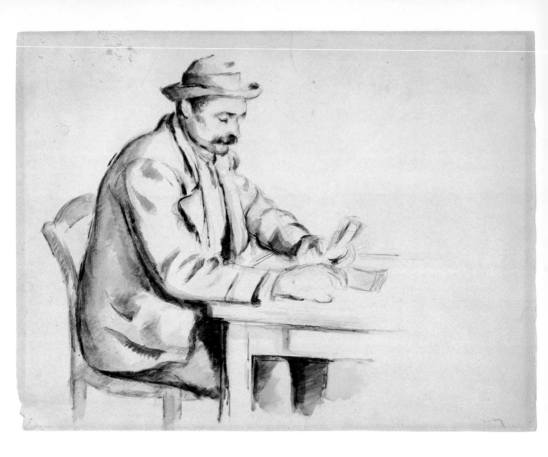

shares the stately silhouette, ritual mood and the unusual, pointed gesture of the lifted card that shape the silent poetry of Chardin's aristocratic genre paintings. Even Cézanne's refined dialogue here between brilliant passages of blank paper and dark washes seems an echo of Chardin's luminous canvas. Additionally, the inclusion in the large Barnes painting of the young girl as a mute observer of the scene recalls a device favoured by Chardin in several of his best-known paintings (*eg* his *Soap Bubbles*), where curious small children peer quietly at omniscient older figures likewise engrossed in silent play. (Some scholars have also suggested an implicit *vanitas* theme for Cézanne's large *Cardplayers* paintings: playing cards had frequently served as metaphors for the role of chance in earlier moralizing still lifes. This underlying concept might also have owed something to Chardin – several of his paintings show a

166
Study for *The Cardplayers*,
1890–2.
Pencil and watercolour;
36·2 × 48·5 cm,
14¼ × 19⅛ in.
Private collection,
on loan to the Art Institute of Chicago

167
Jean-Siméon Chardin,
House of Cards,
1737.
Oil on canvas;
77 × 68 cm,
30¼ × 26¾ in.
Musée du Louvre, Paris

young man building a house of cards, clearly intended to symbolize the vanity of worldly plans and ambitions.) But it is above all in Chardin's novel transformation of casual genre figures and scenes into paintings of meticulous and motionless absorption that his legacy was essential for Cézanne's painting in Aix in the 1890s.

Several large pictures of peasants seem to have been produced in the wake of the first *Cardplayers* canvases, and they explore the resonant possibilities suggested by the conflation of rustic genre subject and traditional form. In Cézanne's *Smoker*, for example, a strangely sombre painting of *c.*1890–2 in which one of *The Cardplayers* models reappears in a conventional pose of melancholy against a luminous background, the artist includes fragments of his own, earlier works to add a new dimension to

his composition. Cézanne would pursue the visual conundrums of such 'pictures within a picture' on a far more elaborate scale in later works (*eg* 177). But here we just glimpse the lower edge of a bathers painting behind and, more prominently, the left side of his *c.*1871 canvas *Still Life: Black Bottle and Fruit*, a work that seems to participate in the present image. Though clearly part of a canvas tacked unframed to the back wall, the prominent dark wine bottle of the earlier painting also seems to stand now just behind the seated figure, as if it shared the same receding plane of his table. It makes the painting not only a visual pun but also lends it the moody ambience of a café, and thus forces us to view the image in terms of two competing perspectives and milieus. In addition, it anticipates the black wine bottles that will anchor the smaller, darkened and two-figured versions of *The Cardplayers* yet to come.

Cézanne's subsequent images of common labourers and peasants, though removed from the card-playing genre and often steeped in distinctive settings arranged by the artist in his home or studio, borrow little from the Romantic tradition of peasant imagery that had been shaped by many earlier nineteenth-century artists. They reject not only anecdote but the moralizing social commentary that had accompanied the theme of the peasant in the art of Jean-François Millet (1814–75), Daumier and many other painters of the period who dwelt on either the misery or supposed idealized sentiments of their rustic subjects. Nor do they share artistic ground with the generalized depictions of peasants and rural workers from these same years (*c.*1890) by Renoir and Pissarro, both of whom returned to the subject on a new, epic scale in populous landscapes that suggested a natural or utopian harmony between country life and agrarian labour. In fact, it is only in Van Gogh's paintings of the townspeople of nearby Arles from 1888–9 that we can find an analogous portrait gallery of sturdy rural types, one that powerfully communicates a

new conception of the French peasantry in the restructured world of Third Republic France.

By this period, in fact, despite a few pockets of discontent, the rural population of France had been converted to the new republican regime. Even in provincial backwaters it had become clear that the Republic – especially after its years of 'moral order' under MacMahon – offered the best hope of maintaining the prosperity and stability that the country had by now come to expect. The railway, education, military conscription and, above all, a deep-seated national pride, though often of a regionalist variety, had helped to convert peasants not only into republicans but also into Frenchmen. Thus invested and to some extent empowered, they became keepers of a new political, economic and cultural equilibrium. This was the new reality which prime minister Jules Ferry referred to in 1885, when he pronounced the French peasantry the stable basis of its new society, a bedrock 'for the Republic, a granite foundation'. And although the solitary Cézanne would never venture into the minefield of provincial politics, the heroic, rustic denizens of his genre portraits from the 1890s, like those of Van Gogh's from Arles, seem to be shaped by a corresponding view. However, Cézanne's work in this genre has an added dimension because he was also able to wrest from his subjects a modern, monumental and powerfully expressive figural language to rival, as he himself stated, the art of the museums.

Cézanne's **Standing Peasant with Crossed Arms** (168) and his **Woman with a Coffeepot** (169), both of c.1893–5, offer two of his most powerful icons of the solid, working-class citizenry that the artist's late genre portraits celebrate as a whole. The vertical canvas of the male worker, which barely accommodates his towering form, reads like a totemic configuration of a rugged, and decidedly rural, masculinity. The rigidly frontal, hieratic disposition of his figure – its upright mass emphasized by the door-frame at left and the

elongated, X-shaped inner edge of his rumpled jacket – is opposed by his powerfully crossed arms and the crudely splayed feet that solidly anchor the weight and bulk of his body. Together with his generalized features and impassive expression, the figure suggests the sense of physical strength and stalwart solemnity that, in the 1890s, would repeatedly draw Cézanne to extract a kind of resonant universality from the farmworkers he had known for years at the Jas de Bouffan.

Equally frontal, bold and even majestic is Cézanne's monumental *Woman with a Coffeepot*, a painting of a domestic servant that may have been made either in Paris or in Provence but clearly shares in the formal language and spatial logic of Cézanne's other portraits of working-class types from this period. These speak for themselves to some extent, but the artist's own words have often been summoned to describe their heroic pictorial language. Writing to Émile Bernard in April 1904, Cézanne passed on to his disciple the advice that, in painting, one should 'treat nature by means of the cylinder, the sphere, the cone'. And *Woman with a Coffeepot* clearly gives form to his dictum: the woman's massive shape, a volumetric pyramid locked in place against the panelling of the background by the insistent vertical axis that bisects her pleated dress, creates a composition of dynamic tension and pictorial geometry. There are more 'painterly' elements – touches of pink tones on her face and blue skirt soften her commanding presence and reflect the graceful floral wallpaper at left – but the cylindrical coffee pot, cup and upright spoon at right reassert the controlling framework and vertical thrust of the whole. A typical domestic scene becomes a powerfully encrypted geometry – two forms, almost two still lifes, held in dynamic balance.

For all its imposing form, however, Cézanne's *Woman with a Coffeepot* also resonates with a genuine sense of the

168
Standing Peasant with Crossed Arms, c.1893–5. Oil on canvas; 80 × 57 cm, 31$\frac{1}{2}$ × 22$\frac{1}{2}$ in. Barnes Foundation, Merion, Pennsylvania

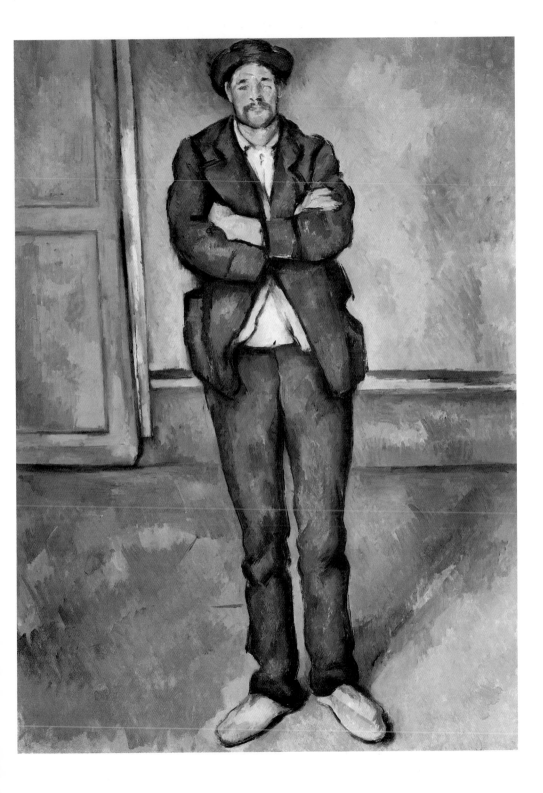

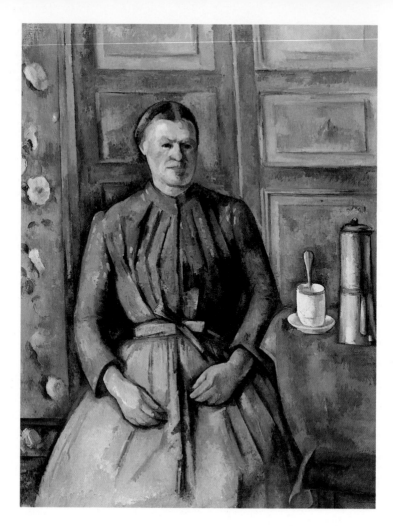

169
*Woman with
a Coffeepot*,
c.1893–5.
Oil on canvas;
130×97cm,
51¼×38⅛in.
Musée d'Orsay,
Paris

170
*Woman in a
Red-Striped
Dress*,
c.1898.
Oil on canvas;
93·2×73cm,
36¼×28¾in.
Barnes
Foundation,
Merion,
Pennsylvania

subject's unvarnished reality. Such telling details as her
hands, hardened by work, her meticulous servant's costume,
severe coiffure and her rough but august face confer on the
woman a natural grandeur and dignity. Thus, Cézanne's
structured visual language creates a dual icon of unshake-
able design and magnetic vitality. Equally forceful is his
image of a type of working-class, rural femininity in *Woman
in a Red-Striped Dress* (170), painted a few years later in Aix.
Here, the figure's massive form and resolute presence is
magnified by her brightly patterned dress, stern features
and the pose of her hands clenched around a book. Wedged
into a corner by a bucket on one side and tools of the

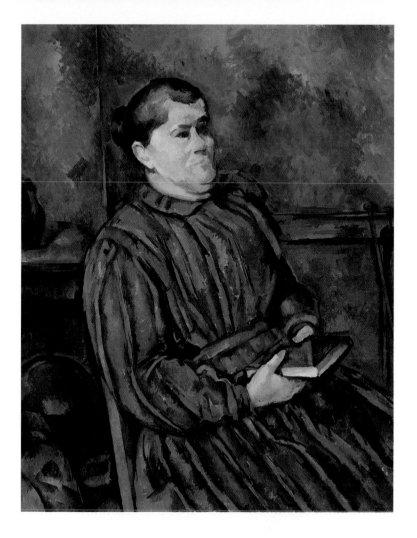

hearth on the other, she fills the space to the point of
bursting. Though unidealized, her brusque, wilful humanity
is thus thoroughly acknowledged even in the artist's
composition. In such large and imposing portraits of his
stolid genre types, then, Cézanne found a new basis from
which to explore a harmonious and expressive balance
between technical experimentation, the evocation of tradi-
tional themes and the honesty and humanity of a working-
class society from which he seems to have drawn strength.

Cézanne's moving pictures of workers and Aixois peasants
form a vivid contrast to the handful of paintings from the

1890s that were intended as true portraits, some of them
executed during the artist's stays in Paris later in the
decade. Among this small body of work, Cézanne's
Portrait of Gustave Geffroy (171), a sympathetic art
critic, seems to stand alone. One of his most complex
late paintings and strangely aloof for a portrait, it can be
securely dated, thanks to the sitter's records, to 1895–6.
Of considerable aesthetic interest, it also serves as a
crucial document of Cézanne's growing acclaim.

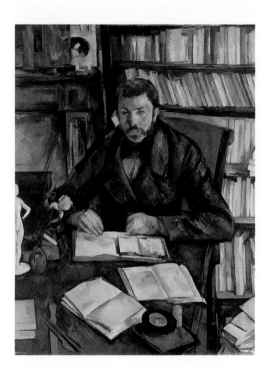

Though Cézanne's reputation was bolstered by the critical
reappraisal of the late 1880s, he was still little known beyond
a tiny circle of vanguard painters and collectors. In the
early 1890s, however, he experienced a small but renewed
spate of attention, and this time the effects were lasting.
In 1892, Émile Bernard, who would soon become one of
his most faithful disciples, published a short biographical
sketch, and another painter and later disciple, Maurice
Denis, emphasized in print Cézanne's influence at that

year's Salon. In Brussels, too, the critic Georges Lecomte singled out Cézanne as a precursor for the contemporary painting on view that year by the Belgian group Les Vingts. A year later, Geffroy, who was familiar with Cézanne's works in Tanguy's shop and was fascinated by the myth that still surrounded the reclusive Provençal, celebrated Cézanne's work in several short, laudatory articles. And in March 1894, fortuitously just before Tanguy's collection – including a number of canvases by Cézanne – was sold at auction, Geffroy contributed the first article by a recognized critic to deal solely with the artist's painting in a prestigious

171
*Portrait of
Gustave Geffroy,*
1895–6.
Oil on canvas;
116 × 89 cm,
45³⁄₄ × 35 in.
Musée d'Orsay,
Paris

172
Edgar Degas,
*Portrait of
Edmond Duranty,*
1879.
Pastel, tempera
and watercolour;
100·9 × 100·3 cm,
39³⁄₄ × 39¹⁄₂ in.
Glasgow
Museums,
Burrell
Collection

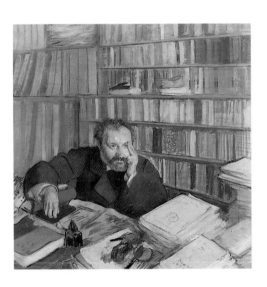

publication, *Le Journal*. Clearly, then, when Cézanne finally met Geffroy in person and offered to paint his portrait, his efforts would be informed by gratitude and the confidence that acclaim bestows.

It has often been noted that in his composition of Geffroy at work in his library, Cézanne studiously emulated Degas's earlier *Portrait of Edmond Duranty* (172), which he could have seen at the fourth Impressionist exhibition in 1879. The two paintings draw on the established motif of the scholar in his study (one that Manet had already updated in his *Portrait of Zola* of 1868): against the stiff horizontals of

the book-lined walls and above the repeated diagonals of books and papers on a desk, the writers emerge at centre in both canvases, pictured as modern intellectuals in the context of their professions. Much as Geffroy boosted the reputation of Cézanne, Duranty had publicly heralded Degas as an artist of rare intellect, a major force in the 'New Painting' (as he called the movement of Impressionism), even a painter of ideas. In his portrait of Duranty painted a few years later, Degas visibly repaid the favour, perhaps most tellingly in the beautifully expressive gesture of deep thought and penetrating gaze he gives the critic.

Cézanne's related portrait of Geffroy is far more sombre and detached: moulded into a simple, stable triangle and graced with a mask-like face and a still life comprising a rose and a small, plaster nude, the painting becomes a symbol, rather than an affecting physiognomic portrait, of the critic's intelligence. And Cézanne's new, muted palette – far more subdued than Degas's earlier pastel – of thinly painted blacks and deep greys in the figure's coat and the browns and purplish-greys of the mantel, enlivened by scattered touches of deep rose and the orange and white spines of books, suggests a new aura of formality. We learn from Geffroy that the artist struggled with the portrait, putting off painting the face and hands until, after months of work, he finally left them unfinished in despair. Yet, even so, his famous sitter delighted in its 'incomparable tonal richness and harmony'.

Cézanne's adaptation of Degas's auspicious precedent proved to be a timely one in terms of the larger visual culture of the period: the portrayal of the journalist and art critic as intellectual types would have a huge significance in the 1890s. A major review of 1891 discussed the numerous portraits of journalists at the Salon that year, noting how important and prominent they had become. And in mid-1893, the powerful Parisian press syndicate mounted their

own large public exhibition entitled 'Portraits des écrivains et des journalistes du siècle'. Displaying numerous portraits of writers and critics by famous artists, its express purpose was to help legitimize the status of contemporary journalists. This show was only one of several in which portraits of art critics shared space with those of philosophers, writers and artists. The promotional intent of such eclectic groupings was not lost on their many viewers. Thus, Geffroy, who recognized that Degas's *Duranty* had guided Cézanne in fashioning his image, must have taken pleasure not only in the aesthetic qualities of the work but in the recognizable and timely mantle of genius conferred upon him.

Thanks in part to Geffroy's critical support, many of the artist's paintings sold at the auction of Tanguy's collection (the paint merchant had died in 1894) were acquired by the art dealer Ambroise Vollard, already a patron of several of the older Impressionists. In November 1895, encouraged by Pissarro, Monet and others of their old circle, Vollard organized a retrospective of 150 paintings by Cézanne (exhibited on a rotating basis) that aroused intense interest and finally established – at least in avant-garde circles – the artist's reputation. It was here that Pissarro was so moved by Cézanne's pivotal *Bathers at Rest* (see 99); that Renoir publicly expressed his deep admiration for Cézanne's achievement; that Monet enthusiastically bought more of his work; and even the genteel Degas would find himself, as Pissarro wrote to his oldest son, 'seduced by the charm of this refined savage', and purchased several paintings, including the tiny, exquisite *Apples* of c.1878 (see 119).

Yet Cézanne's art could still provoke enormous animosity and the painter continued to suffer the effects of hostile criticism even as his art was lauded within an élite circle in Paris. When, in 1894, three of his five paintings from the collection of the Impressionist painter and patron Gustave Caillebotte were rejected as gifts to the

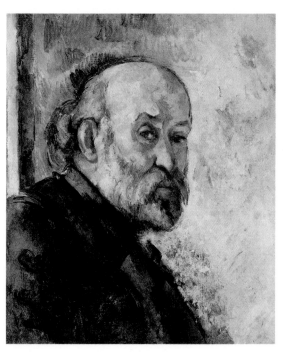 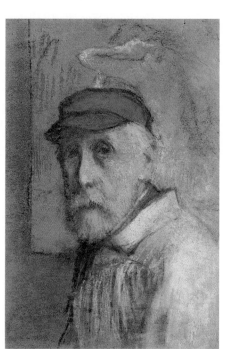

Luxembourg Museum, his humiliation contributed to a growing melancholy. Likewise, he derived little pleasure from the new attention which Vollard had fostered, missing the exhibition itself – though he often travelled to Paris – and even railing against the resulting loss of his treasured privacy. His increasing age and poor health did little to improve his mood.

Much of this can be read from Cézanne's *Self-Portrait* of c.1895 (173), which is far from the image of confidence and success one might expect from his hand at this point. A tragic portrait of old age and even despair, its fragile, thinly washed surface of pinks, greens and bluish-greys on a luminous white ground reflects its probable genesis in a rare, blue-toned watercolour, the only self-portrait by the artist in this medium and one of a number of watercolours, as we shall see, to influence his late painting style in oils. The two works share the same profile, beard and passages of a soft, blue pigment, but even such delicate effects do little to diminish the artist's haunting gaze of defeat.

An equally disquieting *Self-Portrait* in pastel (174) was executed by Degas between c.1895 and 1900, and the correspondence between the two may, in fact, point to a distant dialogue late in their careers between the two recalcitrant painters whose interests had so often run a parallel course in the past as they held one another at bay. As a young man and later, in the heyday of Impressionism, Degas had conspicuously dominated the field of portraiture, but his production in this area had fallen dramatically, with such superb summations as the *Portrait of Edmond Duranty* of 1879, one of his last great likenesses.

Cézanne's mastery of portraiture was greatly in evidence in the 1895 exhibition at Vollard's, where, among the paintings on view were at least one of the *Boy in the Red Waistcoat* canvases, several pictures of Madame Cézanne, two self-portraits by the artist (including another from this period)

173
Self-Portrait,
c.1895.
Oil on canvas;
55 × 46 cm,
21⅝ × 18⅛ in.
Private
collection

174
Edgar Degas,
Self-Portrait,
c.1895–1900.
Pastel;
47·5 × 32·5 cm,
18¾ × 12¾ in.
Collection Rau,
Zurich

and genre portraits as well. Degas would subsequently buy from Vollard an earlier self-portrait by Cézanne and a vigorous portrait by the artist of Chocquet. He came to treasure these works, and it is possible that his renewed admiration may have also encouraged his own return to portraiture. Degas's moving late self-portrait is testimony both to the continuing viability of the genre that Cézanne had so recently demonstrated and to the example and kindred spirit which Degas seems to have found in the reclusive painter from Provence, whose work always spoke more clearly than the painter himself.

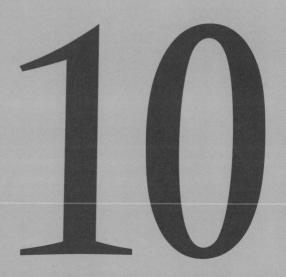

Cézanne's consummate achievements in still-life painting
were also well in evidence at Vollard's seminal 1895 exhibi-
tion. A number of collectors, including the critic Geffroy,
purchased still lifes from the dealer, and in time, the avant-
garde as a whole would come to regard Cézanne's balanced
and complex paintings as modern paradigms of the still-life
genre. Even in 1895, Cézanne's skill in the field was becom-
ing widely recognized. One of the favourable reviews of the
Vollard show in fact suggested that Cézanne had already
assumed in French painting 'the position of the new master
of still life'. His *Basket of Apples* (175), exhibited by Vollard,
may well have helped to garner such accolades. Among the
artist's most complex and calculated compositions in this
genre to date, it set the stage for his masterful still lifes of
the mid-1890s, which now seem a virtual lexicon of form.

But even works of formative genius are not without prece-
dent, and once more Cézanne seems to have looked to
Chardin. The round and burnished golden basket, tilted
forward, and the tall, dark bottle that offsets its breadth
recall Chardin's frequent, complementary pairing of
such objects. Still lifes by both artists, moreover, share an
implicit pictorial logic that stems directly from the artful
arrangements they composed in their studios and then
transformed into motifs: in Cézanne's painting, for
example, the scattered apples contrast with the rigid
order of the plate of biscuits at right, and the tall bottle
at centre bisects his painting nearly in half. And here, as in
many of Chardin's still lifes (*eg Still Life on a Stone Ledge*
of *c.*1731), Cézanne's swelling and cylindrical forms veil the
underlying geometry and reveal the painter's mastery of
abstract formal relationships. Yet the careful symmetry of

175
*Basket of
Apples,*
*c.*1890–4.
Oil on canvas;
65 × 80 cm,
25⅝ × 31½ in.
The Art
Institute of
Chicago

Cézanne's painting is offset by its new subtle dynamism, an effect quite unlike the impressive stillness and stable hierarchies of Chardin. Thus, the tilting bottle struggles to anchor Cézanne's composition at centre, while the plunging cloth and apples highlight its shifting and sloping planes.

Cézanne took this concept a step further in the mid-1890s, when he brought both the legacy of Chardin and the formal drama of his own recent still-life painting to bear on two superb related compositions, *Still Life with Peppermint Bottle* (176), *c.*1893–5, and *Still Life with Plaster Cupid* (177), usually dated *c.*1895. In both works Cézanne transformed the notion of still life itself – a genre that had been, even before Chardin, the epitome of the controlled, empirical subject – into one that now fully embraced paradox, instability and relative pictorial values: in other words, into something we would come to think of as 'modern'.

In the earlier of the two works, Cézanne replaced his signature tilted tabletop with an inventive arabesque of bluish-black lines and expansive swells that animates his heavy blue tablecloth and suspends his painted objects in a narrow, vertical plane. The overall palette of deep, luminous blues further flattens his composition and offsets the brighter tones and volumes of the fruit. Against the rectilinear austerity of the paler rear wall, which is marked by a wide, vertical plinth and thin horizontal line of dark trim, the luxurious curves of the foreground objects take on a new prominence and formal role. Thus, the daring asymmetry of the rounded peppermint bottle, though it defies pictorial logic, becomes key to his composition of rhyming large and small curves – the pairs of apples grouped in front of it, the larger curves of the drapery below, even the rounded fruit glimpsed through its tinted blue glass. This freedom of form and colour would be part of Cézanne's legacy.

Perhaps recognizing the audacity of this work, Cézanne included a corner of it in his subsequent *Still Life with*

176
Still Life with Peppermint Bottle,
*c.*1893–5.
Oil on canvas;
65·7 × 82 cm,
26 × 32 ³⁄₈ in.
National Gallery of Art, Washington, DC

Plaster Cupid, an even more ambitious composition that
seems, in its unusual collection of objects, to hark back
to the inner conflicts that marked Cézanne's earliest
works, and perhaps even to question the nature of represen-
tation itself. Moving far beyond his habitual motifs, the
painting's complex subject matter is matched by the artist's
complicated formal means.

Cézanne's small plaster statuette of Cupid, a cast after a
work then attributed to Puget, figures frequently in his
works from these years and is one of a number of decorative
sculptures whose rippling curves seem to have captured
the ageing painter's eye. Nowhere else, however, does the
diminutive figure of Eros exhibit the monumentality and
importance conveyed upon it here by the artist's elevated
and close-up vantage point. Placed at the centre of this rare
vertical still life and bordered on either side by the upright
edges of an unreadable canvas behind, it clearly dominates
Cézanne's composition. Yet the Cupid is also framed by
two works we can recognize, two 'pictures within a picture'
that share space in the artist's studio with his real tabletop

motif: on the right, part of a painted copy after another plaster cast that Cézanne owned and often drew, the flayed man (or *écorché*) then attributed to Michelangelo Buonarroti (1475–1564), and at left, the quotation from his own *Still Life with Peppermint Bottle*. Though only fragments, they too add to the present work's complexity:

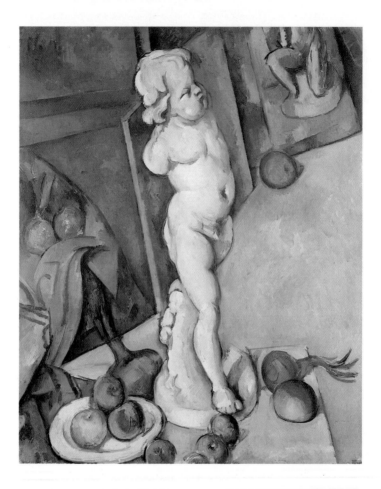

177
Still Life with Plaster Cupid, c.1895.
Oil on paper mounted on panel;
70 × 57 cm,
27$\frac{1}{2}$ × 22$\frac{1}{2}$ in.
Courtauld Institute Gallery, London

the anguished kneeling nude serves to counter the rococo sensuality of the Cupid, while the artifice of the painted still life contests its realism.

Artifice prevails even in the studiously arranged still life in the foreground: the rich blue drape that surrounds the apples in the painting behind appears to spill onto the actual table in front, the green stem of an onion at left

seems to fuse with the painted still life behind, and the globes of both onions and apples on the table are carefully positioned to echo the rounded contours and spiralling form of the plaster putto. Finally, a lone apple in the upper right-hand corner – next to the flayed man – seems poised to roll down the incongruously forward-sloping floor. An intricate parallelism reigns and the suggestions of potential dual themes – sensuality/physical torment, art or artifice/reality – are left equally unresolved, as Cézanne defies both the Realist norms and readable subjects of still-life painting as a whole.

Not every work in this vein, however, represented a departure. Perhaps prompted in part by the death of his mother in 1897, Cézanne would return to the traditional subject of the *memento mori* in his later still lifes in a series of beautiful but haunting paintings and watercolours of skulls from *c.*1898–1906 (**eg 202**). Even before this, thoughts of morbidity and his own demise had surfaced in his letters. As early as 1885 he had written to Zola: 'I shall leave this world before you' (Zola would in fact die in 1902, four years before Cézanne) and in 1891, the artist confessed to Paul Alexis that his dread of imminent death had made him an observant Catholic: 'I feel that I have only a few days left on earth – and then what? I believe I shall survive and do not want to risk roasting *in eternum*.' Thus, the sombre palette, meditative figure and symbolic still life in **Boy with Skull** (178), a monumental canvas of *c.*1895, have long provoked biographical readings. Along with other late paintings, it seems to convey Cézanne's attempts to contain diminution and death, as he once struggled to contain the hectic boundaries of sensuality.

The image of a young man contemplating death is as frequent in art as it is rich with poetic allusions, and its elegiac undertones could not have been lost on the aged Cézanne. Joachim Gasquet, whose (somewhat embellished)

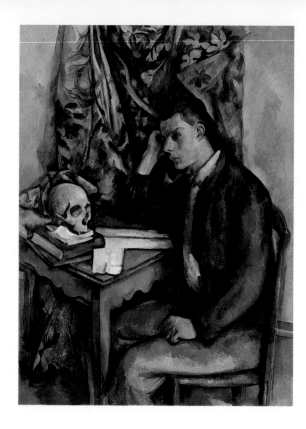

178
Boy with Skull,
c.1895.
Oil on canvas;
127 × 94 · 5 cm,
50 × 37¹4 in.
Barnes
Foundation,
Merion,
Pennsylvania

179
*Old Woman
with a Rosary,*
1895–6.
Oil on canvas;
85 × 65 cm,
33¹2 × 25³8 in.
National
Gallery,
London

**180
Vincent
van Gogh,**
La Berçeuse,
1889.
Oil on canvas;
92 × 72 cm,
36¹4 × 28³8 in.
Museum of
Fine Arts,
Boston

recollections shed light on the painter's later years, noted the work's significance for Cézanne, who 'loved that paint-ing ... one of the few he would sometimes mention after he had stopped working on it'. The composition is beautifully crafted to wrest from the image a poignant expression of his theme. Against the decorative swirls of a sumptuous, floral-patterned hanging, the foreground figure and still life create a strident system of angular forms: the knife-like edges of the books, the jutting point of the table, even the sharply triangular pose and profile of the boy – whose three-quarter gaze is mirrored by that of the skull – all seem part of a familiar dialogue between opposites. Yet the painting resists morbidity, and some of its import for Cézanne may have rested on his harmonious resolution not only of opposing forms but of poetic symbol and observed reality. The painting's overall tonality of blues and glowing ochres, its consistent and sometimes delicate touch, and

such artistic conceits as the mound of drapery that crowns
the skull and echoes its radiant yellows, or the way the
curiously upright square of paper on the table flattens
itself against the canvas, allow the painter's prodigious
skill to triumph over dark musings on his fate.

More simple in format and melancholic in mood is
Cézanne's *Old Woman with a Rosary* of 1895–6 (179),
which is marked by the resonant dark blues found in
many of the late works but surrounded by a mythology of
its own. According to Gasquet, Cézanne gave him the canvas
after the poet found it abandoned in a corner at the Jas
de Bouffan; the artist had apparently tossed it aside after
many reworkings. Its dense and heavily encrusted surface,
so different from that of *Boy with Skull*, would seem to
support this story. The poet's avowal, however, that the
model was an old defrocked nun taken in by the solitary

artist in an act of charity, seems far more contrived. Hunched beneath a rough peasant shawl, eyes downcast, coarsened hands clutching a rosary and with her weathered face turned aside and framed by a simple white cap, Cézanne's figure in fact echoes the intense inwardness and soulful melancholy that characterizes many French paintings of the 1890s that are part of the emerging Symbolist aesthetic, a belated romantic flowering marked by works of introspection and sombre reverie. In addition, *Old Woman with a Rosary* conforms to an established vernacular type for depicting older and often provincial women absorbed in prayer, meditation or even household chores. It would be fascinating to know if Cézanne was familiar with Van Gogh's kindred painting from Arles of *La Berçeuse* (180), which the Dutch painter himself, as Zemel points out, had designated a religious icon. Its pensive, unmoving rural subject, Madame Roulin, has likewise retreated into a personal reverie, and she holds the cord to an unseen cradle much as Cézanne's praying figure clasps her wooden rosary.

Yet the most profound inspiration for this moving image of worshipful old age was no doubt the artist's own increasing meditations on death. Part of the painting's modern renown stems from the critical recognition it received when included in several important early twentieth-century exhibitions. At a seminal exhibition of avant-garde painting organized in London in 1910 by Roger Fry (who, as we have seen, was never loath to champion 'difficult' modern art), the canvas was singled out as an 'extraordinary character study' by one American critic. And at the Armory Show in New York in 1913, a landmark exhibition that would introduce a vast range of avant-garde European art to an unsuspecting America, its asking price exceeded everything else on view. Among other visitors, the collector Henry Clay Frick was impressed by it, as was Theodore Roosevelt, who allegedly stood transfixed before it.

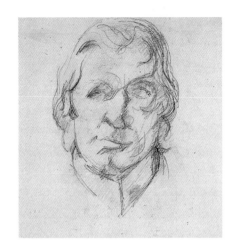

181
*Father de la
Tour* (after
Coustou)
(detail),
c.1895.
Pencil on
paper;
20 × 12·2 cm,
7⅞ × 4¾ in.
Öffentliche
Kunst-
sammlung,
Kupferstich-
kabinett,

Although he shunned the attention he now regularly
received in the capital, Cézanne continued to spend
considerable time in the north (at Giverny he once mistook
Monet's words of encouragement for derision and abruptly
fled), painting landscapes in the countryside of the Île de
France and often retaining a studio within Paris itself,
where he worked mostly in seclusion. While some of
Cézanne's still lifes and genre figures from the mid-1890s
are imbued with a grave, contemplative mood that seemed
to well up in French painting as a whole as the century
drew to a close, a number of other works are marked by
an elegance and dazzling vitality that set them poignantly
apart. That he turned to copy so many portraits in the
Louvre and made studies of historic plaster casts available
to students for copying in the Musée Trocadero, at a time
when he was deeply engaged in portraiture himself, seems
to have been anything but coincidental.

A study (**181**) from *c.*1895 of the early eighteenth-century
bust of *Father de la Tour* by Guillaume Coustou (1677–1746)
offers masterful evidence of how the art of the past contin-
ued to shape Cézanne's work. Drawn from a specific angle
that divides the subject into areas of radiant light and soft
shadow and emphasizes the brilliant patch of bare surface
on the forehead, Cézanne's study – one of a series – reveals

the sculpture's unifying structure of repeated and aligned diagonals and conveys a powerful sense of its subject's formidable character. In his own likeness of Joachim Gasquet from the spring of 1896 (182), Cézanne similarly manipulated the fall of light to underscore both the commanding gaze of his sitter and the subtle skein of diagonal lines that orders his painting. Even the expressive tilt of Gasquet's figure, which lends the image of the young regional poet an unprecedented air of gravity, is beautifully synchronized with his surroundings: the rounded shapes of his hair are echoed in the decorative screen behind (a detail

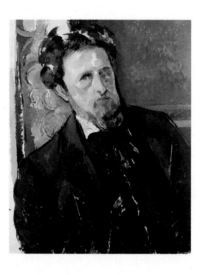

182
Portrait of Joachim Gasquet, 1896.
Oil on canvas; 65 × 54 cm, 25³⁄₈ × 21¹⁄₄ in.
Národní Galerie, Prague

183
Portrait of Ambroise Vollard, 1899.
Oil on canvas; 100 × 82 cm, 39³⁄₈ × 32¹⁄₄ in.
Musée du Petit Palais, Paris

of Cézanne's earliest work, see 8), and the whole is rendered with broad touches of diluted paint that give it a delicate, uniform consistency akin to watercolour.

After relatively few, brief studio sessions, Cézanne seems to have put the painting of Gasquet aside, unfinished, by early summer. In contrast, his 1899 *Portrait of Ambroise Vollard* (183), was painted in over a hundred tortuously long sittings a few years later in Paris. The result was a far more muted, mask-like portrait and perhaps, like his portrait of Geffroy, more a testimony of the dealer's professional status than of his vivacious character. But it too reflects the painter's

studies in the Louvre. When, after months of posing, the dealer inquired about two remaining patches of blank canvas, Cézanne explained: 'If my study in the Louvre presently goes well, perhaps tomorrow I shall find the right tone to fill the white spaces ... If I put something there at random I should be compelled to go over the whole picture again starting at that spot.' The much-tried dealer remembered shuddering at the prospect.

Cézanne's late landscapes drew on a wider range of sources, as has been made clear by records of his travels. And these allow us to date various canvases and identify their motifs, which is especially helpful as they do not chart a consistent stylistic development. Beyond their subject matter, however, the late landscape paintings relate only in a general way to

Cézanne's personal life, which became increasingly solitary and uneventful. To a considerable degree, the discoveries, joys and frustrations Cézanne encountered in his painting and described in his letters replaced those of a more intimate nature. However, although he began to avoid all personal contacts, to the dismay of many of his old friends, the artist would not permanently retire to Aix until 1899, and even then made a few excursions outside Provence to paint new subjects in the landscape.

In July 1896, Cézanne took a rare trip beyond his habitual haunts to the Haute-Savoie region of France, near the Swiss border. In the two months he spent with his family on the shores of Lac d'Annecy at Talloires, the artist seems to have produced only a handful of works: a few figure studies, some very sketchy watercolours and a single, radiant painting of the majestic blue lake (184). Talloires was a well-known tourist haven, its scenic lake dramatically ringed by alpine greenery, steep mountains and a small château at the water's edge, but the artist claimed to find little in the picturesque site that fascinated him. 'It's still nature,' he noted in a letter to Gasquet, 'but a bit like we've learned to see it in the travel sketchbooks of young ladies.' To another friend in Aix he wrote wistfully of missing Provence: 'To relieve my boredom, I paint; [but] it is not much fun ... not as good as our home country ... when one was born down there, it's all lost – nothing else means a thing.'

Perhaps, like Monet, who dreaded the visual seduction of Venice and stayed away until late in his long career, Cézanne feared the easy appeal of such an overtly picturesque setting and so transformed his already idyllic subject into one of a compelling formal order. The framing tree at left whose diagonal branches echo a far-off mountain, the distant shoreline that cuts the painting precisely in half, the château and shrubs neatly centred, the broad, even brushwork, though of varied consistency – all contribute, as the

184
Lac d'Annecy,
1896.
Oil on canvas;
65 × 81 cm,
25⅝ × 31⅞ in.
Courtauld
Institute
Gallery,
London

Cézanne scholar Lionello Venturi described, to 'a unity of vision so complete that the lake waters throb with the same pulse as trees, houses and mountains'. One of his most serene and exquisite late works, and in some ways a painting that stands apart from much of his late *œuvre*, Cézanne's *Lac d'Annecy* also presages the chromatic dazzle and fluid brushwork that will characterize the best landscapes of his final decade.

In contrast to the tranquil *Lac d'Annecy*, others of the artist's late landscapes are marked by dark palettes, restless moods and dense, impenetrable motifs that stubbornly reject his customary systems of order. Chief among these are Cézanne's paintings from the Forest of Fontainebleau. Between 1892 and 1898, he spent several extended periods working there, according to some accounts even acquiring a house in the neighbouring village of Marlotte. Like his resonant late genre portraits, the Fontainebleau landscapes and subsequent paintings in Aix may have served as expressive vehicles for the ageing painter, but they also provided a rich spectrum of motifs that inspired brilliant and diverse new pictorial achievements.

Fontainebleau's rocky, thickly wooded terrain had been virtually discovered as a landscape subject by the young Corot in the 1820s, and its appeal for many of the later Barbizon artists was obvious. A large tract of rugged, untrammelled wilderness close to Paris, it drew, by mid-century, both artists and tourists, and soon, a pictorial tradition of *plein-air* painting for the area was established. Monet and Bazille arrived as early as 1863, and Renoir and Sisley the following year. But the site's romantic associations, already established in literature, also persisted. Étienne Pivert de Senancour's *Oberman* (1804), an important early Romantic novel inspired by Jean-Jacques Rousseau, was one of the first to use Fontainebleau as a natural stage to explore the theme of melancholy withdrawal. Its protagonist, deeply ill at ease

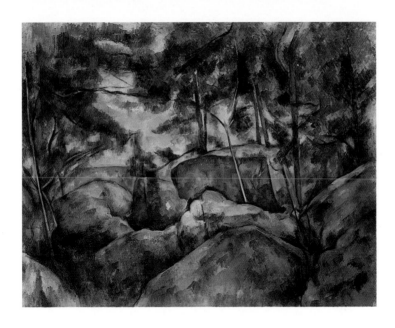

185
*Rocks at
Fontainebleau,*
c.1894–8.
Oil on canvas;
73 × 92 cm,
28¼ × 36¼ in.
Metropolitan
Museum of
Art, New York

in society, escapes to the primeval chaos of the forest to
find the isolation he craves. Gustave Flaubert picked up
this thread in his *Sentimental Education* of 1869, when
two lovers flee the terrors of Paris in 1848 and find refuge
in the same dark, boulder-strewn woods.

Cézanne renews these romantic associations in such works
as *Rocks at Fontainebleau* (185) of c.1894–8 and the related
canvas *Pines and Rocks* of c.1897, with their compelling
views of geometric stone slabs and fantastic rocky outcrop-
pings in dense, pine-shaded forests. Though some of the
portraits of the mid-1890s, such as that of Geffroy, reveal
similar autumnal palettes, these landscapes share elements
unique to their Fontainebleau setting: a cool northern
light, glimpses of a flat horizon and greyish granite stone
tinged with violet shadows. Additionally, the artist's thin
layers of paint in both works are applied in short, slanted,
watercolour-like patches and point to the growing signifi-
cance of watercolour techniques in Cézanne's late style
(Vollard's portrait of 1899 exhibits equally diluted colours).
Yet here, the delicate touches of diffuse colour also seem
specifically attuned to the landscape's contours: they

counter the massiveness of the rocks and soften their hard edges with flickering shadow. It is not only their synthesis of form and technique, but also the brooding ambience and haunting visions of a solitary, inaccessible nature that gives these landscapes their unique poignancy. Once again Cézanne had found a way to make nature speak for him of the ambivalent gift of imposed solitude. 'This is what we try to do in writing,' Ernest Hemingway would later remark to his son of Cézanne's *Rocks at Fontainebleau*.

Cézanne's telling predilection, in his last decade, for dramatic landscapes in remote areas would lead him to sites of comparable romantic appeal and heightened pictorial value within the environs of Aix itself. Though sun-drenched and swept by the mistral winds, the deserted quarry at Bibémus was one such site, and it offered arresting motifs not unlike those the artist had found at Fontainebleau. Marked by unnaturally angular boulders – the man-made legacy of extracted stone – deep rocky crevices and hidden grottoes alternating with areas exposed to the elements, the quarry offers a striking panorama even today.

Located between Aix and Mont Sainte-Victoire and just above the village of Le Tholonet, Bibémus was one of many ancient quarries in the Provençal mountains, some of which dated back to Roman times. Though it was long abandoned by Cézanne's day, its distinctive yellow stone still graced the façades of elegant, eighteenth-century mansions in Aix and the surrounding countryside. Cézanne must have known the quarry's wild and chaotic landscape in his youth, overgrown in places even then with dense thickets of underbrush. But it was only in his old age that the site yielded motifs for his painting, and its appeal no doubt involved issues of form as well as of mood. Between 1895 and 1899, the artist rented a small hut at the quarry where he stored his painting gear, and it is from this period that most of his Bibémus pictures date.

In one of the first of the large Bibémus landscapes (186), dated *c*.1895, Cézanne exploits its gouged and eerily cubic topography to create a landscape of peculiar geometric character. With small, meticulous strokes of thin paint and crisp lines, he accentuates the steep vertical planes of sharply honed rock that give his canvas an overall, patterned precision and pull the motif oppressively near to the surface. The colour – a Provençal palette already more intense than that inspired by Fountainebleau – is height-ened even further to render the relief-like motif more animated: thus, the yellow ochre of the rocks is tinged with a sun-scorched red, the scrub pines a brilliant green, the shadows and sky braced with vivid shades of blue. Reff has aptly linked the Bibémus paintings, built around such saturated complementary colours (even more pronounced in works such as *Red Rock* of *c*.1895–1900), to a general shift away from an Impressionist aesthetic in French painting of the period, but few of Cézanne's peers achieved comparable results without sacrificing fidelity to nature. No less a master than Matisse described Cézanne's pre-eminence as a colourist in 1908: 'Cézanne used blue to make his [comple-mentary] yellow tell, but he did it with a discrimination, as he did in all other cases, that no one else has shown.'

The grounds of the old quarry also afforded spectacular vistas of the surrounding area. In his later *Mont Sainte-Victoire Seen from Bibémus* (187), *c*.1897–8, Cézanne combined two of the area's most distinctive motifs, playing off across a deep gorge the man-made landscape against the mythic. Framed by trees, the vertical planes of the chiselled cliff walls serve as a stratified pedestal for the looming drama of Sainte-Victoire; the twinned subjects share with the surrounding pines a brushwork of thin, parallel strokes and touches of yellow, orange and blue. But the mountain that dominated Cézanne's life, as it did the landscape of Aix, takes on an oceanic energy of its own, its ascending contour etched with a clear blue line that defies its distance

186
*Bibémus
Quarry,*
*c.*1895.
Oil on canvas;
65 × 80 cm,
25⅜ × 31½ in.
Museum
Folkwang,
Essen

187
*Mont Sainte-
Victoire Seen
from Bibémus,*
*c.*1897–8.
Oil on canvas;
65 × 81 cm,
25⅜ × 31⅞ in.
Baltimore
Museum of Art

188
Château Noir,
c.1903–4.
Oil on canvas;
73·6 × 93·2 cm,
29 × 36¾ in.
Museum of
Modern Art,
New York

189
Mont Sainte-
Victoire and the
Château Noir,
c.1904–6.
Oil on canvas;
65·6 × 81 cm,
25¾ × 31⅞ in.
Bridgestone
Museum of
Art, Ishibashi
Foundation,
Tokyo

from the foreground. We glimpse here a reawakened passion for Provence that had long sustained him.

In 1899, the Jas de Bouffan was sold to settle the family estate – an event that must have been wrenching for the painter – the proceeds divided between him and his two sisters, and Cézanne moved into modest lodgings in a narrow street in Aix. His wife and son, for the most part, remained in Paris, where Paul began to act as an agent for his father with Parisian dealers, while Cézanne's sister Marie took charge of his finances in Aix. Cézanne tried, unsuccessfully, to purchase another country estate, popularly known as the 'Château Noir'. Located near Bibémus and built from the quarry's stone, the château was surrounded by dense woods, caves and local legend. Begun some years earlier by a coal magnate who, rumour had it, sometimes practised the occult, the bizarre pseudo-Gothic structure, which was left unfinished, was also called the 'Château du Diable'.

Cézanne knew this area well: by 1899, he had painted there for over a decade, often hiring a driver to take him by carriage, and he no doubt relished the seclusion of its nearly impenetrable woods. His first views of the folly, however, offer little hint of the site's forceful appeal. In contrast to his spare early views, many of his later paintings of the Château Noir are executed with intensely hued, rhythmic brushwork and approach the site from angles that emphasize its unfinished state in a sombre, restless landscape. In *Château Noir* of c.1903–4 (188), for example, a canvas once owned by Monet, Cézanne envisions the Gothic structure as a luminous, spectral façade punctuated at centre by a reddish door. With a palette of juxtaposed primary and complementary tones just as saturated as those of his late quarry paintings, Cézanne blends fantastic architecture, turbulent landscape and brilliant, agitated sky into a virtual summation of a private romanticism that characterizes many of his late landscapes.

Yet while the Château Noir is among the most haunting
of his late landscape subjects, this motif too would be
transformed in Cézanne's final years into one of heroic
triumph. In *Mont Sainte-Victoire and the Château Noir*
of *c*.1904–6 (189), the artist silhouettes the château against
the familiar icon and ties the upward slant of its geometry
from this new vantage point to the thrusting energy of
the mountain itself. Above, a delicate canopy of green
and purple strokes (they may refer to foliage, sky or both)
celebrates Sainte-Victoire's illustrious profile. Even the
brushwork now is one of a balanced, unifying harmony;
rapid, watercolour-like patches cover the canvas in its
totality and translate all parts of his motif into a vibrating,
seamless image of resounding hope – as if Cézanne's polar-
ized vision has been transformed by his reconciling hand.

This is more than an aberrant triumph. The uniform, fluid
patches of colour that seem to float across this last painting
of the Château Noir herald a sea-change in Cézanne's art:
at the very end of his career, the painter revealed himself
a rebel still. As early as the 1860s, Cézanne had known that
a consistent pictorial structure could be realized in the
handling of the paint itself, and throughout the intervening
years he cherished his individual touch as a signature, the
mark of his own vision. 'How does he do it?' Renoir once
asked. 'He can't put two strokes of colour on canvas without
it [already] being very good.' By the end of his career, after
decades of focusing in his art on the tactile objects and
solid, physical structures of nature, while his Impressionist
colleagues concentrated on more transient effects, Cézanne
increasingly described his goals in terms of that distinctive
touch in itself.

The result of this new preoccupation is work that can be
both complex and breathtakingly fresh. The possibilities of
painting in terms of modulated colour first emerged in the
late watercolours, and it is instructive to compare two views

of Mont Sainte-Victoire, one executed in watercolour and one in oil, in discussing Cézanne's late work. In a splendid pencil, gouache and watercolour image of *c*.1900–2 (190), for example, the artist lays in scattered touches of vivid blue, violet and grey atop a lean drawing, irrespective of its outlines. With interspersed, exposed patches of white paper generating its own brilliant light and underscoring the image's pulsating surface, the small watercolour becomes a pictorial metaphor of the painter's animated experience of nature.

In an oil painting that is surprisingly close in effect, despite the difference in medium and scale, Cézanne's *Mont Sainte-Victoire Seen from the Château Noir* (191), *c*.1904, the motif is fully rendered in muted colour patches that fuse the painter's awareness of his subject with the complex workings of his modulated colour harmonies. These amorphous touches of colour – long and linear above, block-like below – bear little relation to the landscape's familiar texture, but create instead a sweeping, undulating skein of subtle colour contrasts that transform his motif into a kindred artistic vision. One of his freest (one hesitates here to use the word 'abstract') and yet most finished late paintings of Mont Sainte-Victoire, this superb work also seems to embody fully Cézanne's lifelong goal to create in his art 'a harmony parallel to nature'.

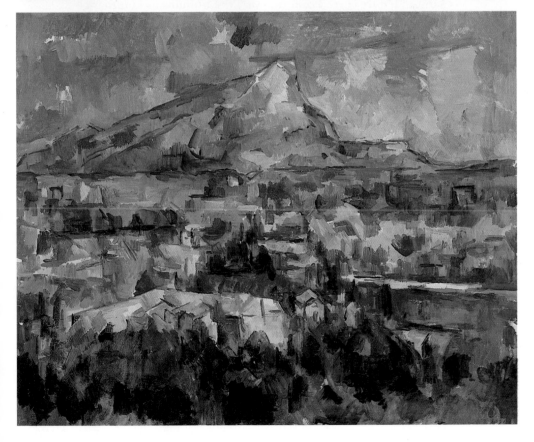

Cézanne's *Mont Sainte-Victoire Seen from the Château Noir* stands apart from a cluster of late landscapes painted at Les Lauves, a hilly precinct on the northern edge of town whose views of the Provençal countryside are central to his final years. The small, makeshift studio that the artist had devised in one of his rented rooms in Aix proved woefully inadequate, and in 1901 Cézanne purchased a modest tract of land halfway up the slopes of Les Lauves. There he built a studio (192) specifically designed to accommodate the momentous projects of his final years and also painted views of the garden, the distant horizon to the south and the town below. Further up the steep road that runs in front of the studio Cézanne found a new panoramic vista of Mont Sainte-Victoire (193). From this site, the ubiquitous landmark that had always measured his achievement was somehow even more awe-inspiring than before, its now quite distant peak more stark and soaring above the limitless plains that stretched to the east.

The scant dozen canvases of Mont Sainte-Victoire painted from the crest of Les Lauves were probably done over a span of about four years and at varying times of the day; each of them tackles the motif with a slightly different aim. Most scholars have cautiously discerned in the series a stylistic progression towards a more generalized, impassioned late manner. Thus, the series of patchwork strokes that suggest the small units of farmhouses and trees that dotted the fields in one version coalesce into a more abstract system of coloured facets that lend a sense of perspective and breathing space to another (eg 194, of 1902–4). As Cézanne wrote in an unusually effusive letter of 1904:

Lines parallel to the horizon give breadth, whether it is a section of nature or, if you prefer, of the spectacle which the Pater Omnipotens Aeterne Deus spreads out before our eyes. The lines perpendicular to this horizon give depth but nature for us men is more depth than surface, whence the need to introduce into our

195
Mont Sainte-Victoire from Les Lauves, 1904–6.
Oil on canvas; 60 × 73 cm, 23⅜ × 28¼ in.
Pushkin State Museum of Fine Arts, Moscow

vibrations of light, represented by the reds and yellowness, a sufficient amount of blueness to give the feeling of air.

Often, the immensity of his undertaking prevented the artist from filling the surface fully, as he described in a letter of frustration the following year: 'Now being old, nearly seventy years, the sensations of colour, which give light, are for me the reasons for the abstractions that do not allow me to cover my canvas entirely.' Yet he held out hope, insisting still that 'nature, if consulted, gives us the means of attaining this end'.

In his final paintings from Les Lauves the artist seemed to rekindle in his consultation with nature the fires of his youth, as if in a passionate, liberating embrace of his native landscape. The dark, churning version now in Moscow (195),

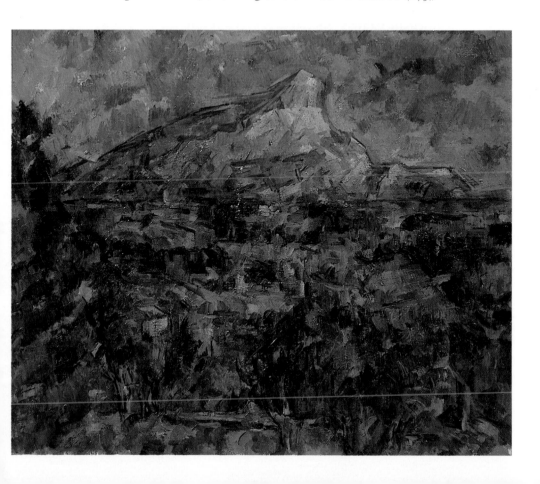

of 1904–6, in which thick layers of seething paint virtually transform Cézanne's patchwork system into vibrating, molten marks of colour, is usually considered among the last in the heroic late series. As in other of these works, even the sky is animated by dense patches of blue and green, so heavily worked that they are no longer figurative but retain their identity as paint. Though Cézanne still voiced doubts, as he wrote to his son, about his ability to 'attain the intensity that is unfolded before my senses', or to capture 'the magnificent richness of colouring that animates nature', the artist's expressive force and triumphant presence in front of his motif are here unmatched.

Surrounded by sparse furnishings, familiar objects and reproductions of earlier art, Cézanne also painted at Les Lauves his last still lifes, portraits and three large canvases of female bathers. Special slits were cut into the north wall of his studio to accommodate the latter, which were too big to be carried down the winding stairs to the door, and they vie with the series of Les Lauves landscapes as the crowning achievements of his prolific late years.

Throughout this period, Cézanne had continued to paint large ambitious canvases of nudes in the landscape, fantastic hybrid constructions that draw together his endless fascination not only with figure and landscape painting but with the polar realms of imagined and experienced (or at least sensate) motifs. Though usually more populous and marked by a range of fluid painting techniques, the late bathers canvases, to a remarkable degree, build on conventions that the artist had rehearsed in his nudes from the middle period. Once more spawned by earlier art, his own painting and his still vivid imagination (and thus shunning all signs of contemporaneity), Cézanne's late bathers continue to inhabit, for the most part, segregated spheres, and their gendered domains vividly determine their thematic and pictorial formats. For all their brilliant

originality and mythic formative role in the early modernist vocabulary of the figure, however, Cézanne's final paintings of bathers, like those of his earlier career, function most fully within the culture and logic of his own era.

Although his paintings of female nudes are now much better known, Cézanne's masterful painting of male bathers, *Bathers at Rest* (see 99), was his most famous work in the 1890s. As we have seen, it had represented the artist in the pivotal 1877 Impressionist show; it was recalled in his monumental *Large Bather* (see 103) of c.1885–7; it garnered further publicity as an infamous part of the Caillebotte bequest; and it hung to considerable acclaim in Vollard's show of 1895 (and, for a while, even in his shop window). Shortly afterwards, the dealer requested that Cézanne produce a transfer drawing of it for a lithograph, which Vollard would reproduce and sell in several editions, adding even further to its renown and identification with the painter. Thus, the celebrated image was far from forgotten in the artist's final years. And in his late paintings of male bathers, Cézanne continued to explore the contextual framework he had established in the 1870s as crucial for the modern subject of the male nude.

Cézanne's *Bathers* of c.1890 (196), larger and more luminous than any of the other late male bathers paintings, is in many ways his culminating painting of male nudes in the landscape. Once more, the artist's robust masculine figures draw their expressive power from the traditional language of the idealized male nude: the athletic standing nude at centre, for example, which Cézanne had studied in a series of drawings and oil sketches, is taken from an antique sculpture in the Louvre of a Roman orator. The same figure (which Couture had also recast in his *Romans of the Decadence* of 1847; see 43) had often anchored Cézanne's smaller canvases of male bathers from his middle period, but it here assumes a new, commanding role. At the centre

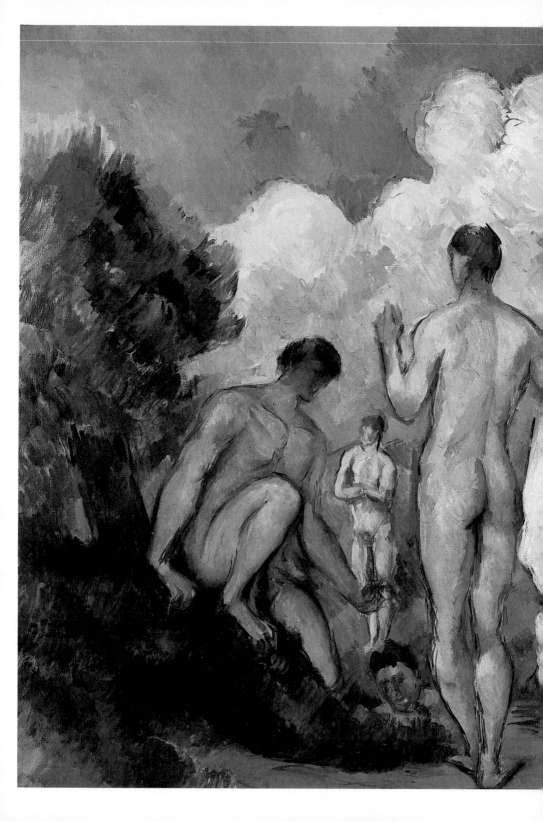

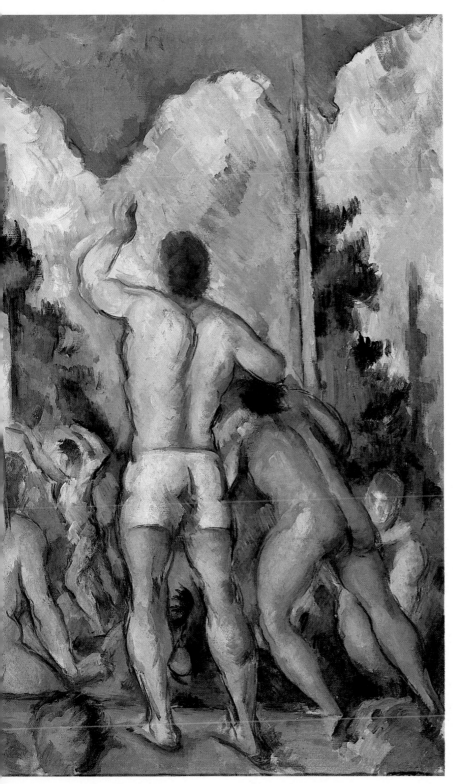

196
Bathers,
c.1890.
Oil on canvas;
60 × 81 cm,
23 ⅝ × 31 ⅞ in.
Musée d'Orsay,
Paris

of the shallow horizontal landscape, this figure's elegant, vertical form is echoed in the mirror figure beyond, the plinth-like trees, even in the creviced folds of his white towel. He is surrounded by perhaps the most unconstrained, vigorously athletic ensemble of nudes in nature that Cézanne ever painted: the lunging figure at far right, the gesticulating male next to him, the diver across the water. Even the clouds, like those in *Bathers at Rest*, seem infused with a carved, muscular sensibility echoing the figures in the landscape. It is hard to imagine a more compelling, even hopeful, image of a vital, physical rejuvenation, a conflation of the corporeal and moral ideal that had long accompanied the tradition of the heroic male nude in art. This discourse hangs heavily over Cézanne's ponderous *Bathers at Rest*, but here it is revived in a jubilant, expansive form.

Reclusive as he was, Cézanne was still attuned to the emotional energy of the time: an image of physical vigour and confidence had particular relevance in the emerging *fin-de-siècle* era. A general aura of decadence and impermanence was once again descending on France, feeding its long-standing anxieties about the nation's physical and moral vitality. In fact, when the contemporary French writer Georges Casella later characterized the art that the listless national culture needed to lift it out of its decrepitude, he could have been describing Cézanne's *Bathers*:

The art that we will like, in fact, does not yet exist. It would be of very sober conception, of the harmonious line with simplicity; it would magnify human beauty, the splendour of the nude, the imperishable joy of healthy flesh; it would exalt the happiness of life, the serenity of the strong, the nobility of natural pleasures.

As subject and image, the male nude had historically been a more public affair than its female counterpart, and frequently one with more universal implications. Thus, in Cézanne's three monumental late canvases of female bathers we encounter the artist on a far more intimate level.

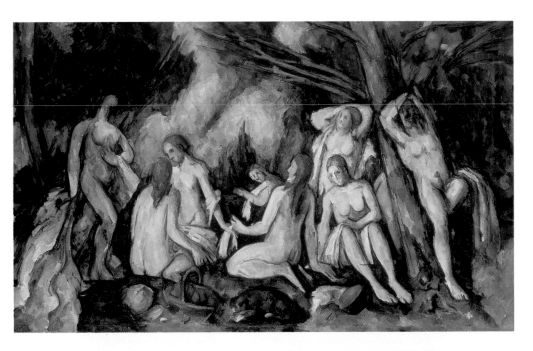

197
Large Bathers,
1895–1906.
Oil on canvas;
133 × 207 cm,
52³⁄₈ × 81¹⁄₂ in.
Barnes
Foundation,
Merion,
Pennsylvania

198
**Émile
Bernard**,
Cézanne in
front of *Large
Bathers*, 1904

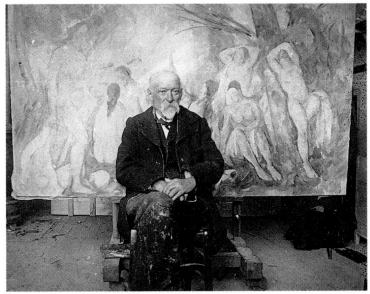

Though they are inscribed, like the *Bathers* in the Musée d'Orsay (196), with the painter's exalted ambitions to perpetuate in his art the eminent traditions of the Old Masters, they also resonate with Cézanne's long-standing private fascination with the subject of the female nude. As with his landscapes, he seemed astonishingly able, at a late and infirm age, to ask old questions in new ways. Although they date as a group to the artist's last decade, share some pictorial elements in common and may even have been worked on simultaneously, Cézanne's three late paintings of *Large Bathers* differ significantly in terms of composition, execution and thematic impulse.

The probable chronology of these works, for which there is considerable evidence, is key to understanding the singularity of each. We know from Vollard that one version, probably the painting now in the Barnes collection (197), was begun in 1895 and still in progress when the dealer sat for his portrait in 1899. And its crude, paint-laden surface is only one indication that this canvas was later reworked: in 1904, Émile Bernard captured Cézanne in front of the Barnes canvas (198), but the photographed painting differs significantly from the present work. The London version (199), begun a few years later, was still under way in the painter's final years, while the third and largest picture, now in Philadelphia (200), was painted quickly in the last months of Cézanne's life.

In both its raw, turbulent texture and visceral imagery, the Barnes version of the late bathers theme harks back, as has often been pointed out, to the primordial paintings of sexual anxiety that date to Cézanne's first decade. Vestiges of the abrasively erotic nudes, phallic landscapes and picnic still lifes from his first *Temptation of Saint Anthony* (see 42), the early *Déjeuner sur l'herbe* (see 48) and early bathers canvases seem to bring us full circle, as if the artist needed to touch a primal base in his own art before undertaking his

final, harmonious restatements of the theme. Recollections of his own barbarous nudes share space with those of other masters: for example, the kneeling nude at centre refers to an antique Venus he copied in the Louvre, and just beyond we see a memory of an early Manet nymph.

The most disconcerting elements in this dark, congested landscape are the two standing nudes at either side, who bear the marks of some of Cézanne's most heated reworkings. As several recent scholars have noted, not only their framing position but charged, ambivalent sexuality situate them outside his cryptic narrative. The leftmost nude, who drags a voluminous white sheet, has been radically altered from its ancestor in Bernard's photograph: the figure is smaller now and its bald head replaced by a huge, literal phallus. And the flanking figure at right has been brutally assaulted on the canvas, its sex and even its eyes, like those of Cézanne's sightless *L'Éternal féminin* (see 93), gouged out, carved away, as if offensive or threatening. Perhaps, as in his *Bathers at Rest*, Cézanne's frustration here with what he saw as his inability to realize the fullness of his vision is reflected on that tortured physical surface. Clearly, in both

199
Large Bathers,
1894–1905.
Oil on canvas;
136 × 191 cm,
53¹₂ × 75¹₄ in.
National
Gallery,
London

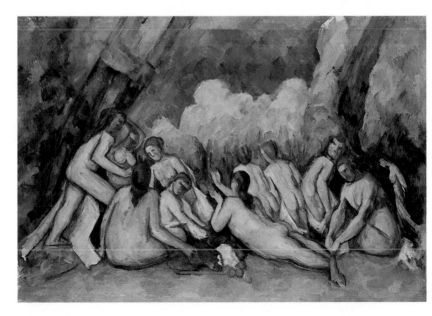

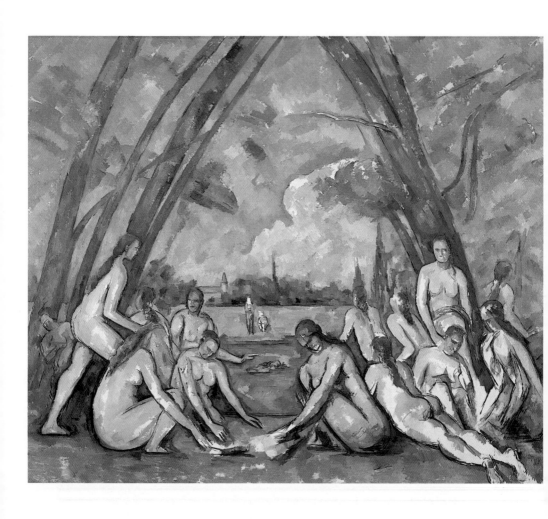

200
Large Bathers,
1906.
Oil on canvas;
208 × 249 cm,
82 × 98 in.
Philadelphia
Museum of Art

its imagery and material state, the Barnes painting holds, as T J Clark has written, 'a staging of some ultimate sexual material' for the aged artist, one that is as fascinating in its savage intensity as it is irretrievable.

Although the London version of the *Large Bathers* (199) was also the product of a protracted campaign by Cézanne, the painting's mood is ineluctably becalmed: its battle scars are few, its palette brighter, the artist's composition still built around triangular groupings but more contained, his figures (the cast has now swelled to eleven) less erotically charged. And though thick, the paint is evenly applied in successive layers to produce a kind of lustrous overall texture that seems more appropriate to its sensual subject. Marked by broad areas of opaque colour, the canvas is unified by its polished surface and limited palette: the rich Prussian and deeper blues that Cézanne often preferred in his late works, for example, are here used for sky, trees and the contours of the loosely rendered nudes, and likewise tinge the clouds and drapery. Only the pensive, underscaled figure at far right who strides into the pyramidal scheme and brings to it a dark memory of a lingering romanticism interrupts Cézanne's tranquil, painterly vision.

The *Large Bathers* painting in Philadelphia (200) has always been seen as the artist's grand, conclusive restatement of the theme that had for so long exercised a powerful hold on his imagination. Its epic scale, its graceful, open space (finally there is room for water), the vault of arcing trees that reflect and enshrine the triangles of nudes below and the subtle parity it establishes between figure and landscape have conferred upon the painting the stature of a modern masterpiece. Its triumph for the painter, however, was essentially one of its surface, which is flatter, thinner and far less laboured than the two preceding versions. Many of the nudes and figural groupings are quoted quite literally from the earlier canvases but are integrated more fully and,

most of all, effortlessly, into the whole. For example, the prone, diagonal figure, whose tangible, misshapen foot in the London painting revisits all of the wilful ineptitude of the past, is rendered here only schematically, but the effect is somehow far more satisfying and complete. And the exquisite twin figures viewed from behind at right stiffen against a dense wall of greenery in the second painting, but here descend gracefully as a pair into the water and into the open weave of Cézanne's cool, ethereal surface.

In the Philadelphia painting, there are now fourteen bathers on the shore and also figures in the distance, and the newcomers add much to Cézanne's equation. A swimmer at centre lends a touch of reddish-ochre to the water, and on the far bank two small, unreadable figures look on, mirroring the position of the viewer. Most interesting, as the art historian Tamar Garb has shown, is the crouching nude at far right, whose rounded shoulders and muscular, extended arms should also be read – simultaneously – as legs and buttocks for the standing nude just behind. Other pictorial subtleties, such as the hand of the tall, striding nude at left that merges with the figures kneeling before her, fill the ample canvas. It is the painter's refusal to finish and assign such forms that makes them so compelling, not as subjects but as visual emblems of his process.

As in his late paintings of Mont Sainte-Victoire (**eg 195**), where patches of colour cling to their identity as paint and boldly declare the artist's hand, Cézanne forces us to confront painting as an animated, exploratory exercise. Even in the case of the female nude – the most impassioned realm of his manifold creative sphere – the viewer's attention is wrenched away from the image to focus on the fluid means and process of its construction. This is why the open, flat, in parts even bare, surface of the Philadelphia *Large Bathers* is not, as has often been maintained, unfinished. What it brings to fruition is the power of the painter's mark, the

201
Maurice Denis,
Homage to Cézanne,
1900.
Oil on canvas;
180 × 240 cm,
71 × 95 in.
Musée d'Orsay, Paris

immediacy of visual sensation that Cézanne had struggled
for a lifetime to achieve and here confers, with humility and
masterful detachment, upon what is essentially an imagi-
nary subject. Its surface, in fact, is not only sparsely painted,
but peaceful. Bereft of the familiar signs of *angst* and
struggle, we sense within it the artist's letting go; he'd won.

By 1906 Cézanne was finally enjoying considerable acclaim
and critical exposure: Vollard had organized several more
successful showings of his work, including one in 1905 devot-
ed to watercolours, and the artist's paintings had figured in
the 1900 Universal Exposition in Paris and others devoted to
modern art in Brussels, The Hague, Vienna, Berlin, London
and even in that most parochial of venues – Aix. In addition,
he regularly showed works at the Salon des Indépendants, a
large uncensored exhibition in Paris structured like those of
the Impressionists and sponsored by the Société des Artistes
Indépendants. At the related subsequent Salon d'Automne,
a large, posthumous retrospective in 1907 would establish
definitively the breadth of Cézanne's achievement.

By then, a small coterie of young poets, writers and artists
had made a pilgrimage to Aix to meet him, and the solitary

old painter was moved by these signs of reverence and respect, so long denied. In his *Homage to Cézanne* (201), a painting exhibited in Paris in 1901, Maurice Denis portrayed a number of the artist's better-known admirers and followers, trying to capture, as he wrote to Cézanne, 'the admiration which you evoke and the enlightened enthusiasm of a group of young people to which I belong and who can rightly call themselves your pupils, as they owe to you everything which they know about painting.' But even these lustrous last years had their occasional dark moments. Cézanne's art was still viciously attacked in the press, and the painter, often unstable and infirm (his letters to his son in 1906 record his progressive suffering from diabetes), at the end of his life withdrew even more into his work.

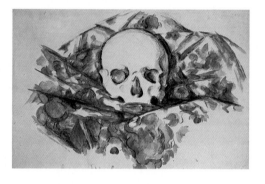

202
Still Life: Skull,
c.1902–6.
Pencil and
watercolour;
31·7×47·6cm,
12^1₂×18^3₄in.
Private
collection

203
*The Garden at
Les Lauves,*
c.1906.
Oil on canvas;
65·5×81·3cm,
25^3₄×32in.
The Phillips
Collection,
Washington,
DC

Recognition of Cézanne's instinctive and brilliant restructuring of the discourse of painting itself on the surface of his canvases, and its effect on the art of his final years, came only slowly. Thus debates about the question of 'the unfinished', or what became for the aged artist an almost perpetual inability to cover his surfaces with paint, long loomed almost as large in Cézanne scholarship as those that persist today concerning the chronology of his *œuvre* as a whole. Even to the painter, whose moments of hope continued to be shadowed by doubt, this new path seemed at times a daunting one. As he wrote to Bernard in 1905, 'I believe I have in fact made some more progress ... It is,

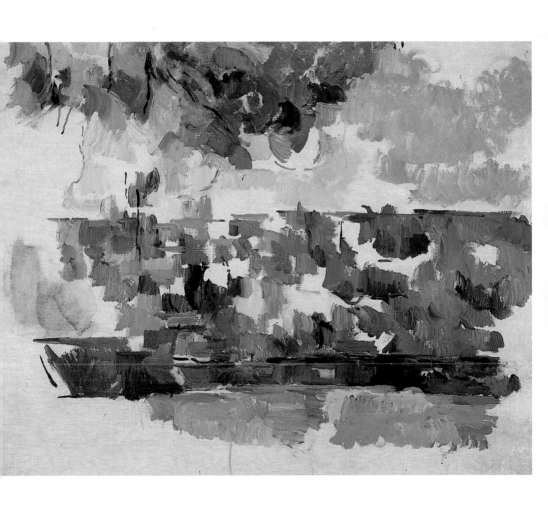

however, very painful to have to state that the improvement produced in the comprehension of nature from the point of view of the picture and the development of the means of expression is accompanied by old age and a weakening of the body.' To his son he likewise noted, 'I regret my advanced age, because of my colour sensations.' Though fragile, he continued to the very end to work towards mastering those sensations, in beautiful late watercolours of bathers, landscapes and even still lifes of skulls (*eg* 202) that would be morbid but for the fact that they are so lyrical and delicately wrought, and in subjects for his paintings that he studied from nature.

Cézanne died on 23 October 1906, a week after being caught in a violent thunderstorm as he painted in the landscape around Les Lauves. Yet even his last paintings are marked by brilliant discovery and summations of all that he had achieved. An epitome of these final months has to be the radiant *Garden at Les Lauves* (203), a painting so spare in its means and so rich in its effects that its subject is not immediately apparent. With short jabbing strokes of brilliant colour, brief, dashed lines, touches of thin wash and an astonishingly bold use of the exposed primed canvas, Cézanne captures once more the vital, organic unity of nature that had become the very substance of his art. If, in its dazzling economy, it was a vision that could inspire future generations, it was for Cézanne a truthful, intuitive and, in the end, impassioned attempt faithfully to record his perception of the world he knew.

Epilogue

Even before his death in 1906, Cézanne was celebrated in
Paris as a forefather, and a crucial aesthetic force whose
influence on a new generation of avant-garde painters had
become virtually inescapable. 'Cézanne, you see,' Matisse
would explain, 'is a sort of god of painting. Dangerous, his
influence? So what? Too bad for those without the strength
to survive it.' Equally telling was the account of the young
German Paula Modersohn-Becker (1876–1907), who, recalling
her first visit to Vollard's gallery, described the lasting effect
of Cézanne's work on her own in a letter to Clara, Rainer
Maria Rilke's wife, 'He was one of the three or four painters
who has acted upon me like a thunderstorm and a great
adventure.' And she would portray Rilke himself in a boldly
expressive portrait that both resembled one of the early
Uncle Dominique paintings that the dealer had in stock, and
also embraced Cézanne's new vision of portraiture itself.
And Cézanne's successive shows at Vollard's and larger salons,
the formidable cache of paintings kept by Vollard, and even
the artist's mythical status as a renegade and solitary south-
erner in the Parisian art world, helped to shape Cézanne's
critical status in the annals of early modernist art.

In the first decade of the twentieth century, in fact, an era
of prolific artistic invention in France, Cézanne cast one
of the most imposing shadows. Not only his formal innova-
tions but the perceived classical tradition and uniquely
Mediterranean flavour embodied in Cézanne's art would
find rich and varied reflections in the work of his most
gifted first followers.

For Henri Matisse, as we have seen, André Derain and their
fellow painters who were branded as *Fauvists* (or 'wild

204
Pablo Picasso,
*Boy Leading
a Horse,*
1906.
Oil on canvas;
220·3 ×
130·6 cm,
86¾ × 51¼ in.
Museum of
Modern Art,
New York

beasts') at the 1905 Salon d'Automne because of their ferocious colour, Cézanne's bathers would constitute a rare hybrid breed: their primal awkwardness – proof of his uncorrupted originality – was matched by a seemingly instinctive classicism that linked him to Poussin and to the French classical tradition as a whole. And in the Fauvists' paintings of nudes, the progeny and pertinence of Cézanne's dual legacy for their art were evident. Matisse would always treasure his small canvas of Cézanne's *Three Bathers* (see 94), which he had bought in 1899, and would turn to Cézanne throughout his long career as a virtual sourcebook for formal inspiration, colour harmonies and compositions of monumental grandeur. But in such timeless images from his Fauvist years as his large mural *Joy of Life* of 1905 or his famous *Blue Nude* of 1907, Matisse both extended Cézanne's revived classical vision and affirmed its quintessential cultural lineage for France and for modernist painting in an age that was still pervaded by a potent nationalist climate.

If Cézanne's bathers could inspire, or even validate, the arcadian pastorals so central to the Fauvist aesthetic, they were equally crucial, as we have seen, to what may have been their antithesis in these same watershed years: Picasso's raw, sexually charged paintings of barbaric nudes and prostitutes, such as his *Demoiselles d'Avignon* (see 95) of 1907 or *Three Women* of 1908. Years later, Picasso would capture the strikingly personal input in such works that so commanded his attention, noting: 'What forces our interest is Cézanne's anxiety, that's Cézanne's lesson ... the rest is a sham.' And in his own painting Picasso laid bare both the sexual undercurrents and pictorial processes that shaped this new vision of the nude.

But the Spanish painter also understood the heroic traditions the artist had revived in his monumental male figures. Even before completing his historic *Demoiselles d'Avignon*,

Picasso had enshrined Cézanne's *Large Bather* (see 103) within his own paean to the classical tradition, *Boy Leading a Horse* (204) of 1906: the massive scale, forceful stride, rigid posture and defined contour of Picasso's figure, as well as the schematic and planar landscape he inhabits, align the later work with Cézanne's prescient, iconic nude of c.1885–7.

Just as his evocative figure paintings were transforming the genre and image of the nude in the first years of the twentieth century, Cézanne's landscapes were inspiring a new formal lexicon of their own. It must have been, at least in part, the sunlit Mediterranean colours and brilliant formal contrasts the artist discovered at L'Estaque that drew Georges Braque to its dramatic terrain in the autumn of 1906 and again in the following two years. Like Picasso, Braque would absorb the lessons of Cézanne's new figural mode, and in such works as *Large Nudes* of 1907–8 even translating Cézanne's signature constructive stroke into a connective tissue of paint (or *passage*) that ties figural and spatial planes together on his fluid and flattened surface. But at L'Estaque, Braque explored even more boldly the

205
Georges Braque,
Houses at L'Estaque,
1908.
Oil on canvas;
73 × 65·1 cm,
28³⁄₄ × 23⁵⁄₈ in.
Kunstmuseum,
Bern

implications of Cézanne's new formal systems, and in the landscapes he painted there we see most clearly Cézanne's generative role in the early years of the Cubist movement.

Vestiges of Cézanne's ordered classical landscapes underly such stable harmonious views painted by Braque in 1907 as his *Viaduct at L'Estaque*. And in such later works as *Houses at L'Estaque* (205) of 1908, Cézanne's example looms even larger: the warm Provençal palette, solid geometric forms framed by arching trees, even the short parallel strokes of paint, are all strikingly familiar. Yet here, Braque's subtle manipulation of Cézanne's pictorial syntax thrusts his work into the more abstract realm that Cubism would inhabit: within Braque's shallow, relief-like composition light and shadow fall in arbitrary patterns, the emphatic geometry of his forms defy a single, coherent perspective, and the dense space of his airless landscape, lacking even a horizon, pushes his image forward onto the shifting, animated surface that subverts the resonant sensations before nature that Cézanne's landscapes had always celebrated.

Thus, Cézanne's formative impact on the radical new art that ushered in the twentieth century can hardly be overstated. As the art historian William Rubin has shown, successive avant-garde painters throughout the century often viewed Cézanne's art through the lens of these first disciples' works, and the results could be imitative and weak or strikingly bold, but all of them inconceivable without his example. But as we look back at the art of an entire century that has been so decisively shaped by the possibilities allowed in Cézanne's revolutionary new vision, we must also continue to assess his place within his own distinctive era and culture. Cézanne's art and voice were not only those of a prophet but of a pioneering painter firmly grounded in history and in the historic traditions and genres he would so boldly transform for the legions of followers – and viewers – who were to come.

Glossary

Barbizon School A group of French painters who worked in the environs of the village of Barbizon, near the Forest of Fontainebleau (and elsewhere), and included Corot, Théodore Rousseau (1812–67), Millet and **Daubigny**. Working from the early 1830s to the 1870s, an age of growing industry and urbanism, the Barbizon circle became known for humble rural landscapes and peasant genre scenes. Equally unconventional were their unidealized compositions and sketch-like techniques of painting with broad, rough strokes from a palette of greens and earthtones, both based on their truthful observations of nature. As a whole, the Barbizon technique and approach to landscape provided crucial precedents for Impressionism; some of their group, especially Daubigny, also offered the young Impressionists public support.

Constructive Stroke Cézanne's distinctive overall system of disciplined, short, parallel and usually diagonal brushstrokes that appears in some of his works in the late 1870s and more consistently in the early 1880s. A technique he jealously guarded as his own, it lent a rigorous and tactile order to his motifs, both imagined and observed. His constructive-stroke paintings seem to have been particularly prized by his colleagues. A hallmark of Cezanne's middle period and used much less often in portraits than in his work in other genres, passages of short diagonal brushwork can be found in later canvases in conjunction with other techniques, but are usually rendered more loosely or with thinner pigments.

École Provençal An informal school of landscape painters established in Marseille in the 1850s under the leadership of Émile Loubon (1809–63). Including such regional artists as Prosper-Joseph Grésy and **Paul Guigou**, the group's distinctive style was characterized by its bold impasto and high-keyed palettes that conveyed the dramatic textures and brilliant light of the Provençal landscape. Often these artists employed large, horizontal canvases and panoramic viewpoints to capture the rugged beauty and epic scale of their native terrain. Their work was frequently shown at regional exhibitions, but by the 1860s their art was recognized at the Paris **Salon** and often applauded by critics as products of a distinctly Provençal school.

Le Félibrige An association of Provençal poets, established in 1854, who spearheaded in their own era the cultural revival of Provence that had begun earlier in the century. Their foremost member was the writer Frédéric Mistral, whose poetic evocations of the Provençal landscape extended the influence of the group far beyond its immediate literary circles.

Franco-Prussian War Though Napoleon III's France had earlier dominated Europe, Prussia's defeat of Austria in the Seven Weeks' War of 1866 posed a critical threat to French supremacy. After trying unsuccessfully to block the ascent of a German prince to the Spanish throne, France declared war on Prussia in July 1870. Far better-trained and better-armed Prussian forces made light work of the French army and on 2 September Napoleon III capitulated. Within weeks Paris was under siege and suffered bombardment and famine before signing an armistice on 28 January 1871. In the Treaty of Frankfurt France agreed to pay an indemnity of five billion francs within three years and also lost most of Alsace-Lorraine. Not only the war but also the humiliating loss of these eastern provinces shaped the climate of animosity that would draw these two powers into conflict again in the early twentieth century.

Hierarchy of Genres The official ranking of artistic themes, as perpetuated by the Academy, its **Salons** and patrons. Demanding and exalted subjects from historical, literary or biblical sources were determined as superior to all others because they were conducive to public edification and heroic treatment. Thus defined, History Painting dominated at the Paris Salons in the late eighteenth and early nineteenth centuries, with Jacques-Louis David's *Oath of the Horatii* (1784) serving as a paradigm. Napoleon I would often use the stock motifs and massive scale of history painting for his own propaganda. But in the wake of the Napoleonic empire, the parameters of history painting expanded to include anti-heroic, contemporary tragedy (Théodore Géricault's *Raft of the Medusa*, 1819), modern political allegory (**Delacroix**'s *Liberty Leading the People*, 1830) and even to embrace a new category, the historical landscape, whose acceptance did much to raise the lesser status of landscape painting in the nineteenth century. After the 1848 Revolution, the Realist painter **Courbet** brazenly challenged the hierarchy of genres as a whole in his *Burial at Ornans* (1849–50), which echoed in format and imposing scale but not in its peasant subject the increasingly moribund tradition of history painting. Additionally, Courbet's views of his native Ornans revealed a new regionalist sympathy and meaning for landscape that Cézanne would later discover in Provence. **Manet**

likewise turned away from the staid academic hierarchies of the past and, with a new focus on the painting of everyday life that was crucial to later Impressionists, breathed new life into the realms of figure painting, still life and portraiture.

Paris Commune At the end of the **Franco-Prussian War** (1871), Parisians opposed both the national government in Paris, established under Adolphe Thiers, and the National Assembly that had retreated to Versailles, as too conservative and too accepting of the humiliating terms of the peace with Prussia. Unable to disarm the Parisian national guard, Thiers fled to Versailles in March, and Parisians elected a largely left-wing governing council, the Commune of 1871. To regain control, loyal national troops began a siege of the city (11 April) culminating in government soldiers storming the city and killing 25,000 suspected Communards in the infamous Bloody Week (21–8 May). Lingering memories of such brutal reprisals poisoned political relations between radicals and conservatives for many years afterwards.

Plein Air The practice of painting outdoors, directly from the observed motif, so that the transient effects of light and atmosphere can be captured firsthand. Usually associated with the Impressionists, painting *en plein air* was a common practice at least as far back as the late eighteenth century, when artists produced small, vibrant oil sketches of specific motifs studied in nature that served as source material for larger, more formally composed landscapes they painted in the studio. Later, the Aixois painter **François-Marius Granet** produced countless *plein-air* landscapes in Italy and in his native Provence. For the **Barbizon school**, *plein-air* painting was a crucial means of assuring the truthfulness that distinguished their rural landscapes. But, while many of their canvases were painted indoors, it is only with the Impressionists that the *plein-air* landscape became uniformly regarded as the final and finished product in itself.

Salon/Salon des Refusés Although the Paris Salon originally served as the official exhibition for members of the French Academy (founded in 1648 under royal patronage), in post-revolutionary France it was opened to all artists. Early nineteenth-century Salons remained modest in size, but as the number of submissions grew (from 485 exhibited works in 1801 to 3000 works in 1831), a jury system was established and was quickly dominated by academicians who rewarded artists who conformed to academic norms. The Salon grew in popularity and prestige, drawing as many as one million visitors in 1841 and wielding a huge influence over the fate of many French artists. At mid-century it was the only real forum where artists could establish a public reputation and attract significant commissions. Even vanguard painters such as **Manet** would strive throughout their careers to be successful at the staid, official Salons. By the 1860s, however, as the number of rejections grew and the jury system became marked by abuse, protests mounted. In 1863, Napoleon III, ever wary of dissent, authorized a Salon des Refusés, a temporary exhibition where critics and the public could judge the rejected works for themselves. Although Manet's *Déjeuner sur l'herbe* was a success (Cézanne's submissions cannot be identified), few artists benefited from the negative overtones. In the early years of the **Third Republic**, the influence of the Academy began to weaken at the Salon; by 1881 jury members were entirely elected by fellow artists, competing exhibitions were frequently organized in Paris by independent artists' societies (including the Impressionists) and a new generation of art dealers began to shape the avant-garde art market for their bourgeois clientele.

Second Empire Elected president of the Second Republic after the revolution of 1848, Louis-Napoleon Bonaparte (nephew of Napoleon I) extended his term by seizing absolute power in a *coup d'état* in December 1851 and proclaiming himself Emperor Napoleon III. Though his reign was marked by an autocratic regime and misguided foreign policy, the Second Empire was an era of economic growth, prosperity and colonial expansion. After a wave of strikes and protests, Napoleon III instituted more liberal measures in 1869, but their effects were short-lived, as his empire ended with the onset of the **Franco-Prussian War**.

Third Republic The Third Republic was proclaimed after the capture of Napoleon III by the Prussians in 1870, and its provisional government faced immediate civil dissension. After the bloody suppression of the **Paris Commune** by Adolphe Thiers, the royalist sympathizer Marshal MacMahon, a former leader of anti-Communard forces, was elected president in 1873 with a mandate for a restoration of order. His repressive, authoritarian government lasted until 1879, when Jules Grévy steered the nation onto a more moderate, stable course. The 1880s saw the expansion of railroads, public education, military conscription and a restored nationalist pride. But in the following decade France was severely shaken by the Dreyfus Affair, which discredited monarchists, brought moderate leftists into power and made socialism a major political force in the years leading up to World War I.

Les Vingt (Les XX) A jury-free, independent exhibition society, originally with twenty members, which held annual shows in Brussels between 1884 and 1893 organized by Octave Maus. With a broad international scope to its exhibitions, the group sought out young artists from London, Paris and the USA; Cézanne was one of several French painters invited to exhibit in its 1890 show. Emphasizing not only the fine arts but also literature, music and the decorative arts, the group hoped to provide a range of avant-garde alternatives to established academic models.

Brief Biographies

Frédéric Bazille (1841–70) The son of a wealthy family of vintners in Montpellier, Bazille moved to Paris in 1862 and enrolled in both a medical faculty and the painting studio of Charles Gleyre (1808–74), where he met **Monet**, **Renoir** and Alfred Sisley. After failing his medical exams in 1864, he devoted himself to painting and became especially close to Monet. As part of the Café Guerbois circle, Bazille helped with preliminary plans for the group's independent exhibitions and his studio on the rue de la Condamine (immortalized in one of his last paintings) became a frequent meeting place. However, during the **Franco-Prussian War** he enlisted and was killed in action.

Émile Bernard (1868–1941) Having absorbed the lessons of Impressionist and Pointillist painting, Bernard worked very closely with **Gauguin** between 1888 and 1891 and developed a canon of Pictorial Symbolism that would shape his own and some of Gauguin's Breton paintings. Later, Bernard became briefly associated with the Nabis. But he was already an ardent admirer of Cézanne's work, and wrote his first article about the painter in 1892. Bernard sought out Cézanne in Aix in 1904 and, as prolific a theoretician as an artist, attempted to engage the aged painter in discussions of his views about art. Bernard published them in a series of enthusiastic if not always accurate essays, later collected in his *Souvenirs sur Paul Cézanne* (1926)

Victor Chocquet (1821–91) A minor customs official in Paris, Chocquet was a passionate art lover and collector, at first buying paintings by **Delacroix** and then, in 1875, by **Renoir**. On Renoir's recommendation, he also bought his first painting by Cézanne that year at **Tanguy**'s paint shop. Shortly afterwards, he met the artist and became a friend and patron. Chocqet lent a number of his Cézanne canvases – including a heavily worked portrait of himself – to the third Impressionist exhibition (1877), where he staunchly defended Cézanne's works to dismayed critics and viewers. Both in his letters and commissions he also offered the struggling artist crucial support in the late 1870s and 1880s, and assembled the first important private collection of Cézanne's art. Following the death of his widow, the sale of these paintings at auction in July 1899 introduced many new collectors to the artist's work.

Gustave Courbet (1819–77) A native of rural Ornans in eastern France, Courbet established himself as the leader of the Realist movement in Paris in the late 1840s with such massive, unvarnished views of everyday life as his *Burial at Ornans* (1849–50). Though he acquired a small band of patrons, Courbet continued to court controversy throughout the following decade, and in 1855 set a crucial precedent for later avant-garde painters when he opened his own one-man exhibition across from the Universal Exposition. And even in the 1860s, when **Manet** was the new champion of the Realists, the older painter's influence was still widely felt: **Monet**'s first landscapes reflected his work, and Cézanne's portraits of Uncle Dominique of 1866 extended the palette-knife technique of Courbet's landscapes into a new figural genre.

Charles-François Daubigny (1817–78) Daubigny studied with several minor academic painters in Paris before turning to landscape painting in the Forest of Fontainebleau. Though he would always be criticized for his sketchy execution and lack of finish, Daubigny became a fixture at the Paris **Salon** at mid-century. A member of the **Barbizon school**, he was known for his riverscapes and attention to fleeting atmospheric effects. In 1866 he was elected to the Salon jury. Daubigny's enthusiasm for many vanguard young painters, including Cézanne, brought him additional notice late in his career. He resigned from the Salon jury in 1870, when a painting by **Monet** was rejected, and spent his last years in Auvers-sur-Oise, attracting the aging artists Corot and Daumier to join him in the village where Cézanne also painted.

Edgar Degas (1834–1917) Born into a wealthy, aristocratic family, Degas studied briefly at the École des Beaux-Arts in Paris and then in Italy, dreaming of becoming a history painter. His earliest studies suggest the rigorous draughtsmanship that would always be central to his art. But in the 1860s, Degas was exposed to the work of **Manet** and the early Impressionists, and his own painting took a crucial turn towards more contemporary subjects carefully studied from life. Although he would participate in all but one of the Impressionist group shows, Degas defined early on the specific and realist focus of his own work: urban scenes of horseraces, the ballet, cafe habitués, bourgeois interiors and penetrating portraits made up the bulk of his Impressionist works. At the last show (1886), Degas included a stunning suite of pastel bathers that announced one of the major themes of his late career, as well as his interest in other media. His success allowed him to form a formidable collection that included several of Cézanne's canvases.

Eugène Delacroix (1798–1863) The leading figure of the French Romantic movement whose loose brushwork, vibrant palette and emotional literary and historic themes formed a vivid antithesis to the remote classicism of his contemporary and lifelong rival, Jean-Auguste-Dominique Ingres, Delacroix profoundly influenced such later painters as Cézanne and Picasso. In the large canvases and decorative cycles that punctuated his career, Delacroix explored a vivid fascination with Orientalism, the volatile political climate of his era and the epic themes of antiquity, while in his oil sketches and watercolours he developed a vibrant technique and explosive range of colour that matched his choice of subjects and came to embody, in the eyes of his followers, the essence of his brilliant originality.

Achille Emperaire (1829–98) Like Cézanne, Emperaire studied at the municipal drawing school in Aix with Joseph Gibert before moving to Paris. He too worked in the Académie Suisse in the 1860s, and it was here that the two painters probably met. But although Cézanne respected his artistic gifts, paid him tribute in an important early portrait that also highlighted his stunted physique, and shared his company even in his old age, Emperaire enjoyed little success, as Cézanne noted in sympathetic letters to **Zola**. He died in abject poverty in Aix.

Gustave Flaubert (1821–80) Born in Rouen to a prominent physician, Flaubert suffered a nervous breakdown as a young law student and turned his attention to writing. The range of his work was broad: it could incite contempt for French bourgeois society (*Madame Bovary*, 1857), inflame a romantic taste for the exotic (*Salammbô*, 1862), or evince a bitter satiric edge (*Bouvard and Pecuchet*, unfin.). Flaubert's extravagant and visionary *Temptation of St Anthony*, published in its final version in 1874, offered a compelling vehicle for self-revelation for both the author and Cézanne, who drew from it some of his early sensual themes. And though Flaubert's public notoriety was ensured when he was prosecuted for immorality following the publication of *Madame Bovary*, his genius was recognized by many of the literary giants of his day.

Joachim Gasquet (1873–1921) The son of Henri Gasquet, one of Cézanne's childhood friends, Joachim Gasquet was a regional poet and later a member of **Le Félibrige**. His writings reveal his early attraction to Symbolist literature, his strong provincial sympathies and devout Catholic faith. Gasquet met Cézanne in 1896, and is remembered above all for his biography and dramatized recollections of the painter's thoughtful musings about art. These works reflected the nationalism of postwar France from a regionalist perspective, an interpretation that would both fascinate and frustrate later Cézanne scholars.

Paul Gauguin (1848–1903) Born in Paris, Gauguin lived in Peru as a child, and

travelled widely before returning to Paris after the **Franco-Prussian War** to become a stockbroker. He also studied painting and through **Pissarro**, with whom he would sometimes work, Gauguin was introduced to the Impressionists and participated in their later exhibitions. After the stockmarket crash of 1882 he turned entirely to painting, and in the later 1880s led the Pont-Aven group in Brittany, painted briefly in Martinique and with **Van Gogh** in Arles. His search for timeless primitive themes and expressive forms would lead him to lengthy stays in Tahiti in the 1890s and finally to the Marquesas Islands, where he would build his own allusive iconography with forms derived from Western and Oriental traditions.

Gustave Geffroy (1855–1926) A vanguard writer, critic and close friend of **Monet**, Geffroy contributed art criticism to Georges Clemenceau's paper *La Justice* in the 1880s and *Le Journal* from 1893. He supported many unrecognized artists of merit, among them Cézanne, whom he first applauded in an article in *Le Journal* in 1894 and whose paintings he also collected.

François-Marius Granet (1775–1849) A native of Aix, Granet studied with the Provençal landscapist Jean-Antoine Constantin (1756–1844) there before making his first brief trip to Italy in 1802. The following year he returned to Rome and would remain until 1824, becoming a leader of the community of French artists and friends with Ingres, among others. His Italian landscapes, including many small, **plein-air** oil sketches, offer exquisite testimony to his prolific output in these years. And Granet's reputation in Paris and at the **Salon**, grew accordingly. In 1826 he moved to Paris to become a curator at the Louvre, and in 1833 was asked by King Louis-Philippe to organize a history museum at Versailles. Granet left the bulk of his estate to the Aix museum, which became the Musée Granet.

Paul Guigou (1834–71) Born near Apt, as a young man Guigou moved to Marseille, where he later studied law. He also sketched in the nearby countryside, became a follower of Émile Loubon, the leader of the **École Provençal**, and exhibited at provincial venues. After moving to Paris in 1862, Guigou showed regularly at the **Salon**, but returned every summer to Provence, which remained the focus of his work. While his early painting is marked by a bold impasto and high-keyed palette, Guigou's later work is much more subdued, despite the fact that he knew the Café Guerbois group in Paris.

Armand Guillaumin (1841–1927) Guillaumin met Cézanne at the Académie Suisse in 1861, introduced him to **Pissarro** and later painted with them in Pontoise where he knew Dr Gachet. One of the lesser-known Impressionists, he took an active role in their group shows, and became known for his industrial landscapes. Guillaumin supported himself as a railway worker, but in 1891 his winnings from a national lottery allowed him, finally, to paint full time.

Antoine Guillemet (1841–1918) Born into a wealthy shipping family, Guillemet worked early on with members of the **Barbizon school**, and first exhibited at the **Salon** in 1865. At the Académie Suisse and elsewhere in Paris he met **Pissarro**, Cézanne, **Monet** and **Zola**. A lively friend of Cézanne's, Guillemet painted with him near Paris, travelled to Aix and is credited with inventing the colourful names of some of Cézanne's early imaginative works. However, Guillemet never emulated Impressionist painting, and instead showed his work continuously at the Salon. He became a member of the jury in 1882 and was instrumental in getting one of Cézanne's paintings admitted to the Salon that year – the only one ever to be accepted.

Édouard Manet (1832–83) The son of a wealthy civil servant in the Ministry of Justice in Paris, Manet captured in his art the broad new range of urban experiences that shaped bourgeois French life in the 1860s. At eighteen, Manet entered the studio of the academic painter Thomas Couture. Though Manet's own art would focus on contemporary themes and reflect many earlier schools of Realist painting, he continued throughout his career to submit his work to the **Salon**, often with notorious results. His *Déjeuner sur l'herbe*, refused from the 1863 Salon, became notorious at the **Salon des Refusés**. Two years later, his painting of a nude prostitute, *Olympia*, cemented his position in the vanguard of French art; countless later artists, including Cézanne, alluded to it in their work. But although he was a stylish and admired central figure in the Café Guerbois group, Manet refrained from participating in any of the Impressionist exhibitions. In his last years, however, he adopted a brighter palette, freer brushstroke and a new range of **plein-air** subjects that reflected their painting.

Antoine-Fortuné Marion (1846–1900) A friend of Cézanne and **Zola** in Aix, Marion studied painting as a young man and was deeply influenced by Cézanne (for whom he was also a model). His letters to the German musician Heinrich Morstatt are invaluable documents of Cézanne's early career. But Marion's interest in geology and discoveries of fossils and ancient artifacts in the environs of Aix prompted him to give up painting for a career in the natural sciences. He became a professor of Zoology at the University of Marseille and also director of the Natural History Museum there.

Claude Monet (1840–1926) Monet grew up in Le Havre and studied at the Académie Suisse in Paris, where he met **Pissarro**, and then at Gleyre's studio, where he met **Renoir**, Sisley and **Bazille**. After attempting to vie with **Manet**'s figural paintings of the mid-1860s, he turned almost exclusively to landscape. By the summer of 1869, when he painted with Renoir at La Grenouillère, Monet had captured the theme of sunlit, suburban leisure and developed the spontaneous, open brushwork style that would become synonymous with early Impressionism. At the first Impressionist exhibition Monet's *Impression, Sunrise* (1872) became the most famous of several works from which the term 'Impressionism' was coined by critics, and to many his art would continue to define the movement as it evolved. Like many of his peers, Monet's art was transformed after c.1880; dramatic new motifs from a broader spectrum of the French landscape replaced his earlier subjects and inspired new palettes and techniques that expanded the language of Impressionism. By the 1890s, Monet was conceiving of his art in series and enjoying a degree of commercial viability few of his colleagues shared. His success allowed him to collect his friends' work, including Cézanne's.

Camille Pissarro (1830–1903) Born in the Danish (now US) Virgin Islands into a Jewish family of French descent, Pissarro studied there with the Danish artist Fritz Melbye (1826–96) and painted with him in Venezuela. In 1855 Pissarro moved to Paris, attended the École des Beaux-Arts and from 1859 the Académie Suisse, where he would meet **Monet**, Cézanne and **Guillaumin**. In this period he also worked closely with Corot, exhibited at the **Salon**, and began to paint the rural scenes and landscapes that would become the focus of his Impressionist œuvre. In 1866 Pissarro moved to Pontoise but remained in close contact with the Café Guerbois circle and took an active role in organizing the Impressionist exhibitions; he alone would exhibit in all eight shows. In the 1870s Pissarro was joined in the Pontoise area by Cézanne and Guillaumin (and later by **Gauguin**), and they benefited from his encouragement and shared his commitment to rural themes and a rough-hewn Impressionist technique. A socialist and passionate supporter of the peasantry, Pissarro's paintings of his rural subjects often revealed the political sympathies defined more fully in his graphic work. However, after briefly adopting a Neo-Impressionist technique and exploring the politics of French anarchist circles, Pissarro produced in the 1890s a large series of views of Paris, Rouen, Le Havre and Dieppe that were marked by a new sense of energy and that significantly enlarged the range of his Impressionist contribution.

Pierre-Auguste Renoir (1841–1919) Born into a working-class family in Limoges, Renoir was raised in Paris and apprenticed to a porcelain painter. But in 1861 he entered Gleyre's studio, where he met **Monet**, **Bazille** and Sisley, and the following year was accepted at the École des Beaux-Arts. After exhibiting several works at the **Salon**, Renoir began to paint with his friends from Gleyre's studio. In the summer of 1869, he worked with Monet at La Grenouillère, where they established the dazzling palette and fragmented brushstroke that would come to characterize early Impressionist painting. Renoir exhibited at the first three Impressionist shows and established the female subject as central to his work; his success as a portrait painter in the late

1870s brought unprecedented notice and important commissions. But by c.1880, Renoir, like Monet, sought new avenues and travelled to Italy to study the nudes and draughtsmanship of Renaissance masters. His late painting eschewed not only the technique but also the contemporaneity of his earlier Impressionist work, focusing on monumental, mythological nudes and bathers in vaguely Mediterranean settings.

Georges Seurat (1859–91) After studying at the École des Beaux-Arts in 1878–9, Seurat embraced contemporary subjects, both rural and urban, and a calculated new style that would mark his mature painting. Influenced by contemporary scientific treatises on colour theory, Seurat tried to establish a rational basis and method of painting to discipline the rapid technique and spontaneous effects of earlier Impressionism. In such works as *Bathers at Asnières*, which was rejected from the 1884 **Salon**, Seurat transformed the sketchy, Impressionist depictions of bourgeois recreation into a quasi-scientific study of working-class figures at leisure and at odds with their rigorously ordered depiction. His best-known work, *A Sunday Afternoon on the Island of La Grande Jatte*, offered a masterful demonstration of his Pointillist style at the last Impressionist show (1886), and ensured his role as leader of the Neo-Impressionists. Though Seurat's career was cut short, he influenced both a group of young artists that included Paul Signac, and also, briefly, **Pissarro**.

Julien-François (Père) Tanguy (1825–94) A former Communard, Tanguy was a merchant of paints and art supplies in Paris known especially for his generous dealings with struggling vanguard artists: he often accepted their works as payment and acted as an agent, though their paintings were difficult to sell. In 1875 **Chocquet** bought his first Cézanne paintings from Tanguy. As late as the early 1890s, his dark, narrow shop at 14 rue Clauzel was the only place in Paris where Cézanne's art could be seen regularly. When Tanguy's stock of paintings was sold at auction after his death in 1894, four works by Cézanne were acquired by the young **Ambroise Vollard**, who would become the artist's first proper dealer.

Vincent van Gogh (1853–90) Although he would acquire mythic status in modern art history, the Dutch painter was twenty-seven before he chose painting as a profession. After a solitary youth in rural Holland as the eldest son of a clergyman, Van Gogh was apprenticed as an art dealer in London and Paris in the early 1870s. But his deep-seated evangelical fervour conflicted with the demands of business, and he studied and worked as a preacher in Belgium before finally turning to painting full time in 1880. Van Gogh's sombre images from the early 1880s vividly recorded his sympathy for the rural poor. In 1886 the painter moved to Paris where he adopted new subjects, palettes and energetic brushwork that reflected his rapid absorption of Impressionism and Neo-

Impressionism. But in early 1888 Van Gogh left Paris for Arles, drawn to the Mediterranean light, rustic landscape, rural inhabitants and by a growing desire to establish a community of fellow artists. Though **Gauguin** would visit briefly late in 1888 and admire the bold new decorative style and brilliant colour of such paintings as *Sunflowers*, Van Gogh's lifelong emotional instability was soon intensified by recurrent attacks of insanity. By May 1889, the artist was hospitalized at the asylum at San Remy, where he painted his celebrated nocturnal vision, *Starry Night*. A year later he moved to Auvers-sur-Oise to be treated by Dr Gachet, who had befriended many of the Impressionists. Still plagued by illness, Van Gogh died in Auvers by his own hand in July 1890.

Ambroise Vollard (1867–1939) A native of Réunion, Vollard came to Paris as a law student, but after a brief apprenticeship with an established dealer, set up his own small art gallery in 1894 on the fashionable rue Laffitte. Vollard was introduced to Cézanne's art at **Tanguy**'s shop, bought four of the artist's works at the auction of Tanguy's estate, and soon became Cézanne's dealer. In 1895, he organized Cézanne's first one-man exhibition, showing 150 works on a rotating basis and establishing himself and Cézanne in avant-garde circles. Working closely with Cézanne's son, Vollard acquired a large stock of the artist's work over the next decade and became commercially successful as his dealer by attracting an international range of clients, including the Russian collector Sergei Shchukin, the German dealer Paul Cassirer, and the French industrialist Auguste Pellerin.

Émile Zola (1840–1902) Born in Paris but raised in Aix-en-Provence, Zola was Cézanne's closest boyhood friend in Aix and confidante during his early career in Paris. He rose to prominence in Paris in the 1860s as a journalist, art critic and defender of the realist painter **Manet**. Zola's first important novel, *Thérèse Raquin*, was published in 1867. In his subsequent work, Zola espoused the theories of French naturalism, and tried to apply scientific techniques of observation and analysis to his study of French society. In his massive series of twenty novels, *Les Rougon-Macquart* (1871–93), which included *L'Oeuvre* (1886), a critical portrait of the **Second Empire** art world and early Impressionism that ended his friendship with Cézanne, he studied the effects of heredity and environment on a single family. But despite his quasi-scientific methods, Zola's greater gift was for evoking modern urban life and the lower-class milieus his characters inhabited. An ardent social reformer, he wrote many anti-clerical attacks, and became most famous in his later career for his article 'J'Accuse' (1898), a bold attack on the French establishment over the controversial Dreyfus affair. Although he was prosecuted for libel, Zola's efforts led to a crucial retrial of Dreyfus. Zola died accidentally, suffocated by charcoal fumes.

Key Dates

Numbers in square brackets refer to illustrations

The Life and Art of Paul Cézanne

A Context of Events
(primarily French, unless otherwise noted)

1839 Paul Cézanne born at 28 rue de l'Opéra, Aix-en-Provence, 19 January

1840 Birth of Zola and Monet

1841 Birth of sister Marie

1841 Birth of Renoir, Bazille, Guillaumin and Guillemet

1844 Marriage of Cézanne's parents, Louis-Auguste Cézanne and Anne-Elizabeth-Honorine Aubert

1847 Couture, *Romans of the Decadence* [43] exhibited at the Salon.
Britain: Charlotte Brontë, *Jane Eyre*

1848 Revolution leads to abdication of the king, Louis-Philippe. Second Republic established. Louis-Napoleon elected president. Birth of Gauguin.
Germany: Karl Marx and Friedrich Engels, *The Communist Manifesto.*
Britain: Pre-Raphaelite Brotherhood founded

1849 François-Marius Granet dies leaving bulk of his estate to the museum in Aix

1851 *Coup d'état* of Louis-Napoleon.
Britain: Great Exhibition held in the Crystal Palace, London.
USA: Herman Melville, *Moby Dick*

1852 Enters Collège Bourbon in Aix (to 1858)

1852 Second Empire established. Baron Haussmann begins redevelopment of Paris

1853 Holland: Birth of Van Gogh

1854 Birth of sister Rose

1854 Le Félibrige formed.
Crimean War begins (to 1856)

1855 Universal Exposition. Courbet sets up his own 'Pavilion of Realism'

1857 Enrols at the École Gratuite de Dessin (Free Municipal School for Drawing) in Aix, where he studies under Joseph Gibert (until 1861)

1857 Flaubert, *Madame Bovary*

1858 Passes baccalaureate on 12 November

1858 Zola moves to Paris

1859 Studies Law at the University of Aix. Awarded second prize for painting at the École Gratuite. Father purchases the Jas de Bouffan in September

1859 Birth of Georges Seurat.
Frédéric Mistral, *Mirèio.*
Britain: Charles Darwin, *The Origin of Species*

1861 In Paris April–September. Attends Académie Suisse where he meets Camille Pissarro. Works in his father's bank upon his return

1861 Cabanel's *Nymph Abducted by a Faun* [38] exhibited at the Salon. Wagner's *Tannhäuser* produced at the Paris Opéra.
USA: Start of Civil War (to 1865).
Russia: Serfdom abolished by Alexander II

The Life and Art of Paul Cézanne	A Context of Events
1862 Leaves his father's bank. Returns to Paris in November and registers at Académie Suisse	**1862** Flaubert, *Salammbô*. Prussia: Otto von Bismarck becomes prime minister
1863 Exhibits at the Salon des Refusés. Applies for a permit to make copies in the Louvre. Meets Renoir through Frédéric Bazille	**1863** Death of Delacroix. Salon des Refusés includes Manet's *Déjeuner sur l'herbe* [21]
1864 Returns to Aix in July and in August is in L'Estaque	**1864** Switzerland: International Red Cross founded
1865 Most of the year in Paris. Submission to the Salon refused. Winter in Aix	**1865** Manet's *Olympia* [84] shown at the Salon. Britain: Lewis Carroll, *Alice's Adventures in Wonderland*
1866 February back in Paris. In the summer visits Bennecourt with Zola, Valabrègue and Baille, paints *A View of Bonnières* [51]. August to December in Aix. Takes walks with Marion and Valabrègue, whom he paints setting out for the motif [50], and paints palette-knife pictures [27–9, 31–3]	
	1867 Death of Ingres. Universal Exposition; Manet and Courbet hold their own exhibitions nearby. Zola, *Thérèse Raquin*. Mexico: Emperor Maximilian executed
1869 Spends most of the year in Paris. Meets Hortense Fiquet (b.1850)	**1869** Suez Canal opens. Birth of Henri Matisse. Flaubert, *Sentimental Education*
1870 Two works rejected by Salon – a nude (now lost) and *Portrait of Achille Emperaire* [104]. Witness to Zola's marriage on 31 May. Returns to Aix and spends autumn at L'Estaque with Hortense	**1870** France declares war on Prussia. Abdication of Napoleon III following French defeat at Sedan. Third Republic proclaimed, led by Adolphe Thiers. Paris besieged by Prussian troops. Death of Bazille in action
1871 Leaves L'Estaque in March, spends time in Aix and goes to Paris in the autumn	**1871** Paris capitulates to Prussians. Paris Commune declared in March. Brutally suppressed by government troops in May. France cedes Alsace and Lorraine in peace treaty with Prussia
1872 On 4 January Hortense Fiquet gives birth in Paris to a son, Paul. Family moves to Pontoise and then Auvers-sur-Oise. Cezanne works with Pissarro and copies one of his paintings [60–1]	**1872** Monet paints *Impression, Sunrise* [68]
	1873 Marshal MacMahon elected president. Prussian army of occupation leaves French territory
1874 *House of the Hanged Man, Auvers-sur-Oise* [67], *A Modern Olympia* [85] and a landscape exhibited at the first Impressionist exhibition 15 April–15 May. Cézanne then goes to Aix. Returns to Paris in the autumn. Pissarro paints his portrait [106]	**1874** First Impressionist exhibition. Flaubert, *Temptation of St Anthony*
1875 Part of the year in Aix. Meets Victor Chocquet through Renoir	**1875** Opera House designed by Charles Garnier opens in Paris
1876 Spends summer in L'Estaque	**1876** Second Impressionist exhibition. USA: Alexander Graham Bell invents the telephone
1877 Spends most of the year in and around Paris. Exhibits sixteen works, including *Bathers at Rest* [99] at third Impressionist exhibition	**1877** Third Impressionist exhibition. Zola, *L'Assommoir*. Death of Courbet in Switzerland. Britain: Queen Victoria proclaimed Empress of India

The Life and Art of Paul Cézanne	A Context of Events
1878 Spends time in Aix and L'Estaque. Hortense and Paul in Marseille. In March his father finds out about Hortense and Paul	**1878** Universal Exposition
1879 In March returns to Paris. In April moves to Melun with Hortense and Paul until spring 1880. Salon rejection even though Guillemet is a member of the jury. Visits Zola at Médan	**1879** Fourth Impressionist exhibition. Jules Grévy becomes president. USA: Thomas Edison invents the electric light bulb
1880 March to April 1881 in Paris. Paints at Médan in the summer, including *Château at Médan* [123]	**1880** Fifth Impressionist exhibition. Zola, *Nana*
1881 May to October in Pontoise with Pissarro. Meets Gauguin. In the autumn Hortense and Paul are in Paris and Cézanne in Provence	**1881** Sixth Impressionist exhibition. Control of the Salon is transferred from the state to the Société des Artistes Français. Spain: Birth of Pablo Picasso
1882 Renoir visits Cézanne in L'Estaque. In May a painting is accepted for the Salon	**1882** Seventh Impressionist exhibition. Birth of Georges Braque
1883 Renoir and Monet visit Cézanne in L'Estaque in December	**1883** Zola, *Au Bonheur des Dames*. Death of Manet. Britain: Death of Karl Marx
1884 Paul Signac buys *The Oise Valley* [126] in Père Tanguy's shop	
1885 Brief love affair in Aix. Attack of neuralgia in March. Visits Renoir at La Roche-Guyon. Also stays at Villennes and Vernon. By August back in Aix. In autumn moves to Gardanne (until summer 1886) with Hortense and Paul	
1886 Publication of Zola's *L'Oeuvre* ends their friendship. On 28 April marries Hortense in Aix. Father dies 23 October	**1886** Eighth and last Impressionist exhibition
1888 In Paris at end of year	**1888** Louvre exhibition of self-portraits. USA: George Eastman introduces the Kodak camera
1889 *House of the Hanged Man, Auvers-sur-Oise* [67] displayed at the Universal Exposition	**1889** Universal Exposition celebrates centennial of the French Revolution. Opening of the Eiffel Tower
1890 In January exhibits three paintings, including *House of the Hanged Man, Auvers-sur-Oise* [67], with Les Vingts in Brussels. Spends five months in Switzerland with Hortense and Paul. Hortense then goes to Paris and Cézanne returns to Aix. Begins to suffer from diabetes	**1890** Death of Van Gogh. London to Paris telephone line opened
1891 Hortense and Paul settle in Aix when Cézanne reduces their allowance. He lives at the Jas de Bouffan with his mother and sister Marie. Becomes a devout Catholic	**1891** Death of Victor Chocquet and Georges Seurat. Gauguin travels to Tahiti
1892 Works in the Forest of Fontainebleau. Émile Bernard publishes an article on Cézanne	
1894 Gustave Geffroy publishes an article on Cézanne in *Le Journal*. Cézanne visits Monet at Giverny	**1894** Death of Caillebotte leaving his collection to the French state. Death of Père Tanguy. Vollard opens gallery in rue Lafitte, Paris. Captain Alfred Dreyfus found guilty of treason

The Life and Art of Paul Cézanne	A Context of Events
1895 Begins Portrait of Gustave Geffroy [171]. First one-man show at Ambroise Vollard's gallery in November. Rents a hut at Bibémus quarry (to 1899)	**1895** Britain: Oscar Wilde, *The Importance of Being Earnest* USA: Stephen Crane, *The Red Badge of Courage*
1896 Meets Joachim Gasquet, son of his childhood friend Henri Gasquet, and paints his portrait [182]. Spends two months in the summer with Hortense and Paul at Talloires on Lac d'Annecy [184]. Autumn and winter in Paris	**1896** France annexes Madagascar
1897 Mother dies on 25 October	
	1898 Death of Achille Emperaire. Zola publishes 'J'Accuse', an open letter to President Faure in defence of Dreyfus. Pierre and Marie Curie discover radium
1899 Most of year spent in and around Paris. Paints *Portrait of Ambroise Vollard* [183]. Jas de Bouffan sold. Cézanne moves into Aix. Henri Matisse buys *Three Bathers* [94] from Vollard	**1899** Paul Signac, *D'Eugène Delacroix au neo-impressionnisme.* Death of Sisley
1900 Three paintings exhibited at the Universal Exposition	**1900** Universal Exposition. Paris metro system opens. Austria: Sigmund Freud, *The Interpretation of Dreams*
1901 In November purchases land for a studio at Les Lauves	**1901** Maurice Denis's *Homage to Cézanne* [201] exhibited at the Salon. Britain: Death of Queen Victoria. Marconi transmits first radio signals across the Atlantic
1902 Les Lauves studio completed in September. Makes will naming his son as sole heir	**1902** Death of Zola
	1903 Death of Gauguin in the Marquesas Islands and Pissarro in Paris. USA: Wright brothers make first powered flight
1904 Visited in Aix by Émile Bernard. An entire room is devoted to his work at the second Salon d'Automne in Paris	**1904** Frédéric Mistral joint winner of Nobel Prize in Literature
1905 Exhibition of his watercolours at Vollard's gallery. Works at Fontainebleau in the summer	**1905** The Fauves group of artists exhibit at the Salon d'Automne. Germany: Die Brücke Expressionist group formed in Dresden
1906 Visited by Maurice Denis in January. Dies at 23 rue Boulegon, Aix on 23 October (tombstone incorrectly says 22 October)	**1906** Picasso paints *Portrait of Gertrude Stein* [144] and *Boy Leading a Horse* [204]. USA: San Francisco earthquake

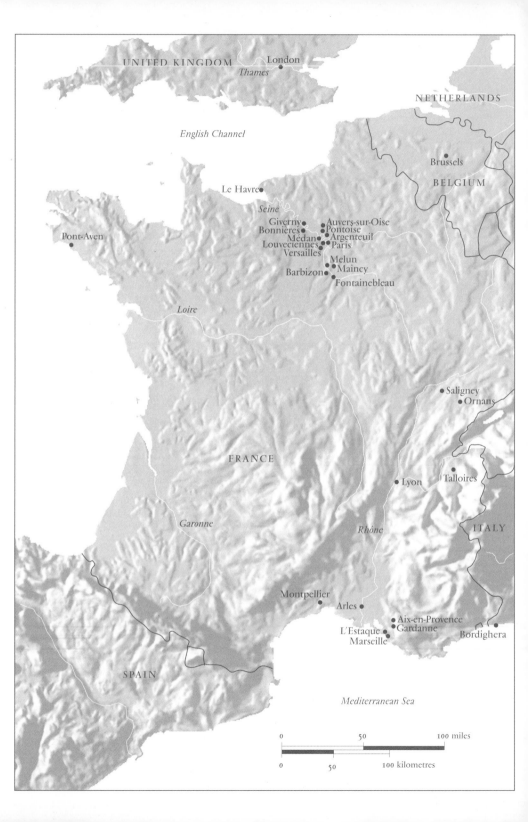

Further Reading

Primary Sources and Biographical Studies

Paul Cézanne, *Letters*, ed. John Rewald, trans. by Seymour Hacker (revised edn, New York, 1984)

P M Doran (ed.), *Conversations avec Cézanne* (Paris, 1978)

Joachim Gasquet, *Joachim Gasquet's Cézanne: A Memoir with Conversations*, trans. by C Pemberton (London and New York, 1991)

Camille Pissarro, *Letters to His Son Lucien*, ed. John Rewald (New York, 1943)

John Rewald, *Cézanne, A Biography* (New York and London, 1986)

Ambroise Vollard, *Cézanne* (Paris 1914, repr. New York, 1984)

Catalogues Raisonnés

Adrien Chappuis, *The Drawings of Paul Cézanne: A Catalogue Raisonné*, 2 vols (Greenwich, CT and London, 1973)

John Rewald, *Paul Cézanne: The Watercolours: A Catalogue Raisonné* (Boston and London, 1983)

John Rewald with Walter Feilchenfeldt and Jayne Warman, *The Paintings of Paul Cézanne: A Catalogue Raisonné*, 2 vols (New York and London, 1996)

Exhibition Catalogues (in chronological order)

Lawrence Gowing, *Cézanne* (Arts Council of Great Britain, London, 1954)

William Rubin (ed.), *Cézanne: The Late Work* (Museum of Modern Art, New York; Museum of Fine Arts, Houston, 1977–8)

Götz Adriani, *Cézanne Watercolors* (New York, 1983)

Joseph J Rishel, *Cézanne in Philadelphia Collections* (Philadelphia Museum of Art, 1983)

Denis Coutagne, *Cézanne au Musée d'Aix* (Musée Granet, Aix-en-Provence, 1984)

Lawrence Gowing, *Paul Cézanne: The Basel Sketchbooks* (Museum of Modern Art, New York, 1988)

Lawrence Gowing (ed.), *Cézanne: The Early Years 1859–1872* (Royal Academy of Arts, London; National Gallery of Art, Washington, DC; Musée d'Orsay, Paris, 1988–9)

Mary Louise Krumrine, *Paul Cézanne: The Bathers* (New York, 1990)

Denis Coutagne, *Sainte-Victoire, Cézanne 1990* (Musée Granet, Aix-en-Provence, 1990)

Richard Verdi, *Cézanne and Poussin: The Classical Vision of Landscape* (National Galleries of Scotland, Edinburgh, 1990)

Götz Adriani, *Cézanne Paintings* (Cologne, 1995)

Françoise Cachin and Joseph J Rishel (eds), *Cézanne* (Grand Palais, Paris; Tate Gallery, London; Philadelphia Museum of Art, 1995–6)

Terence Maloon (ed.), *Classic Cézanne* (Art Galleries of New South Wales, Sydney, 1998)

Katharina Schmidt (ed.), *Manet, Zola, Cézanne: Das Portrat des modernen Literaten* (Kunstmuseum, Basel, 1999)

Cézanne Watercolors (Acquavella Galleries, New York, 1999)

Cézanne und die Modern (Foundation Beyler, Basel, 1999)

Cézanne and Japan (Yokohama Museum of Art; Aichi Prefectural Museum of Art, Nagoya, 1999–2000)

Felix Baumann *et al.*, *Cézanne: Finished-Unfinished* (Kunstforum, Vienna; Kunsthaus, Zurich, 2000)

Monographic Studies and Critical Studies

Kurt Badt, *The Art of Cézanne*, trans. by Sheila Ann Ogilvie (Berkeley, CA, 1965)

Yve-Alain Bois, 'Cézanne: Words and Deeds', *October*, 84 (Spring 1998)

Françoise Cachin *et al.* (eds), *Cézanne aujourd'hui: Actes du colloque organisé par le musée d'Orsay, novembre 1995* (Paris, 1997)

Isabelle Cahn, *Paul Cézanne* (Paris, 1995)

Denis Coutagne, *Cézanne ou la peinture en jeu* (Limoges, 1982)

—, *Les Sites cézanniens du pays d'Aix* (Paris, 1996)

Douglas Druick, 'Cézanne's Lithographs' in William Rubin (ed.), *Cézanne, The Late Work*, op.cit., pp.119–138

Roger Fry, *Cézanne: A Study of His Development* (New York, 1927, repr. Chicago, 1989)

Tamar Garb, 'Cézanne, Identifying the Body', *Tate*, 8 (Spring 1996), pp.22–8

Clement Greenberg, *The Collected Essays and Criticism*, ed. John O'Brian, 4 vols (Chicago, 1986–93)

John House, 'Completing the Picture', *Tate*, 8 (Spring 1996), pp.29–33

Richard Kendall (ed.), *Cézanne and Poussin: A Symposium* (Sheffield, 1993)

—, 'Degas and Cézanne: Savagery and Refinement' in *The Private Collection of Edgar Degas* (exh. cat., Metropolitan Museum of Art, New York, 1997), pp.197–219

Jean-Claude Lebensztejn, 'Persistance de la memoire', *Critique*, 49 (August–September 1993)

Mary Tompkins Lewis, *Cézanne's Early Imagery* (Berkeley, CA, 1989)

Erle Loran, *Cézanne's Composition* (Berkeley, CA, 1943)

Pavel Machotka, *Cézanne: Landscape into Art* (New Haven and London, 1996)

Maurice Merleau-Ponty, 'Le Doute de Cézanne', *Fontaine*, 47 (December 1945)

Robert Ratcliffe, 'Cézanne's Working Methods and Their Theoretical Background' (PhD dissertation, University of London, 1960)

Theodore Reff, 'Reproductions and Books in Cézanne's Studio', *Gazette des Beaux-Arts*, 56:1102 (November 1960), pp.303–9

—, 'Cézanne's Constructive Stroke', *Art Quarterly*, 25:3 (Autumn 1962), pp.214–27

—, 'Copyists in the Louvre', *Art Bulletin*, 46:4 (December 1964), pp.552–9

—, 'The Pictures within Cézanne's Pictures', *Arts Magazine*, 53:10 (June 1979), pp.90–104

John Rewald, *Cézanne and America, Dealers, Collectors, Artists and Critics, 1891–1921* (Princeton and London, 1989)

Rainer Maria Rilke, *Letters on Cézanne*, trans. by Joel Agee (New York, 1985)

Joseph J Rishel, *Great Paintings from the Barnes Foundation* (New York and London, 1993), cat. entries pp.102–63

Meyer Schapiro, *Paul Cézanne* (New York, 1952)

—, 'The Apples of Cézanne: An Essay on the Meaning of Still-Life', *Art News Annual*, 34 (1968), pp.34–53, reprinted in *Modern Art: Selected Papers* (New York and London, 1978)

Richard Shiff, *Cézanne and the End of Impressionism* (Chicago and London, 1984)

—, 'Cézanne's Physicality: The Politics of Touch' in Salim Kemal and Ivan Gaskell (eds), *The Language of Art History* (Cambridge, 1991), pp.129–80

Paul Smith, *Interpreting Cézanne* (London, 1996)

Leo Steinberg, 'Resisting Cézanne: Picasso's "Three Women"', *Art in America*, 66:6 (November–December 1978), pp.114–33

Lionello Venturi, *Cézanne* (Geneva, 1978)

Richard Verdi, *Cézanne* (London, 1992)

Jayne Warman (ed.), 'L'Année Cézannienne', *Bulletin de la Société Paul Cézanne*, 1 (Aix-en-Provence, 1999)

Judith Wechsler, *The Interpretation of Cézanne* (New York, 1972)

Historical and Artistic Background

Albert Boime, *The Academy and French Painting in the Nineteenth Century* (New Haven and London, 1986)

Richard Brettell et al., *A Day in the Country: Impressionism and the French Landscape* (exh. cat., Los Angeles County Museum of Art, 1984)

Timothy J Clark, *The Painting of Modern Life: Paris in the Art of Manet and his Followers* (New York and London, 1985)

Nicholas Green, *The Spectacle of Nature: Landscape and Bourgeois Culture in Nineteenth-Century France* (Manchester and New York, 1990)

Robert L Herbert, *Impressionism: Art, Leisure, and Parisian Society* (New Haven and London, 1988)

Richard Hobbs (ed.), *Impressions of French Modernity* (Manchester, 1998)

Sara Lichtenstein, 'Cézanne and Delacroix', *Art Bulletin*, 46:1 (March 1964), pp.55–67

Patricia Mainardi, *Art and Politics of the Second Empire: The Universal Expositions of 1855 and 1867* (New Haven and London, 1987)

John McCoubrey, 'The Revival of Chardin in French Still-Life Painting, 1850–1870', *Art Bulletin*, 46 (March 1964), pp.39–53

Charles S Moffett et al., *The New Painting: Impressionism 1874–1886* (exh. cat., The Fine Arts Museums of San Francisco, 1986)

Linda Nochlin, 'Impressionist Portraits and the Construction of Modernity' in *Renoir's Portraits* (exh. cat., National Gallery of Canada, Ottawa, 1997), pp.53–75

—, *Cézanne's Portraits* (Lincoln, NE, 1996)

Philip Nord, *The Republican Moment: Struggles for Democracy in Nineteenth-Century France* (Cambridge, MA, 1995)

Daniel Pick, *Faces of Degeneration: A European Disorder, c.1848–1918* (Cambridge, 1989)

John Rewald, *The History of Impressionism* (4th revised edn, London and New York, 1973)

Jane Mayo Roos, *Early Impressionism and the French State, 1866–1874* (Cambridge and New York, 1996)

Robert Rosenblum, *Nineteenth Century Art* (New York, 1984)

—, *Paintings in the Musée d'Orsay* (New York, 1989)

James H Rubin, *Impressionism* (London, 1999)

Meyer Schapiro, *Impressionism, Reflections and Perceptions* (New York, 1997)

Aaron Sheon (essay), *Paul Guigou, 1834–1871* (exh. cat., William Beadleston Inc., New York, 1987)

Richard Thomson (ed.), *Framing France: The Representation of Landscape in France, 1870–1914* (Manchester, 1998)

Gary Tinterow and Henri Loyrette, *Origins of Impressionism* (exh. cat., Metropolitan Museum of Art, New York, 1994)

Martha Ward, 'Impressionist Installations and Private Exhibitions', *Art Bulletin*, 73:4 (December 1991), pp.599–622

Carol Zemel, *Van Gogh's Progress: Utopia, Modernity, and Late-Nineteenth-Century Art* (Berkeley, CA, 1997)

—, *Mon Salon, Manet, Ecrits sur l'art*, ed. Antoinette Ehrard (Paris, 1970)

Chapter 1

André M Alauzen, *La Peinture en Provence* (Marseille, 1984)

Marcel Bernos et al., *Histoire d'Aix-en-Provence* (Aix-en-Provence, 1977)

Frédéric Mistral, *The Memoirs of Frédéric Mistral*, trans. by George Wickes (New York, 1986)

Hugh Quigley, *The Land of the Rhone: Lyons and Provence* (Boston and London, 1927)

Chapter 2

Virginia Bettendorf, 'Cézanne's Early Realism: "Still Life with Bread and Eggs Reexamined"', *Arts Magazine*, 56:5 (January 1982), pp.138–41

Albert Boime, 'The Salon des Refusés and the Evolution of Modern Art', *Art Quarterly*, 32 (Winter 1969), pp.411–26

Fenton Bresler, *Napoleon III: A Life* (London and New York, 1999)

David P Jordan, *Transforming Paris, The Life and Labors of Baron Haussmann* (New York and London, 1995)

Chapter 3

Giula Ballas, 'Paul Cézanne et la revue "L'Artiste"', *Gazette des Beaux-Arts*, 98:1355 (December 1981), pp.223–32

Albert Boime, *Thomas Couture and the Eclectic Vision* (New Haven and London, 1980)

Pierre Drachline, *Le Crime de Pantin* (Paris, 1985)

Mary Louise Krumrine, 'Parisian Writers and the Early Work of Cézanne' in Lawrence Gowing (ed.), *Cézanne: The Early Years*, op.cit., pp.20–31

Mary Tompkins Lewis, 'Literature, Music and Cézanne's Early Subjects' in Lawrence Gowing (ed.), *Cézanne: The Early Years*, op.cit., pp.32–40

Theodore Reff, 'Cézanne, Flaubert, St Anthony, and the Queen of Sheba', *Art Bulletin*, 44:2 (June 1962), pp.113–25

Robert Simon, 'Cézanne and the Subject of Violence', *Art in America*, 79:5 (May 1991), pp.120–35, 185–6

Chapter 4

Albert Boime, *Art and the French Commune, Imagining Paris after War and Revolution* (Princeton, 1995)

Richard Brettell, *Pissarro and Pontoise: The Painter in a Landscape* (New Haven and London, 1990)

—, 'The "First" Exhibition of Impressionist Painters' in Charles S Moffett et al., *The New Painting*, op.cit., pp.189–202

—, 'Pissarro, Cézanne and the School of Pontoise' in Richard Brettell et al., *A Day in the Country*, op.cit., pp.175–204

Rupert Christiansen, *Tales of the New Babylon, Paris 1869–1875* (London 1994; New York, 1995)

L'Estaque, Naisance du paysage modern 1870–1910 (exh. cat., Musée Cantini, Marseille, 1994)

Alastair Horne, *The Fall of Paris. The Siege and the Commune, 1870–1871* (London, 1965, 2nd edn, 1989)

J Kaplow, 'The Paris Commune and the Arts' in J Hicks and Robert Tucker (eds), *Revolution and Reaction: The Paris Commune 1871* (Amherst, 1973), pp.144–67

Joachim Pissarro, *Monet and the Mediterranean* (exh. cat., Kimbell Art Museum, Fort Worth; Brooklyn Museum of Art, New York, 1997–8)

Jean Rollin, *La Commune de Paris 1870–71* (exh.cat., Musée d'Art et d'Histoire de Saint-Denis, 1971)

Jaques Rougerie, *Paris insurge, la Commune de 1871* (Paris, 1995)

Paul Tucker, 'The First Impressionist Exhibition in Context' in Charles S Moffett et al., *The New Painting, Impressionism 1874–1886*, op.cit., pp.93–117

—, 'Monet's "Impression, Sunrise" and the First Impressionist Exhibition: A Tale of Timing, Commerce and Patriotism', *Art History*, 7 (December 1984), pp.465–76

—, *Monet at Argenteuil* (New Haven and London, 1982)

Barbara Erlich White, *Impressionists Side by Side* (New York, 1996)

Chapter 5

Wayne Andersen, 'Cézanne's "L'Éternal féminin" and the Miracle of Her Restored Vision', *Journal of Art* (December 1990), pp.43–4

Timothy J Clark, 'Freud's Cézanne' in *Farewell to an Idea: Episodes from a History of Modernism* (New Haven and London, 1999)

Hollis Clayson, *Painted Love, Prostitution in French Art of the Impressionist Era* (New Haven and London, 1991)

Benjamin Harvey, 'Cézanne and Zola: a reassessment of "L'Éternel féminin"', *Burlington*, 140 (May 1998), pp.1312–8

John House, 'Cézanne and Poussin: Myth
and History' in Richard Kendall (ed.),
Cézanne and Poussin, A Symposium, op.cit.,
pp.129-149

Athena S Leoussi, *Nationalism and Classicism:
The Classical Body as National Symbol in
Nineteenth-Century England and France*
(London and New York, 1998)

Linda Nochlin, *Bathtime: Renoir, Cézanne,
Daumier and the Practices of Bathing in
Nineteenth-Century France* (Groningen, 1991)

Theodore Reff, 'Cézanne's "Bather with
Outstretched Arms"', *Gazette des Beaux-Arts*,
59:1118 (March 1962), pp.173-90

Richard Shiff, 'Cézanne and Poussin: How
the Modern Claims the Classic' in Richard
Kendall (ed.), *Cézanne and Poussin: A
Symposium*, op.cit., pp.51-68

Paul Tucker, 'Monet and Challenges to
Impressionism in the 1880s' in *Monet in the
90s, The Series Paintings* (exh. cat., Museum of
Fine Arts, Boston; Royal Academy of Arts,
London, 1989-90), pp.15-37

Chapter 6

Nina Athanassoglou-Kallmyer, 'An Artistic and
Political Manifesto for Cézanne', *Art Bulletin*,
72:3 (September 1990), pp.482-92

Theodore Reff, 'Pissarro's Portrait of
Cézanne', *Burlington*, 109 (November 1967),
pp.627-33

Chapter 7

William J Berg, *The Visual Novel: Émile Zola
and the Art of his Times* (University Park, PA,
1992)

Lawrence Gowing and John Rewald, '"Les
Maisons provençales": Cézanne and Puget',
Burlington, 132 (September 1990), pp.637-9

John House *et al.*, *Landscapes of France:
Impressionism and its Rivals* (exh. cat.
Hayward Gallery, London; Museum of
Fine Arts, Boston, 1995)

Patricia Mainardi, *The End of the Salon: Art
and the State in the Early Third Republic*
(Cambridge, 1993)

Jane Mayo Roos, 'Within the "Zone of
Silence": Manet and Monet in 1878', *Art
History*, 3 (1988), pp.372-407

Paul Smith, 'Joachim Gasquet, Virgin and
Cézanne's Landscape: "My Beloved Golden
Age"', *Apollo*, 148 (October 1998), pp.11-23

Chapter 8

Françoise Cachin and Charles S Moffet,
Manet, 1832-1883 (exh. cat., Metropolitan
Museum of Art, New York, 1983)

Philippe de Chennevières, 'Les Portraits
d'artistes au Louvre' in *Souvenirs d'un
directeur des Beaux-Arts* (Paris, 1889)

Michel Deleuil, *Paul Cézanne, Les quinze mois
à Gardanne, l'invention de la Sainte-Victoire*
(Paris, 1997)

Jean-Max Guieu and Alison Hilton (eds),
Émile Zola and the Arts (Georgetown, 1988)

Richard Shiff, 'Sensation, Movement,
Cézanne' in Terence Maloon (ed.), *Classic
Cézanne*, op.cit., pp.13-27

Chapter 9

Jean Sutherland Boggs *et al.*, *Degas* (exh. cat.,
Metropolitan Museum of Art, New York,
1988)

Mary Louise Krumrine, 'Les "Joueurs de
cartes" de Cézanne: un jeu de la vie' in
Françoise Cachin *et al.* (eds), *Cézanne
aujourd'hui*, op. cit., pp.65-74

Lynne Lawner, *Harlequin on the Moon:
Commedia dell'arte and the Visual Arts* (New
York, 1998)

—, 'Cézanne and Chardin' in Françoise Cachin
et al. (eds), *Cézanne aujourd'hui*, op. cit.,
pp.11-28

—, 'Cézanne's "Cardplayers" and Their
Sources', *Arts Magazine*, 55:5 (November
1980), pp.104-17

Martha Ward, *Pissarro, Neo-Impressionism, and
the Spaces of the Avant-Garde* (Chicago and
London, 1996)

Eugene Weber, *Peasants into Frenchmen: The
Modernization of Rural France, 1870-1914*
(Stanford, 1976)

Chapter 10

Tamar Garb, 'Visuality and Sexuality in
Cezanne's Late Bathers', *Oxford Art Journal*,
19 (1996), pp.46-60

Lawrence Gowing, 'The Logic of Organized
Sensations' in William Rubin (ed.), *Cézanne:
The Late Work*, op.cit., pp.55-71

James D Herbert, *Fauve Painting, The Making
of Cultural Politics* (New Haven and London,
1992)

Theodore Reff, 'Painting and Theory in
the Final Decade' in William Rubin (ed.),
Cézanne: The Late Work, op.cit., pp.13-53

John Rewald, 'Cézanne's Last Motifs at Aix' in
William Rubin (ed.), *Cézanne: The Late Work*,
op.cit., pp.83-106

Epilogue

Jack Flam, *Matisse on Art* (revised edn,
Berkeley, CA, 1995)

William Rubin, 'Cézannisme and the
Beginnings of Cubism' in *Cézanne: The
Late Work*, op.cit., pp.151-202

Peter Selz, *German Expressionist Painting*
(Berkeley, CA, 1954)

Index

Numbers in **bold** refer to illustrations

Acknowledgements

In writing this book, I am enormously indebted to the numerous Cézanne scholars listed in the Further Reading, several of whom offered advice and encouragement as well as authoritative models of scholarly research. Jayne Warman was also helpful in tracking down images, Betsy Coman at the National Gallery of Art in Washington kindly scoured the John Rewald Papers in the archives for obscure data, and Denis Coutagne and Anna Corsy generously enabled me to visit Cézanne's sites and the family estate in Aix. In addition, I have benefited much from new historical studies of Provence, the Franco-Prussian War and the Third Republic, from a wide range of recent exhibition catalogues, essays and scholarly lectures by John House, Tamar Garb, Linda Nochlin, Paul Tucker, Carol Zemel and others that encourage a broader cultural scope, and from my students at Trinity, who listened and asked the right questions. Finally, I must thank Paul F Ready for judicious counsel, Sarah Montague and Fronia Simpson for meticulous editing, the extraordinarily patient team at Phaidon Press, especially Julia MacKenzie, who contributed so much to the final product, and Jim Lewis, who survived this, too, with his usual aplomb.

This book is dedicated to Bridget and Brian, and to the memory of my father.

Photographic Credits

Acquavella Galleries Inc, New York: photo Scott Bowron 28; AKG London: 205, photo Erich Lessing 32, 54, 92, 107–8; Art Institute of Chicago: Anonymous Loan, photo © 2000 166, Helen Birch Bartlett Memorial Collection 175, A A Munger Collection, photo © 1999 100, Mr & Mrs Martin A Ryerson Collection, photo © 2000, photo courtesy of the Art Institute of Chicago 5; Artothek, Peissenberg: 53; Baltimore Museum of Art: Cone Collection 143, 187; Barnes Foundation, Merion, PA: 52, 89, 99, 136, 164, 168, 170, 178, 197; Bibliothèque Nationale de France, Paris: 35, 96; Bildarchiv Preussischer Kulturbesitz, Berlin: photo Jorg P Anders 66; Bridgeman Art Library, London: 45, 49, 195, 202; Bridgestone Museum of Art, Ishibashi Foundation, Tokyo: 97, 189; Christie's Images, London: 18, 50, 76, 90; Cincinnati Art Museum: gift of Mary E Johnston 24; Collection Rau, Zurich: 69, 174; Columbus Museum of Fine Art, Ohio: Museum Purchase, Howald Fund 112; Courtauld Institute Gallery, London: 177, gift (1932) 184, gift (1934) 134; Detroit Institute of Arts: 146; Edsel and Eleanor Ford House, Grosse Pointe Shores, MI: 191; Fitzwilliam Museum, University of Cambridge: 36, 119; Fogg Art Museum, Harvard University Art Museums: bequest of Annie Swan Coburn, photo David Mathews, image copyright President and Fellows of Harvard College 64; Foundation E G Bührle Collection, Zurich: 42, 142, 151, 158; Frances Lehman Loeb Art Center, Vassar College, Poughkeepsie, New York: bequest of Loula D Lasker, class of 1909 22; Giraudon, Paris: 39, 130, Lauros-Giraudon 38; J Paul Getty Museum, Los Angeles: 30, 93, 120 ; Glasgow Museums: the Burrell Collection 123, 172; photo Jacqueline Hyde, Paris: 126; Kröller-Müller Museum, Otterlo: 122; Kunsthaus Zurich: ©2000 all rights reserved 124; Metropolitan Museum of Art, New York: the Walter H & Leonore Annenberg Collection, partial gift of Walter H & Leonore Annenberg (1993) 31, (2000) 118; H O Havemeyer Collection, bequest of Mrs H O Havemeyer (1929) 133, 185, bequest of Gertrude Stein (1947) 144, bequest of Stephen C Clark (1960) 149; Mountain High Maps © 1995 Digital Wisdom Inc: p.340; Musée d'art et d'histoire, Genève: Fondation Jean-Louis Prevost, photo Yves Siza 98; Musée des Beaux-Arts, Dijon: 128; Musée Faure, Aix-les-Baines: 51; Musée Granet, Aix-en-Provence: photo Bernard Terlay 1, 6, 10, 12, 17, 23, 102, photo G Bernheim 192; Museum Folkwang, Essen: photo J Nober 186; Museum of Fine Arts, Boston: Juliana Cheney Edwards Collection (1939) 78, bequest of Robert Treat Paine 2nd 114, bequest of John T Spaulding 127, 180; The Museum of Fine Arts, Houston: gift of Audrey Jones Beck 77; The Museum of Modern Art, New York, photos © 2000 Museum of Modern Art: Joan & Lester Avnet Fund 161, acquired through the Lillie P Bliss Bequest 95, Lillie P Bliss Collection 103, gift of Mrs David M Levy 188, William S Paley Collection 129, 204; Nasjonalgalleriet, Oslo: photo J Lathion © Nasjonalgalleriet 1998 150; National Gallery, London: 2, 109, 115, 125, 179, 199, property of Graff Limited, photo courtesy National Gallery 106; National Gallery of Art, Washington, DC: Chester Dale Collection, 63, 177, gift of Mr & Mrs P H B Frelinghuysen in memory of her father and mother, Mr & Mrs H O Havemeyer, photo Lyle Peterzell 19, collection of Mr & Mrs Paul Mellon 27, 33, 88, photo Bob Grove 156; National Museums & Galleries of Wales, Cardiff: 81, 91; Board of Trustees of the National Museums & Galleries on Merseyside: 34; Öffentliche Kunstsammlung, Basel, Kupferstichkabinett: photo Martin Bühler 105, 138, 139, 155, 159, 181; Philadelphia Museum of Art: 194, Mr & Mrs Carroll St Tyson Jr Collection 113, Samuel S White III & Vera White Collection 145, Henry P McIlhenny Collection in memory of Frances P McIlhenny 148; purchased W P Wilstach Collection 200; Phillips Collection, Washington, DC: 203; Photothèque des Musées de la Ville de Paris: photo Pierrain 9, 94, 183; Picker Art Gallery, Colgate University, Hamilton, New York: gift of Joseph Katz 13; Portland Art Museum, Oregon: purchased with funds from private donors 58; RMN, Paris: 11, 16, 21, 29, 44, 46–7, 75, 121, 169, photo Arnaudet 37, 110, 135, 167, photo Bellot/Blot 171, photo J G Berizzi 84, 157, 160, 162, 190, photo Gérard Blot 154, photo B Hatala 104, photo C Jean 201, photo C Jean/Hervé Lewandowski 25, photo Hervé Lewandowski 43, 67, 71, 83, 85, 101, 116, 117, 141, 165, 196, photo R G Ojeda 79, 198; Roger-Viollet, Paris: 14, 56; Scala, Antella (Florence): 153; Sotheby's, New York: 15; Sterling and Francine Clark Art Institute, Williamstown, MA: 111; photo Studio Lourmel, Paris: 61; Tate Gallery, London: 57; Van Gogh Museum, Amsterdam: Van Gogh Foundation 74, 152; Yale University Art Gallery, New Haven, CT: collection of Mary C & James W Fosburgh, BA 1933, MA 1935 62

Phaidon Press Limited
Regent's Wharf
All Saints Street
London N1 9PA

First published 2000
© 2000 Phaidon Press Limited

ISBN 0 7148 3515 3

A CIP catalogue record for this book is
available from the British Library.

Typeset in Vendôme

Printed in Singapore

Cover illustration *Self-Portrait, c.*1880–1
(see p.183)